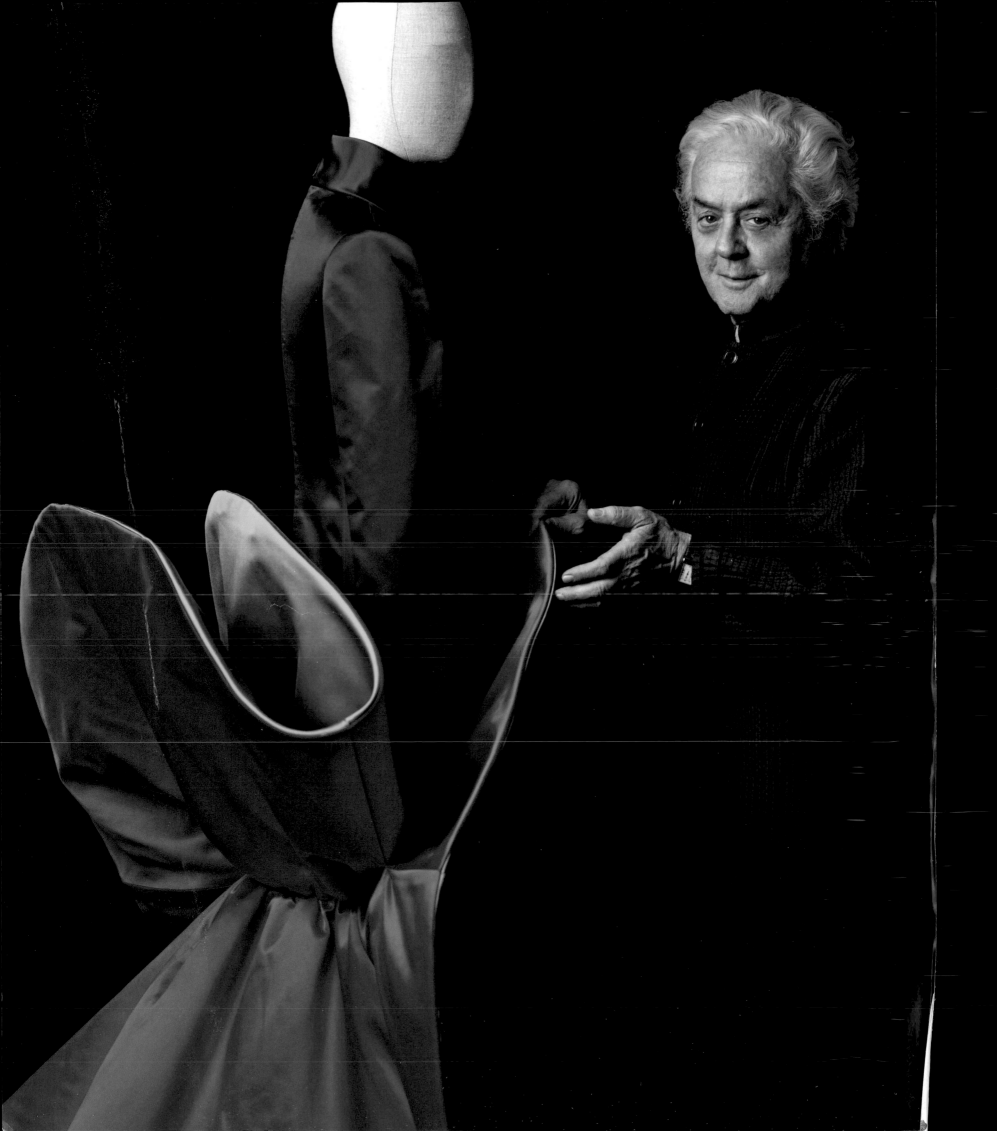

# ROBERTO CAPUCCI

# ROBERTO CAPUCCI ART INTO FASHION

DILYS E. BLUM

**Philadelphia Museum of Art**
in association with
**Yale University Press, New Haven and London**

Published on the occasion of the exhibition *Roberto Capucci: Art into Fashion*, Philadelphia Museum of Art, March 16–June 5, 2011

This exhibition was organized by the Philadelphia Museum of Art and the Fondazione Roberto Capucci, and funded by The Women's Committee of the Philadelphia Museum of Art, The Pew Charitable Trusts, The Annenberg Foundation Fund for Exhibitions, the Robert Montgomery Scott Fund for Exhibitions, and The Kathleen C. and John J. F. Sherrerd Fund for Exhibitions. Additional funding was provided by The Wyncote Foundation as recommended by Frederick R. Haas and Daniel K. Meyer, M.D., Barbara B. and Theodore R. Aronson, Mr. and Mrs. Jack M. Friedland, and Martha McGeary Snider, and by members of Le Capuccine, a group of generous supporters including Marla Green DiDio, Mr. and Mrs. Robert A. Fox, and Mr. and Mrs. Bernard Spain. Promotional support was provided by NBC 10 WCAU. This publication was supported by The Andrew W. Mellon Fund for Scholarly Publications.

[Credits complete as of December 9, 2010.]

*Front and back covers*: Sculpture Dress, 1980 (figs. 59a,b); *endpapers*: detail of figs. 75b,c; *frontispiece*: Roberto Capucci with his *Cerchio* (*Circle*) Sculpture (figs. 111a–e), 2009 (photograph by Fiorenzo Niccoli); *page 6*: detail of fig. 41

Produced by the Publishing Department of the Philadelphia Museum of Art
2525 Pennsylvania Avenue, Philadelphia, PA 19130
www.philamuseum.org

Published by the Philadelphia Museum of Art in association with
Yale University Press
PO Box 209040, 302 Temple Street
New Haven, CT 06520-9040
www.yalebooks.com/art

Edited by Sarah Noreika
Photography by Claudia Primangeli / L.e C. Service (except as noted)
Production by Richard Bonk
Designed by Andrea Hemmann, GHI Design, Philadelphia
Printed and bound in Singapore by Tien Wah Press Pte Ltd

**Notes to the Reader**
The designs by Roberto Capucci illustrated in this catalogue are from the collection of the Fondazione Roberto Capucci at the Villa Bardini in Florence. The foundation's object number for each design appears in parentheses at the end of the corresponding photography caption. Works in the foundation's collection are dated by year of creation.

**Library of Congress Cataloging-in-Publication Data**

Blum, Dilys, 1947–
  Roberto Capucci : art into fashion / Dilys E. Blum.
    p. cm.
  Published on the occasion of an exhibition held at the Philadelphia Museum of Art, Mar. 16–June 5, 2011.
  Includes bibliographical references.
  ISBN 978-0-87633-229-0 (PMA pbk.) — ISBN 978-0-300-16958-4 (Yale pbk.)
1. Capucci, Roberto, 1930—Exhibitions. 2. Fashion design—Italy—Exhibitions.
I. Capucci, Roberto, 1930– II. Philadelphia Museum of Art. III. Title.
IV. Title: Art into fashion.
  TT502.C355 2010
  746.9'2—dc22
                                        2010045296

# CONTENTS

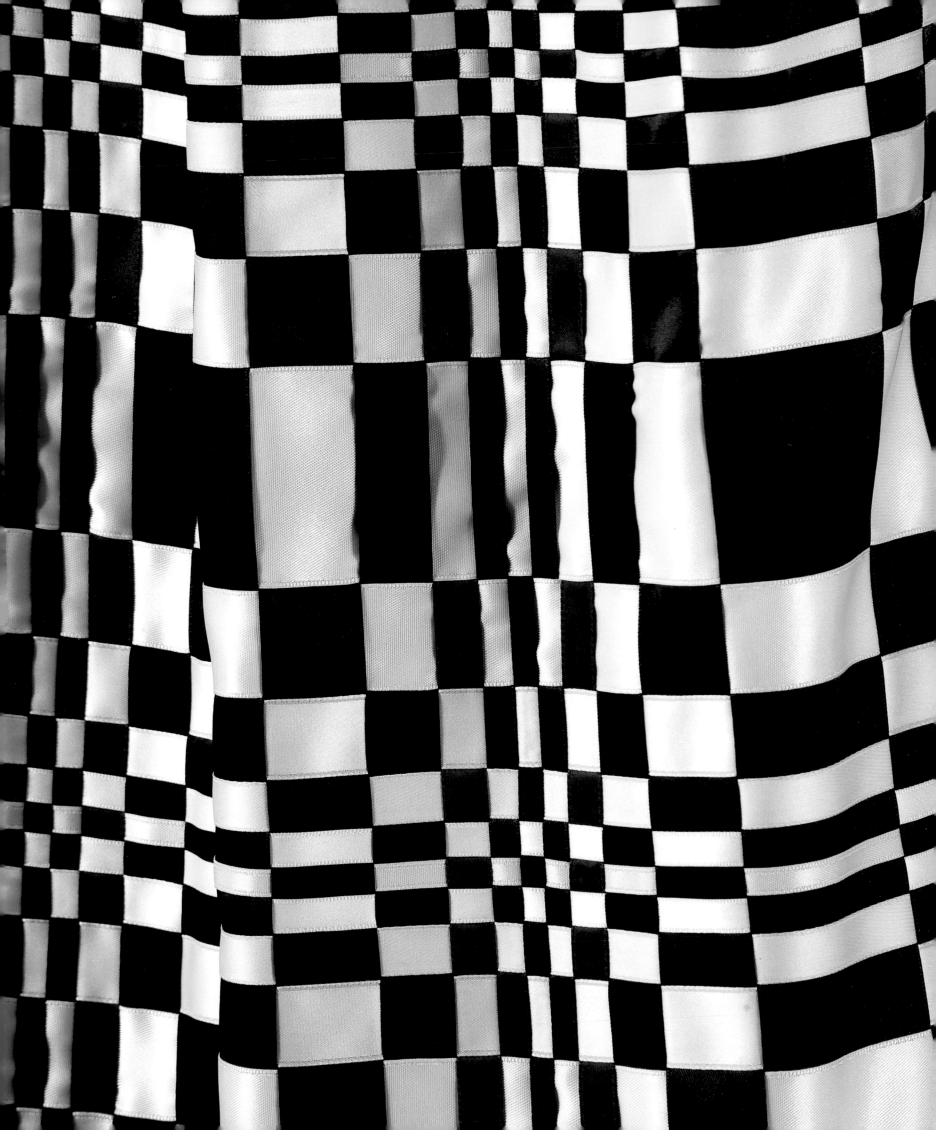

## FOREWORD

ONE OF THE GREAT TREASURES OF THE PHILADELPHIA MUSEUM OF ART is its remarkable collection of costume and textiles, which is among the finest of its type in the nation. Its utilization and continued development—aided in recent years by the opening of the Joan Spain Gallery for Costume and Textiles and the Dorrance H. Hamilton Center for Costume and Textiles, which features a state-of-the-art storage facility and study rooms—represent the long-term commitment that the Museum has made to presenting exhibitions and facilitating research in this important field.

One of the most significant developments, economic as well as artistic, in Europe in the decades immediately following World War II was the emergence of Italy as a leading player in the world of fashion design. This was par-alleled by success in many other fields, most notably filmmaking, and characterized by attributes for which Italy had long been admired: fine materials, skilled craftsmanship, and a sense of design—elegant, and yet playful—that was distinctive in its look and feel.

It was in this context, of the revitalization of Italy's economy and of its creative arts, that Roberto Capucci captured the attention of the fashion world at a remarkably young age. This catalogue and the exhibition it accompanies— the first of its kind in this country and, as such, a survey that is long overdue—tell the fascinating story of his early success as one of Europe's leading designers of haute couture and of the creative vision that has sustained Capucci's work over the past six decades.

I would like to express our thanks to several individuals who played an instrumental role in the development of this project. Dilys E. Blum, the Jack M. and Annette Y. Friedland Senior Curator of Costume and Textiles at the Philadelphia Museum of Art, enthusiastically pursued the possibility of an exhibition and has skillfully overseen the development of every aspect of this project. Martha McGeary Snider, a member of our Board of Trustees, was one of its early supporters and was an ardent—and effective—advocate for the presentation of Capucci's work to audiences here in the United States, for it is a regrettable fact that he is far better known in other parts of the world than in this country.

We are also grateful to the members of several departments within the Museum for their contributions, most notably to the staff of our Publishing Department, which produced this catalogue, so handsomely designed by Andrea Hemmann, and to Jack Schlechter and his colleagues in our Installation Design Department, whose lively and elegant exhibition design provided the perfect setting for the display of Capucci's work.

It is always a pleasure to express our appreciation to the many friends of the Philadelphia Museum of Art who support the programs and publications of our special exhibitions. *Roberto Capucci: Art into Fashion* was funded by The Women's Committee of the Philadelphia Museum of Art, The Pew Charitable Trusts, The Annenberg Foundation Fund for Exhibitions, the Robert Montgomery Scott Fund for Exhibitions, and The Kathleen C. and John J. F. Sherrerd Fund for Exhibitions. Additional funding was provided by The Wyncote Foundation as recommended by Frederick R. Haas and Daniel K. Meyer, M.D., Barbara B. and Theodore R. Aronson, Mr. and Mrs. Jack M. Friedland, and Martha McGeary Snider, and by members of Le Capuccine, a group of generous supporters including Marla Green DiDio, Mr. and Mrs. Robert A. Fox, and Mr. and Mrs. Bernard Spain. Promotional support was provided by NBC 10 WCAU. This publication was supported by The Andrew W. Mellon Fund for Scholarly Publications.

Finally, our greatest thanks go to Roberto Capucci himself and to the leadership and staff of the Fondazione Roberto Capucci in Florence. They have been the most gracious of partners, and it has been a great and lasting pleasure to work with them on the realization of this important project.

TIMOTHY RUB
*The George D. Widener Director and Chief Executive Officer*

## PREFACE AND ACKNOWLEDGMENTS

THE PHILADELPHIA MUSEUM OF ART is honored to present the first survey in the United States of the work of the visionary Italian couturier Roberto Capucci, renowned for his masterful use of colors and materials, and his unique creations that bridge fashion and sculpture. Capucci's story is intertwined with the rise of the Italian fashion industry and of Italian high fashion, under the enlightened guidance of Florentine nobleman Giovanni Battista Giorgini, during the postwar years. Capucci was born in December 1930 in Rome, where he attended the Liceo Artistico and the Accademia di Belle Arti from 1947 to 1950. He then served a brief apprenticeship with the Roman couturier Emilio Schuberth, a favorite among Italian actresses and aristocracy for his flamboyant and lavishly embroidered evening gowns. At age twenty Capucci opened an atelier in Rome on the Via Sistina, and shortly thereafter Giorgini invited him to present at the second Italian fashion showings in Florence in July 1951. He quickly rose to fame, winning acclaim from both the international and national press, which hailed his originality and ability to combine the wearability of fashion with virtuoso artistry. In 1980, however, after three decades of success, Capucci announced he would withdraw from the official couture calendar, and between 1982 and 1994 he staged solo presentations, no more than once a year, in grand architectural spaces in cities in Asia, Europe, and the United States. No longer held to the confines of the seasonal calendar or the fashion industry's increasing demands for mass-producible, less expensive styles, Capucci has embraced fully his medium as art, creating unique, wearable works—his "sculpture dresses"—and magnificent sculptures in fabric.

From the beginning Capucci has worked out his ideas in notebooks filled with hundreds of sketches, developing forms as series and variations, and reinterpreting and reconfiguring his ideas into innovative new shapes. Never afraid to break with tradition, his work combines the sensuality of the Italian baroque with surrealist fantasies tempered by non-Western aesthetics. Color is used to emphasize volume, and volume to emphasize color. Textile selection is crucial; Capucci chooses the fabric for a design only after he completes a colored drawing of it. The interpretation of the drawing is an almost spiritual event involving the talented hands of his workroom staff who manipulate and hand-sew layers upon layers of silk organza that form the understructures of the fantastic shapes of Capucci's sculpture dresses. Each work is unique, never to be duplicated. For Capucci the act of creation is a complete sensory experience, a synesthetic response to the world around him; he has described it as an assault—of art, beauty, color, emotion, music, nature, poetry. The geometry of his designs—achieved through manipulation of color, light, and materials—reveals the delicate balance between discordance and harmony. For the viewer the experience is magical and unforgettable.

Capucci's work has appeared in thirty-five monographic and more than forty collective exhibitions in Asia, Europe, and the Middle East, as well as in New York. In 1995 he received the ultimate honor when he was invited to show twelve original sculptures at the major international art exhibition, the Venice Biennale. Although as a young couturier Capucci established a strong presence in the American fashion market, since his resignation from the couture calendar—a decision that resulted in him having less presence in fashion advertisements and magazines, and almost no association with other commercial products, such as designer-label accessories—his name is less widely recognized in the United States, where his work has appeared in only a handful of group exhibitions, all in New York, including the monumental survey of postwar Italian art, *Italian Metamorphosis, 1943–1968*, at the Solomon R. Guggenheim Museum in 1994, which featured ten of his dresses.

The Philadelphia Museum of Art, with its early support of and long-standing appreciation for Italian art and fashion, is a fitting venue for this exhibition. In 1951, the year of Giorgini's first fashion showings in Florence, a benefit for the Museum's nascent Fashion Wing featured the work of leading American and European couturiers, including fourteen from Italy. Ten years later, in 1961, Philadelphia commemorated the centennial of Italian unification by hosting the Festival of Italy, for which Giorgini organized a fashion show featuring designs by his country's top couturiers, including Capucci. In 1966 Italian style again was celebrated here, during the Philadelphia Fashion Group's Crystal Ball, a fund-raiser to benefit the Museum's Fashion Wing. The event honored the Italian couturiers Arocle Datti, Princess Irene Galitzine, and Marchesa Olga di Gresy as well as the American expatriate Ken Scott, who worked in Milan.

This exhibition and catalogue owe their origins to the late Anne d'Harnoncourt, director of the Philadelphia Museum of Art, who introduced me to Capucci's creations. Prior to her death in 2008, we had discussed the possibility of an exhibition of his work, and fortuitous meetings with my friend and colleague Roberta Orsi Landini in 2007 at a textile conference in Como and in late 2008 in Florence helped further the idea. Roberta, who had been working as a consultant for the Fondazione Roberto Capucci, kindly arranged for me to meet with the foundation's director, Enrico Minio, with whom I began discussions about organizing an exhibition in Philadelphia. Museum trustee Martha McGeary Snider, who coincidentally also was visiting Florence, shared my excitement for the small exhibition of the designer's work then on view at the Capucci foundation, and enthusiastically offered her support to the project.

The Fondazione Roberto Capucci was established in September 2005 at the Villa Bardini in Florence to preserve and promote Capucci's creations and contributions, and to encourage the originality and superior artistry and craftsmanship for which Italy is renowned by providing a place for artists of various disciplines to exchange ideas and engage in technical workshops and innovative projects. The foundation maintains an archive of Capucci's work comprising more than twenty thousand sketches, four hundred designs, three hundred drawings, and twenty model books, as well as audiovisual materials, photographs, and press clippings.

In 2009, shortly after his appointment as the Museum's Director, Timothy Rub, along with President Gail Harrity and Deputy Director Alice Beamesderfer, gave his wholehearted approval of the exhibition and publication. My discussions with Sherry Babbitt, the Museum's Director of Publishing, helped the catalogue achieve its present form, providing an introduction to Capucci in the context of the rise of the Italian fashion industry and its American connections, while remaining at its core a visual survey of his magnificent works created between 1951 and 2007, captured so beautifully in the stunning photographs by the exceptionally talented Claudia Primangeli. My deep gratitude goes to the museum's Publishing staff, particularly Sarah Noreika, who moved the catalogue forward at an accelerated pace, and Richard Bonk for so capably seeing the project through its final stages. Andrea Hemmann of GHI Design in Philadelphia embraced the project readily, and to her I am indebted the fabulous design of this book.

A project such as this requires the support of many talented individuals from institutions here and abroad. I extend my sincere gratitude to Cristina Acidini and Caterina Chiarelli, Polo Museale Fiorentino, Florence; Hamish Bowles, *Vogue* magazine, New York and Paris; Neri Fadigati, Archivio Giorgini, Florence; Nan Halperin, ITN Source, New York; Joy S. Holloway, ABC News VideoSource, New York; Linda Moroney, John Lewis Partnership, London; photographers Fiorenzo Niccoli and Amedeo Volpe; Lisa Raven and Allen Sabinson, Drexel University, Philadelphia; couturier Ralph Rucci; and Rosina Rucci. For the wonderful historical photographs in this catalogue I offer my thanks to Kathleen Adelson, Katherine Baird, Alessandra Biagianti, Matteo Di Castro, Alex Deluca, Michelle Franco, Lorraine Goonan, Joshua Greene, Ghyslaine Leroy, Gerben van der Meulen, Mariangela Mignone, Miriam Neugebauer, Barbara Nicolini, James Penrod, Ulrich Pohlmann, Lori Reese, Rudolf Scheutle, Elke Seitz, Carlos Silva, Lauren Stanley, Elisabeth Stürmer, and Vanessa Usov.

I am honored to have such dedicated and talented colleagues at the Philadelphia Museum of Art, many of whom offered assistance, enthusiasm, and guidance. My sincere gratitude goes to the staffs of the departments of Communications; Costume and Textiles, especially Laura Camerlengo; Development; Editorial and Graphic Design; Education, particularly Marla K. Shoemaker and Mary Teeling; Installation Design, in particular Jack Schlechter; and the Library and Archives; as well as to Carlos Basualdo and Adelina Vlas, Modern and Contemporary Art; Conna Clark, Rights and Reproductions; Tara Eckert, Office of the Registrar; Bill Ristine, Information Services; Eliza deForest Johnson and Suzanne F. Wells, Special Exhibitions; and Jason Wierzbicki, Photography. Furthermore, I am so fortunate to work with passionate and supportive museum committees, including the Costume and Textiles Committee, chaired by trustee Barbara B. Aronson, and the Women's Committee of the Philadelphia Museum of Art.

Finally, this project would not have been possible without the support and cooperation of the Fondazione Roberto Capucci and its staff, especially Enrico Minio, Serena Angelini Parravicini, and Ilaria de Santis, as well as Roberta Orsi Landini. Above all, my profound thanks go the artist, Roberto Capucci, whose work continues to keep me in awe.

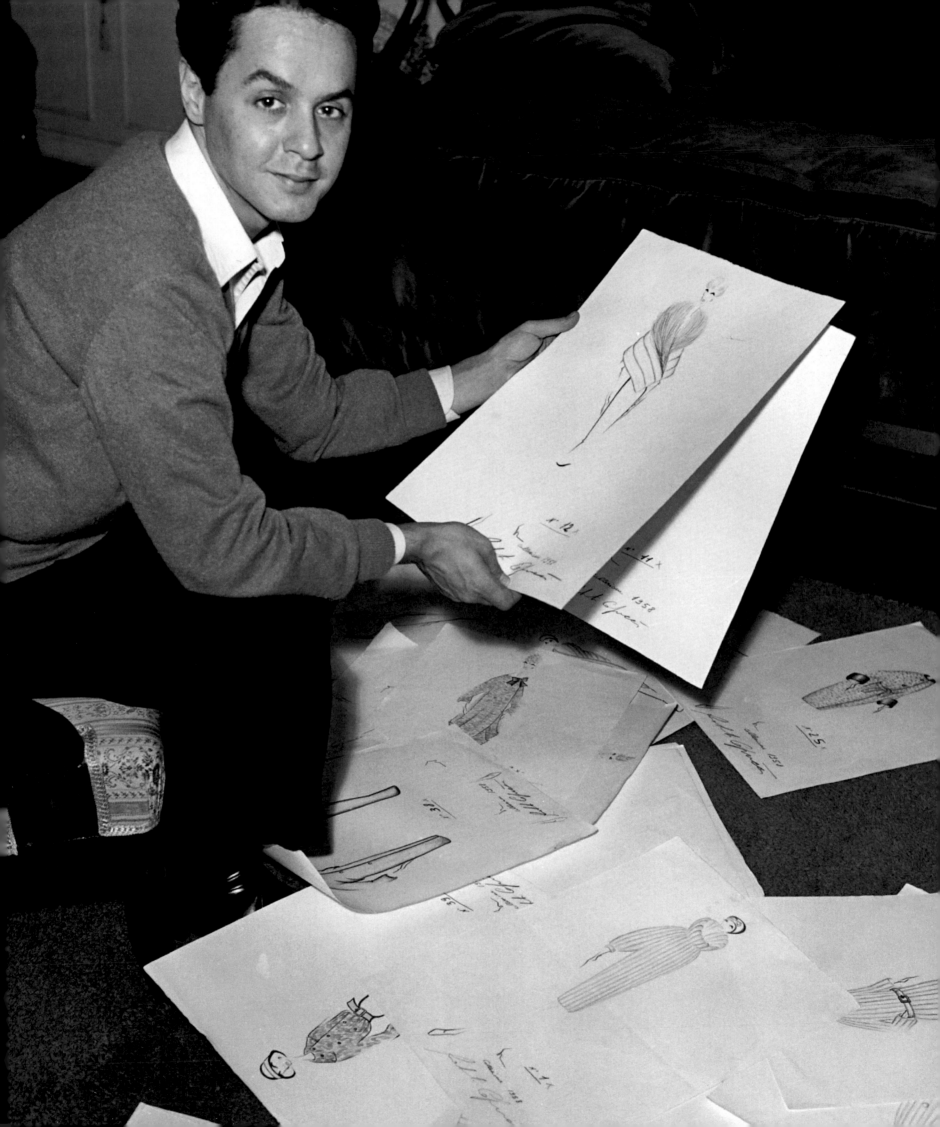

# Roberto Capucci and the Birth of Italian Fashion, 1951–61

IN ITALY ONE OF THE MAJOR OBJECTIVES OF THE VARIOUS POST–WORLD WAR II reconstruction programs, such as the U.S. Government's Marshall Plan, was the revitalization of its textile industry.[1] Yet, despite the country's established textile manufacturers and long history of fine craftsmanship, Italy (a unified country as of only 1861) lacked an organized fashion industry. From the aftermath of the war, however, emerged new and passionate creative talent—artists, writers, designers. This surge of creativity coupled with the war-related disruption of the historically dominant French couture presented Italy with the opportunity to establish a presence in the international fashion market. In January 1947 *Vogue* correspondent Marya Mannes observed that Italy had "everything necessary to a vital and original fashion industry: talent, fabric, and beautiful women"; what the country lacked was the "expert direction" to exploit its resources.[2]

During this period the burgeoning filmmaking industry in Italy played a crucial role in the rise of Italian style. The low production costs and the modern studios of Cinecittà, founded in Rome (the "Hollywood on the Tiber") by Fascist leader Benito Mussolini in 1937, enticed American moviemakers abroad.[3] Hollywood studios filming in Italy hired local dressmakers to produce wardrobes for films such as Mervyn LeRoy's *Quo vadis?* (1951) and Joseph L. Mankiewicz's *Barefoot Contessa* (1954), thereby bringing the country's fashion to the attention of U.S. audiences. Moreover, Hollywood movie stars on location in Rome sought the city's top couturiers for their private wardrobes, providing further publicity of Italian designs.[4]

It would take the enterprising genius and "expert direction" of one man, Florentine aristocrat and businessman Giovanni Battista Giorgini (1898–1971), to give birth to the modernized Italian fashion industry.[5] Since 1923 "Giovan" Giorgini had been the buying agent for several leading American department and specialty stores, purchasing for his clients Italian furniture and crafts, including embroidered linens, fine Florentine leathers, and hand-painted ceramics. I lis experience with the demands of U.S. buyers inspired him to centralize the Italian fashion presentations in one place, Florence. The premise was simple yet innovative: Fashion showings would be combined into one grand event, replacing the current practice of dressmakers presenting their collections individually at their ateliers in Florence, Milan, Rome, or Turin. By uniting the shows it would be possible to promote the idea of, and the sale of, Italian fashion of purely Italian inspiration.

**THE FIRST ITALIAN FASHION SHOW, FEBRUARY 12, 1951**

In February 1951, following the spring/summer haute couture openings in Paris, a group of nine American buyers arrived at Giorgini's eighteenth-century villa in the beautiful, walled Torrigiani garden in the center of Florence for the first collective showing of Italian fashion. Giorgini had asked nine couturiers and four boutiques, representing Italy's best designers, to participate: from Capri, Baroness Clarette Gallotti's boutique, La Tessitrice dell'Isola (founded c. 1947), which was renowned for hand-woven fabrics; from Florence, boutique designer Emilio Pucci (1914–1992), who showed skiwear; from Milan, couturiers Germana Marucelli (1905–1983), Vita Noberasko (active c. 1940s–52), and Jole Veneziani (1901–1989), the couture dress shop Vanna (founded 1930s), and the boutiques of Giorgio Avolio (active c. 1950s–70s) and Mirsa (active 1937–84), Marchesa Olga di Gresy's knitwear company; and from Rome, designers Alberto Fabiani (1910–1987), Emilio Schuberth (1904–1972), and Countess Simonetta Colonna di Cesaro Visconti (professionally known as Simonetta; born 1922), and the fashion houses Carosa (established in 1947 by Princess Giovanna Caracciolo di Avellino Ginnetti) and Sorelle Fontana (founded 1944).

Fig. 1. Federico Patellani (Italian, 1911–1977). Roberto Capucci with some of his sketches, Rome, 1958. © Studio Patellani / Corbis

The first day of the three-day event entailed presentations of boutique (high-quality ready-to-wear), day-, leisure, and sportswear; the second day was free so guests could explore Florence; and the third day featured showings of evening wear, which took place between a cocktail reception and a ball that was attended by Florentine society who, at Giorgini's request, wore fashions of "pura inspirazione italiana" (pure Italian inspiration).[6] During the presentations, models paraded through the villa's elegant drawing room, displaying a total of 180 designs to fashion buyers who represented some of Giorgini's most important clients: the department stores B. Altman and Bergdorf Goodman, of New York; Henry Morgan of Montreal; and I. Magnin of San Francisco. Also in attendance were three unexpected guests from New York who coincidentally were in Florence and had heard about the show—importer Ann Roberts, dress designer and ready-to-wear manufacturer Hannah Troy, and Martin Cole of manufacturer Leto Cohn Lo Balbo—and five Italian journalists, including Elisa Massai, the correspondent for the American trade paper *Women's Wear Daily*.[7] The buyers who were particularly impressed by the hand-embroidered formal gowns and the fine textiles—especially the cottons, silks, and wool tweeds—wired home for allowances. Troy, who would receive the Italian government's Star of Solidarity in 1954 for her influential promotion of the country's fashions, bought extensively from three designers—Simonetta, Sorelle Fontana, and Veneziani—and the copies she produced were sold that spring in the United States, at Lord and Taylor and Jay Thorpe.

**THE SECOND ITALIAN FASHION SHOW, FALL/WINTER 1951–52**

The reports from those who attended Giorgini's first presentation were so enthusiastic that in July 1951 his second show—which he had moved to a more formal setting, the Grand Hotel in Florence—attracted many more buyers than expected: Over three hundred American and international fashion-industry representatives crammed into the hotel's ballroom. *Harper's Bazaar* editor Carmel Snow, who had been unable to attend the February event and had made a particular effort to be at the second show, recalled that "the big open square between the Grand Hotel and the Excelsior [hotel] looked like an extension of Seventh Avenue."[8] Couturiers from Capri, Florence, Milan, Rome, and Turin presented *alta moda* (high-fashion) collections as well as sportswear and boutique clothes. The following month fashion editor Sally Kirkland, who covered the show for *Life* magazine, introduced Italy's leading dressmakers to an American audience in a nine-page article featuring photographs by the legendary Milton H. Greene (1922–1985), including an illustration of Giorgini with his designers.[9]

One couturier not included in the lineup was twenty-one-year-old Roberto Capucci (born 1930; see figs. 1 and 3), who had opened an atelier the previous year on Rome's Via Sistina. Capucci was eighteen when he first sold a design, to Marcella de Marchis Rossellini, then wife of Italian film director Roberto Rossellini. Although his mother and stepfather had wanted him to pursue a more traditional career as an engineer or a lawyer, he wanted to become an architect or a set designer. His parents relented, and after attending art school Capucci served a brief apprenticeship with the renowned Roman couturier Emilio Schuberth, whose elaborate evening gowns were favored by Italian actresses and noblewomen. Giorgini recently had seen the young designer's sketches and instantly recognized his talent and potential. At the last minute he invited Capucci to present five outfits at the closing ball; the other couturiers, however, refused to show with him, protesting he was too young and inexperienced. As a result, the day after the final presentations and the ball (to which Giorgini's wife and daughter, Matilde, wore gowns by Capucci), he showed his collection at Giorgini's home—and sold everything. The media, intrigued by the controversy and the designer who had come out of nowhere, called Capucci a "genius" and the "boy wonder," and praised his debut collection's theatrical look, as seen in his dramatic black wool velour coat lined with leopard fur (fig. 2).[10]

The French press viewed Giorgini's efforts as a direct challenge to Paris, referring to him as "l'ennemi numéro 1 de la couture parisienne." They accused the Italian designers not only of plagiarizing the latest styles, but even worse, of psychological warfare at a time when Paris couture was on the road to recovering its prewar dominance through new talent such as Christian Dior (1905–1957).[11] American journalists, however, insisted that the Italian couturiers were not attempting to supplant the French capital as the high-fashion center, emphasizing that Paris designs remained the most original and trendsetting. Rather, they commented on the distinctive qualities of Italian fashions (particularly of the more casual styles) that would attract U.S. buyers: the tradition of the "fine Italian hand," as evident in the exquisitely worked hand embroidery, needlework, and tailoring; the magnificent woven fabrics; the rich, beautiful colors; the original sportswear and beachwear designs (which would appeal particularly to buyers and manufacturers in California); and of course, the fair prices.[12]

The September 1951 issue of *Vogue* noted that while the Italian market had "fabrics, leathers, basket work, sweaters, and good workers," its dress industry did not yet know how to produce or sell in quantity.[13] An obvious solution

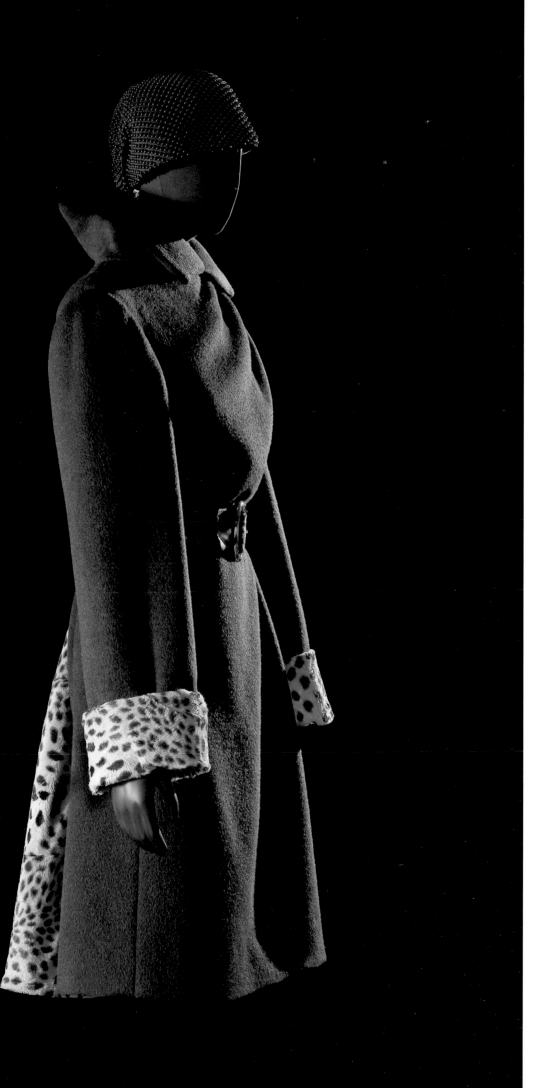

Fig. 2. Coat, 1951, wool velour lined with
leopard fur (later relined with synthetic fur)
(N.183)

was for Italian designers to contract with American department stores and manufacturers. Immediately after Giorgini's second show, Manhattan-based specialty store Bergdorf Goodman arranged for Simonetta, one of the stars of the Florence presentations, to design a special collection of forty pieces that the store would launch in November, and American manufacturer David Crystal Inc. negotiated the exclusive reproduction and U.S. distribution of Pucci's sportswear.[14] Other department and specialty stores soon advertised copies and adaptations produced by their own workrooms or by other American companies. Gimbel Brothers, familiarly known as Gimbels, advertised adaptations of suits and cocktail and evening gowns by Milanese and Roman designers, while Best's Apparel in Seattle featured couture evening gowns by Vanna, sweaters by Roman knitwear designer Laura Aponte (1906–1990), and boutique items including colorful hand-woven cotton skirts.

Giorgini's undertaking in Florence to promote the country's fashion industry was paralleled by efforts in other cities in Italy and in the United States. In August 1951 Franco Marinotti, president of Snia Viscosa, Italy's largest producer of artificial silk, founded the Centro Internazionale delle Arti e del Costume (International Center of the Arts and Costume) to promote new textiles, including synthetics, and to document and display period textiles and historic fashions in an effort to encourage design. The next month the center sponsored a series of fashion shows, held in the eighteenth-century Palazzo Grassi in Venice, as part of the city's Biennale art exhibition. One presentation showcased cocktail and evening wear as well as furs by twelve designers and eight furriers, from Florence, Genoa, Milan, Rome, and Turin. Another show featured designs by members of the Incorporated Society of London Fashion Designers. (French designers had declined to participate.) Although the foreign press and buyers praised the Italian fashions, they agreed Italy's couture was not yet a threat to that of Paris in terms of inspiration.[15]

Fig. 3. Federico Garolla (Italian, born 1925). Capucci with model Luisa Ardenghi, Rome, 1953. © Federico Garolla / Contrasto / Redux

That September in the United States, Macy's department store, backed by the American and Italian governments, launched a one-million-dollar sale of Italian imports in its New York flagship store. The exposition, *Italy-in-Macy's, U.S.A.* (September 10–26, 1951), featured a lavish display billed as the "second Renaissance" of Italian craftsmanship. The display included a full-size Venetian gondola and a massive model of St. Peter's Basilica alongside Italian-made handicrafts, motorcycles, and daily fashion shows of original clothing designs paired with Macy's-made line-for-line copies. The store's forty-eight windows displayed special antique-bronze-colored mannequins with heads sculpted after Classical Roman prototypes, and on the Broadway side, panels painted by the fashionable decorative artist Piero Fornasetti (1913–1988) from Milan.[16] A directory of makers distributed to wholesalers and retailers helped stimulate American awareness of Italian products. The Macy's fair was an enormous success and one of a number of events organized in the United States to endorse Italian products, including the major traveling exhibition *Italy at Work*, which had opened at the Brooklyn Museum in November 1950 and featured 2,500 Italian craft objects, such as hand-woven textiles.[17]

**THE THIRD ITALIAN FASHION SHOW, SPRING/SUMMER 1952**

Giorgini's third show, scheduled for five days instead of three, opened on January 18, 1952, at the Grand Hotel. Capucci presented a small boutique collection that featured dresses with medieval-inspired details, including pleated godets set into circular skirts. At a group show in Rome in April 1952 he reprised this collection, although with several additions: a copper-colored organza afternoon dress with sleeves puffed at the elbow above long, straight, white piqué cuffs; and a dramatic white organza evening gown with an enormous pocket apron, paired with a plaid-patterned stole in appliquéd raffia. The other couturiers also presented expanded spring/summer collections, including adaptations of the latest Paris fashions that were intended for their local customers.

Fabiani and Simonetta did not present in Florence this season, as they had decided to show exclusively in Rome, where their ateliers were located. The couturiers' break with Giorgini and the formation that year of the government-backed Italian Fashion Service for the promotion of fashion shows in Milan and Turin underlined the difficulty Giorgini faced in advocating Florence as the center of Italian couture, as the city was for art and culture. The different factions threatened to derail his dream of developing an Italian fashion industry that would equal that of Paris, if not displace it. Moreover, because Giorgini required his designers to pledge to use only Italian-made materials and designs, Paris couturiers had threatened to cut off the supply of models to dressmakers who participated in his presentations. As a result, several of the smaller Italian houses decided not to show in Florence, as they relied on French-influenced styles for the home market.

Italian fashion, especially the sportswear and playclothes, was finding a ready and appreciative audience in the United States.[18] The French were acutely aware of the danger of losing the critical American market to the Italian interlopers—who had made clear their interest in U.S. buyers and were heavily promoting their fine craftsmanship and reasonable prices (10 to 20 percent below those of Paris that season).[19] Moreover, the Italian designers had the opportunity to learn from the mistake Paris couturiers had made, of catering to a limited customer base of millionaires and movie stars, and instead could concentrate on classic but chic, wearable designs that could easily be copied and would appeal to the more casual American market.

Many of Italy's leading couturiers were gaining international recognition as U.S. manufacturers increasingly copied or adapted their designs. Although the Italian press had been following Capucci's rise closely, the American media now was beginning to take notice. In one of his first interviews for an American newspaper, the designer explained: "My styles are a lot different. I aim for the young, thin, tall girls. I serve youth à la mode."[20] The article described a typical Capucci design as having a high, small collar and a bell-shaped skirt of silk taffeta, and noted his interest in nontraditional materials, such as straw, with which he would experiment further during the 1970s and 1980s (see figs. 53a,b and 54a,b).

Trade fairs like *Italy-in-Macy's* helped acquaint the public with Italian products and served as springboards for increased imports. On May 28, 1952, the exposition *Italy Today* opened in New York at the Grand Central Palace. Fashion editor Barbara Fisher commented that since New York was the largest "Italian" city in the world after Rome (with 1.5 million New Yorkers of Italian birth), the fair was especially welcomed.[21] The exposition of the associated Italian manufacturers showcased Italy's best postwar arts, crafts, and industries, including products from one hundred Italian accessory, apparel, and textile manufacturers as well as a display of Italian fashions from ancient times though the present, a "real" Italian village, and daily fashion shows with glamorous models wearing clothing

by some of Italy's top couturiers: from Milan, Giovanni Fercioni (1886–1961), Germana Marucelli, Giuseppina Tizzoni (1889–1979), the boutique Vanna, and Jole Veneziani; and from Rome, Maria Antonelli (1903–1969), Princess Gabriella di Giardinelli's Gabriellasport (founded 1930s), and Emilio Schuberth as well as the fashion houses of Carosa and Sorelle Fontana. Unfortunately, transit difficulties delayed the arrival of the work of Marucelli, Veneziani, and Sorelle Fontana, so their designs were not presented in the opening gala.

In the spring of 1952 several Italian designers announced tie-ups with American companies. Micol Fontana of Sorelle Fontana and New York dress manufacturer Tafel Gowns formed a partnership under the name Tafel-Fontana. Gimbels in Philadelphia sold, at "thrifty Gimbel prices," line-for-line copies of casual clothes by Emilio of Capri (Pucci's first boutique), Simonetta, and Veneziani in its sportswear and specialty corner.[22] Fabiani created fall collections for two New York clothing manufacturers: a dress collection for Don-Ell Fashions Inc. and a coat collection for Monarch Garment Co. In August Russeks, a Fifth Avenue department store, launched a line of fashions designed by Fabiani and made in the United States.

## THE FOURTH ITALIAN FASHION SHOW, FALL/WINTER 1952-53

In July 1952 Giorgini moved the fourth fashion show to the Sala Bianca, the magnificent white ballroom in the Palazzo Pitti, where fashion shows in Florence would be held until 1982.[23] More international buyers attended than in previous seasons, arriving from Germany, Great Britain, the Netherlands, Scandinavia, and Switzerland. Although two of Italy's leading couturiers, Schuberth and Sorelle Fontana, had chosen to show in Rome with Fabiani and Simonetta, in Florence the participation of Italian fabric companies was expanded greatly with the support of the selling agent Ital Viscosa, which represented textile manufacturers Cotonificio Valle Susa, Lini e Lane, and Snia Viscosa. Critics extolled Italy's fabrics, and suggested that Italian textile companies not only produce special fabrics for the couture but also provide it with a firm economic foundation, as French textile magnate Marcel Boussac had done for Dior.[24] Similar partnerships would develop over the following seasons.

For the first time Capucci showed with the high-fashion group, and his collection looked strikingly modern against the splendid rococo interior and crystal chandeliers of the Sala Bianca. The *New York Times* applauded "the vigor, imagination and uninhibited originality of the young designer's work."[25] Capucci's stunning fabrics, inventive pleating, and elegant sculptural silhouettes (one was modeled after the calla lily) laid the groundwork for his approach to design. His collection included smart, simple tailor-mades, with straight jackets and narrow skirts devoid of trimmings, and evening and at-home ensembles featuring skintight pants worn under open skirts.[26] According to

*Los Angeles Times* fashion editor Fay Hammond, the sensation of the collection was the series of hobble-skirted evening gowns that made it nearly impossible for the models to step onto the runway.[27] Capucci also presented a magnificent purple silk taffeta evening dress with a short straight skirt and trailing overskirt (fig. 5); Milton Greene captured the elegant dress in a stunning photograph of a model posed on an iron spiral staircase, with the dress's cascading overskirt gracefully following the curve of the stairs (fig. 4). The gown also was featured in a contemporary newsreel summarizing the collections presented at the fourth Italian show.

Capucci's work appeared in an American fashion magazine for the first time in September 1952. In a report on the recent show at the Sala Bianca, *Vogue* published a photograph of a model wearing his blue faille evening poncho and an artist's sketch of his off-white hand-loomed tweed coat with bands of the same fabric. The accompanying text described Capucci as "easily Italy's most promising young designer; his collection was full of light and fresh air. The clothes, if too costumey, at least are completely original and full of ideas. Needs developing, but it is extraordinary for someone so young to feel couture as much as he does. These are not just sketchbook dreams tacked together. Fabrics have been studied, anatomy learned, cutting mastered."[28] The article also discouraged Italian dressmakers from adapting or copying French designs, a

*Below*: Fig. 4. Milton H. Greene (American, 1922–1985). Model wearing Capucci's purple silk shot taffeta dress with trailing overskirt (fig. 5), Rome, c. 1952. © 2010 Joshua Greene www.archiveimages.com

*Opposite*: Fig. 5. Dress (back view), 1952, silk shot taffeta (N.210)

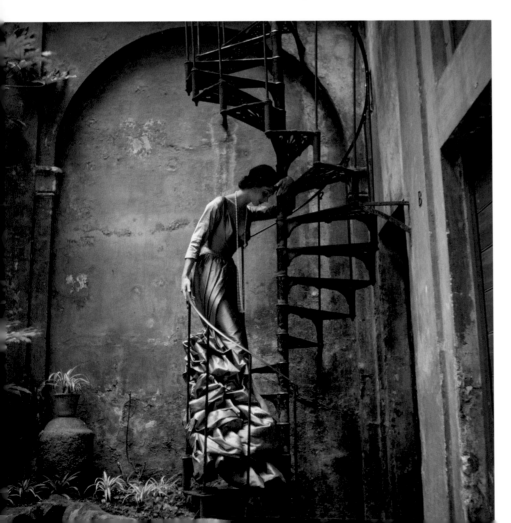

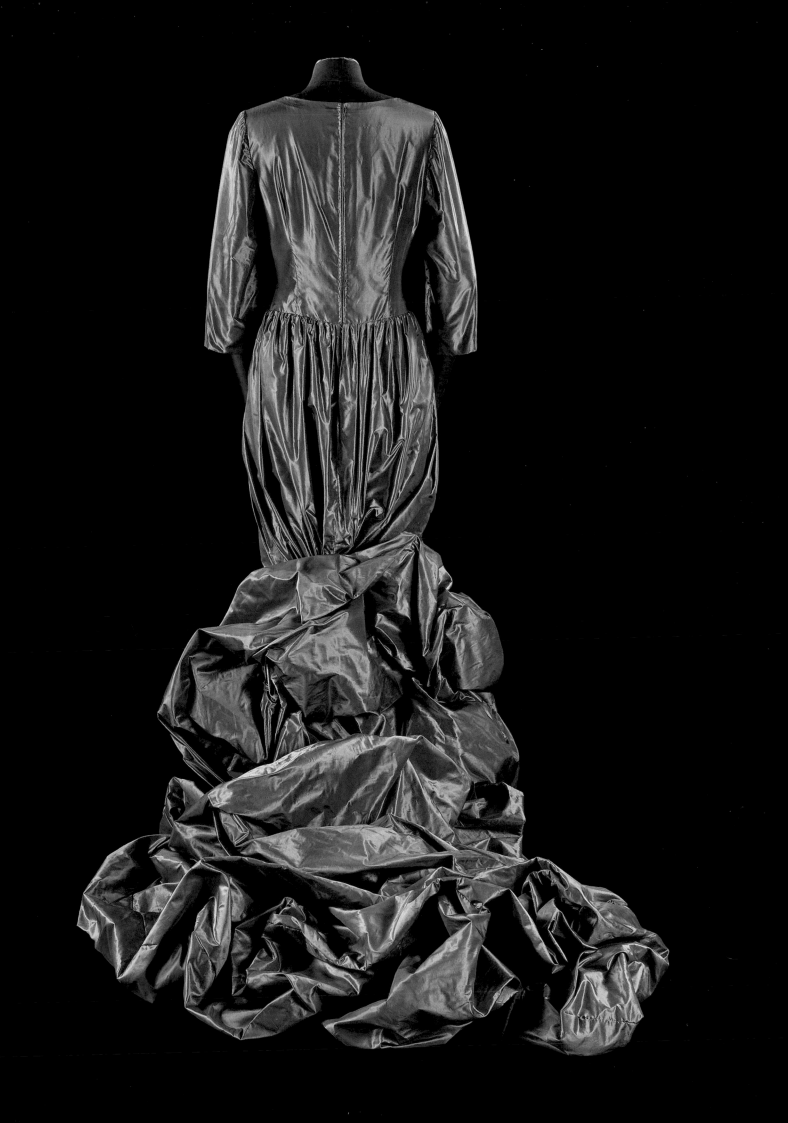

traditional practice, encouraging them to concentrate on native specialties such as boutique wear and accessories, evening dresses, outerwear, and sportswear.

That month Capucci presented abroad for the first time, at the Victoria Hotel in Amsterdam. Dutch photojournalist Ben van Meerendonk (1913–2008) captured the young designer and his mannequins arriving at the city's Schiphol Airport (fig. 6), and posed on the hotel's staircase, with Capucci showing off his *Gran sinfonia* (*Grand Symphony*) evening dress featuring a skirt made of twenty-five yards of white pleated silk under a black pleated overskirt (reversible to white) that doubled as a cloak or stole (fig. 7).

**THE FIFTH ITALIAN FASHION SHOW, SPRING/SUMMER 1953**

In January 1953 Capucci opened Giorgini's fifth fashion show with couturiers Antonelli and Carosa. His collection was toned down from the previous season's, and included simple, youthful silhouettes that appealed to American buyers and manufacturers. One of his more dramatic designs, the *Sole* (*Sun*) dress, was made of silk and had a flaring upturned collar and a full, pleated skirt that resembled sunrays, and was accessorized with long, green gloves. Manufacturer Hannah Troy purchased the model, which she planned to wear to the show's grand ball. New York-based retailer Ohrbach's selected a number of Italian designs to copy line for line, including Capucci's full-skirted beige silk dress with tucking through the midriff.

**THE SIXTH ITALIAN FASHION SHOW, FALL/WINTER 1953–54**

In a move to make Rome the undisputed center of Italian fashion, in May 1953 eight of Italy's foremost fashion houses—those of Fabiani, Vincenzo Ferdinandi (1920–1990), Eleanora Garnett (active c. 1950s–70s), Lola Giovannelli and Stefanella Sciarra, Sergio Mingolini and Carlo Guggenheim, Emilio Schuberth, Simonetta, and Sorelle Fontana—

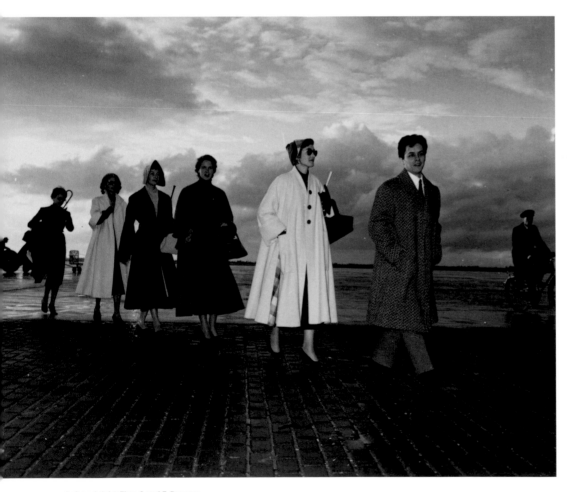

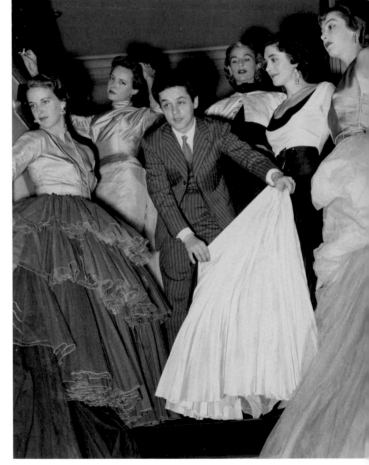

*Left and right*: Figs. 6 and 7. Ben van Meerendonk (Dutch, 1913–2008). Capucci and models, *left*, arriving at the Schiphol Airport; and *right*, posed on the staircase of the Victoria Hotel, with the designer showing off the skirt of his *Gran sinfonia* (*Grand Symphony*) evening dress. Amsterdam, September 1952. © AHF / IISH

announced they would show exclusively in Rome as the Sindacato Italiano Alta Moda (SIAM; Italian Syndicate of High Fashion). Capucci remained loyal to Florence, refusing to abandon Giorgini. At the Palazzo Pitti in July 1953 his inventiveness and imagination were evident in his most controversial silhouette yet, the "dove line," which the *New York Times* described as gracefully provocative as it swept from "slightly curving bust to flowing skirt" (fig. 8). He accessorized the new shape with hats with peaked brims that suggested beaks. His brightly colored silk taffeta cocktail and evening dresses took the new shape to extremes, with "gigantic humps over backs or fronts of gowns, . . . and slits in skirts [that] revealed pedal pushers."[29] Capucci also presented designs using cotton fabrics by the textile company Legler, including a playsuit and a dress made of corduroy so finely ribbed it resembled velvet.[30] Capucci's collection did not appeal to everyone; Cynthia Cabot's retail report for the *Philadelphia Inquirer* noted that, in general, "prices were up but talent was down in bella Italia this year," adding that "Capucci, 'the enfant terrible' of the Italiano [*sic*] moda did some pretty terrible things to cloth."[31] Such disagreement was not unusual, as American buyers and manufacturers looked for easy-to-copy and salable designs, while critics praised creativity and inventiveness.

**THE SEVENTH ITALIAN FASHION SHOW, SPRING/SUMMER 1954**

According to reports, by February 1954 the prices of Italian ball gowns had begun to approach those of the Paris couture.[32] Yet, Italian high fashion continued to be overshadowed by the impeccable tailoring and imaginative style of its sportswear and boutique collections, which American buyers considered better values. The press acknowledged that Italian haute couture evening clothes were "as fabulous as any found anywhere on the continent," but considered the high-fashion day clothes too elaborate and fussy for American taste.[33] Kittie Campbell, fashion

Fig. 8. Federico Garolla. Model wearing a dove-line dress from Capucci's fall/winter 1953–54 collection, Rome, 1953. © Federico Garolla / Contrasto / Redux

editor of the *Philadelphia Bulletin*, observed that Italian couture was trying too hard to please American buyers rather than making collections that expressed "courage of conviction."[34] That season Ohrbach's purchased more Italian designs than ever for its line-for-line copies, particularly of sportswear and playclothes, including Capucci's satin piqué full-gored skirt with removable hem-length pockets. American manufacturer Main Street Fashions announced it would offer an exclusive collection of rainwear featuring designs in bold colors and with full silhouettes by Capucci and six other Italian couturiers.

THE EIGHTH ITALIAN
FASHION SHOW,
FALL/WINTER 1954–55

A standing-room-only crowd of buyers and reporters attended Giorgini's fall/winter 1954–55 fashion show in July 1954. Capucci's innovative collection stole the spotlight, with vividly colored and powder-pastel textured fabrics painstakingly constructed of bias folds of silk layered in narrow horizontal bands or in herringbone patterns. *New York Times* fashion editor Virginia Pope declared the twenty-three-year-old designer one of the rising stars of Italian couture and commended his outstanding formal gowns, one of which was illustrated in her *New York Times Magazine* article "Fine Italian Hand," in which she observed that "beauty of fabric and attention to detail are characteristics of Italian design."[35]

Kittie Campbell's trade report on the season's Italian collections noted that Italy had "grown up" as a market; there were no longer "bargains," as prices were approaching those of Paris. She lamented that, although it made for entertaining copy, the battle between Florence and Rome for the title of Italy's fashion capital was becoming tedious, as it now took almost as long to see the Italian shows as the French ones.[36] The additional venues in the fashion-show calendar were taking a toll on buyers who rushed from Paris to Madrid to Rome to Florence to London to view hundreds of designs and secure orders.

THE NINTH ITALIAN
FASHION SHOW,
SPRING/SUMMER 1955

Capucci's collection for the spring/summer 1955 season featured two very different silhouettes: short, very full crinoline-like dresses with sleeveless bodices and simple bateau or rounded necklines; and late-day dresses in his innovative "banjo line," which were fitted through the thigh and then expanded into skirts with deep, vertical folds that swayed with movement (fig. 9). In February NBC's *Today* program invited Giorgini and four of Italy's top mannequins to its New York studio for the first live showing of Italian fashion in the United States; the appearance coincided with the release of photographs and sketches of the designs to the general press. Twenty-five dresses were sent from twelve couturiers: Antonelli, Avolio, Franco Bertoli (1910–1960), Capucci, Carosa, Fabiani, Marucelli, Mirsa, Pucci, Schuberth, Simonetta, and Veneziani. Two weeks later the Paris couture houses of Jacques Fath (c. 1911–1954), Hubert de Givenchy (born 1927), Jeanne Lanvin (1867–1946), and Jean Patou (1880–1936) traveled to New York for a similar presentation.

THE TENTH ITALIAN
FASHION SHOW,
FALL/WINTER 1955–56

From the beginning Capucci had found inspiration in nature, capturing the emotion of his creative muse rather than its literal representation. For his fall/winter 1955–56 collection, presented at the Palazzo Pitti in late July 1955, he interpreted the three-tiered fuchsia flower as a silhouette that progressed from a slim bodice into three bell-like sections, becoming in effect one tunic over another. The graceful shape dominated his collection, appearing in both daywear and evening clothes; the *New York Times* illustrated two of his triumvirate-tiered evening dresses, including a dark blue satin dress with a matching reversible coat lined with ivory-colored satin, in its August 2, 1955, edition.[37] Capucci would continue to experiment with this silhouette over the course of his career.

THE ELEVENTH ITALIAN
FASHION SHOW,
SPRING/SUMMER 1956

Buyers and journalists in Florence for the January 1956 presentations of Italian spring/summer fashions praised Capucci's collection as his most original yet. American actress Gloria Swanson, who covered the Florence fashion show for the United Press International news service, wired: "Move over, Dior, because the name of Italy's Capucci will soon ring in all the style centers of the world as it did in Florence when he showed his collection to thunderous applause and shouts of 'bravo!' led by me. . . . I didn't believe there was a new wrinkle or silhouette to be added to fashion but Capucci managed it beautifully, all within the bounds of good taste, too. I would like to burn my whole wardrobe so I could replace it with his entire collection."[38] The *New York Times* declared, "Capucci Stunning Success," reporting that "the designer brought down the house, in this case the Palazzo Pitti, with a delightful and inventive collection. . . . There was no trickery. Just pure, fresh designing talent."[39] American critics were not alone in their applause: Ailsa Garland of the *Daily Mirror* (London) proclaimed, "I have just seen the most exciting fashion show since Dior launched his New Look and rocketed to fame."[40]

Fig. 9. Federico Garolla. Model wearing a banjo-line dress from Capucci's spring/summer 1955 collection, Florence, 1955. © Federico Garolla / Contrasto / Redux

The sensation of the show was the *Bocciolo* (*Bud*) evening dress made of red-orange silk taffeta folded and draped to resemble a button rose (see fig. 10). A version of the dress, modeled by Countess Giovannella Ceriana

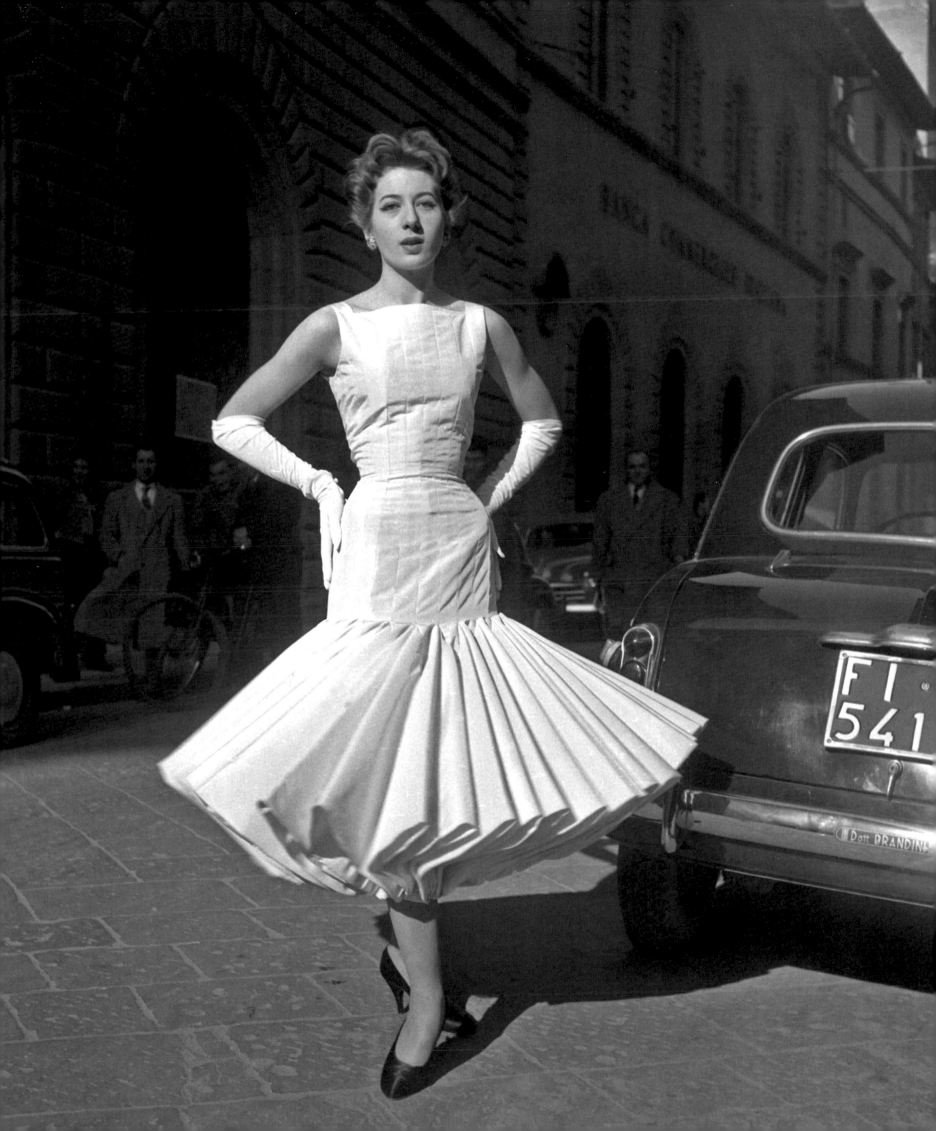

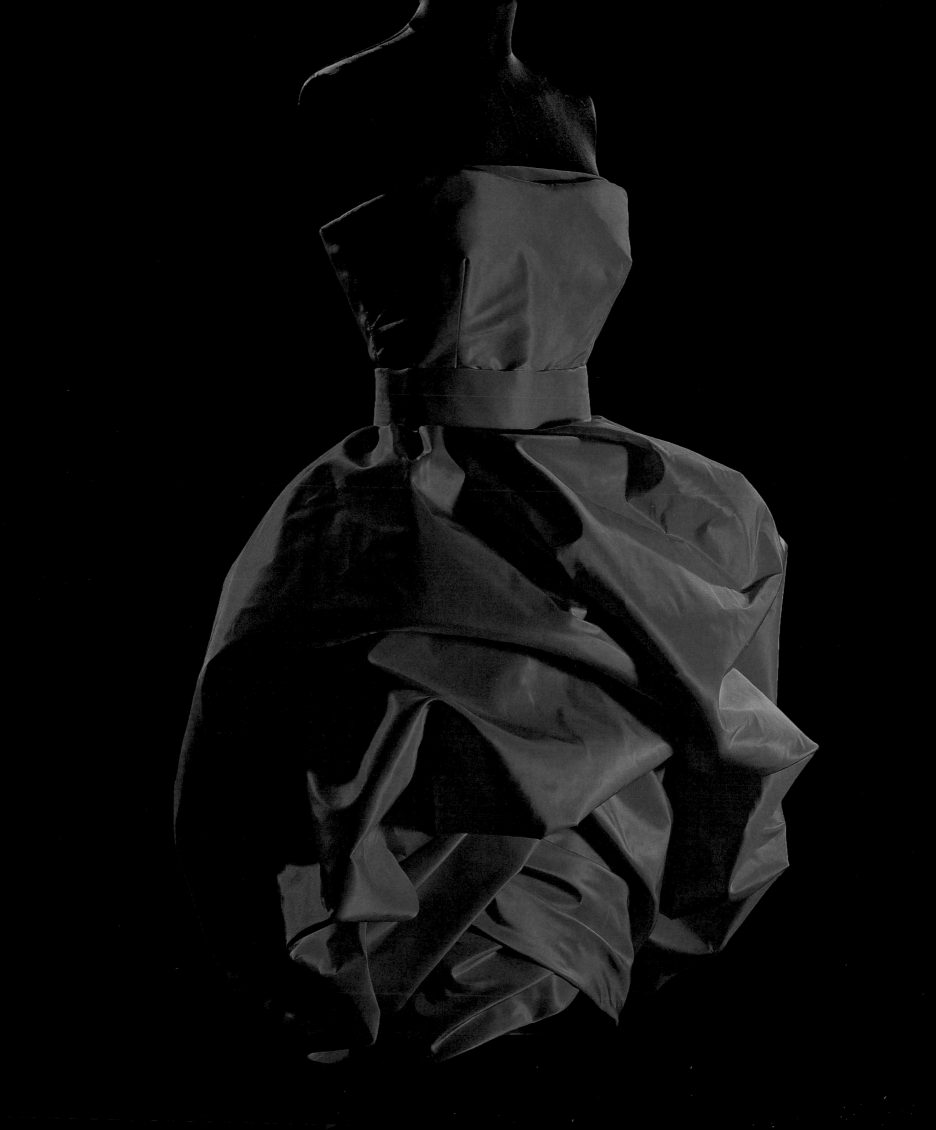

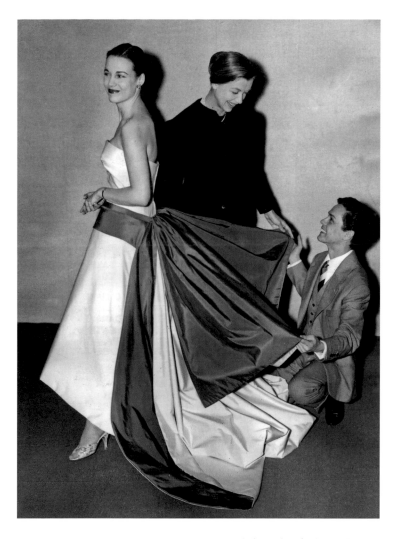

Mayneri, once considered "Rome's most ravishing beauty," appeared in the March 15, 1956, issue of *Vogue*, for a spread featuring four Roman noblewomen wearing evening gowns from the latest Italian collections.[41] The dress was available in the United States at high-end retailers Neiman Marcus and I. Magnin. Capucci's most dramatic design for the spring/summer season was a white faille evening dress with a skirt that curved in a perfect arc from a red sash, set low on the hips, the hemline rising in the front and cascading in the back into a train of panels lined with red taffeta (fig. 11).

In February 1956 Giorgini and eight Italian countesses left for New York on the SS *Cristoforo Colombo* for the famous "fashion cruise," to promote Italian style. Each woman represented a designer; Countess Barbara Biscaretti di Ruffia wore Capucci. *Look* magazine covered the event, and the women modeled the clothing on four American television programs watched by fifty-eight million viewers.[42] The following month Capucci showed his sixteen-piece spring/summer collection in London at Peter Jones, the upscale branch of the John Lewis Partnership department stores; Movietone News filmed the presentation. The retailer purchased a number of toiles, from which the store's workrooms made copies in different materials to be sold in a range of prices, from an evening dress of pink-crystal-colored shot taffeta with a harem hemline, exclusive to Peter Jones at 82 1/2 guineas, to a wool suit adapted from a Capucci dress and jacket, to be sold in all John Lewis branches for 14 guineas in tweed and for 15 guineas in flannel.[43] Peter Jones maintained a Capucci boutique with its own exclusive label until 1958. In the United States, I. Magnin included two gowns from Capucci's spring/summer collection in its March 1956 import show in Los Angeles: the white faille evening dress with red sash and a black silk jersey dress with a floating back panel, which a Magnin's buyer described as "one of the most beautiful dresses to come out of Europe" that season.[44]

Hans Schneider, fashion director of the British retailer Marks and Spencer, whose personal motto was "[h]igh fashion modified into easy wear for every woman—quickly," purchased several designs by Capucci, Fabiani, and Roman couturier Fernanda Gattinoni (1906–2002) to be copied or adapted and then sold in the company's two hundred stores.[45] Capucci's round-necked dress that buttoned up the front, with an unusual paneled bodice and a skirt gathered at the hips, was produced in crisp-finish spun rayon and sold for forty-two shillings and six pence. Fashion editor Alison Adburgham remarked that not all the dresses sold by Marks and Spencer were recognizable as the work of specific designers: Schneider "will point out details such as a Fontana collar, a Gattinoni group of pleats, a Simonetta treatment of a yoke. They pay thousands of lira [*sic*] for a new notion, a new train of thought—and Italy, these days, is the happiest hunting grounds for fresh ideas."[46]

## THE TWELFTH ITALIAN FASHION SHOW, FALL/WINTER 1956–57

In the spring of 1956, Stanley Marcus, president of the Dallas-based department store Neiman Marcus—who had stopped in Rome during his return trip from Monaco, where he had attended the wedding of American actress Grace Kelly (1929–1982) and Prince Rainier III (1923–2005) on April 19, 1956—purchased Capucci's entire fall/winter 1956–57 collection sight unseen.[47] At the Florence fashion show in July, Capucci's designs, with their innovative silhouettes, proved even more successful than the previous season's, and the couturier again received a standing ovation at the conclusion of his presentation. The standouts were truly sculptures in fabrics: an evening dress based on the calla lily (a form that also had inspired a silhouette for fall/winter 1952–53), featuring a tight, full-length silk satin sheath with a stiffened oval panel covering the entire back from shoulders to knees (see fig. 12); and the *Nove gonne* (*Nine Dresses*) dress, a red silk taffeta gown with nine tiered circular skirts that curved high in front over a knee-length sheath and extended to the floor in the back (see fig. 13).[48] Capucci had conceived the idea for the *Nove gonne* dress after observing the concentric rings that formed when a stone was tossed into still water. He then worked out the design by creating a three-dimensional paper model based on his preliminary sketches. The gown was the most celebrated Italian design that season. It appeared in an advertisement for the 1957 Cadillac Series 62 convertible, as part of the General Motors publicity campaign during the 1950s and 1960s that paired the latest luxury cars with fashions by the world's leading couturiers (see fig. 14); and in Mel Casson's syndicated

*Left*: Fig. 10. *Bocciolo* (*Bud*) Dress, 2009 (reproduction of 1956 original), silk taffeta (N.331)

*Above*: Fig. 11. Capucci and client Loredana Pavone (center) admire the red sash on his white faille evening dress for spring/summer 1956, March 1956. Photograph from Ullstein Bild / Alinari Archives

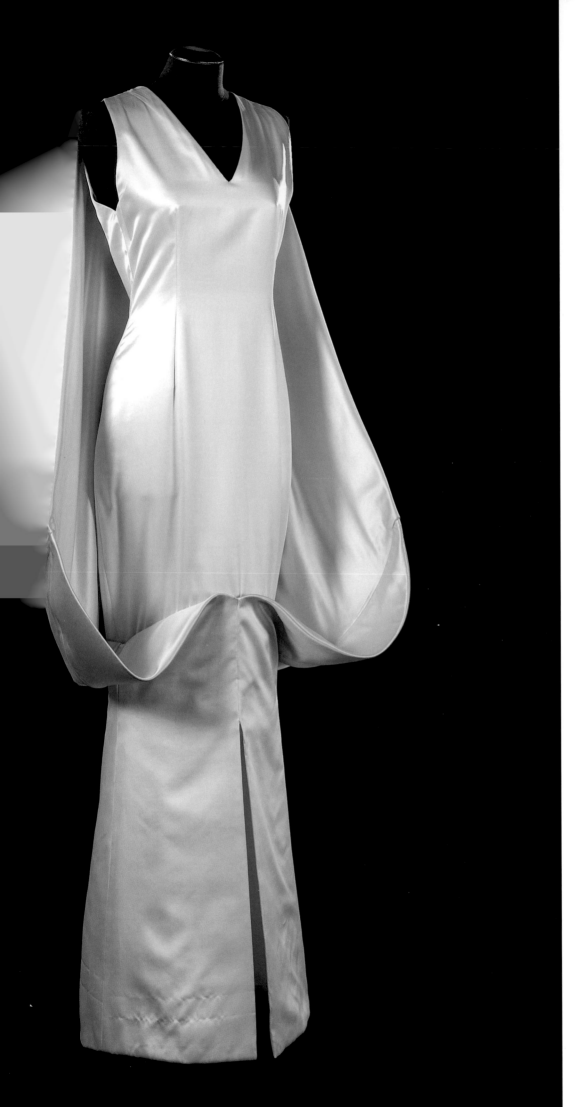

*Left*: Fig. 12. *Calla* Dress, 1956, silk satin (N.19)

*Right*: Fig. 13. *Nove gonne* (*Nine Dresses*) Dress, 1956, silk taffeta (N.39)

*Right, inset*: Fig. 14. Advertisement for the 1957 Cadillac Series 62 convertible featuring a model wearing Capucci's *Nove gonne* dress (fig. 13) in the Roman Forum, c. 1957. Photograph from General Motors LLC. Used with permission, GM Media Archives

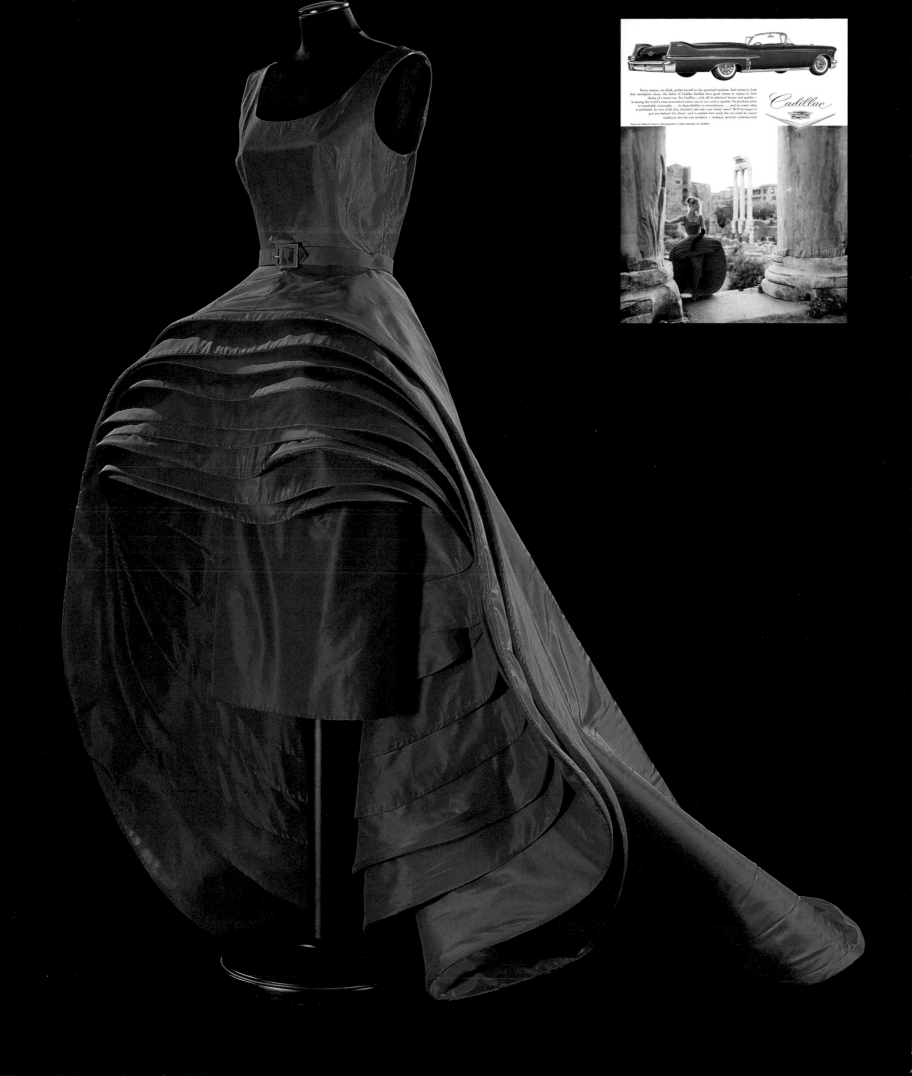

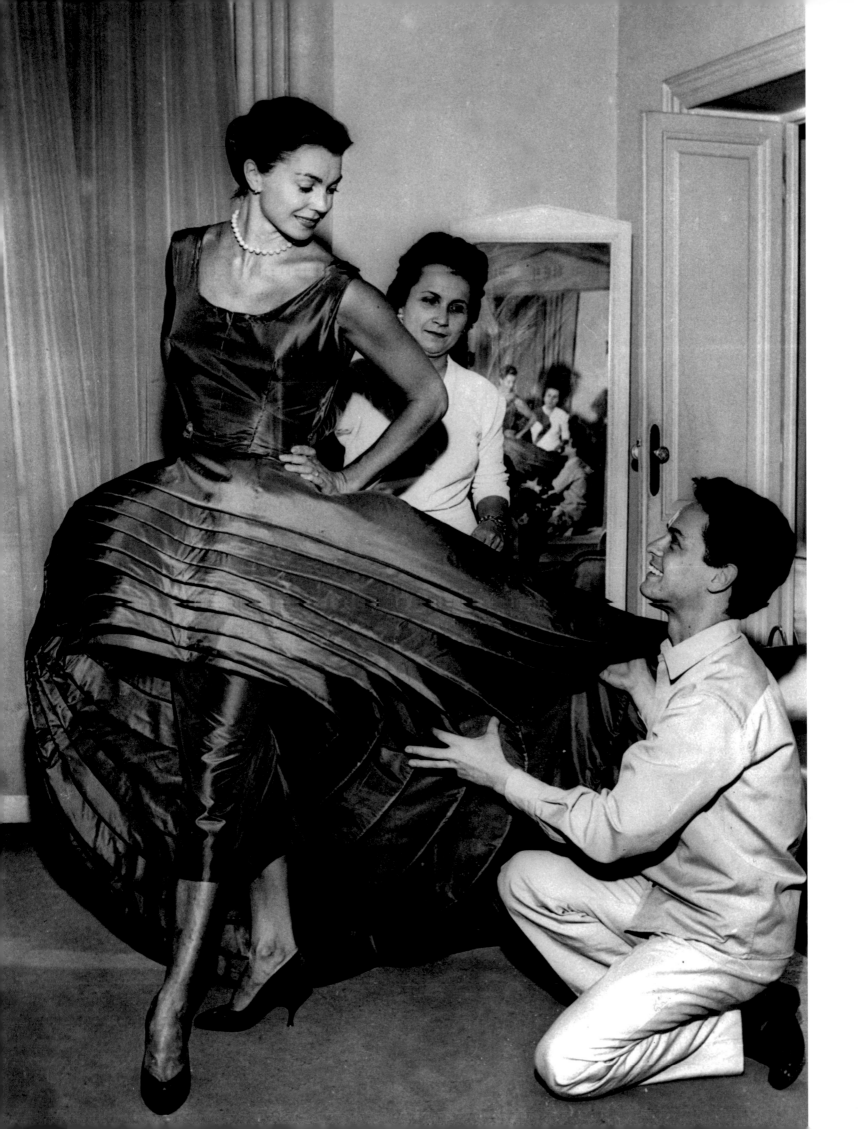

comic strip *It's Me, Dilly*.[49] American swimmer and actress Esther Williams (born 1921/22), who was in Italy to film Richard Wilson's *Raw Wind in Eden* (1958), was photographed with Capucci as she tried on the dress at his atelier (fig. 15). She must have liked what she saw: Gossip columnist Hedda Hopper later reported that Williams had worn a red taffeta ball gown and a coat by Capucci to a benefit for the Italian Red Cross.[50]

In early August 1956 Capucci made his first trip to the United States, traveling to Los Angeles as the guest of California sportswear manufacturer Phil Rose, for a one-month tour of fourteen American cities in which he presented his entire fall/winter 1956–57 collection of approximately ninety models, ranging from sportswear to evening gowns (including the *Nove gonne* dress) as well as his first designs for hats, jewelry, and shoes. Rose was well known for his colorful interpretations of Italian playclothes and stay-at-home fashions; in 1955 Italian actress and model Elsa Martinelli (born 1932/33; fig. 16), the "Italian Audrey Hepburn" who credited Capucci for creating her signature gamin look, was photographed in Rose's Italian-inspired corduroy separates.[51] The tour generated a great deal of curiosity about the young designer. The *Los Angeles Times* reported that "[i]n every case his clothes are unique, outstanding and spectacular. . . In designing the clothes, Capucci has a definite type of woman in mind. He prefers the tall, slim and well-proportioned figure to the much-admired curvaceous [Gina] Lollobrigida and Monroe types. He stated that 'even curves can be out of proportion and that spoils the feeling of balance.'"[52] In September,

*Left*: Fig. 15. Capucci in his atelier with American actress and competitive swimmer Esther Williams while fitting her for his *Nove gonne* dress (fig. 13), Rome, 1957. Photograph from Archivio Farabola

*Below*: Fig. 16. Federico Garolla. Capucci preparing Italian actress and model Elsa Martinelli (center, in profile) for a fashion show while actress Luciana Angiolillo (far right) looks on, Rome, 1953. © Federico Garolla / Contrasto / Redux

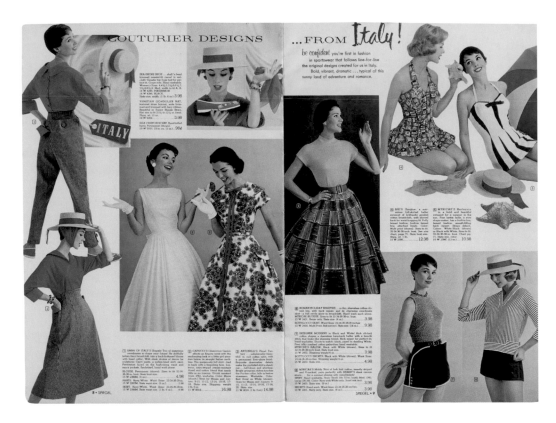

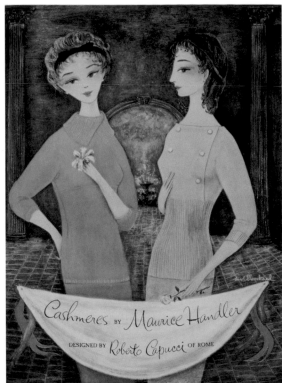

*Left*: Fig. 17. Spiegel's spring/summer 1957 catalogue featuring sportswear separates by Capucci and seven other Italian couturiers, including Capucci's maize-colored "Glamorous Gamin" dress (left, at center). Photograph by Jason Wierzbicki

*Right*: Fig. 18. Carol Blanchard (American, born 1918). Advertisement for Capucci's knitwear collection for manufacturer Maurice Handler, c. 1958. Published in *Harper's Bazaar*, August 1958, p. 155. Photograph by Jason Wierzbicki

the *New York Times Magazine* illustrated several of Capucci's latest designs, and fashion editor Dorothy Hawkins applauded the talented young designer's originality: "Roberto Capucci is a twenty-five-year-old Roman designer who has dared to be different. Breaking loose from Paris, ignoring the current obsession with period-piece fashions, he has followed his own particular star. Capucci's cutting and draping are startlingly original without being bizarre. Evening clothes are his forte, and the sculptured effects he achieves come naturally from the flow of fabric. There are no tricks involved—just a pure, instinctive feeling for fashion."[53]

Capucci made further inroads into the American market with the announcement in December 1956 that Spiegel, the Chicago-based mail-order house, would offer, for the first time in mail-order history, a complete collection of Italian and French designs at popular prices. In the company's spring/summer 1957 catalogue, sportswear separates by Capucci and seven other Italian couturiers were touted as line-for-line "original designs created for [Spiegel] in Italy." Capucci's full-skirted "Glamorous Gamin" dress (no doubt a reference to Martinelli) was the most expensive of the copies at $16.98 and was available in a maize-colored satin-striped Arnel and cotton blend advertised as shrink resistant and requiring little or no ironing (fig. 17). The Montgomery Ward and Sears catalogues also featured line-for-line copies and adaptations of the latest European fashions, primarily targeting seventeen- to twenty-five-year-olds. By 1961 Montgomery Ward was one of the largest customers of Italian and Paris couture.

**THE ROME FASHION SHOW, SPRING/SUMMER 1957**

In January 1957 Capucci decided to show in his home city of Rome, instead of in Florence, joining Fabiani and Simonetta, among others.[54] Chiffon fabric dominated the Italian spring/summer fashions, as seen in Capucci's signature draped panels, which were gathered into soft knots over the hips. In contrast, some of his short evening dresses were structured with bodices that flared out at the back and large, gathered skirts over equally full underskirts. His move to Rome did not affect his popularity with U.S. buyers, as several American firms commissioned him to create exclusive designs. In early January knitwear manufacturer Maurice Handler announced that Capucci would design a fifty-five-piece collection, including evening sweaters, overcoats, and pullovers (fig. 18). Six months later David Furs in New York invited him to create a collection of designer furs, a partnership that continued through 1962. Capucci's beautiful and imaginative capes, coats, and stoles were draped and sculpted as if they were fabric. Patterns, such as those issued by Spadea through the Los Angeles Times International Designer Pattern series, were a favorite way for the American home sewer to wear designer-inspired fashions. The lag time, however, between when a style debuted on the runway and when its pattern, albeit greatly modified from the original

model, was available for sale was significant; a pattern for a version of Capucci's flared bodice dress could be ordered as of May 1958, more than a year after the design debuted on the runway.

**THE FOURTEENTH ITALIAN FASHION SHOW, FALL/WINTER 1957–58**

Capucci, Carosa, Fabiani, and Simonetta, who had retreated to their home city of Rome, agreed to return to Florence for the fourteenth Italian fashion show, scheduled to open at the Sala Bianca on July 23, 1957—a decision that resolved in part the feud that had been simmering between Florence and Rome for the title of Italy's fashion center. Giorgini asserted that the couturiers had realized the strength in unity, and a reporter for the New York Times Service commended his efforts, reminding Americans that "until 80 years ago, [Italy] was entirely a collection of rival city-states. To have wrought fashion peace and confederation out of conflicting temperaments and jealously guarded local interest has been . . . a labor of love and patriotism for Signor Giorgini."[55]

Capucci's fall/winter collection included classically tailored coats and suits in charcoal-gray tweed with collars, lapels, and bows made of black grosgrain ribbon. His evening clothes featured sheaths and hobble- and harem-skirted dresses (fig. 19), "spiralling [*sic*], twisting, turning, . . . all pinched in at the hem."[56] American fashion journalist Eugenia Sheppard lauded Capucci's "forward-looking and beautiful" creations, remarking that he was one of the few Roman designers who actually designed his own clothes, as at least three Italian houses employed the same "assistants"—which accounted for certain similarities in their collections. Alison Adburgham, in her review of the Italian fall/winter fashion shows for *Punch* magazine, remarked that "[Capucci] designs as though for an abstract woman, the woman we never meet. Thus his collection is of the greatest interest, for it shows the way the wind is blowing before it has stirred the weathercocks of designers less sensitive to the *zeitgeist*."[57]

**THE FIFTEENTH ITALIAN FASHION SHOW, SPRING/SUMMER 1958**

In January 1958 Capucci, Carosa, Fabiani, and Simonetta again chose to present in Florence over Rome (where tensions were high as poor scheduling had resulted in the two cities' spring/summer shows overlapping, leaving designers scheduled to present during the final days of Rome's show worried that buyers would depart for Florence before their presentations).[58] Capucci's collection featured ethereal silhouettes with billowing harem skirts (fig. 20), floating draperies or tiers over basic chemises, and skirts that spiraled from the hips to the hem. Saks Fifth Avenue reproduced his red chiffon dress with a harem skirt that floated over a fitted undersheath and tied at the knees with a crimson velvet bow.

*Left*: Fig. 19. Model wearing a harem-skirted dress from Capucci's fall/winter 1957–58 collection, 1957. © TopFoto / The Image Works

*Right*: Fig. 20. Elsa Haertter (German, 1905–1995). Model wearing a harem-skirted dress from Capucci's spring/summer 1958 collection, Rome, 1958. Photograph from s.t. foto libreria galleria

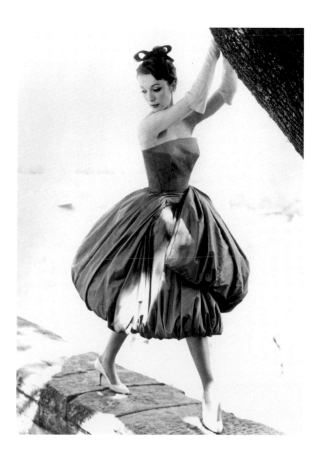
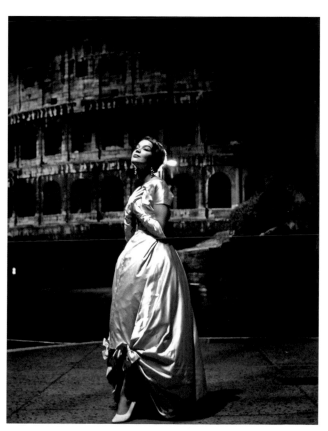

In 1950 the U.S. market accounted for two million dollars of Italy's exports of clothing (beachwear, knitwear, and sportswear) and accessories; within seven years the figure had increased fourteenfold, to twenty-eight million dollars.[59] To promote the country's fashion and further encourage exports, and in appreciation of U.S. aid in the fight against polio, in March 1958 the Italian government sponsored the Italian Festival of Fashions, a series of fashion shows that toured six American cities, with proceeds benefiting the March of Dimes. Each of the fourteen participating couturiers, including Capucci, presented twelve outfits with accessories. Capucci's designs featured versions of the fashionable "cocoon" and "balloon" silhouettes (respectively, wide at the top, tapered at the hem; and round like a sphere). Antonelli, Angelo Vittucci of men's tailoring shop Brioni, and Capucci's sister and business manager, Marcella, accompanied the show as representatives of the Italian fashion industry.[60]

**THE SIXTEENTH ITALIAN FASHION SHOW, FALL/WINTER 1958–59**

In another step to end the competition between Florence and Rome, in early June 1958 several of Italy's high-fashion designers—Antonelli, Princess Caracciolo, Capucci, Fabiani, Schuberth, and Simonetta, of Rome; Cesare Guidi (active 1938–76) of Florence; and Marucelli and Veneziani, of Milan—established the Camera Sindacale della Moda Italiana, the forerunner of the Camera Nazionale della Moda Italiana (National Chamber of Italian Fashion), to oversee and encourage the development and unity of the country's couture, and coordinate collective and individual fashion showings. The next month Capucci thrilled the audience at the Palazzo Pitti, earning bravos for his revolutionary "box line"—a square-sided paper-bag-like silhouette constructed of four flat panels sharply seamed at the front, back, and sides (figs. 21a,b)—which in effect sacked the popular "sack" (a loose-fitting chemise). During Capucci's dramatic presentation eight mannequins came out together, each wearing a black box-line dress, a squared black velvet hat, and long black or white gloves. The shape appeared in several variations of stacked tunics (figs. 22 and 23a,b) and marked a significant departure for Capucci, as he continued to develop a more architectural and sculptural approach to design.

*Above and opposite, top left*: Figs. 21a,b. *Linea a scatola (Box-line)* Dress, 1958, silk satin and silk organza (N.219)

*Opposite, center left*: Fig. 22. *Linea a scatola (Box-line)* Dress, 1958, silk-wool mixture (N.234)

*Opposite, bottom left and right*: Figs. 23a,b. *Linea a scatola (Box-line)* Dress, 1958, silk-wool mixture (N.235)

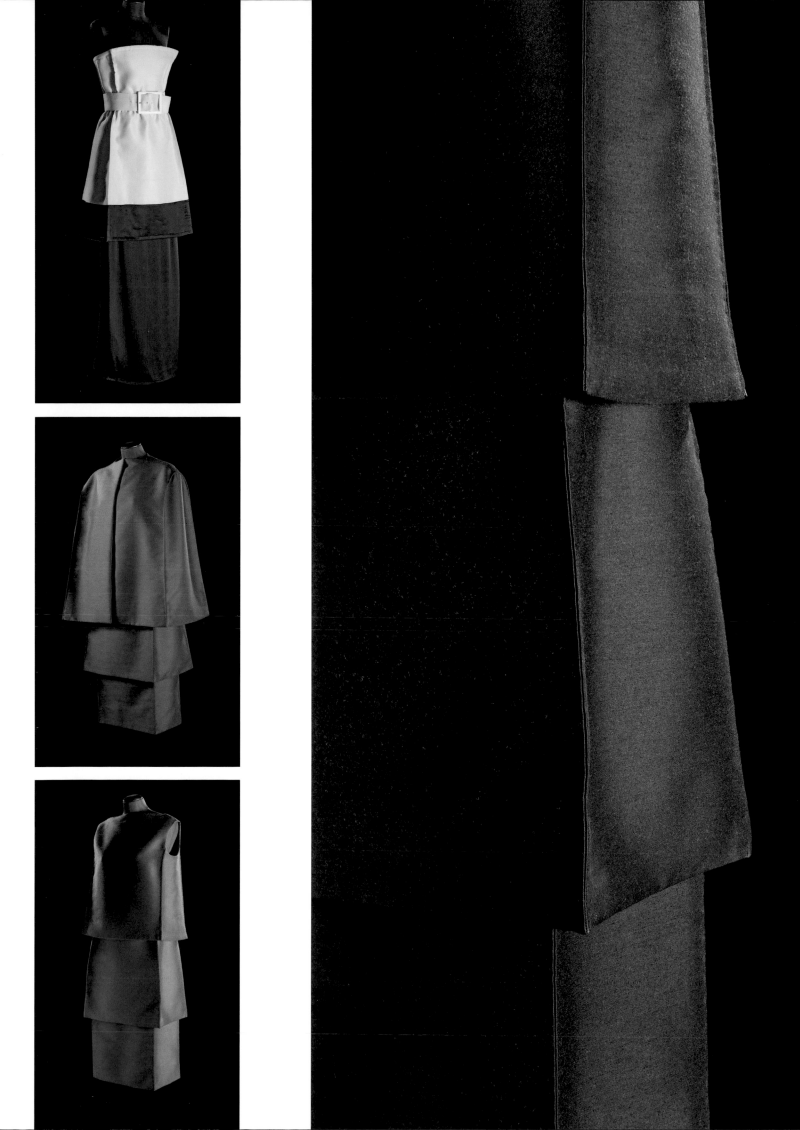

In September 1958 Alexander's department store included several original Capucci designs in its French and Italian import show at New York's Idlewild Airport (now John F. Kennedy International Airport). For the show, models wearing the original designs from which Alexander's would produce line-for-line copies disembarked from a TWA Jetstream airplane.[61] A few days later Capucci, along with Pierre Cardin (born 1922) of Paris and James Galanos (born 1924) of Los Angeles, received Filene's Young Talent Design Award in recognition of his creativity and achievements. Galanos was one of the many couturiers influenced by Capucci's revolutionary silhouettes; in November 1959 the American's striking box-line evening dress appeared on the cover of *Harper's Bazaar* (fig. 24).

**THE SEVENTEENTH
ITALIAN FASHION SHOW,
SPRING/SUMMER 1959**

For his spring/summer 1959 collection, presented in January at the Palazzo Pitti, Capucci experimented further with the box line, modifying the silhouette considerably by emphasizing the waistline and adding oversize, multilayered white collars or boleros to slim, black four-seamed sheath dresses. His designs played with geometry: Collars were formed from multiple rectangles and squares; boleros, from folded circles that undulated into corollas (see figs. 25–27); and layered circular overskirts were cut along the diameter, reworking a concept developed in 1956 for the *Nove gonne* dress (see figs. 28a,b and 29).

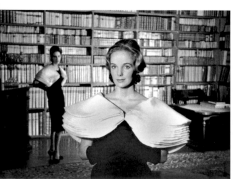

*Top*: Fig. 24. Hiro (American, born 1930). Cover of the November 1959 issue of *Harper's Bazaar* featuring a model wearing a black satin box-line evening dress by American designer James Galanos. Photograph courtesy of *Harper's Bazaar*

*Above*: Fig. 25. Ugo Mulas (Italian, 1928–1973). Models wearing dresses from Capucci's spring/summer 1959 collection, Palazzo Guicciardini, Florence, 1959. Photograph by Ugo Mulas © Ugo Mulas Heirs. All rights reserved

*Right*: Fig. 26. Dress, 1959, silk crepe and satin organza (N.238)

*Opposite*: Fig. 27. Dress, 1959, silk crepe and satin organza (N.237)

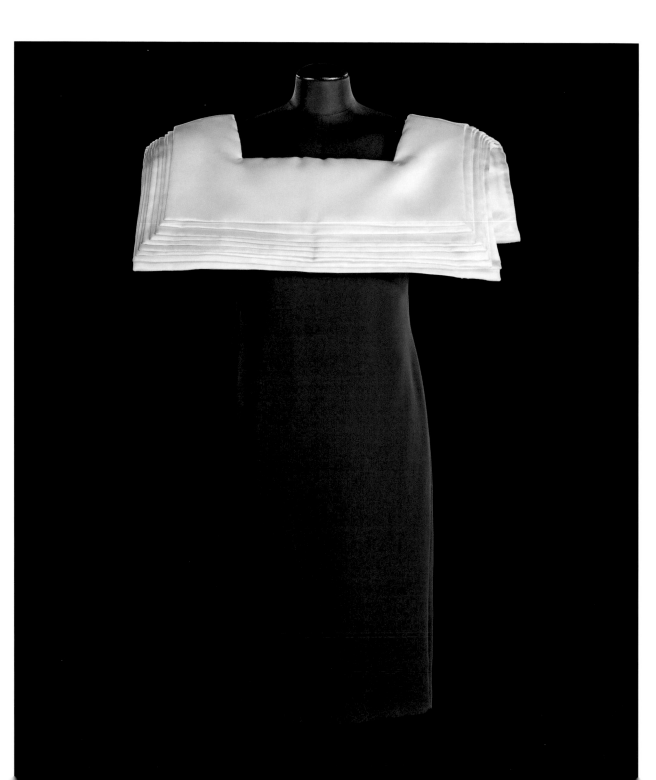

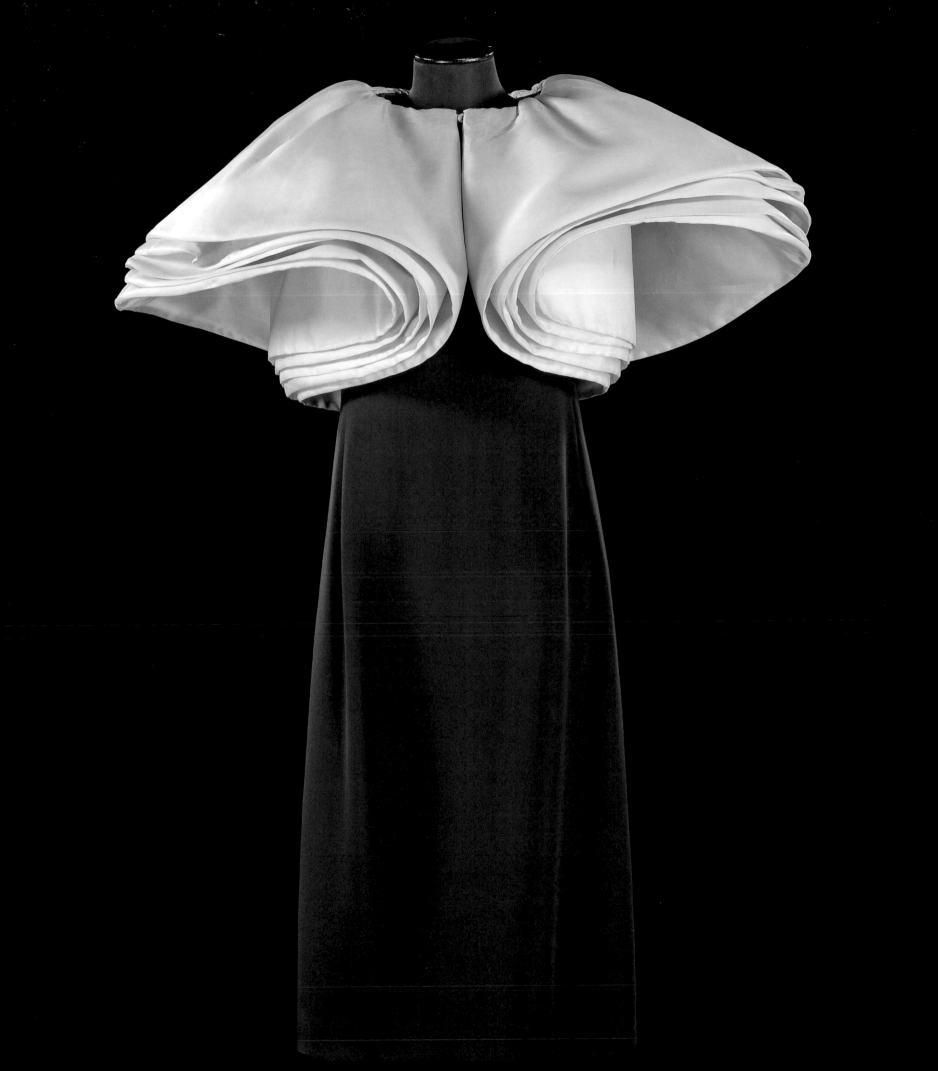

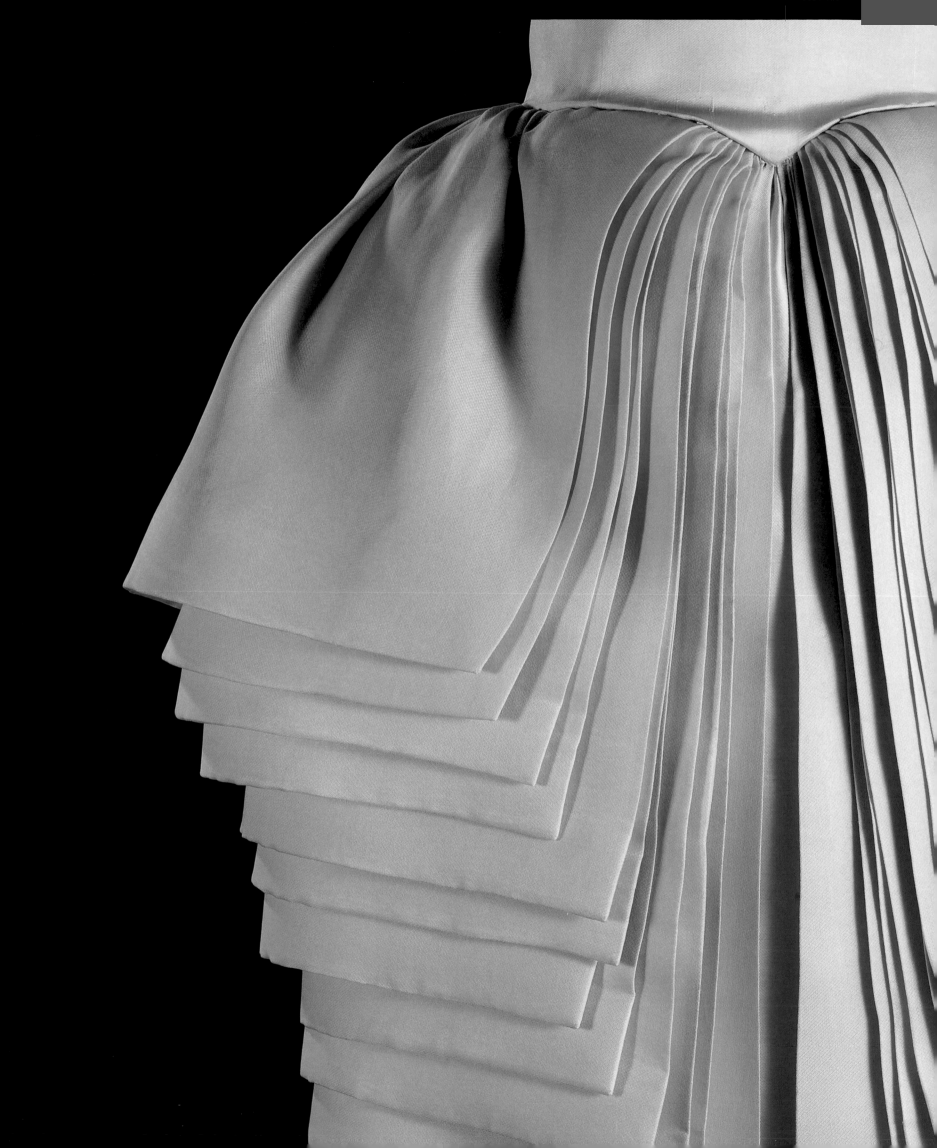

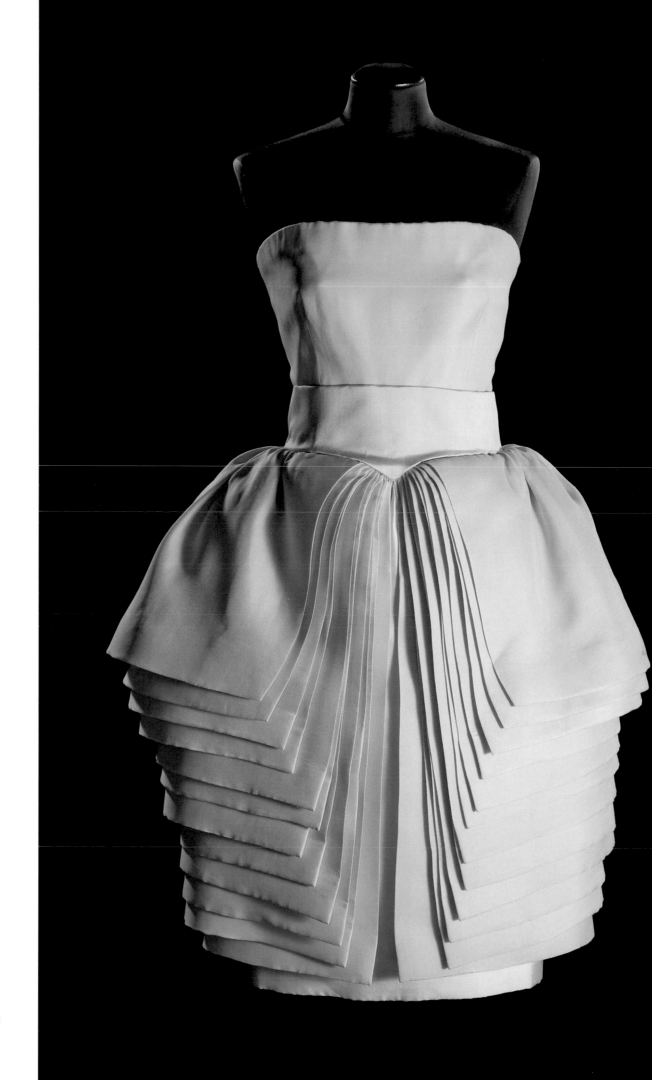

Figs. 28a,b. Dress, 1959, silk satin organza
(N.236)

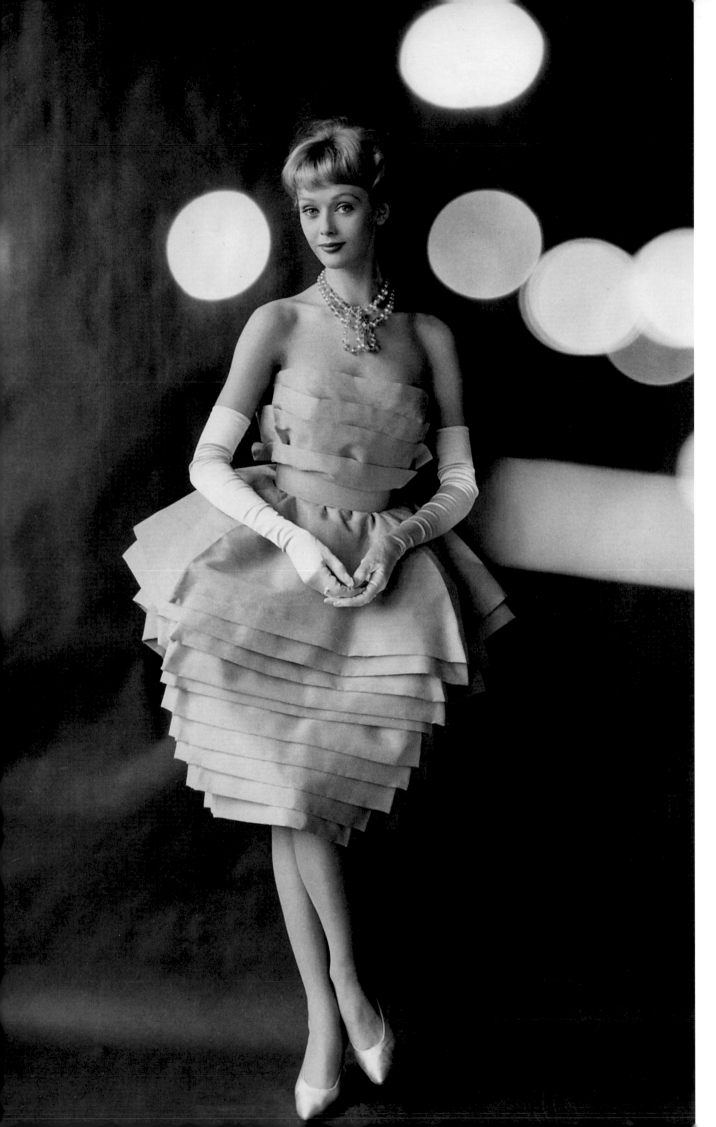

*Left*: Fig. 29. Regina Relang (German, 1906–1989). Model Ina Balke wearing a dress from Capucci's spring/summer 1959 collection, Florence, 1959. © Münchner Stadtmuseum, Sammlung Fotografie. Photograph from *30 Jahre Mode Paris: Regi Relang* (Verlag Hans Schöner, 1983)

*Right*: Fig. 30. Regina Relang. Model Ina Balke wearing Capucci's gold damask lamé hostess ensemble for spring/summer 1961. © Münchner Stadtmuseum, Sammlung Fotografie. Photograph by Jason Wierzbicki

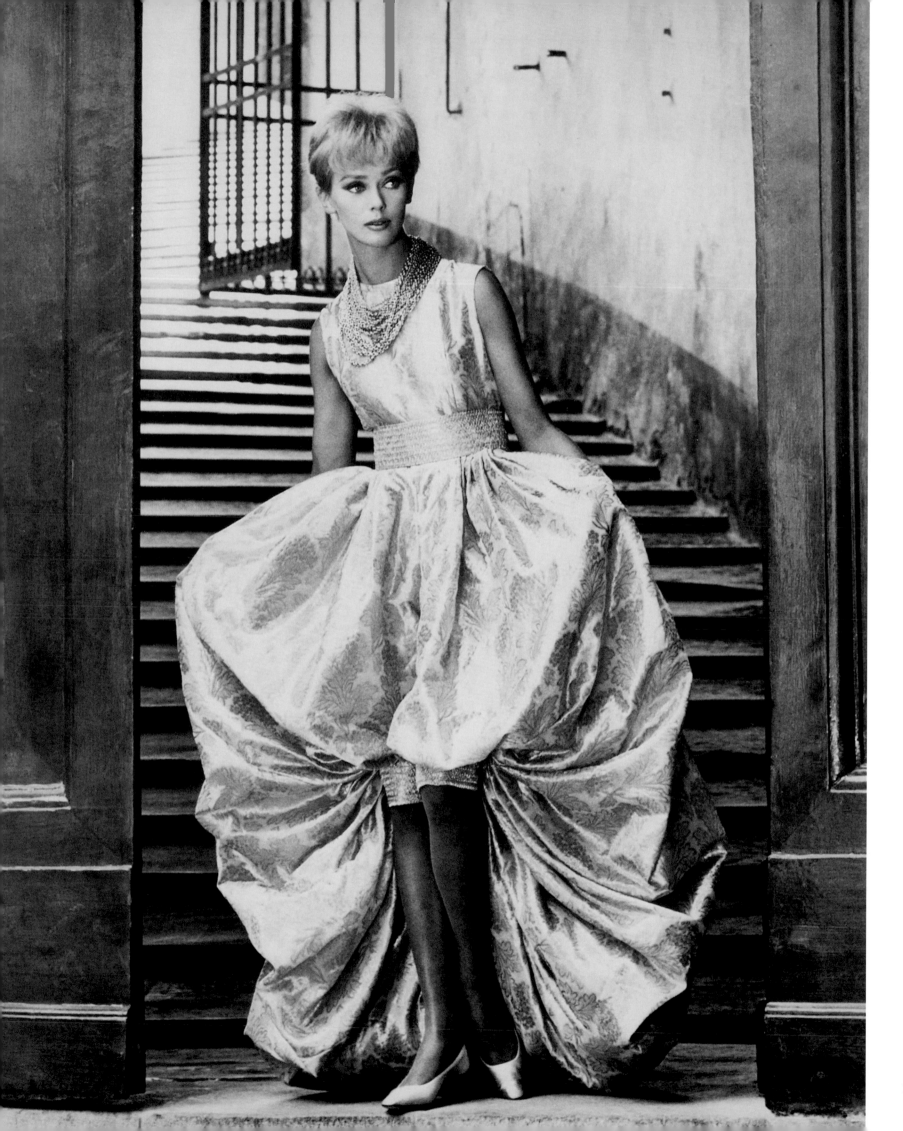

Capucci's new silhouette was highly influential. Other couturiers, including Sorelle Fontana, presented their own versions of the box line. Manufacturers also adopted the innovative shape, although often with extensive modifications; the box line was barely recognizable in manufacturing company Suzy Perette's spring 1959 cotton faille dress, featuring a skirt with four deep pleats softly gathered at the waist and square buttons strategically placed on the bodice to accent the wide shoulder line. That fall Spadea offered a sewing pattern for a dress with a four-gored skirt, pinch-pleated with edge-stitched seams to create a crisp, squared-off silhouette.

THE EIGHTEENTH
ITALIAN FASHION SHOW,
FALL/WINTER 1959–60

In July 1959 Capucci, proclaiming that "the woman of 1960 will be as slender as the profile of a Greek column and as supple as a birch tree," captivated Giorgini's audience during the closing presentation of the fall/winter showings, with a showstopping collection featuring stark, dramatic silhouettes dominated by straight, narrow tunics.[62] Nature and architecture combined in an exquisite long-sleeved black lace evening tunic embroidered with sea flowers made of ribbon, which tied behind the model's neck, revealing her bare back. China Machado, the first non-Caucasian model to appear in major fashion publications, wore the tunic in a striking image by renowned American photographer Richard Avedon (1923–2004) for *Harper's Bazaar* (fig. 31).[63]

THE NINETEENTH
ITALIAN FASHION SHOW,
SPRING/SUMMER 1960

The designer's spring/summer 1960 collection, which debuted in Florence in January of that year, resulted in applause—and controversy. Eugenia Sheppard's column for the *Dallas Morning News* summed up the dispute with the headline "Baby-Faced Robert [*sic*] Capucci's Crazy Mixed-Up Kid or Hero."[64] Although *New York Times* fashion editor Carrie Donovan felt the collection was one of the most polished ever presented in Florence, she reported that the "American fashion press, manufacturers and buyers are expressing opinions that range all the way from 'simply dreadful' to 'absolutely divine,'" and observed that designers' collections rarely evoked such strongly polarized reactions.[65]

American buyers rejected Capucci's straight tunics and chemises, but they adored his round, puffed tunics that revealed only an inch or so of straight underskirt (see fig. 32). They were captivated too by Capucci's fantastic colors for spring—Christmas green and red, black with black-and-white stripes, and one-color silhouettes with accessories in dramatic contrasting shades—which deviated from the season's traditional pastel palette. Alexander's was the first U.S. department store to carry copies of Capucci's puffed tunic—"[S]killfully adapted for the American figure! The look is youthful, the line sublime!"—and sold them at incredible prices: $49.95 for an Alexander's copy versus $292 for a Capucci original, $25 versus $300, $39.95 versus $356.[66] For the April 15, 1960, issue of *Vogue*, American photographer William Klein (born 1928) captured two of Capucci's black-and-white dresses in an iconic photograph of models Simone d'Aillencourt and Nina Devos on the crosswalk of the Piazza d'Espagna in Rome.

THE TWENTIETH
ITALIAN FASHION SHOW,
FALL/WINTER 1960–61

For the fall/winter 1960–61 season, Capucci's designs ranged from pastel velvet suits to a romantic, filmy, black chiffon dinner dress with a tiered skirt and tiered sleeves (see fig. 33). Patricia Peterson of the *New York Times* found Capucci's ideas distracting, describing him as "inventive but like a steamroller."[67] Fay Hammond of the *Los Angeles Times*, however, commended his stunning designs and great artistry. At the end of the presentation he received a standing ovation and was dragged onto the runway to take a bow. Hammond observed, "In nine years of covering the European openings this tribute from buyers and press has never been surpassed."[68]

THE TWENTY-FIRST
ITALIAN FASHION SHOW,
SPRING/SUMMER 1961

Capucci's collection for spring/summer 1961 again divided buyers and critics. For Gerry Golden of Hess Brothers (commonly called Hess's) department stores, based in Allentown, Pennsylvania, the collection was one of his favorites. Hess's was known for buying avant-garde fashions for publicity (it was the first American store to carry Rudi Gernreich's topless bathing suit, the monokini, in 1964). Golden selected Capucci's gold damask lamé hostess ensemble that cascaded from a wide mesh cummerbund into tight-fitting knee-length pants (see fig. 30). The collection also featured a trio of black cocktail dresses with provocative, open backs, paired with white organza puff-ball hats, which were captured in one of fashion photography's most celebrated images, of three models standing on a sidewalk in Florence, with their backs turned toward the viewer, taken by British photographer Norman Parkinson (1913–1990; see fig. 34). Capucci's tie-ups with American manufacturers expanded this season to include Chandler Shoes, which produced a footwear collection featuring designs by Capucci, Fabiani, and Simonetta as well as Paris couturiers Jean Dessès (1904–1970) and Jacques Heim (1899–1967). American children's wear manufacturer Joseph Love launched Capucci's party dresses for young girls, which were based on two of his bestselling silhouettes—the tiered-skirt dress and the bell-shaped dress—and were available in washable Enka nylon organza and wash-and-wear cottons in Capri aqua blue, Genoa green, and Persian pink.

Fig. 31. Richard Avedon (American, 1923–2004). Model China Machado wearing a lace tunic ensemble from Capucci's fall/winter 1959–60 collection, Paris, August 1959. Published in *Harper's Bazaar*, October 1959, p. 150. © The Richard Avedon Foundation

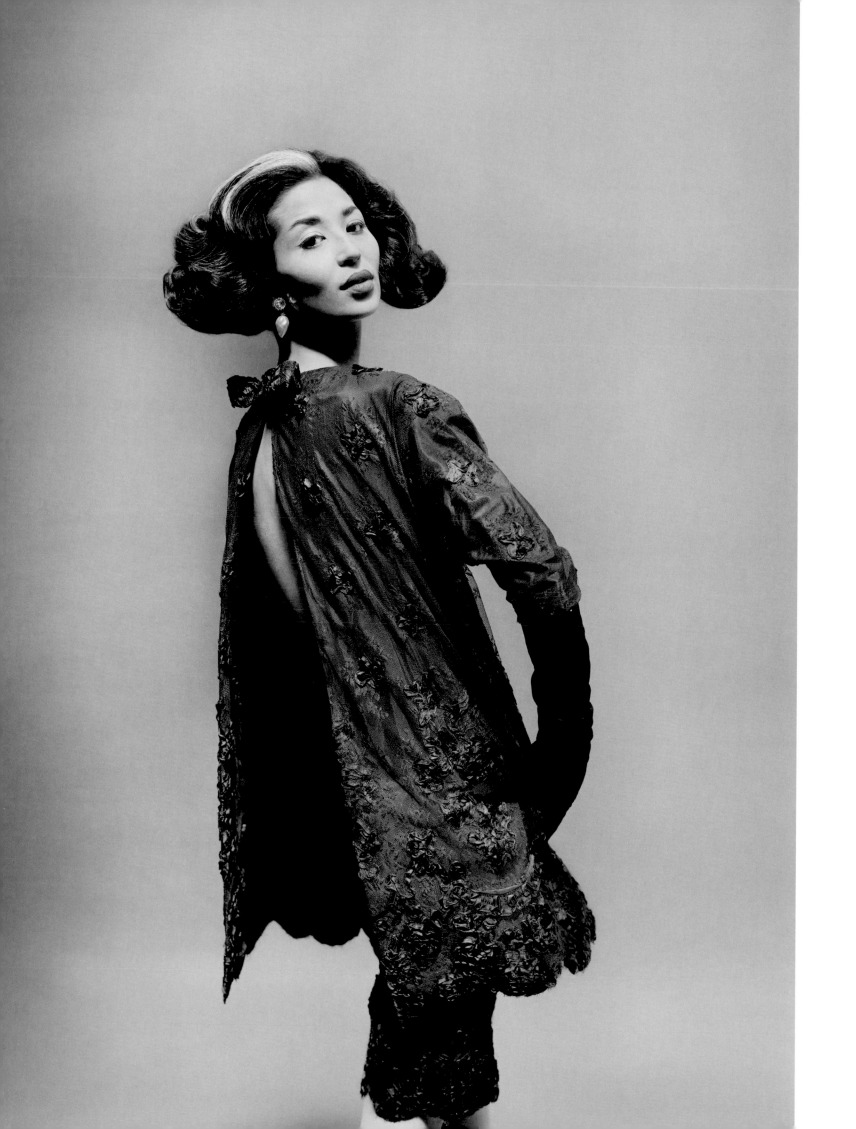

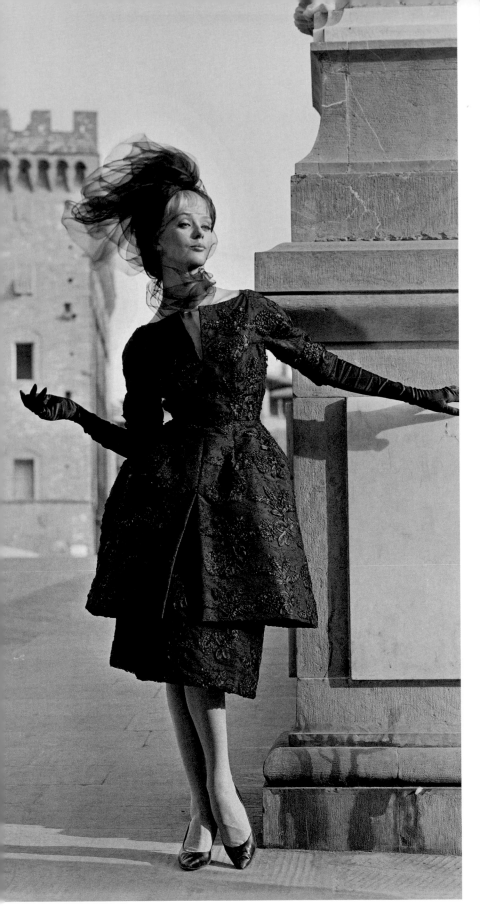 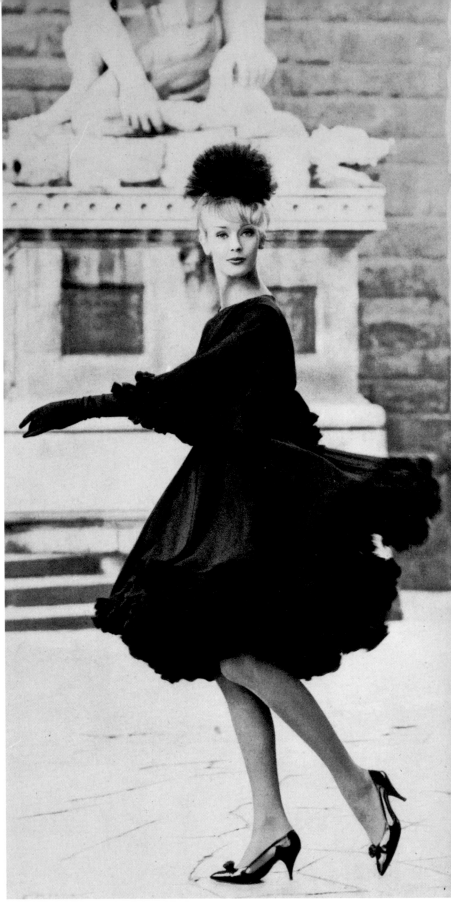

*Left*: Fig. 32. Regina Relang. Ina Balke wearing a tunic with a straight underskirt from Capucci's spring/summer 1960 collection, Rome, c. 1960. © Münchner Stadtmuseum, Sammlung Fotografie

*Right*: Fig. 33. Regina Relang. Ina Balke wearing a dinner dress from Capucci's fall/winter 1960–61 collection, Florence, 1960. © Münchner Stadtmuseum, Sammlung Fotografie. Photograph from Archivio Giorgini

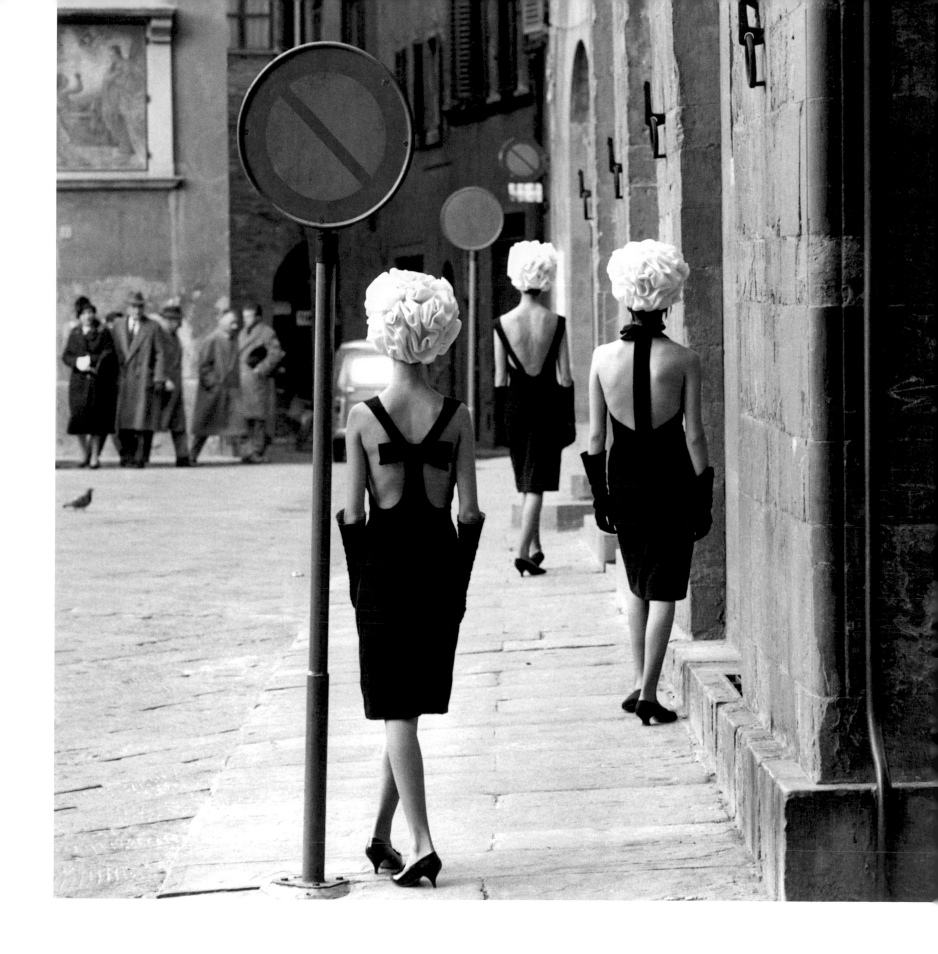

Fig. 34. Norman Parkinson (British, 1913–1990). Models wearing cocktail dresses and puff-ball hats from Capucci's spring/summer 1961 collection, Florence, c. 1961. Published in *Queen* (London), March 1961. © Norman Parkinson / Sygma / Corbis

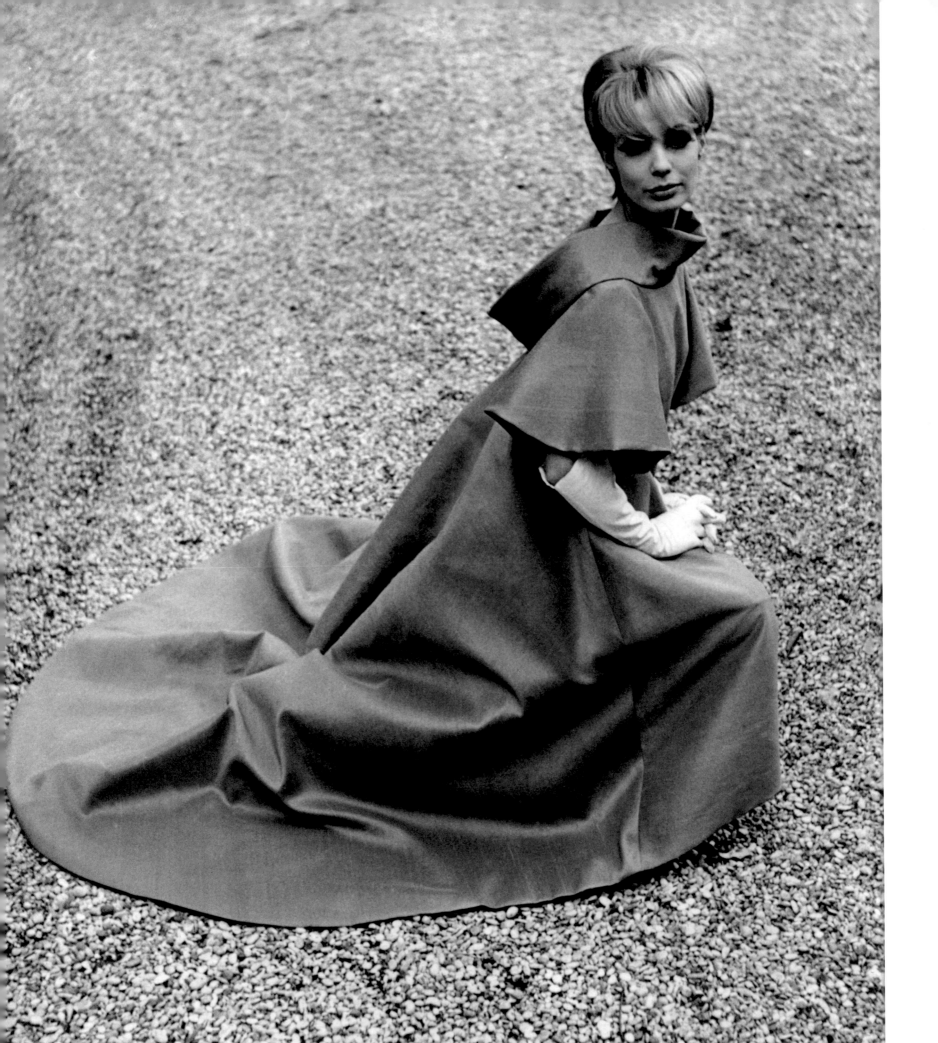

At the peak of his career and encouraged by fashion journalist Eugenia Sheppard, as well as the news that the late French couturier Christian Dior had admired his work, in early 1961 Capucci announced his decision to move to Paris, explaining that he found it difficult to be a perfectionist in Italy, a country without a couture tradition.[69] The Italian fashion community criticized Capucci's decision, as they felt he was deserting the cause. Nonetheless, on February 20, 1961, he participated in a fashion show featuring Italy's best couturiers, organized by Giorgini for Philadelphia's Festival of Italy.[70] The nine-week festival, sponsored by the City of Philadelphia and the Italian government, included an exhibition and events at the city's Commercial Museum in celebration of the centennial of Italy's unification, proclaimed on March 17, 1861. Among Capucci's designs was an evening dress of heavy, rose-colored silk Mikado, short in front, with a silhouette that recalled a cardinal's robe—an homage to the Eternal City (figs. 35 and 36).

In July 1961 Capucci's farewell collection played to a packed house at the Palazzo Pitti and concluded with a five-minute standing ovation. The couturier was at his best, showing some of the most beautiful coats and suits of his career. The extravagant evening clothes, whose drama and theatricality earned them the name "TV clothes," also were undeniably elegant (fig. 37).[71] American retailers and manufacturers accounted for almost two-thirds of the nearly seven hundred designs sold at the show, with Capucci as the top seller, surpassing perennial favorites Fabiani and Simonetta. He sold 180 models: eighteen to Alexander's, seventeen to Lord and Taylor, twelve to Macy's, and various numbers to nine other leading U.S. stores and manufacturers, including Ben Zuckerman and Hannah Troy.[72]

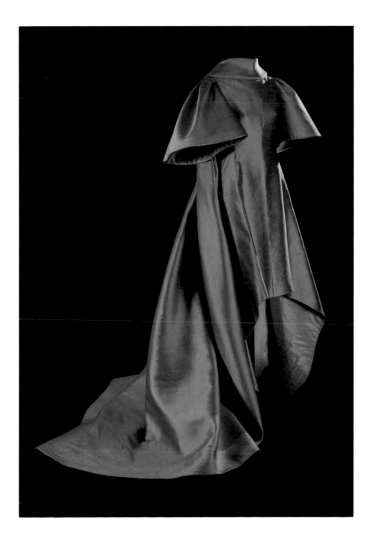 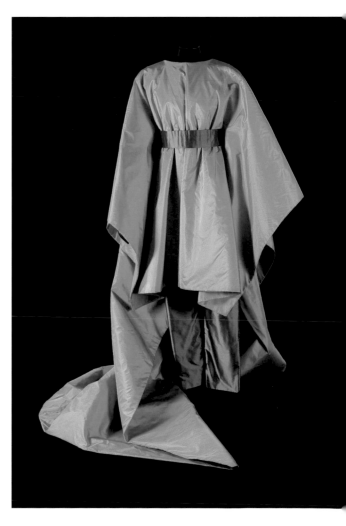

*Opposite*: Fig. 35. Model wearing Capucci's *Azalea Rosa* sculpture dress (fig. 36), Philadelphia, c. February 1961. Photograph from Archivio Giorgini

*Left*: Fig. 36. *Azalea Rosa* (*Azalea Rose*) Sculpture Dress, 1961, silk Mikado (N.32)

*Right*: Fig. 37. Ensemble with cape, tunic, and trousers, 1961, silk sauvage taffeta (N.211)

# From the Tiber to the Seine:
## Capucci in Paris,
# 1962–68

IN EARLY 1962 CAPUCCI MOVED TO PARIS, ESTABLISHING A COUTURE SALON at 4, rue Cambon. His first Paris collection, *Linea pura*, for spring/summer 1962, was a resounding success; even the normally chauvinist French press proclaimed, "Paris adopte Capucci," calling him "la petite Balenciaga de l'Italie."[1] The American press echoed this enthusiasm, declaring that the young designer had "stirred up the most genuine excitement of the week" and received loud shouts of "bravo" at the conclusion of his presentation.[2] The wit and youthfulness for which Capucci had become renowned in his native country were evident in all 120 designs presented, and his marvelous flare for color, whimsy, and clean silhouettes delighted the critics, who deemed his collection "the most exciting, most youthful and most fresh" shown in Paris that season.[3] Capucci's debut in France coincided with the first appearances of two new Paris couture houses, of Philippe Venet (born 1929), a former tailor at Givenchy, and of twenty-five-year-old Yves Saint Laurent (1936–2008), who had been the head designer at Dior. In March 1962 *Life* magazine proclaimed Capucci and Saint Laurent the rising stars of Paris haute couture and strong competition for the established houses.[4]

In July two of Italy's best known fashion designers, husband and wife Alberto Fabiani and Simonetta, followed Capucci to Paris. For the first time the couple opened a house together, although they continued to operate separate ateliers in Rome for their private customers (for similar reasons Capucci also maintained his Rome studio). Capucci, Fabiani, and Simonetta had long been favorites of buyers and the press; their "defection," along with the announcement that designer Patrick de Barentzen (born 1932) planned to leave Italy and return to Paris (where he had grown up and been an apprentice of couturier Jacques Fath), threw Italian high fashion into a crisis.[5] To fill the gaps created by the designers' departures, Giorgini persuaded several top couturiers from Rome—including the houses of Renato Balestra (born 1924), Eleanora Garnett, Fausto Sarli (born 1925), Sorelle Fontana, and Valentino (born 1932)—to participate in the fall/winter 1962–63 presentations at the Palazzo Pitti in Florence. With Rome's capitulation, Florence became the capital of Italian *alta moda* (high fashion), albeit for a short time: The rivalry between the cities continued, culminating in Giorgini's resignation after the spring/summer 1965 fashion show in Florence, and in the Florence and Rome fall/winter 1965–66 presentations being scheduled for the same dates, making it impossible for industry representatives to view every collection. Finally, in late 1965 the dueling factions came to a truce, agreeing that boutique and ready-to-wear collections would be shown in Florence, followed by *alta moda* presentations in Rome, where the majority of Italy's high-fashion designers were located.

Capucci's move to Paris did not compromise his sales in the United States; throughout the 1960s American buyers and manufacturers continued to purchase his designs for line-for-line copies and adaptations. For fall/winter 1963–64 he paired shift dresses with kneesocks—a first for couture. The following spring he designed a line of kneesocks in spring pastels, brightly colored tweed mixtures, and solid colors with a single stripe down each side for American hosiery company Bonnie Doon. Macy's department stores offered four designs by Capucci among its line-for-line copies of spring/summer 1964 Paris fashions (only three couturiers—Chanel; Dior, under the Monsieur X label; and Saint Laurent—were represented by more designs, with five each), and other American retailers, including Alexander's and Ohrbach's, continued to advertise copies of his clothing.[6]

Fig. 38. Detail of figs. 46a,b

## FALL/WINTER 1962-63

Capucci's Paris designs combined "the best from two worlds"—the bright colors and fantasy of Italian fashion and the architectural precision of French silhouettes, as evident in his coats, such as this broad-shouldered ochre wool example from 1961, constructed of a series of set-in squares recalling the interior dome of the Pantheon in Rome (fig. 39).[7] Although the American press found Capucci's creativity and bold colors refreshing, some reviews expressed concern that his collection was too theatrical, even "a bit too bizarre," for Paris.[8] *New York Times* fashion editor Carrie Donovan later reported that despite the Americans' enthusiasm for Capucci's collection, French journalists "all but sat on their hands" during his presentation.[9]

Fig. 39. Coat, 1961, wool (N.186)

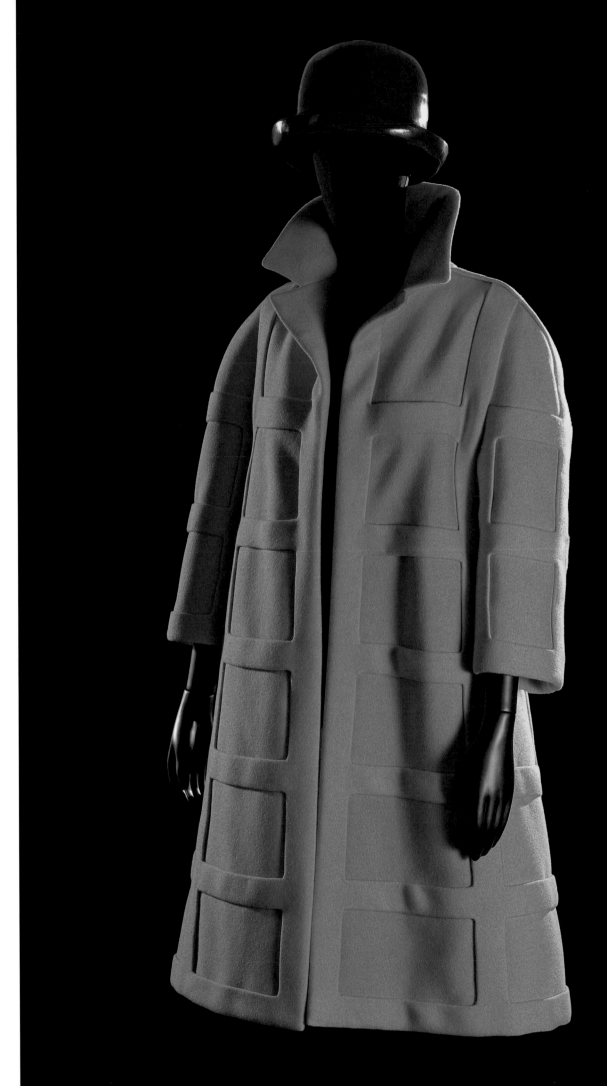

## FALL/WINTER 1965–66

Journalist Gloria Emerson hailed this collection as Capucci's best since he had left Italy for Paris in 1962.[10] His use of black and white, elegantly pared-down silhouettes, and striking Op art–inspired fabrics —constructed of silk satin ribbons woven into dizzying patterns by Luciano Forneris, one of Italy's most famous textile designers— was masterful. The illusory effect of vibrating shapes, produced by juxtaposing patterns and lines, of Capucci's *Omaggio a Vasarely* (*Homage to Vasarely*) dress (figs. 40 and 41) recalls the compositions of acclaimed Op artist Victor Vasarely (French, born Hungary, 1908–1997).[11]

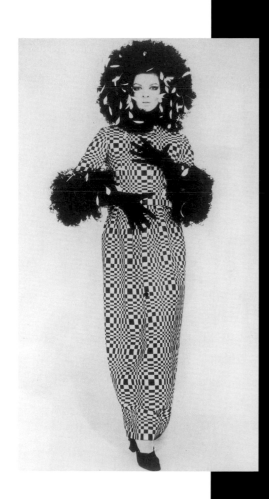

*Above*: Fig. 40. Model wearing Capucci's *Omaggio a Vasarely* dress (fig. 41), August 30, 1965. Keystone Collection / Hulton Archive / Getty Images

*Right*: Fig. 41. *Omaggio a Vasarely* (*Homage to Vasarely*) Dress, 1965, woven silk satin ribbons and ostrich feathers (N.268)

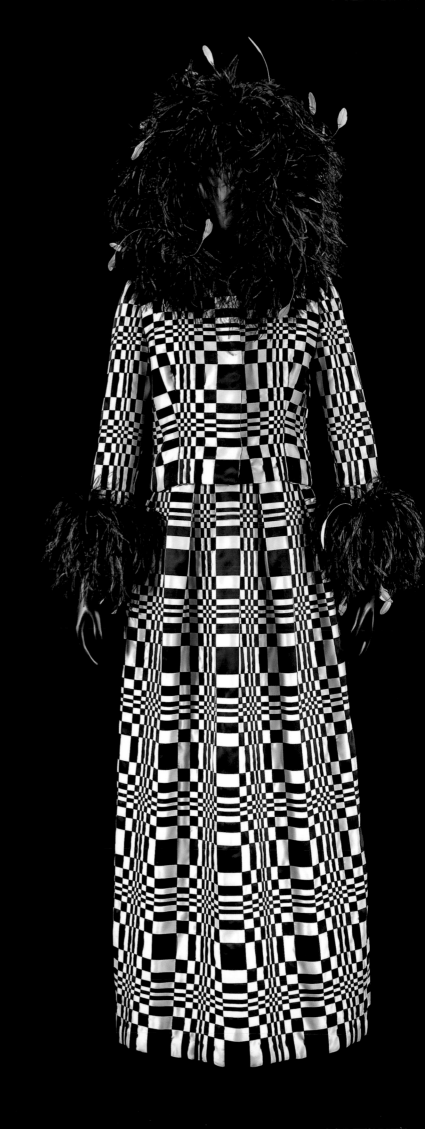

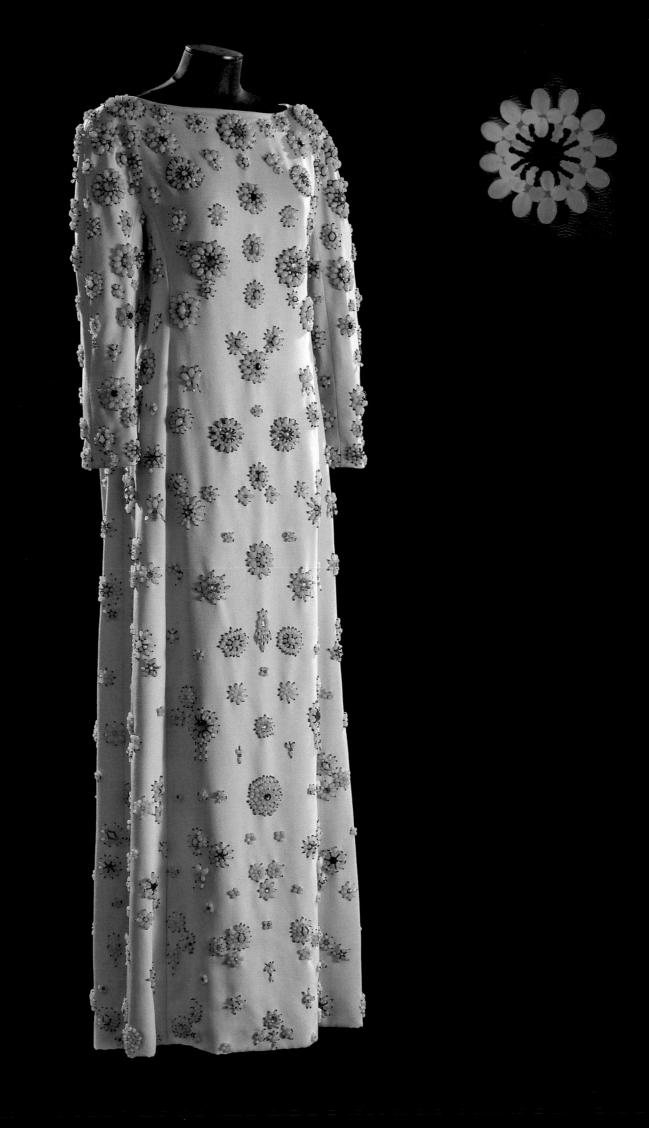

## FALL/WINTER 1965–66

During the presentation of Capucci's collection, the lights suddenly went out and specters of disembodied dress details—bodices, hems, waistlines—began floating down the darkened runway. When the lights were restored, six models stood in pastel evening dresses embroidered with phosphorescent beads (figs. 42a–c; see figs. 43a–c). Capucci's memory of a procession of penitents holding luminescent rosaries on their way to the Sanctuario Madonna del Divino Amore in Rome had inspired the ghostly parade. He ordered the beads by the boxful from the manufacturer in Assisi, and he continued to incorporate them into designs for the following season.

Figs. 42a–c. Dress, 1965, silk crepe embroidered with phosphorescent beads and stones; *opposite, inset*: detail showing the bead embroidery aglow (N.152)

Figs. 43a–c. Dress, 1965, silk crepe embroidered with phosphorescent beads and stones; *opposite, inset*: detail showing the bead embroidery aglow (N.153)

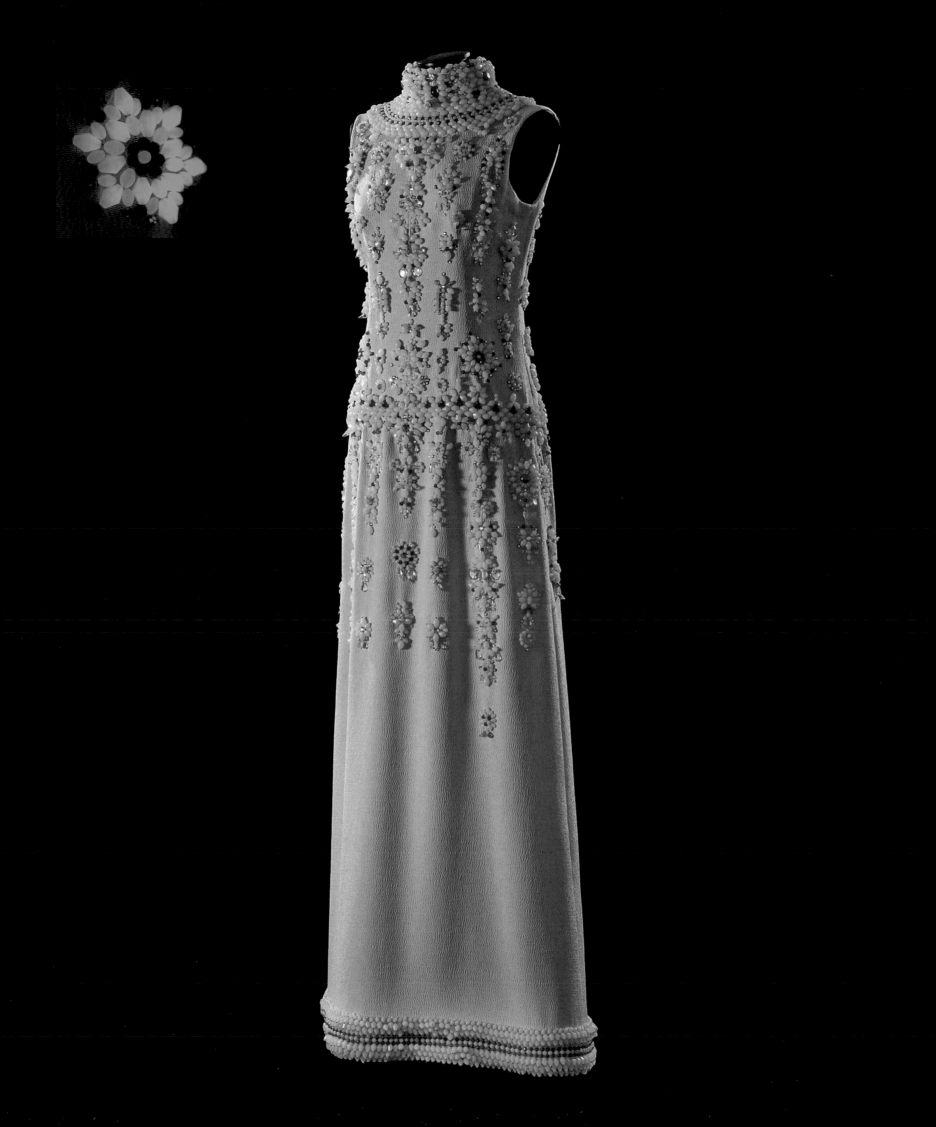

## SPRING/SUMMER 1966

Capucci pushed the boundaries of fashion by experimenting with nontraditional materials. His innovative collection this season was the first in haute couture to use plastic: A short, white cotton dress with crystal embroidery was encased in clear plastic and featured a cut-out above the hem that revealed the model's legs (fig. 44), a satin cocktail dress covered in transparent plastic exposed the model's midriff, and a short, white dress was slip-covered with a clear plastic "box" (fig. 45). He accessorized the dresses with domed hats covered in clear plastic and white evening shoes with clear plastic heels.

*Right*: Fig. 44. Dress, 1966, cotton and plastic embroidered with crystals (N.146)

*Opposite*: Fig. 45. Model wearing a dress and hat, both slip-covered with clear plastic, from Capucci's spring/summer 1966 collection, 1966. © Nylfrance / Roger-Viollet / The Image Works

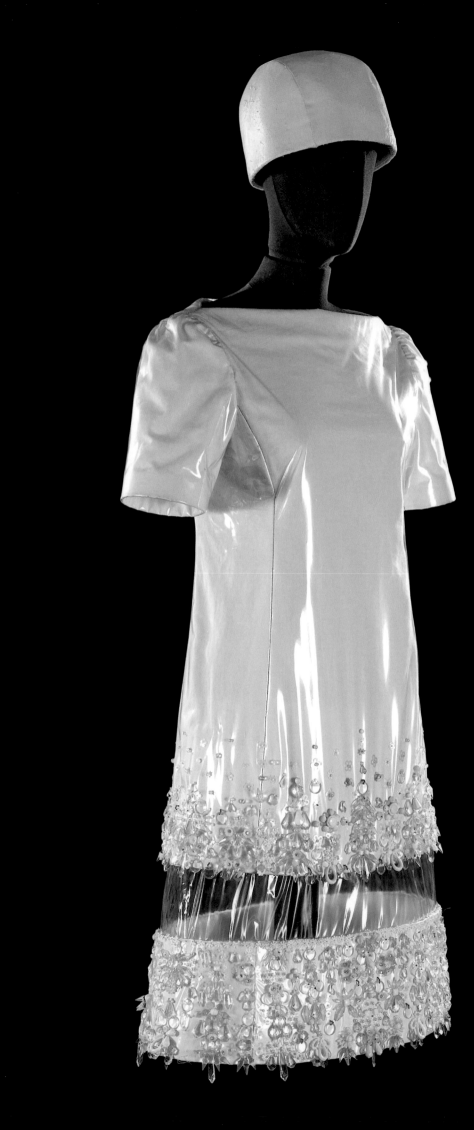

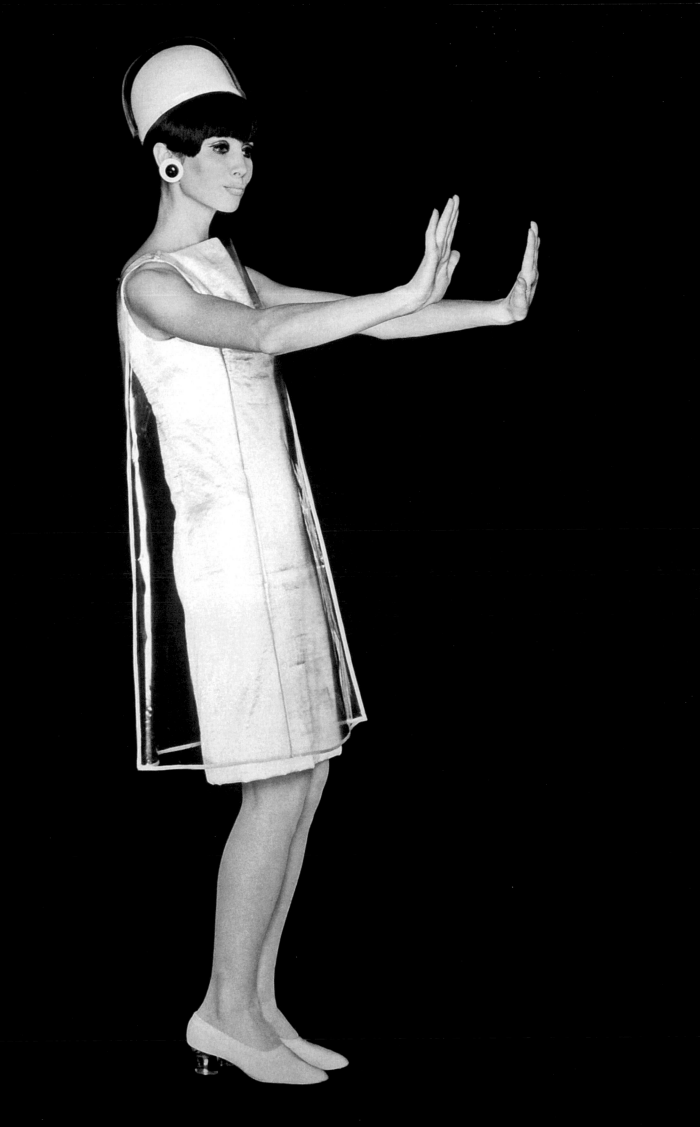

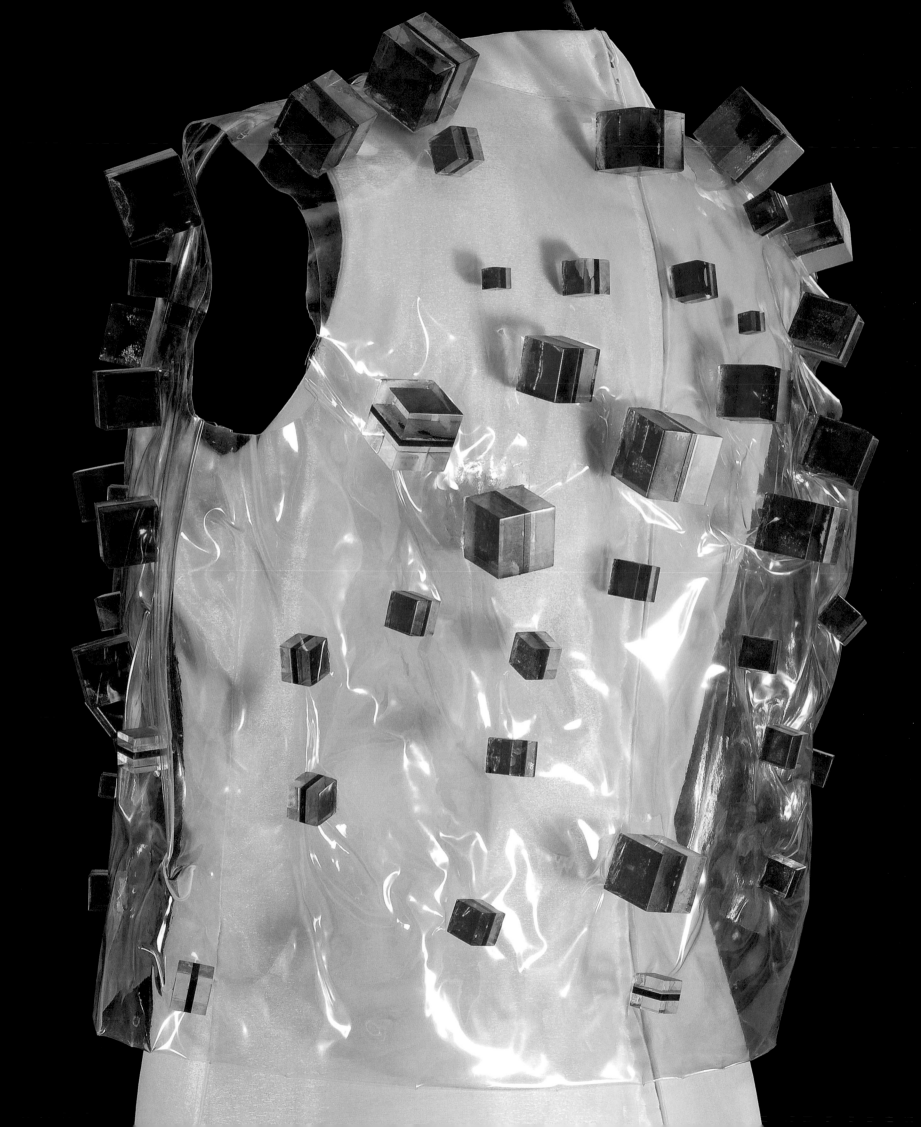

## SPRING/SUMMER 1967

Capucci continued to experiment with plastic, as seen in this sleeveless jacket decorated with two-tone transparent cubes of varying sizes, which accessorized a simple, white silk evening dress (figs. 46a,b; see fig. 38). His designs featured beautiful fabrics paired with "movable and removable parts" put together with zippers and Velcro.[12] The lower half of a coat, when removed, became a jacket worn over a dress, and an evening skirt could be unzipped to reveal party shorts. According to fashion writer Eugenia Sheppard, Capucci's futuristic collection outshone that of American avant-garde designer Joan "Tiger" Morse (1932–1972) and those of the young designers of Paraphernalia, an experimental New York boutique that embraced unusual materials such as paper, plastic, and vinyl, and had introduced the miniskirt to the United States in 1965, the store's inaugural year.[13]

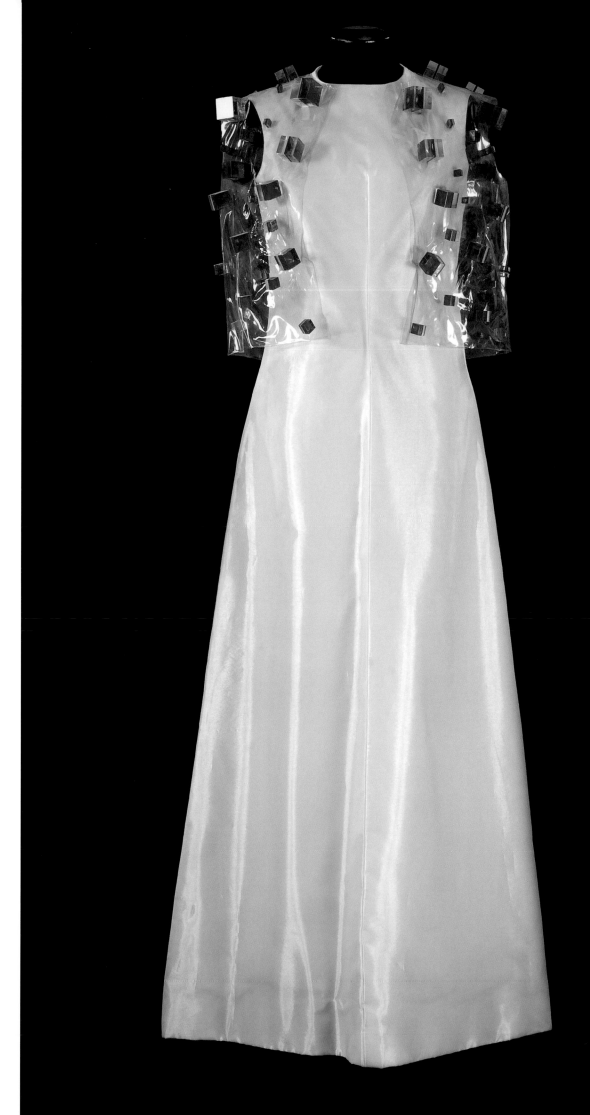

Figs. 46a,b. Dress, 1967, cotton lamé and plastic with plastic cubes (N.148)

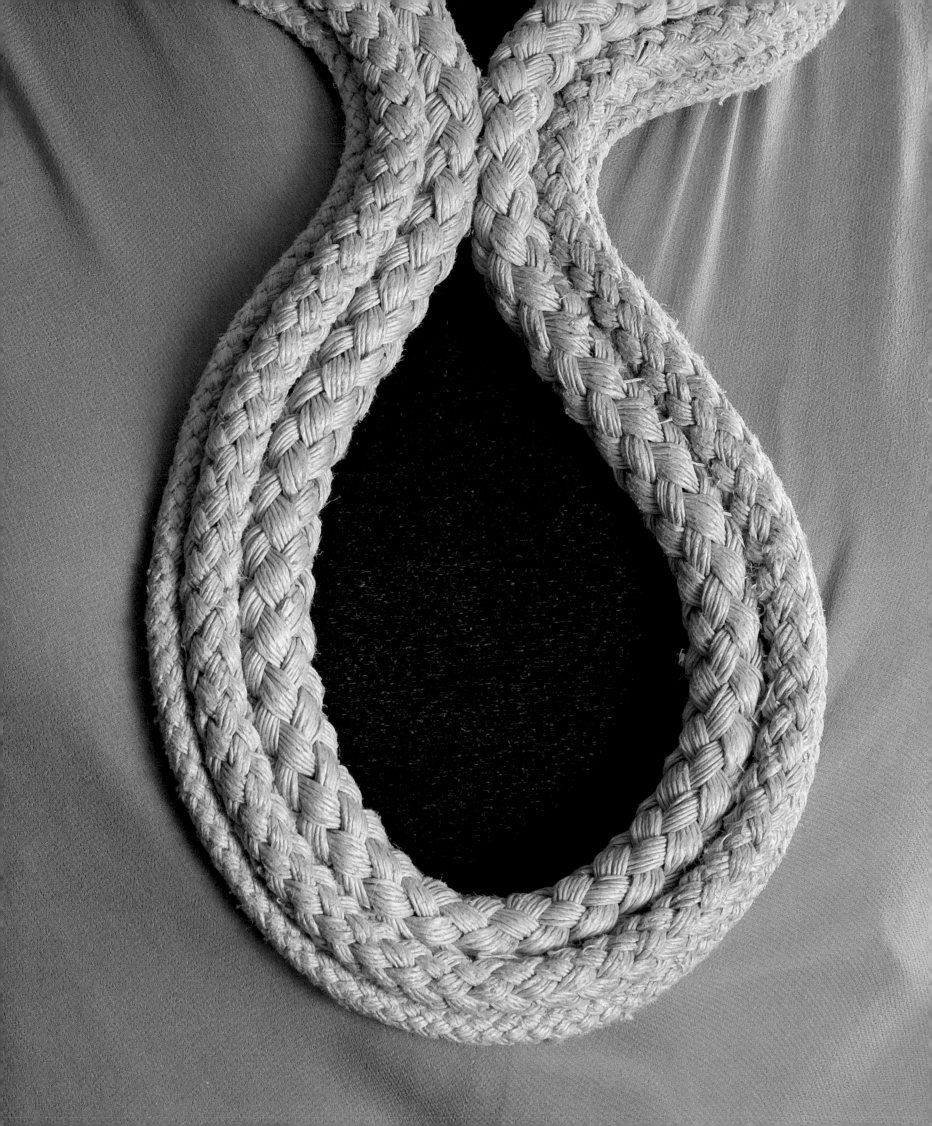

# The Return to Rome: Experimentation and Discovery, 1968–79

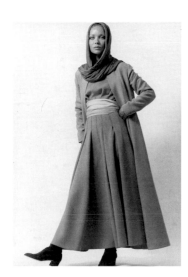

AFTER SIX YEARS IN PARIS, IN 1968 CAPUCCI MOVED BACK TO ROME, returning to his atelier at 56 Via Gregoriana. His time in France had been difficult, as he had struggled with the fickle French press and the changing economics of high fashion, due in part to the great political and social upheaval sweeping through Europe and beyond. A series of student protests persisted for months in Italy, and in March 1968 a Vietnam War protest in Rome shut down the city's university for twelve days. The May 1968 protests in Paris in which millions of students and workers demonstrated against the conservative government of President Charles de Gaulle effectively brought the country's economy to a standstill. Paris couturiers, already facing declining sales as buyers' tastes continued to shift toward more youthful fashions and prêt-à-porter, worried that the labor strikes in the textile and transportation industries would force them to postpone the presentations of their fall/winter 1968–69 collections until September, significantly affecting sales.[1] Moreover, designers in France remained concerned that de Gaulle's foreign policies—including his opposition to U.S. involvement in the Vietnam War and his criticism of Israel—would lead Americans to boycott Paris fashion.[2]

Capucci, meanwhile, had continued to delight the American critics in Paris, but the French press proved unpredictable and increasingly negative; it seemed the Americans were more receptive to his move to Paris than the French were.[3] He realized he had to return to his homeland, later explaining that he had missed the wonderful colors of Rome.[4] Yet Italian fashion, like that of Paris, had undergone dramatic changes. Giorgini resigned as organizer of the Florence fashion shows in 1965, and beginning that year boutique and sportswear collections were shown in Florence, high fashion in Rome under the Camera Nazionale della Moda Italiana, and ready-to-wear in Milan. Italian couturiers faced financial problems similar to those of the Paris designers: It had become increasingly difficult to finance high-fashion collections, and a shrinking client base forced the couture houses to expand into ready-to-wear clothing and merchandise licensing. In a later interview Capucci described his increasing disillusionment, as high-fashion designers were sacrificing creativity in order to satisfy the market: "The happiest moment is the moment of creation. . . . But a creator isn't free to design what he likes any more. It is very sad."[5] Capucci's reflective and somewhat melancholy mood of the late 1960s and early 1970s is reflected in his only experience as a costume designer for film. At director Pier Pasolini's persuasion, Capucci agreed to design Silvana Mangano's and Terence Stamp's wardrobes for Pasolini's film *Teorema* (*Theorem*; 1968).[6] His use of color, or lack of it, underlined the psychological tension in the narrative: He dressed Mangano conservatively and in pale shades, using red only when her character found love.

In 1970 Capucci first traveled to India, where he found a spiritual home and engaged in collaborative ventures with the Handicrafts and Handlooms Export Corporation, founded by the Indian government in 1958 to encourage export of the country's craft goods.[7] The experience refocused him: He explored new colors and fabrics, and adopted a more poetic and fanciful aesthetic, which would resonate in his designs over the following decades. Capucci's fall/winter 1970–71 collection, presented in July 1970 in the moonlit courtyard of the sixteenth-century Villa Giulia in Rome, reflected the designer's introspective sensibility. Models wearing simple, unadorned dresses and pale earth-toned cloaks of sheer wool, silk, jersey, and nun's veiling drifted dreamily among the classical statuary and columns (fig. 48). The setting was pure magic. Patricia Shelton of the *Christian Science Monitor* commented that Capucci's presentation of "lovely" capes and dresses "was more like watching a religious pageant than a fashion show."[8]

*Left*: Fig. 47. Detail of fig. 50

*Above*: Fig. 48. Model wearing a wool crepe coat and dress from Capucci's fall/winter 1970–71 collection. © Australian Wool Innovation Limited 2010. Photograph courtesy of London College of Fashion

## SPRING/SUMMER 1969

In January 1969 Capucci proved he had "lost nothing of his skill" when he presented his homecoming collection at the end of the official eight-day program for the spring/summer high-fashion collections.[9] He experimented with new fabrics, such as wool ombré, and construction techniques, including an intarsia method evident in his *Omaggio a Burri* (*Homage to Burri*) coat made of jagged sections of cloth stitched together (fig. 49). Italian artist Alberto Burri (1915–1995), for whom the coat is named, was renowned for his tactile collages made of unorthodox materials, such as burlap and tar, and later for his *Cretti* paintings, whose cracked and creviced surfaces resemble sun-scorched terrain.[10]

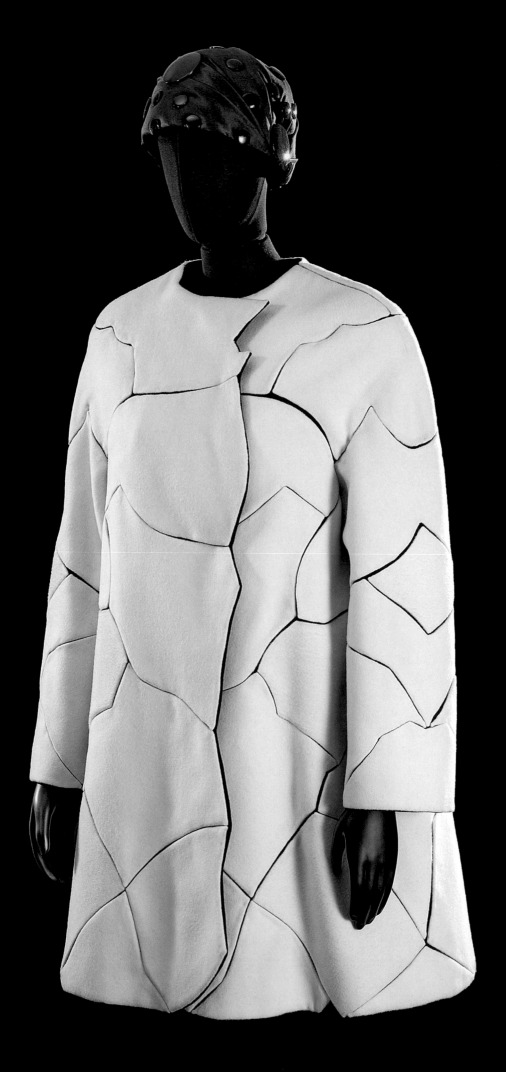

Fig. 49. *Omaggio a Burri* (*Homage to Burri*)
Coat, 1969, silk georgette and wool (N.187)

## SPRING/SUMMER 1971

The influence of Capucci's first trip to India was evident in his graceful, flowing dresses in muted tones of orange, pink, and yellow (a contrast to the shorts and the more structured 1940s-inspired styles that dominated other couturiers collections this season).[11] He presented dresses trimmed with rope (fig. 50; see fig. 47), and provocative but elegant evening dresses slit to the armpits and held together with rope or linen belts. *New York Times* fashion editor Bernadine Morris, whose review included an illustration of one of his "ultimate-slit" dresses, reported that Capucci's models "looked like goddesses."[12]

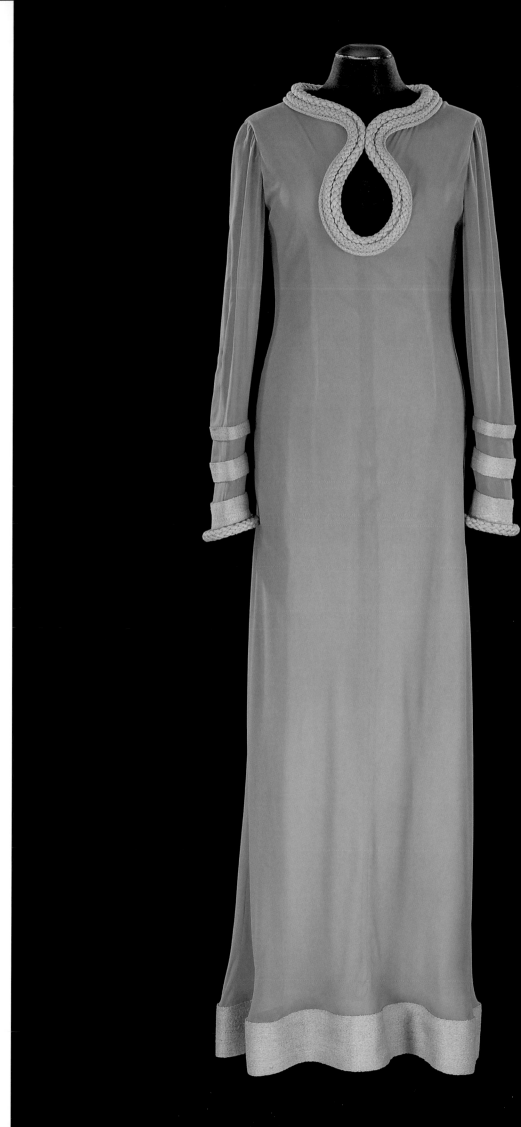

Fig. 50. Dress, 1971, silk georgette with natural-fiber rope (N.135)

## SPRING/SUMMER 1972

Nature has always been a source of inspiration for Capucci, and for the spring/summer 1972 season he experimented with pairing nontraditional materials—bamboo, pebbles, straw—with luxurious silk chiffons and crepes. Bamboo and pebbles outlined cuffs or necklines, or circled waistlines (figs. 51a,b; see figs. 52a,b). He wove straw and raffia, quintessentially Italian materials, into bodices (see figs. 53a,b), a technique he would reprise in 1980 in an evening dress entirely made of straw (see figs. 54a,b). Capucci was among a decreasing number of couturiers who presented in Rome this season, as the Italian high-fashion industry was in financial crisis largely due to decreasing sales and labor strikes.[13]

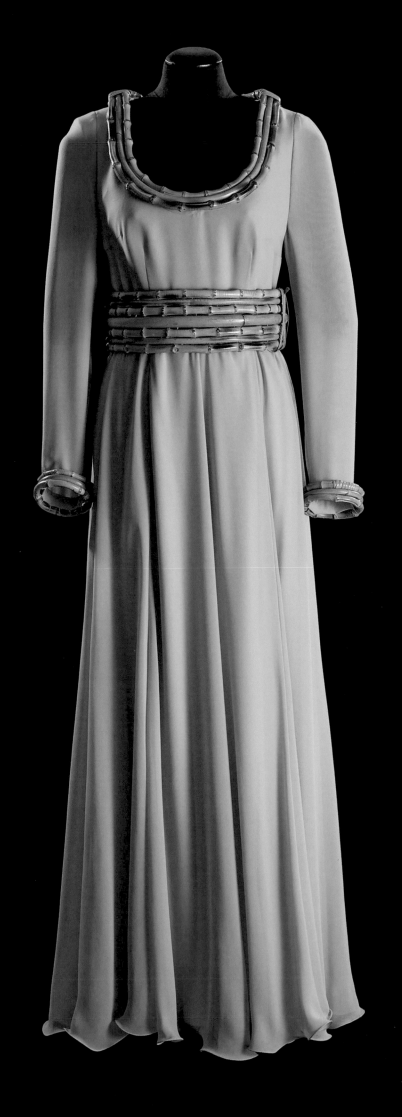

Figs. 51a,b. Dress, 1972, silk georgette with bamboo (N.136)

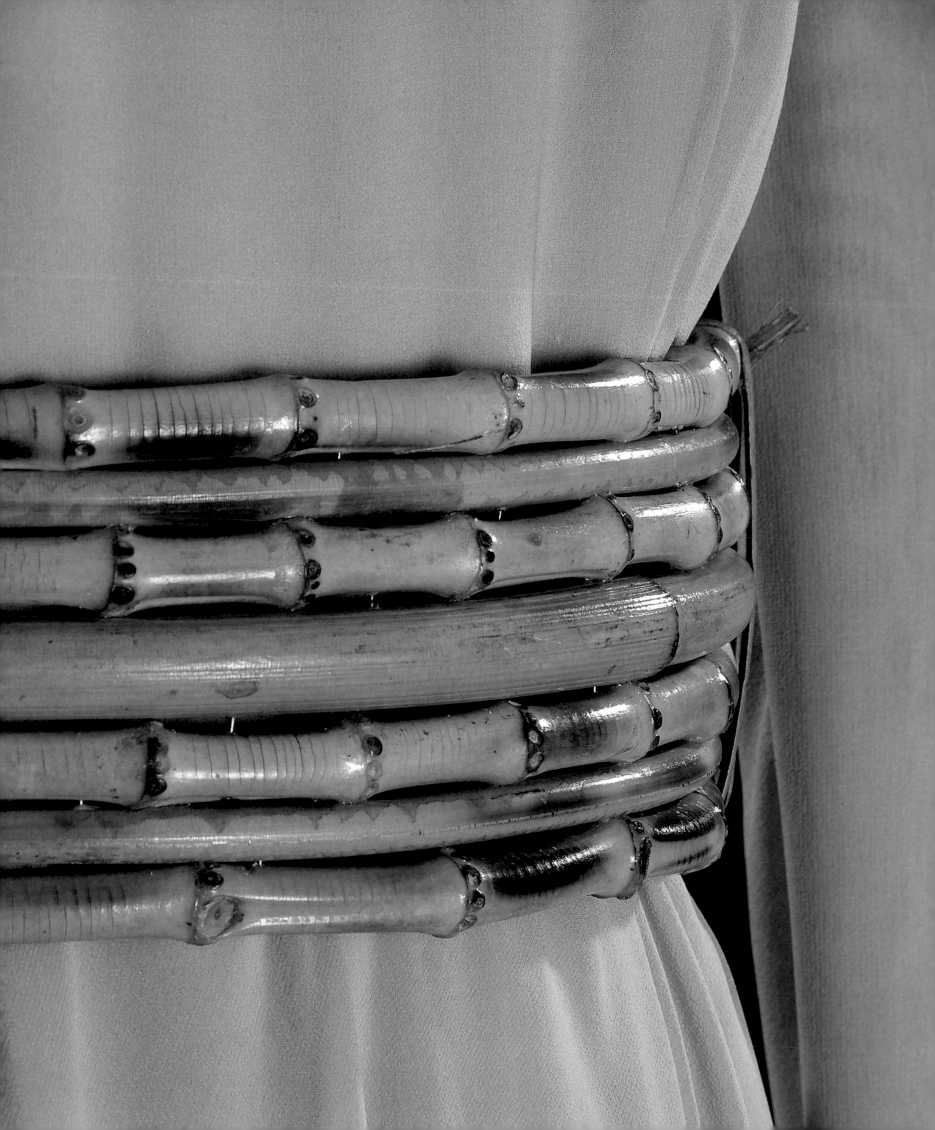

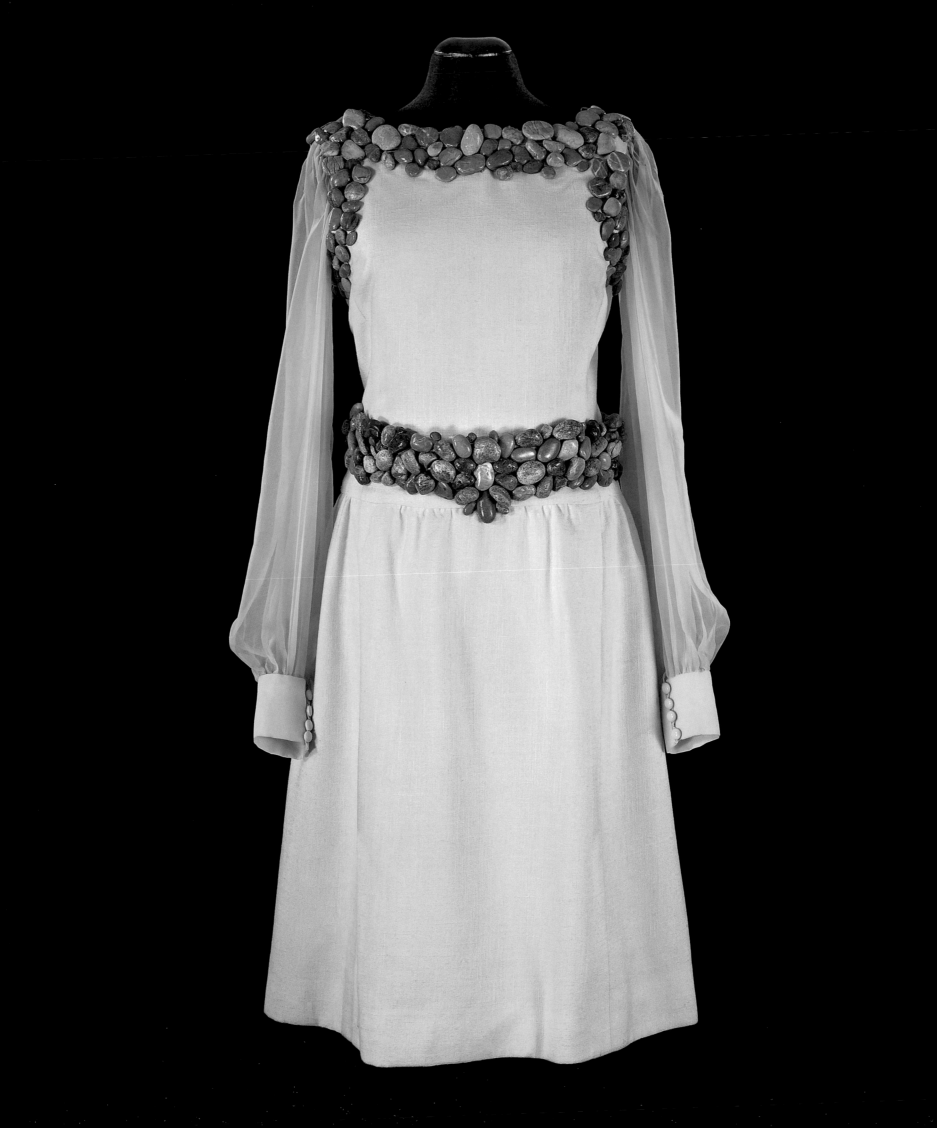

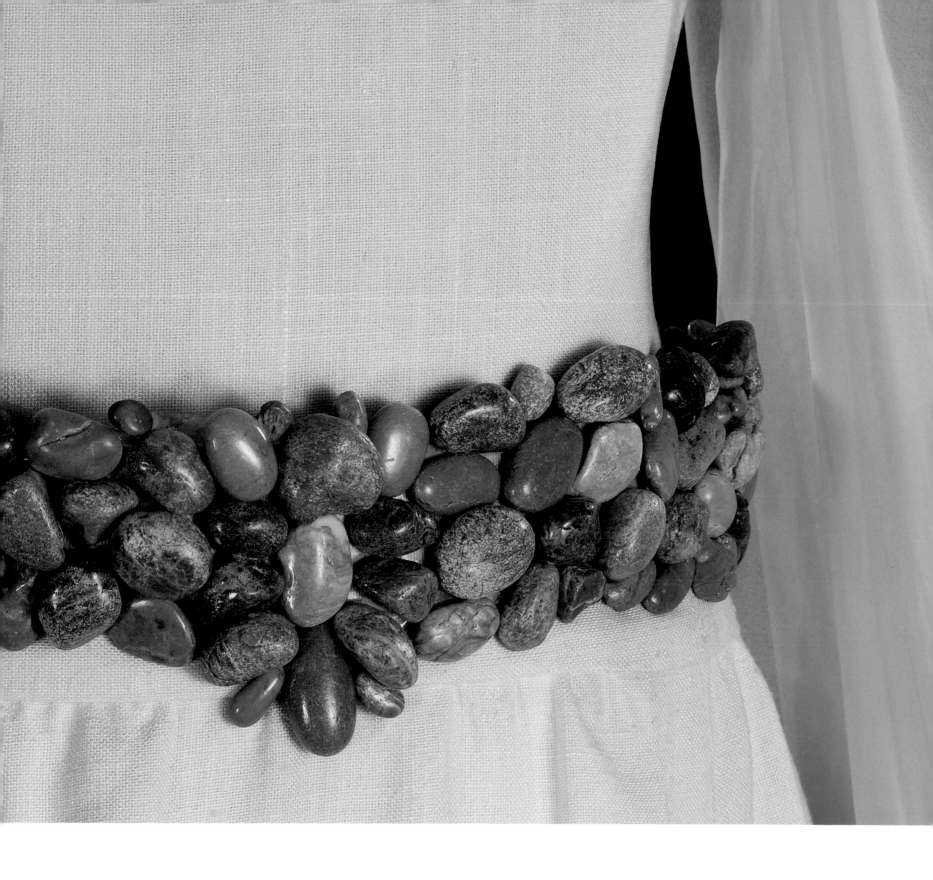

Figs. 52a,b. Dress, 1972, silk shantung taffeta
and silk georgette with pebbles (N.139)

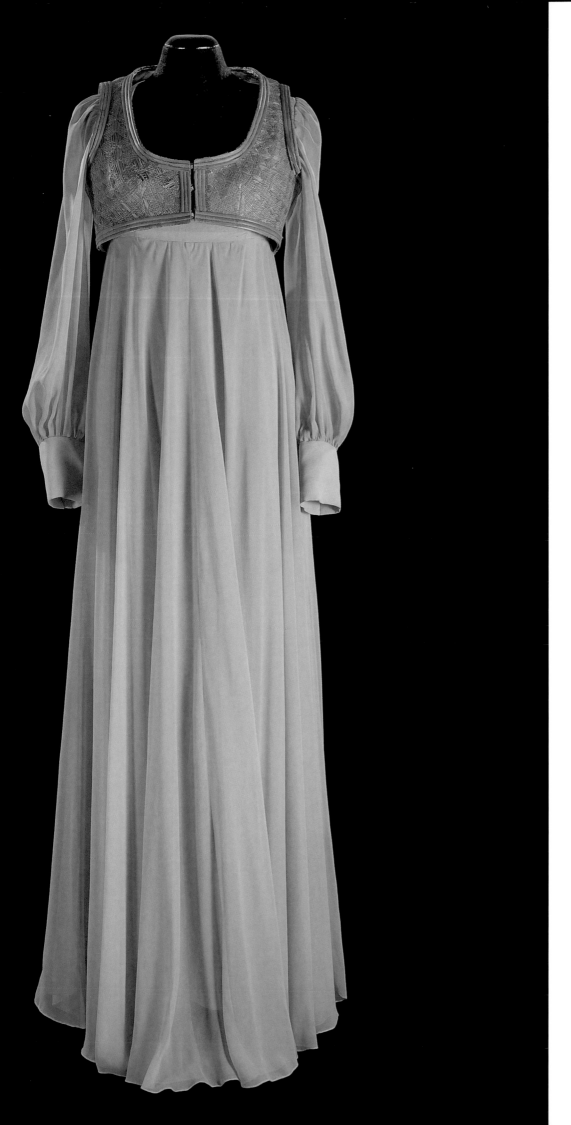

Figs. 53a,b. Dress, 1972, silk georgette with woven straw (N.137)

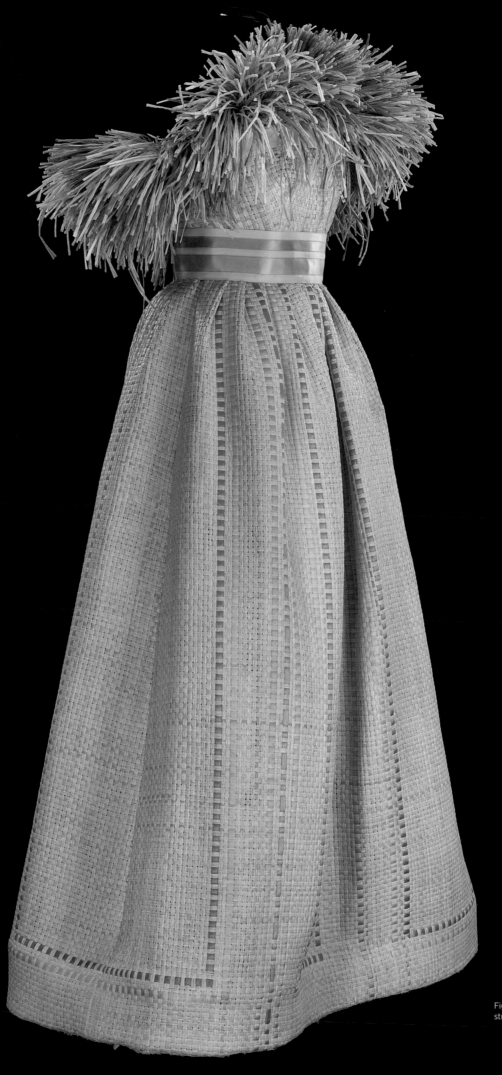

Figs. 54a,b. Sculpture Dress, 1980, woven straw and silk satin ribbons (N.134)

## FALL/WINTER 1978–79

Capucci's designs for fall/winter 1978–79 signaled a profound change of direction, as he reconsidered the relationship of the body to form. His creations were decidedly sculptural, and his striking silk satin evening gown resembling a Doric column was pure architecture (figs. 55a,b). Although the Italian collections this season marked a return to luxury and sophistication (gone were the flowing, ethereal dresses and tunics), the country's high-fashion market continued to struggle, as the industry increasingly focused on the ready-to-wear shows in Milan and Paris (the Rome show, according to the press, was "a shadow of its former self").[14]

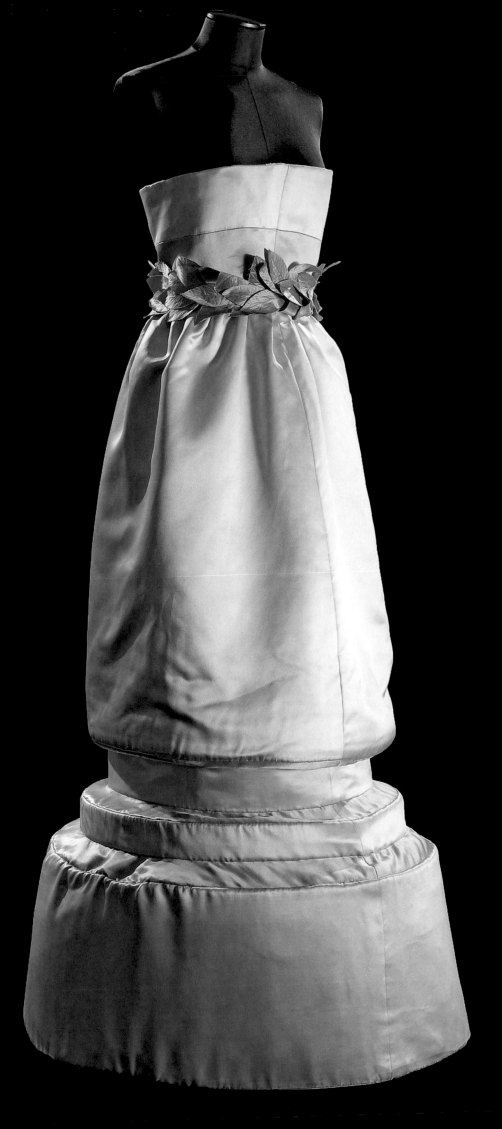

Figs. 55a,b. *Colonna dorica* (*Doric Column*) Sculpture Dress, 1978, silk satin (N.97)

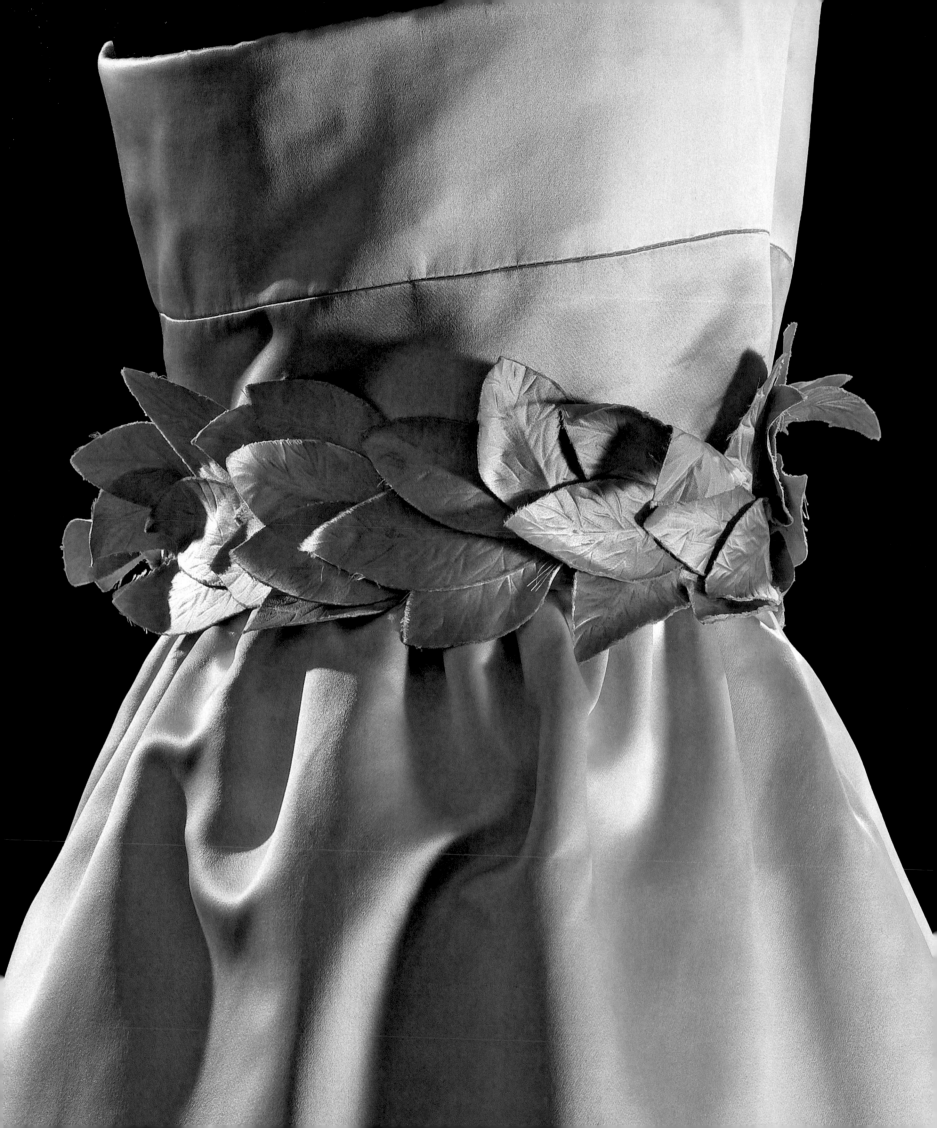

The "theatrical magnificence" of Capucci's beautiful sculpted clothes prompted Associated Press fashion writer Daniela Petroff to declare him the "creator par excellence."[15] For spring/summer 1979 he presented dresses with parts that swayed or otherwise moved when the wearer was in motion; thus, the gowns became in effect kinetic sculptures. The bodice of an evening gown was made of tightly wrapped brass wire, a single coil of which was loose, orbiting but not touching the body (figs. 56a,b); another dress was appended with brass-wire "wings," spiraling out from the bodice (see figs. 57a,b).

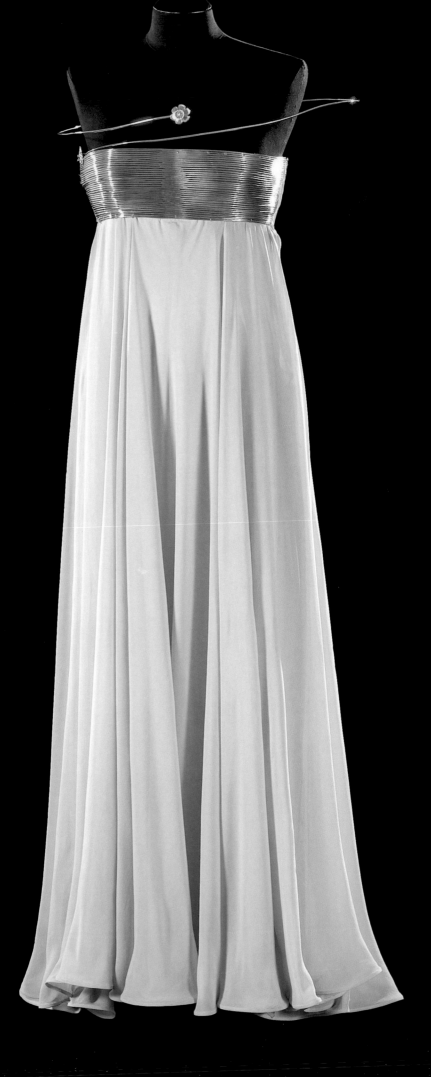

Figs. 56a,b. Sculpture Dress, 1979, silk georgette with brass wire (N.138)

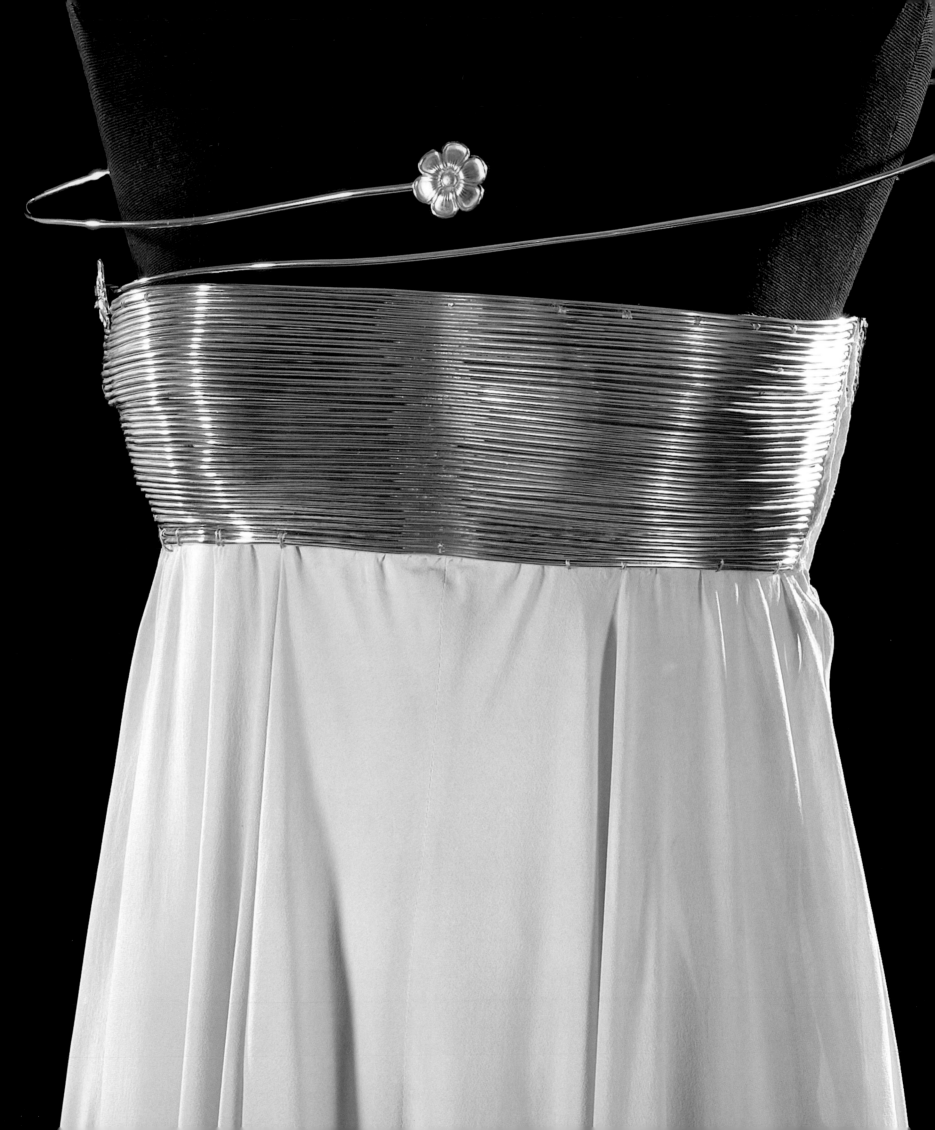

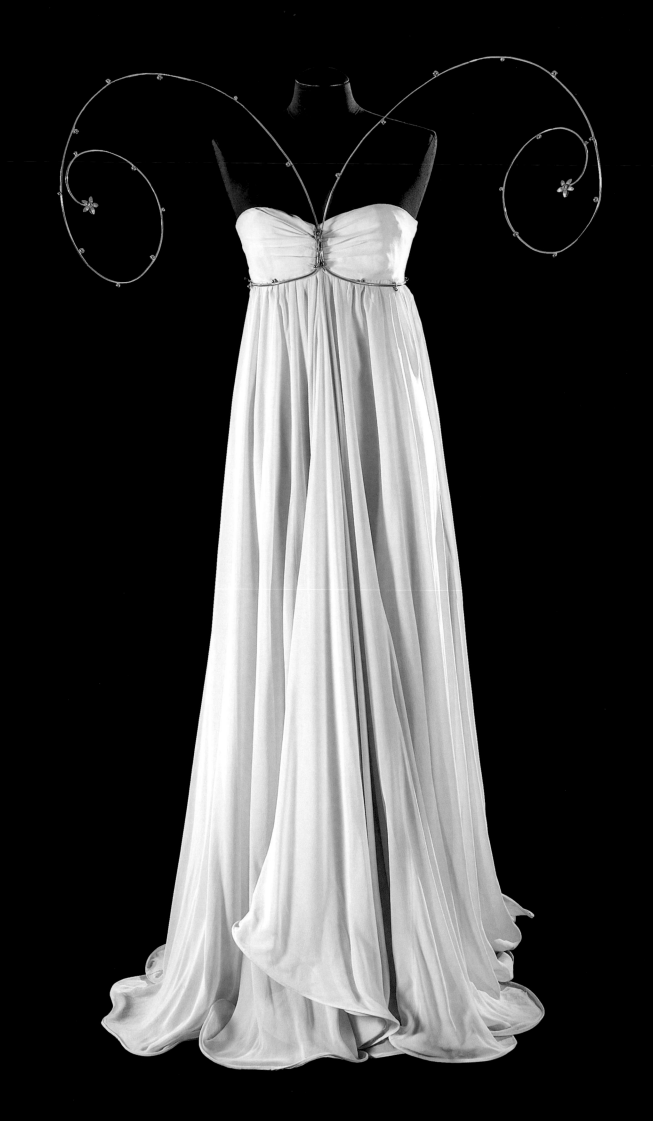

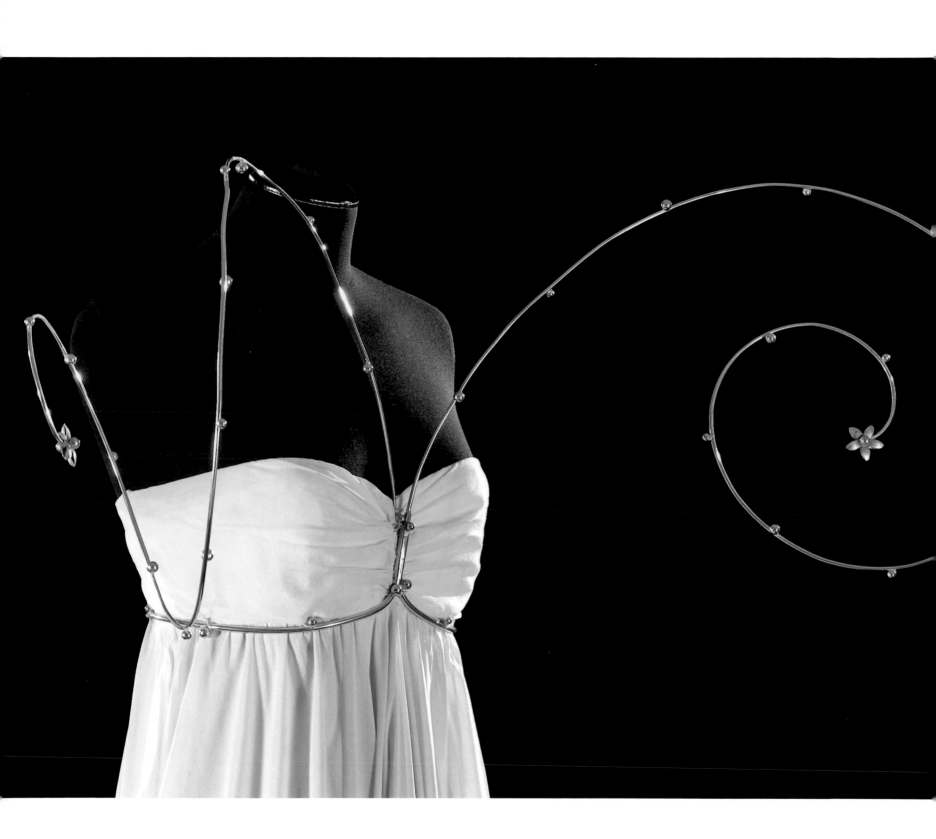

Figs. 57a,b. Sculpture Dress, 1979,
silk georgette with brass wire (N.358)

# Beyond Fashion,
# 1980-2007

INCREASINGLY, CAPUCCI BECAME AN ANOMALY as fashion buyers embraced ready-to-wear over haute couture, "the ailing dowager of the Italian fashion industry."[1] By the late 1970s the main client base for Italian high fashion had shifted away from private customers and the United States, where buyers were promoting American over European designers. As a result, Italian couturiers, like French designers, increasingly used their high-fashion labels to promote so-called parallel design, products such as cosmetics, perfumes, scarves, and the latest fad, sunglasses.[2] Capucci, however, had continued to push the boundaries of fashion, transitioning from wearable designs to sculptures in fabric. With the number of haute couture clients diminishing, he realized he had to make a choice: "I understood something tragic was happening to me: I had to either close or change."[3] He chose not to compromise his artistic vision for commercial success: In 1980 Capucci announced he would resign from the official couture calendar. Beginning in 1982 and continuing through 1994, Capucci presented his work in solo presentations staged in grand architectural spaces in major international cities: Milan (1982), Tokyo (1983), Paris (1984), New York (1985), Rome (1987 and 1989), Munich (1989), Berlin (1992), Vienna (1994), and Graz, Austria (1994). He held his first solo fashion show at the Palazzo Visconti during Milan's spring/summer 1982 ready-to-wear presentations, which had featured couturiers Giorgio Armani (born 1934), Gianfranco Ferré (1944–2007), and Gianni Versace (1946–1997), as well as the houses of Fendi and Missoni (founded in 1925 and 1953, respectively). In her review of that season's collections, *New York Times* fashion editor Bernadine Morris declared that the Italians were "back in the fashion race," and described the sculptural artistry of Capucci's "extraordinary collection of clothes in phantasmagoric shapes that had only a passing relation to the human body."[4]

Removing himself from the seasonal calendar was liberating: "I was exasperated, I'd had enough of rules and calendars. I show when I want to, where I want to. If a painter or a sculptor hasn't finished, he doesn't show. . . . I rediscovered creative freshness, the joy of living."[5] Like works of art, only Capucci's original clothing models were sold; no copies were made. His renewed creativity did not go unnoticed: In 1995 Capucci received the ultimate honor when he was invited to show at the Forty-Sixth Venice Biennale with eighteen other contemporary Italian artists, marking the first time he presented his sculptures in a major international art exhibition.[6]

Capucci continues to recognize the importance of traditional skills to the creative process, explaining: "In order to keep high fashion alive, we have to preserve the artisans and rediscover the old ways of doing things. The cleverest, most talented designer can't produce without these artisans and this heritage."[7] He strives for perfection in all of his creations, refusing to cut corners regardless of cost-savings potential, and continues to seek the finest materials (an increasingly difficult endeavor, as textile manufacturers, like couturiers, have had to adjust to the market's demand for less expensive, more readily available products). Although his approach to design might seem antiquated to designers who have embraced the industry's commercialization, tradition has never restricted his creativity; he always has followed his own muse no matter the mood of the times. Fashion journalist Logan Bentley Lessona described Capucci as "the intellectual genius" of Italian fashion, "the designer's designer": "Where the others often tend to go along with whatever current is prevailing, he goes his own serene way, with the most original, innovative, and yet classically simple clothes. They are cut perfectly, they hang perfectly, they are almost impossible to copy, and they are simply, unmistakably haute couture."[8]

Fig. 58. Detail of fig. 68a

## GALLERIA NAZIONALE
## D'ARTE ANTICA, ROME,
## SPRING/SUMMER 1980

Capucci, "mystic of high fashion," presented this dress with a skirt in the form of a column of purple and yellow pleats (figs. 59a,b), which transcended his rigidly architectonic *Colonna dorica* (*Doric Column*) sculpture dress from the previous season and referenced his banjo line from the 1950s (see figs. 55a,b and 9).[9] The multicolored origami-like pleating gives the skirt the effect of changing color when in motion. Capucci's stunning *Ventaglio* (*Fan*) sculpture dress in red silk sauvage was one of a series of evening dresses inspired by hummingbirds' beating wings, a silhouette that symbolized his achievement of creative freedom (see figs. 60a–c).[10]

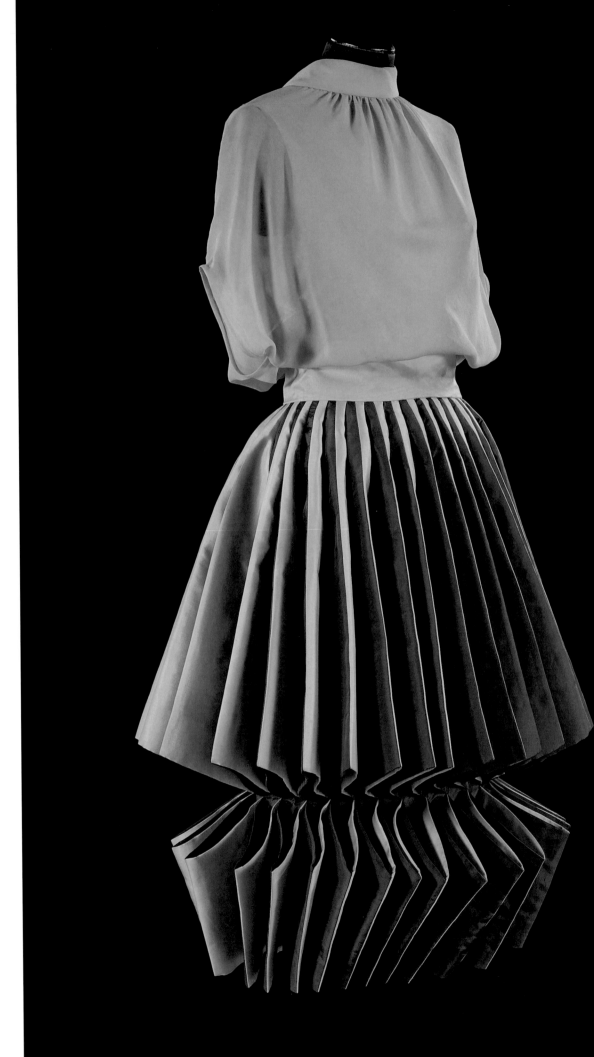

Figs. 59a,b. Sculpture Dress, 1980, silk taffeta and silk georgette (N.251)

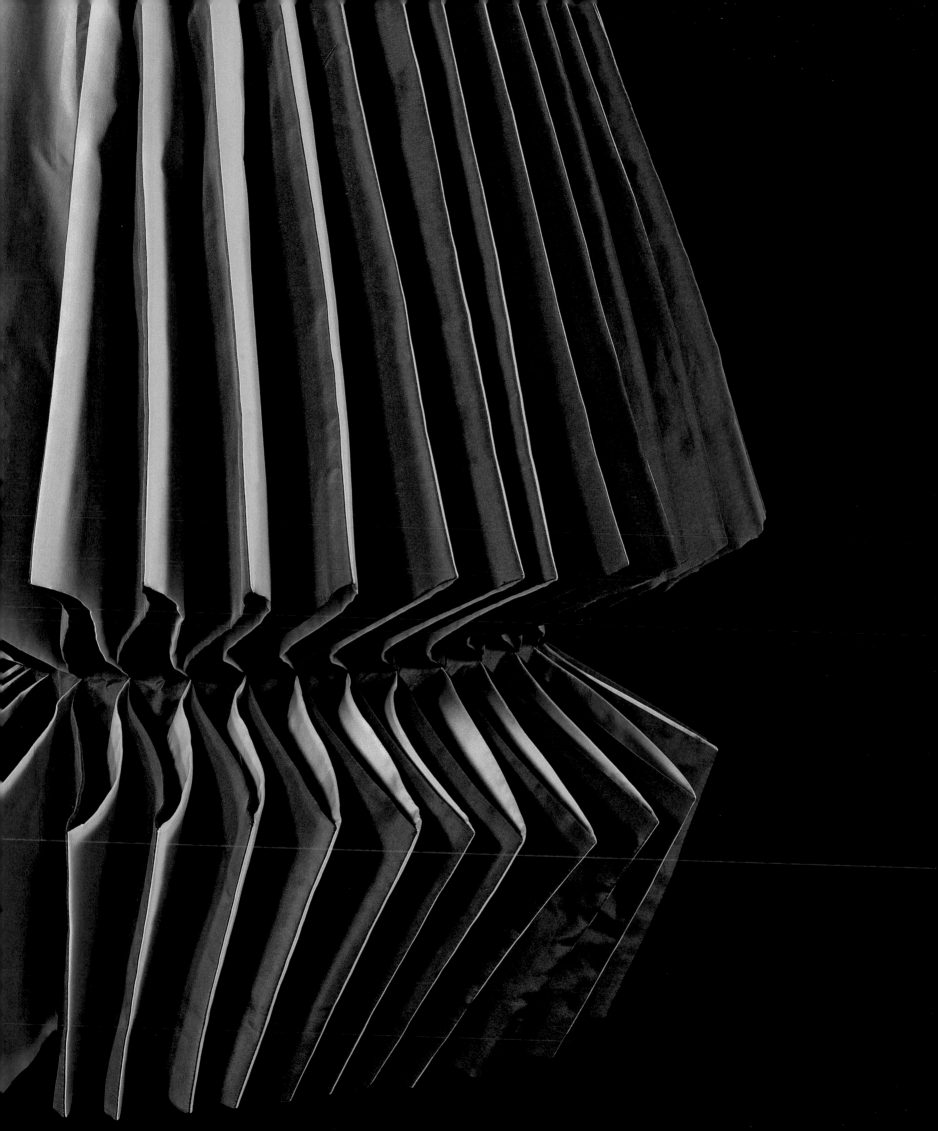

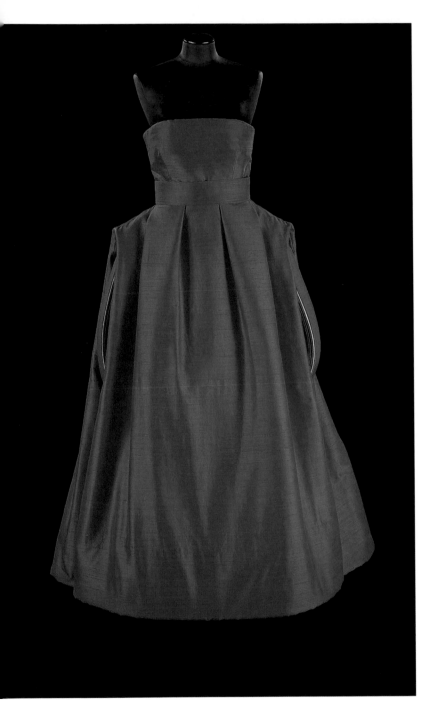
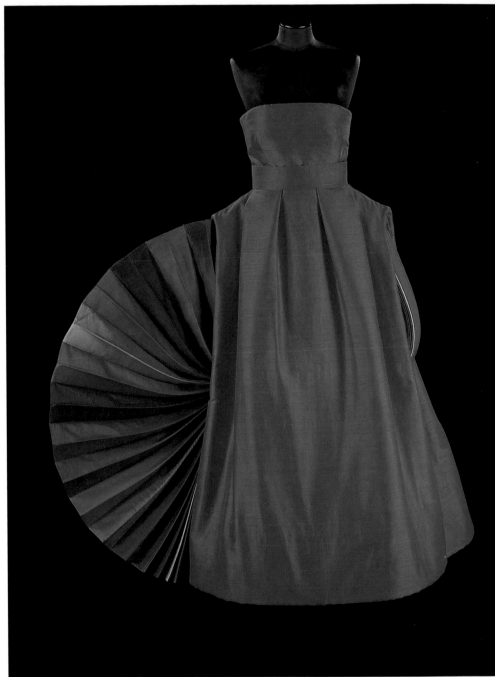

Figs. 60a–c. *Ventaglio* (*Fan*) Sculpture Dress,
1980, silk sauvage (N.3)

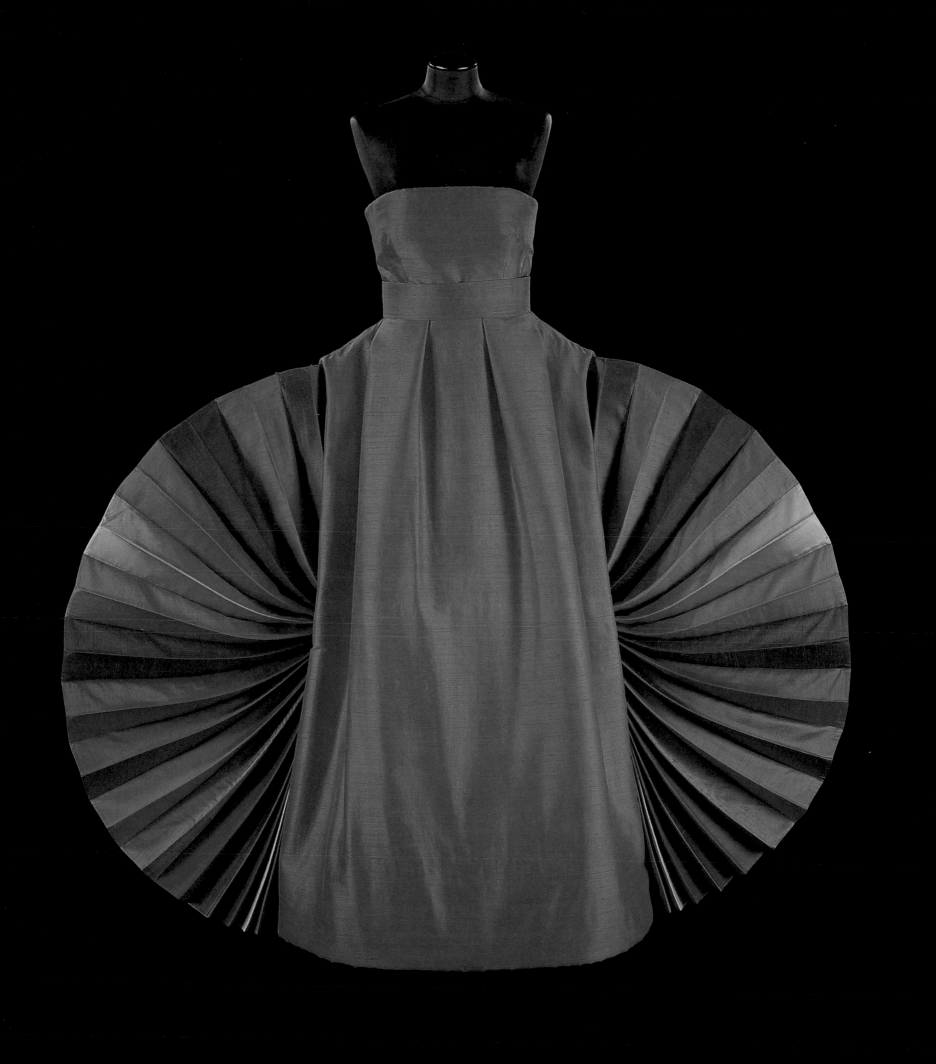

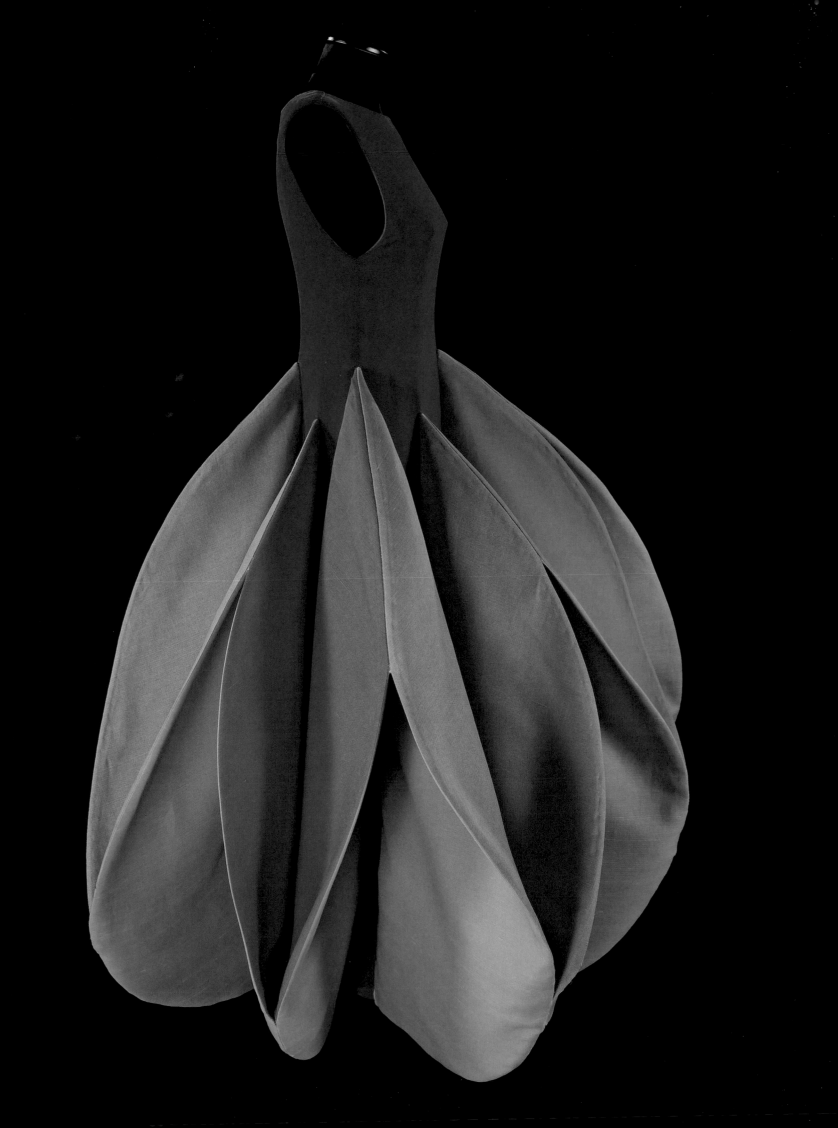

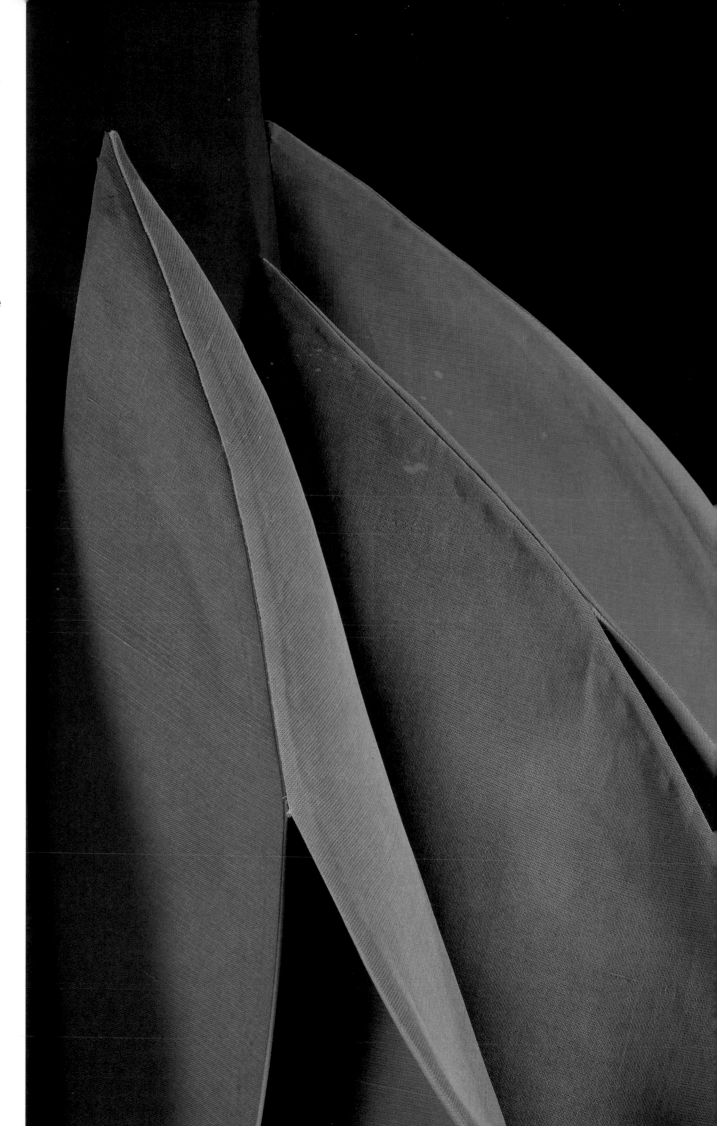

## MILAN, PALAZZO VISCONTI, OCTOBER 1982

In his first fashion show since his resignation from the official couture calendar, Capucci presented sculpture dresses in a wide range of forms, some inspired by nature, others by music: half circles on a skirt were sliced open, revealing glimpses of color and suggesting segmented fruit (figs. 61a,b); the green fabric of a skirt was folded to look like reeds (see fig. 64); and dresses, brightly colored or black and white, resembled the graceful shape of violoncellos (see figs. 62 and 63a,b). The collection featured several designs in royal purple and dark red silks, which he transformed into "great profusions of ruffles, rosettes and jetting circles" (see figs. 65a,b and 66a,b).[11]

Figs. 61a,b. *Arancia* (*Orange*) Sculpture Dress, 1982, silk velvet and silk gazar (N.2)

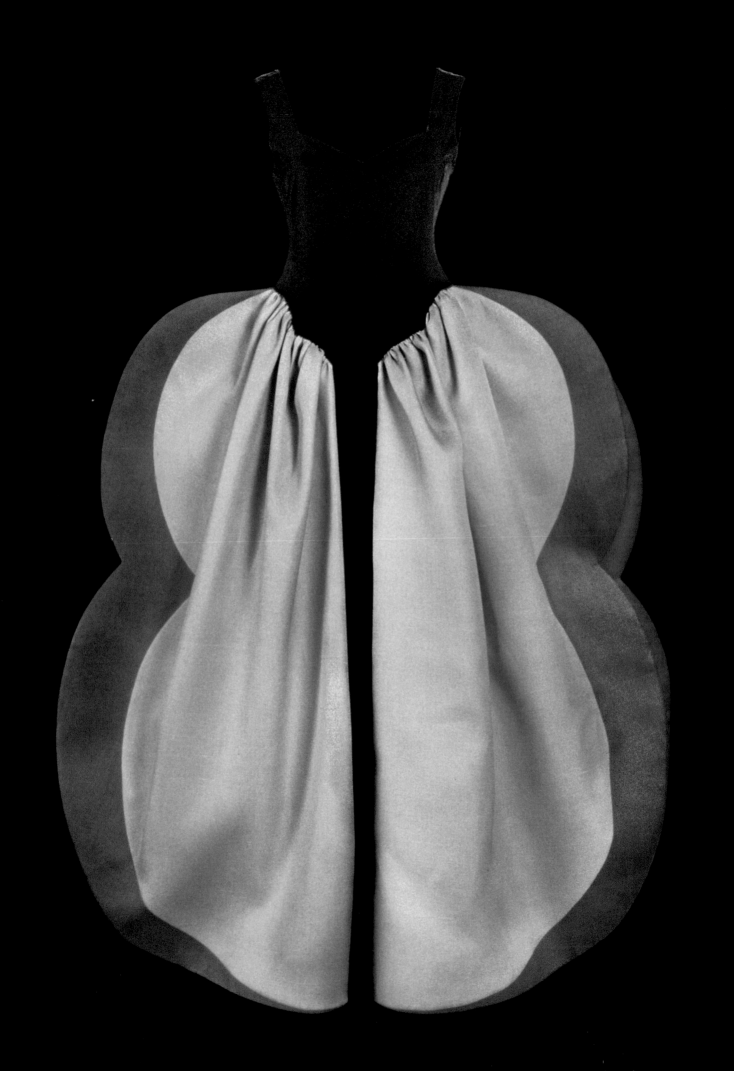

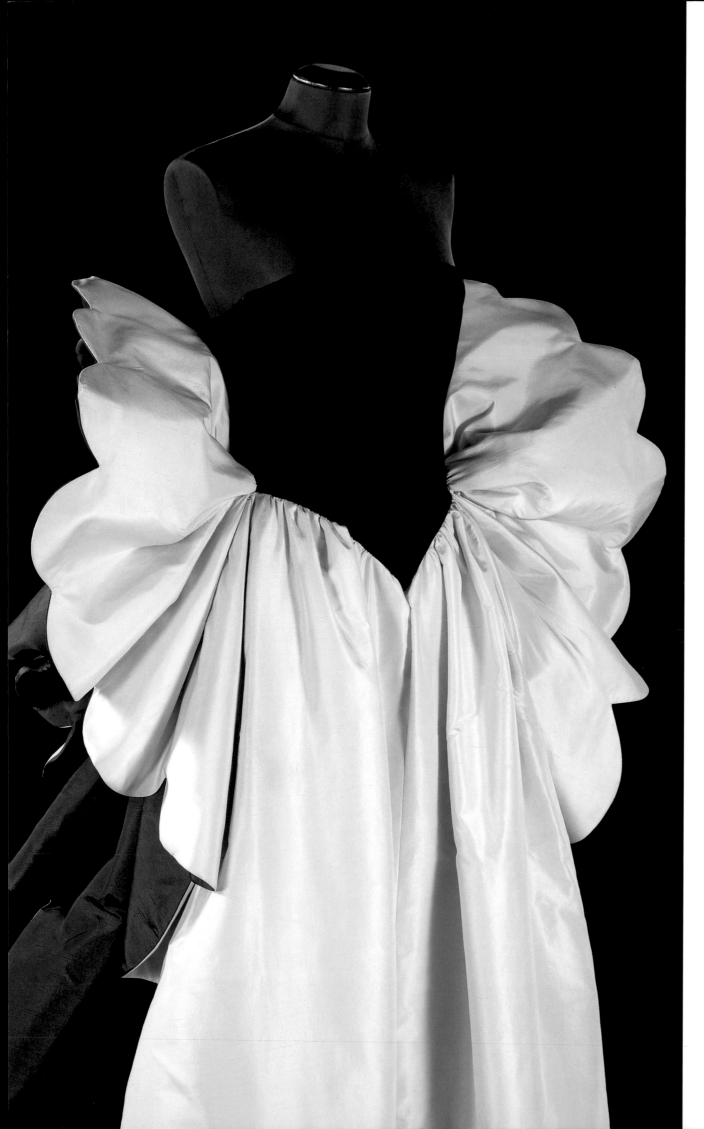

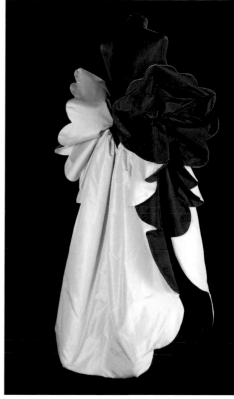

*Opposite*: Fig. 62. *Violoncello* Sculpture Dress, 1982, silk velvet and silk gazar (N.112). Photograph by Amedeo Volpe

*Left and above*: Figs. 63a,b. Sculpture Dress, 1982, silk taffeta and silk velvet (N.1)

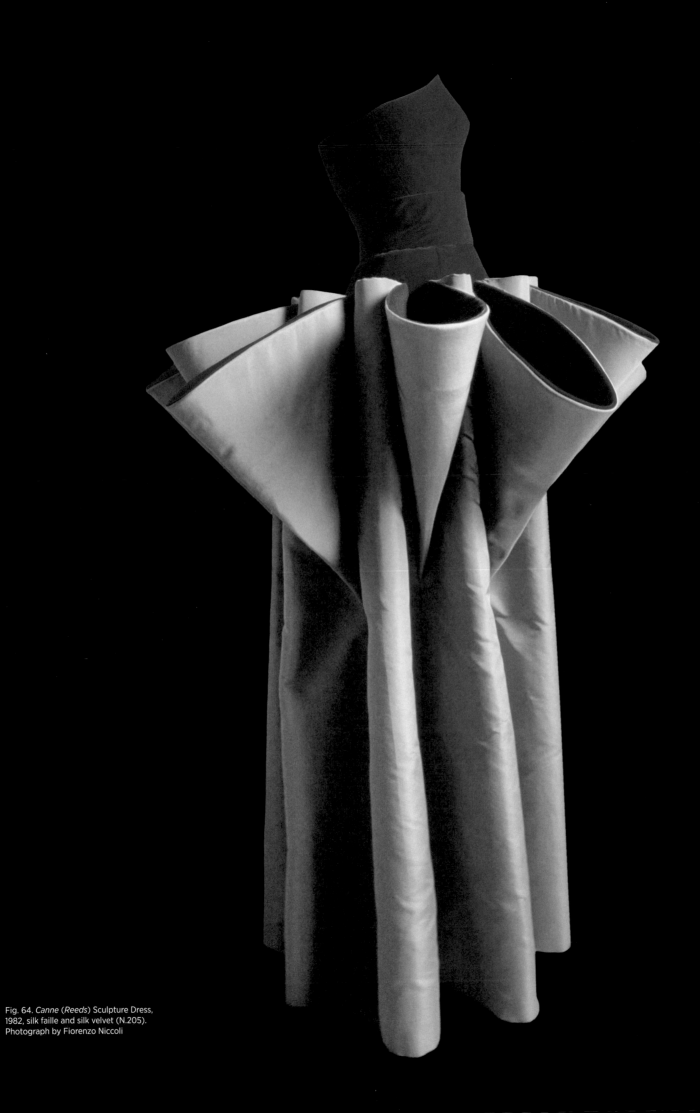

Fig. 64. *Canne* (*Reeds*) Sculpture Dress,
1982, silk faille and silk velvet (N.205).
Photograph by Fiorenzo Niccoli

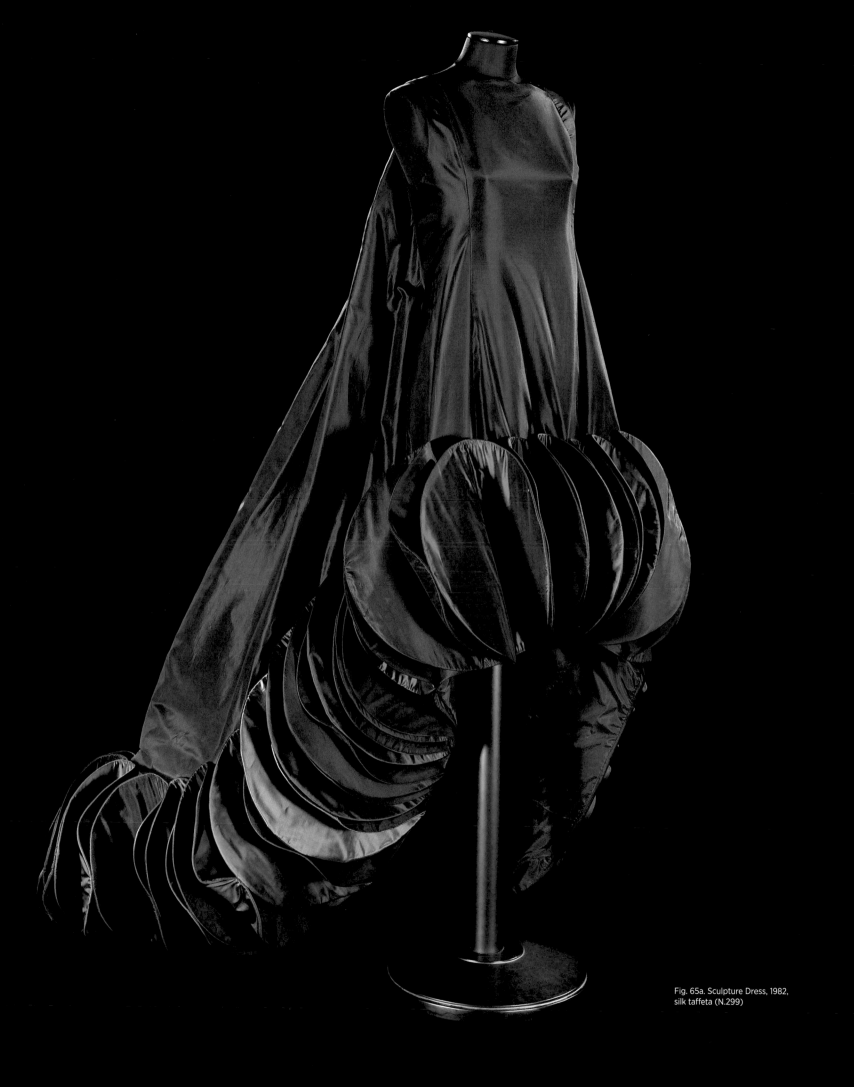

Fig. 65a. Sculpture Dress, 1982,
silk taffeta (N.299)

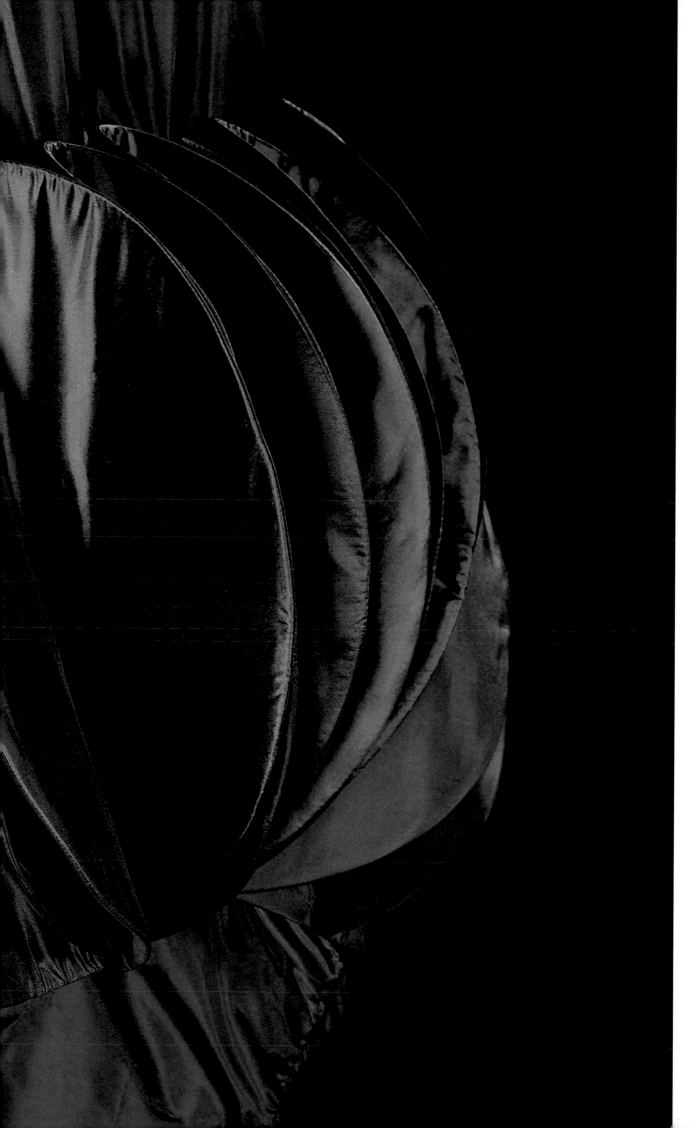

Fig. 65b. Sculpture Dress, 1982,
silk taffeta (N.299)

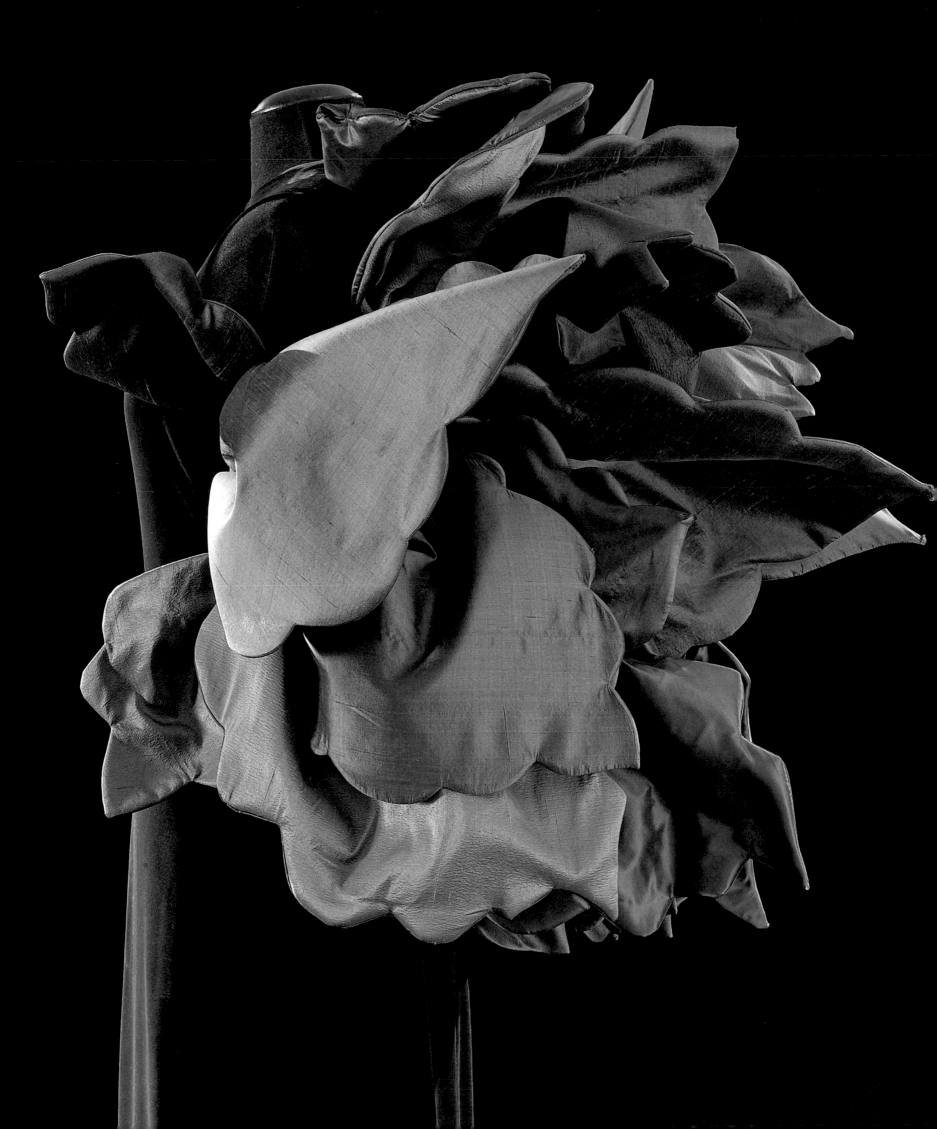

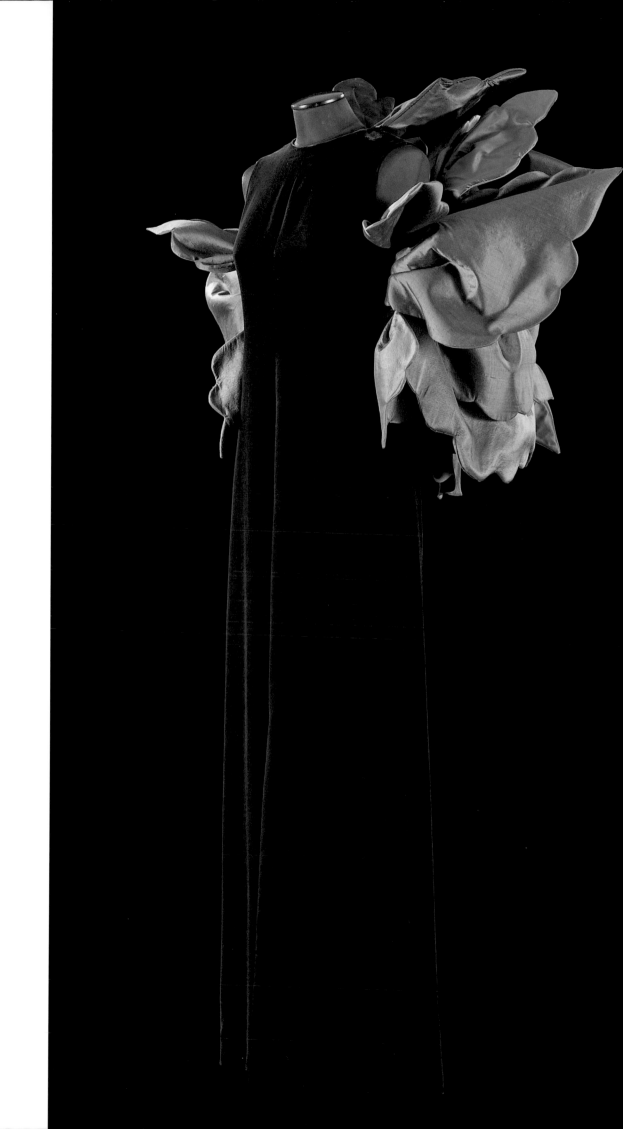

Figs. 66a,b. Sculpture Dress, 1982,
silk velvet and silk taffeta (N.50)

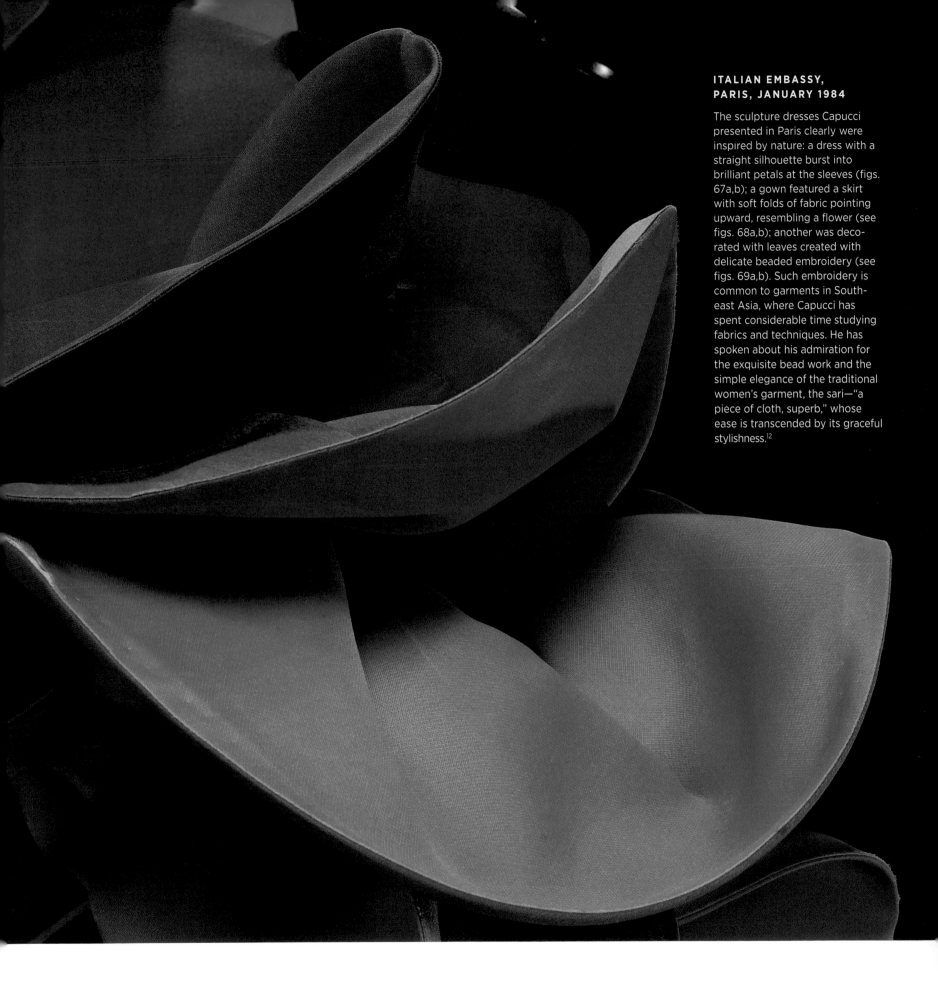

The sculpture dresses Capucci presented in Paris clearly were inspired by nature: a dress with a straight silhouette burst into brilliant petals at the sleeves (figs. 67a,b); a gown featured a skirt with soft folds of fabric pointing upward, resembling a flower (see figs. 68a,b); another was decorated with leaves created with delicate beaded embroidery (see figs. 69a,b). Such embroidery is common to garments in Southeast Asia, where Capucci has spent considerable time studying fabrics and techniques. He has spoken about his admiration for the exquisite bead work and the simple elegance of the traditional women's garment, the sari—"a piece of cloth, superb," whose ease is transcended by its graceful stylishness.[12]

Figs. 67a,b. Sculpture Dress, 1984, silk crepe and silk gazar (N.15)

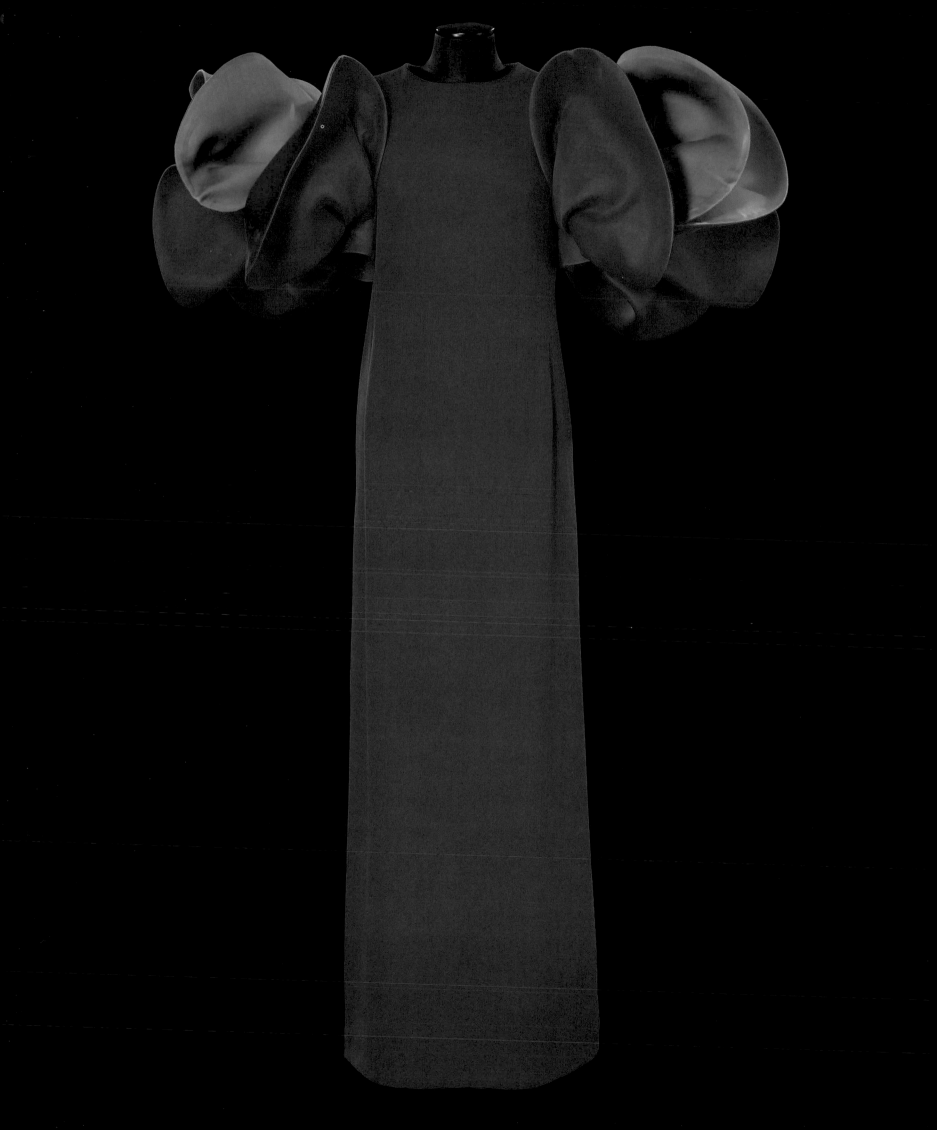

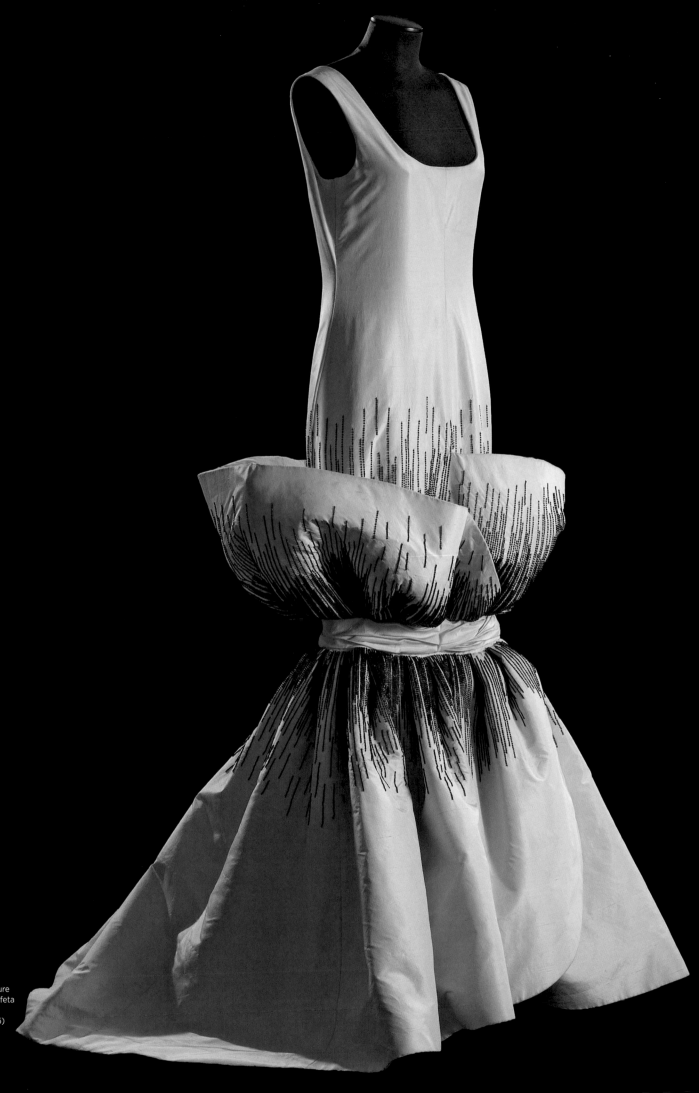

Figs. 68a,b. Sculpture
Dress, 1984, silk taffeta
embroidered with
crystal beads (N.26)

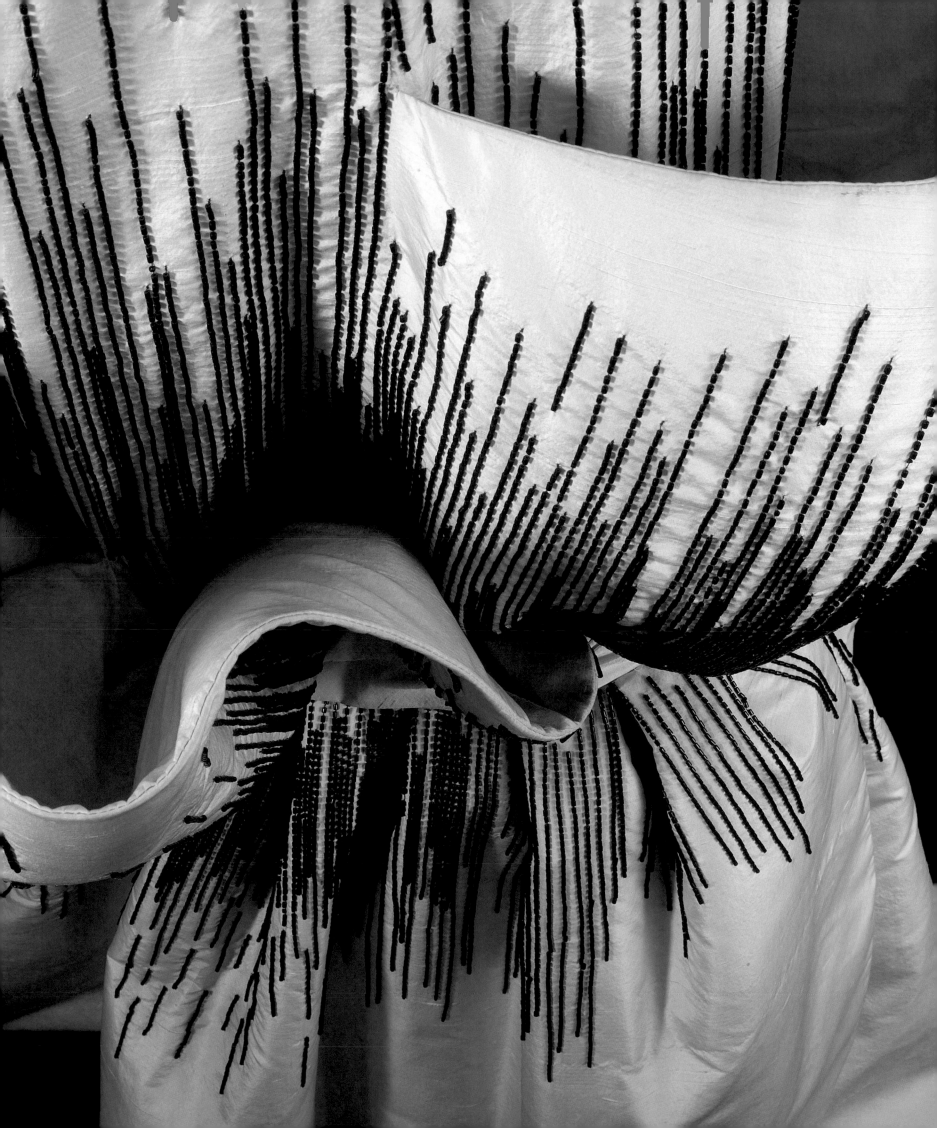

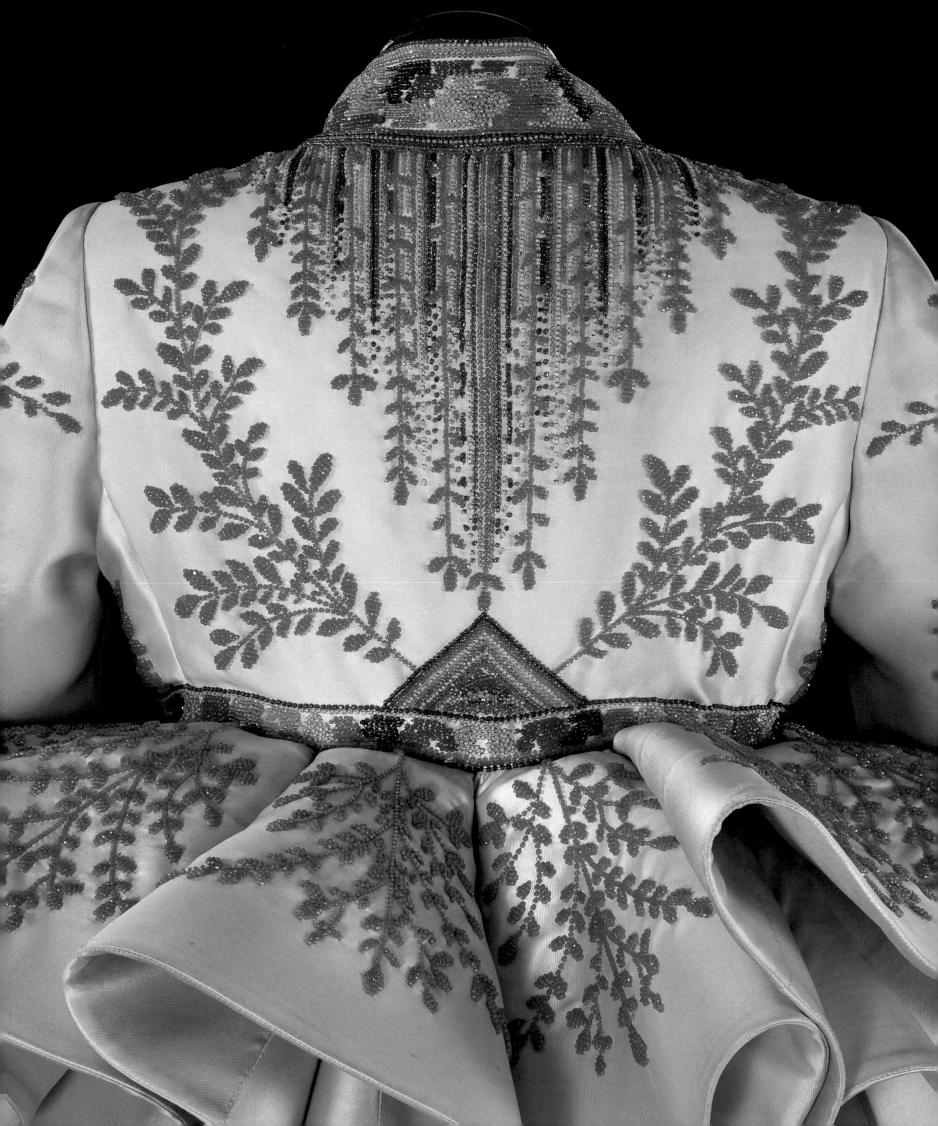

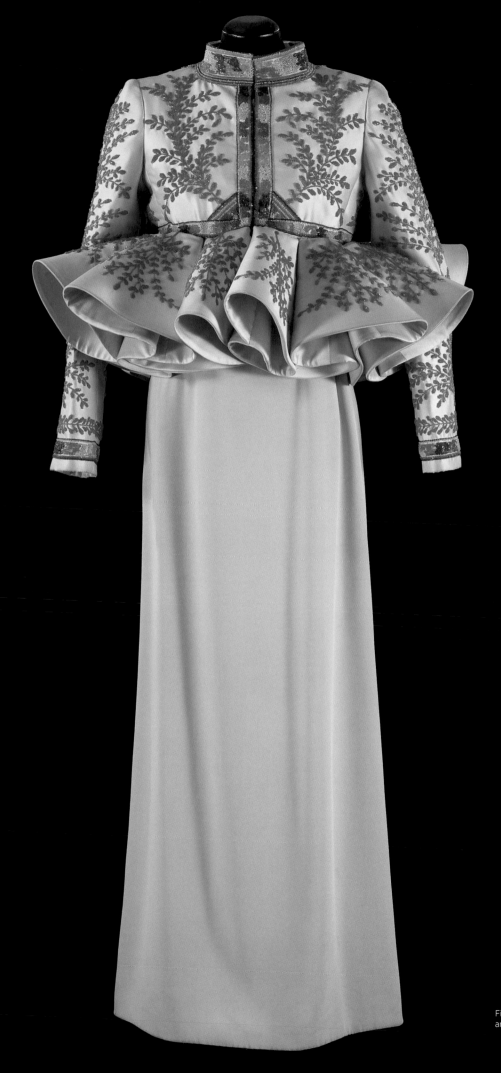

Figs. 69a,b. Sculpture Dress, 1984, silk cady and silk Mikado with silk embroidery (N.46)

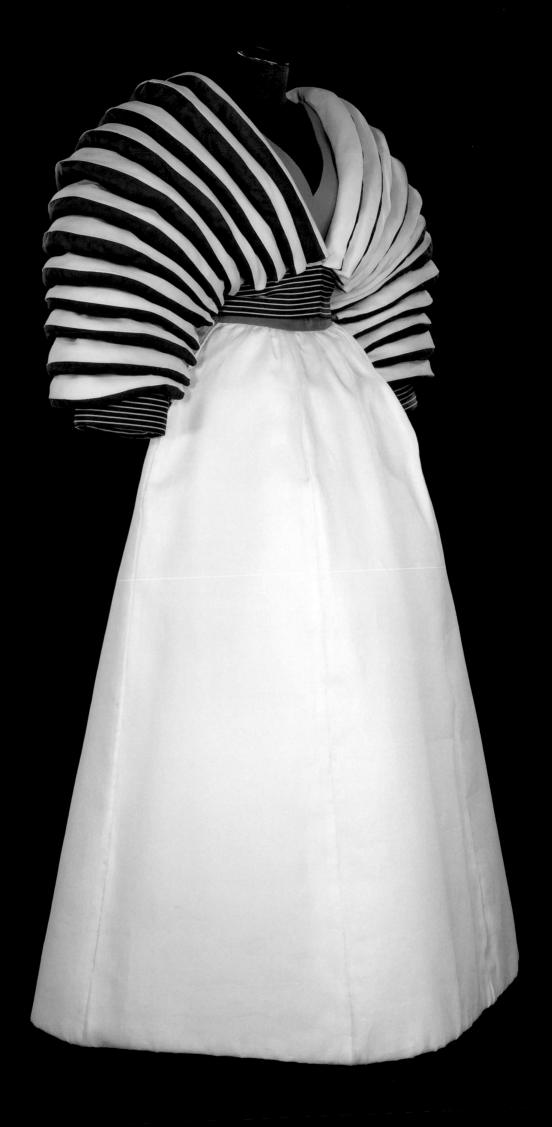

Figs. 70a,b. Sculpture Dress, 1985,
silk gazar (N.20)

## PARK AVENUE ARMORY, NEW YORK, MAY 1985

The spectacular sculpture dresses Capucci presented during the fall fashion showings in New York were wearable, and many were sold (figs. 70a,b; see figs. 71a–c through 75a–c). This enigmatic though playful collection gave "new meaning to the word 'extravagant,'" with intricately beaded, pleated, and ruffled designs, including the *Fuoco* (*Fire*) sculpture dress with a skirt of red ruffles reaching upward like flames (see figs. 74a,b), and a rainbow-colored dress with pleated butterfly wings emerging from the back (see figs. 75a–c).[13] A few weeks later Capucci's gowns were featured in *Nocturnalis*, a spectacular show combining art, fashion, opera, technology, and theater, at the home of renowned Greek scholar Cardinal Giovanni Bessarione (1402–1472) in Rome.[14]

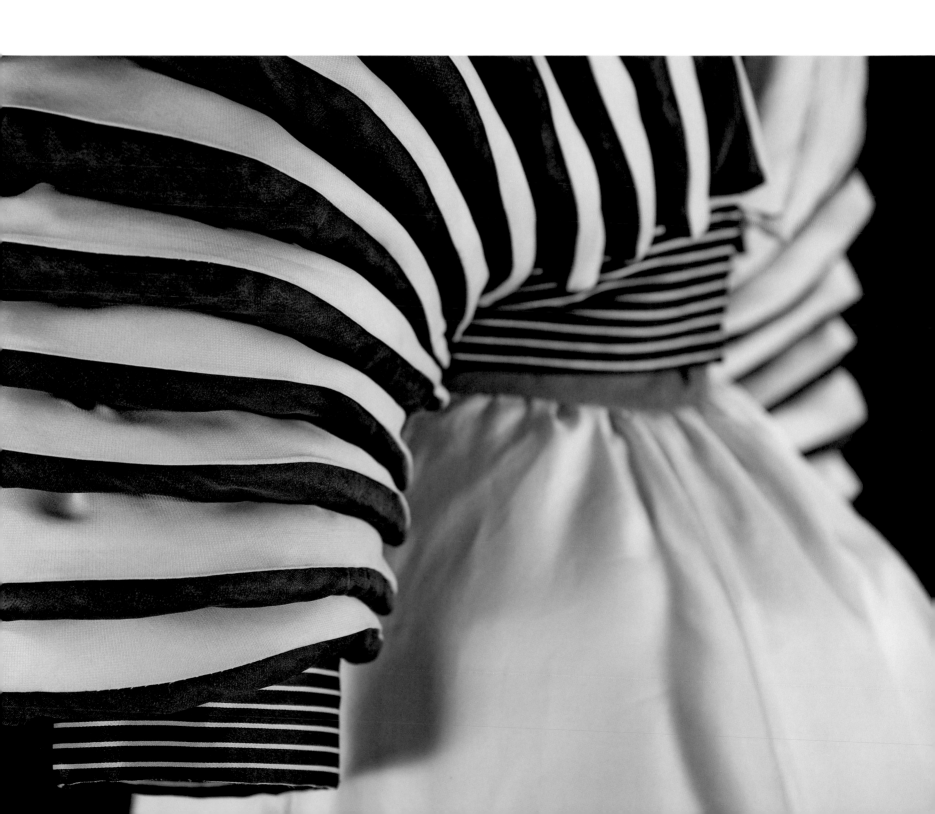

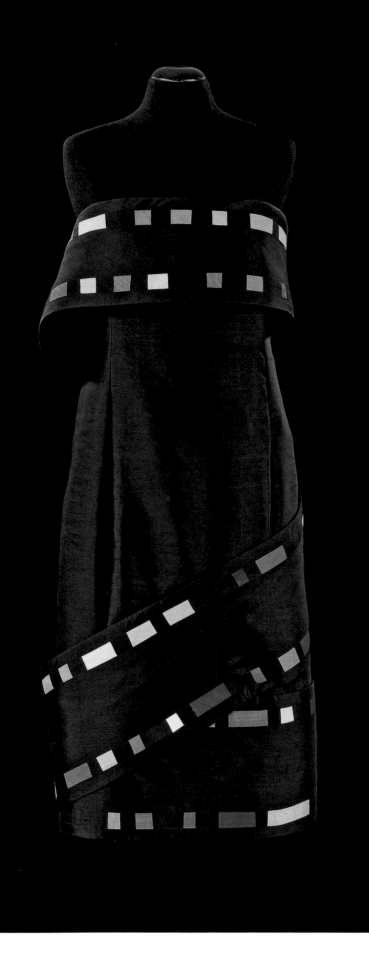
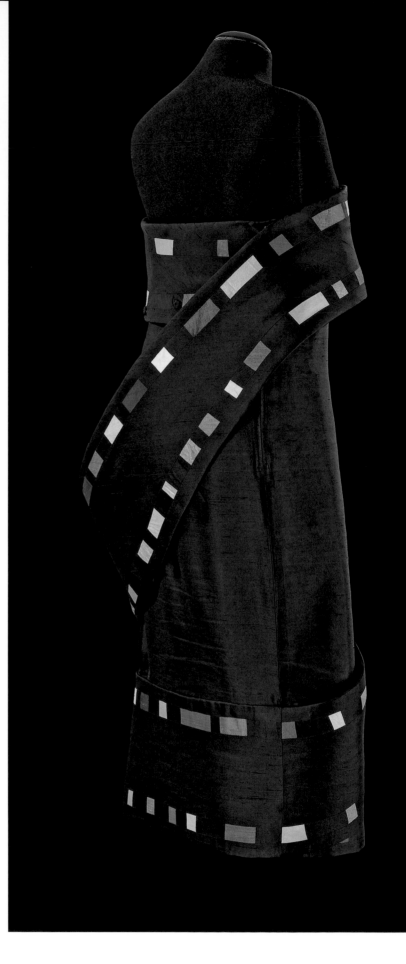

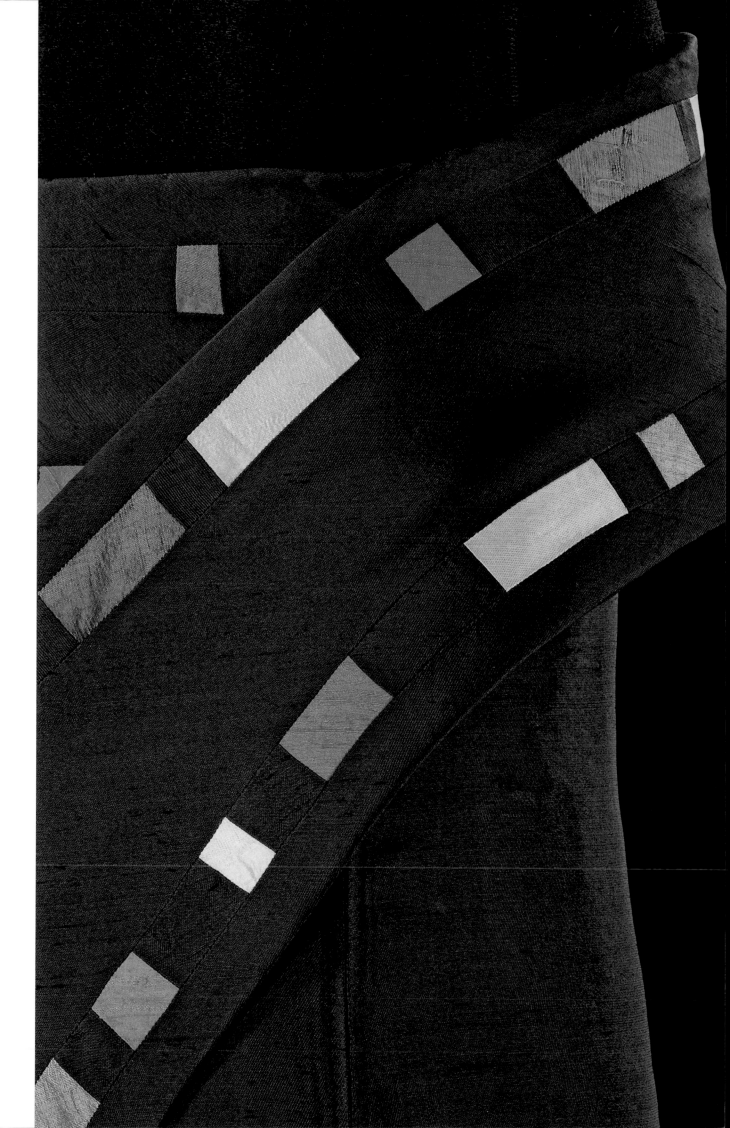

Figs. 71a–c. *Cinema* Sculpture Dress, 1985, silk sauvage (N.239)

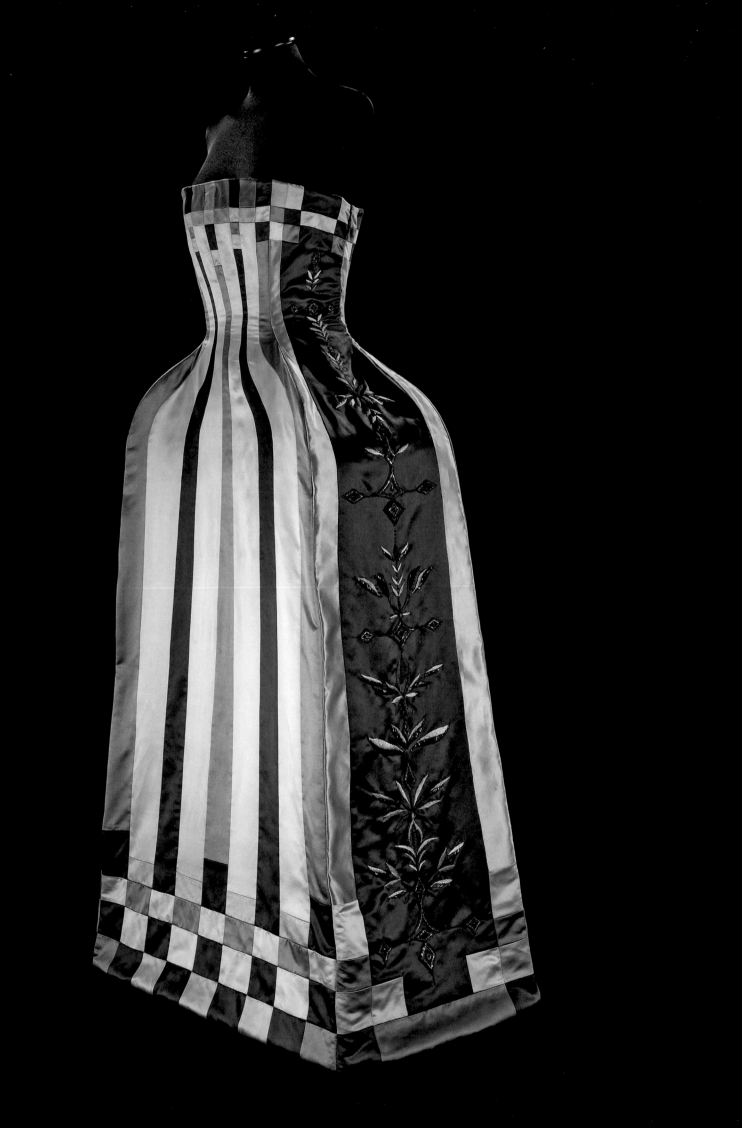

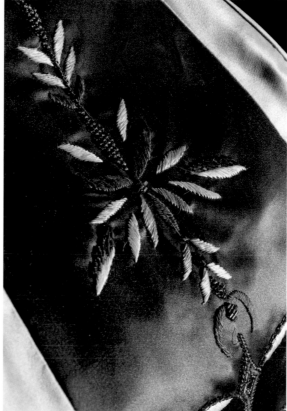

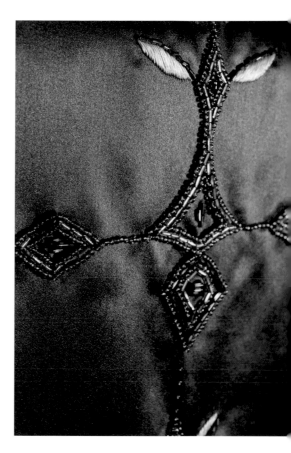

Figs. 72a–d. Sculpture Dress, 1985, silk satin
with embroidery (N.31)

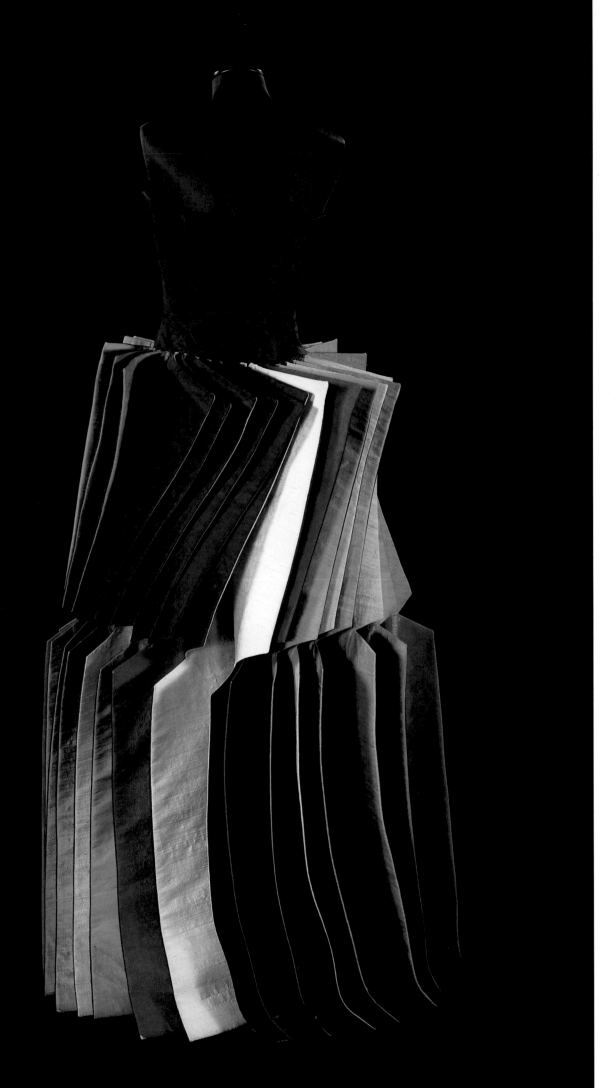

Figs. 73a,b. *Lame* (*Blades*) Sculpture Dress, 1985, silk taffeta (N.74)

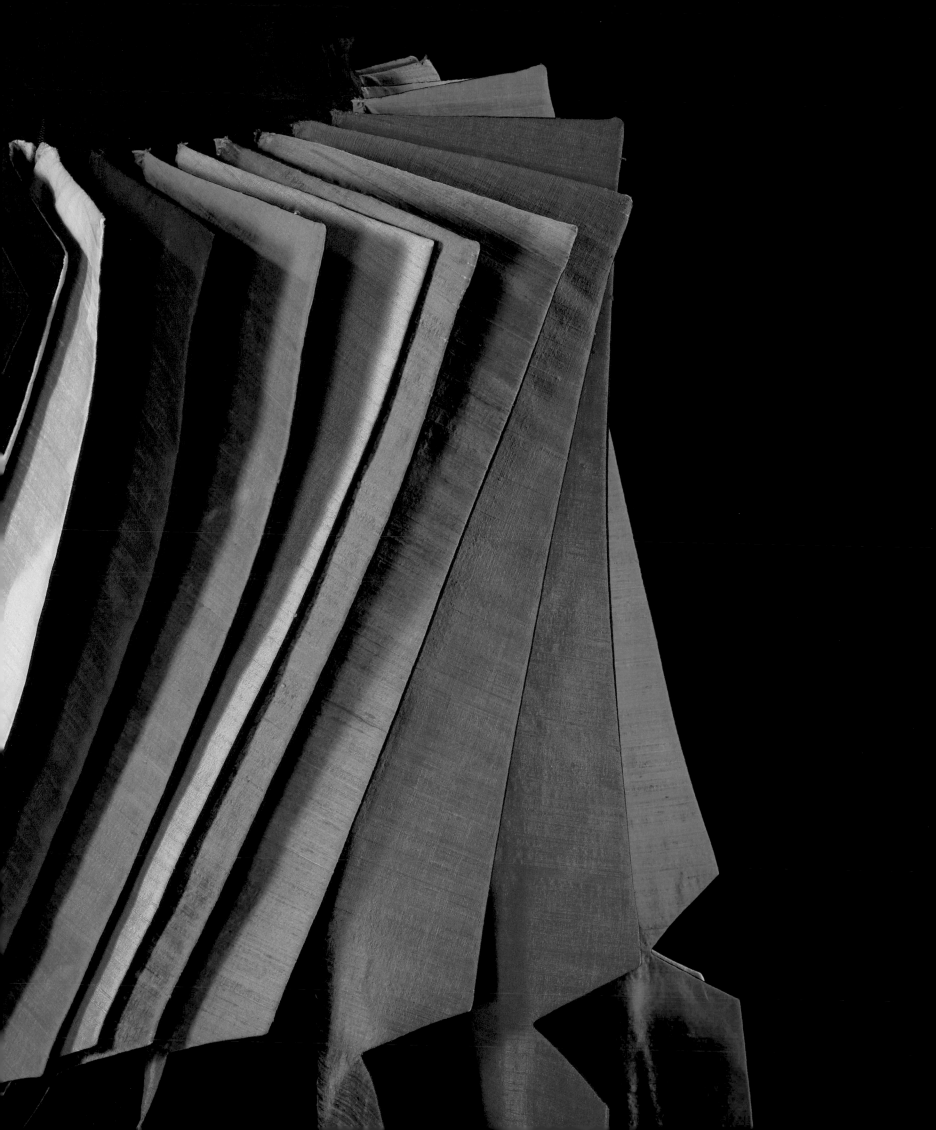

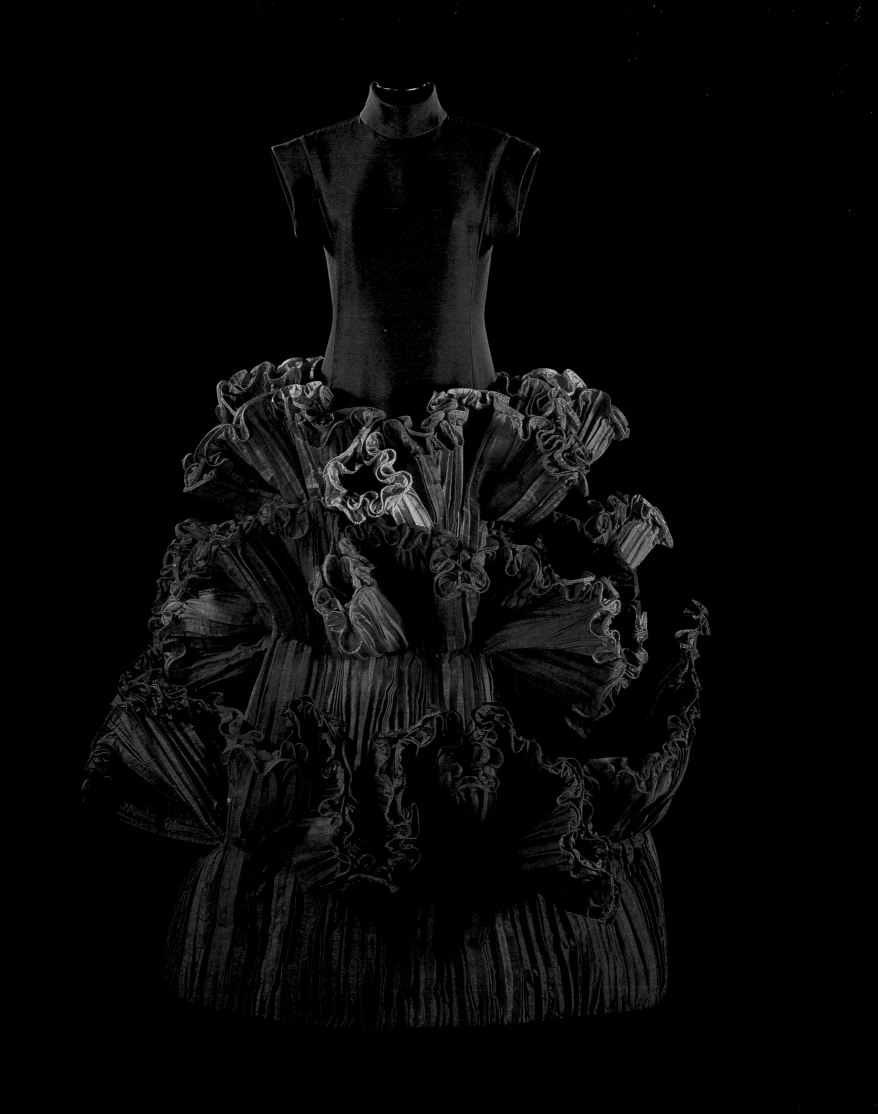

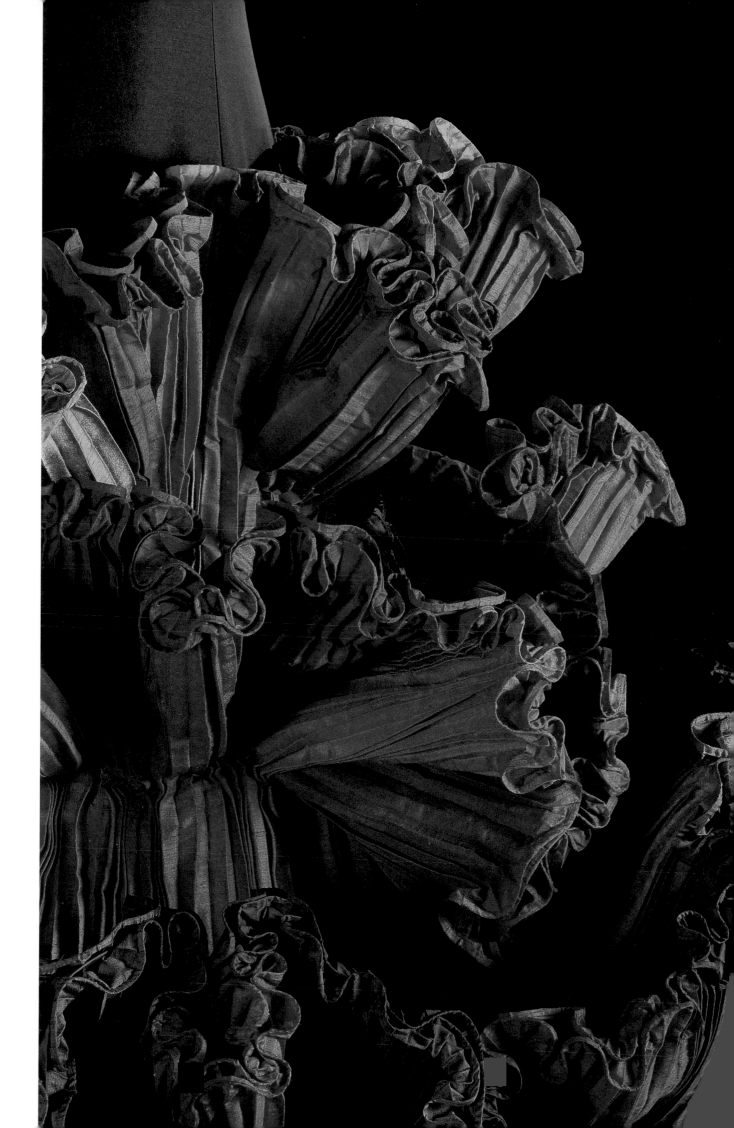

Figs. 74a,b. *Fuoco* (*Fire*) Sculpture Dress, 1985, pleated silk sauvage (N.38)

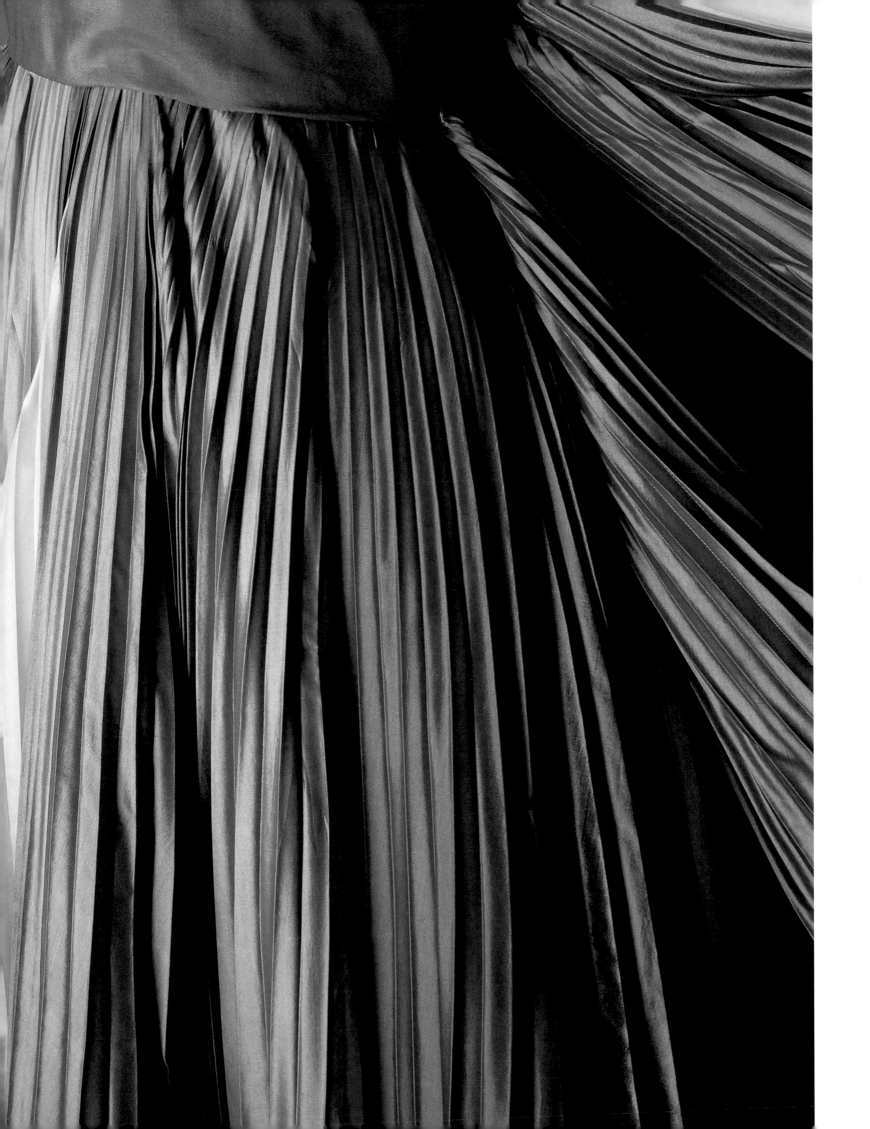

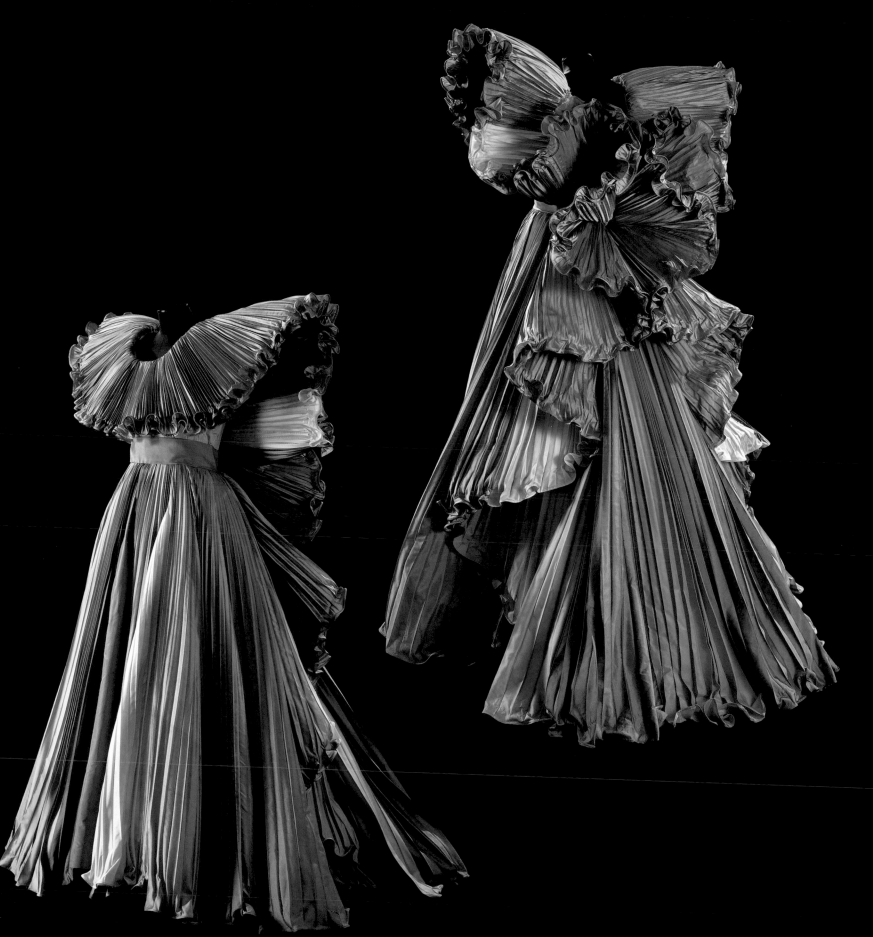

Figs. 75a–c. Sculpture Dress, 1985, pleated
silk taffeta (N.154)

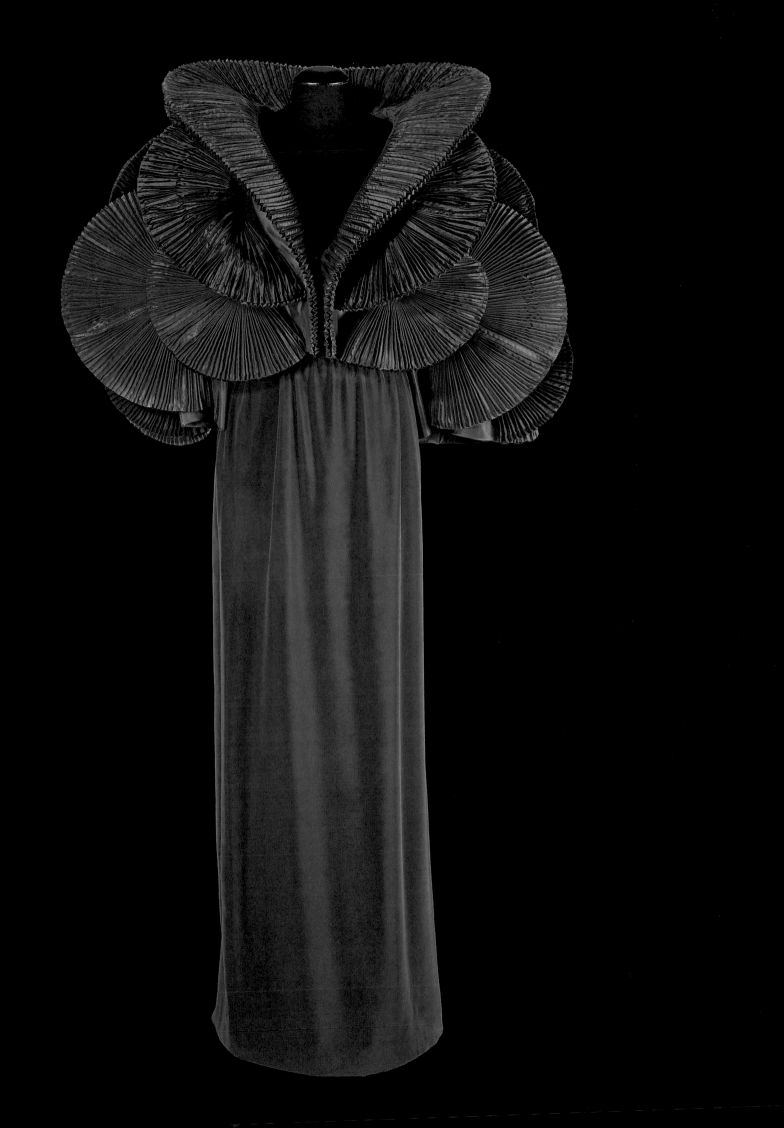

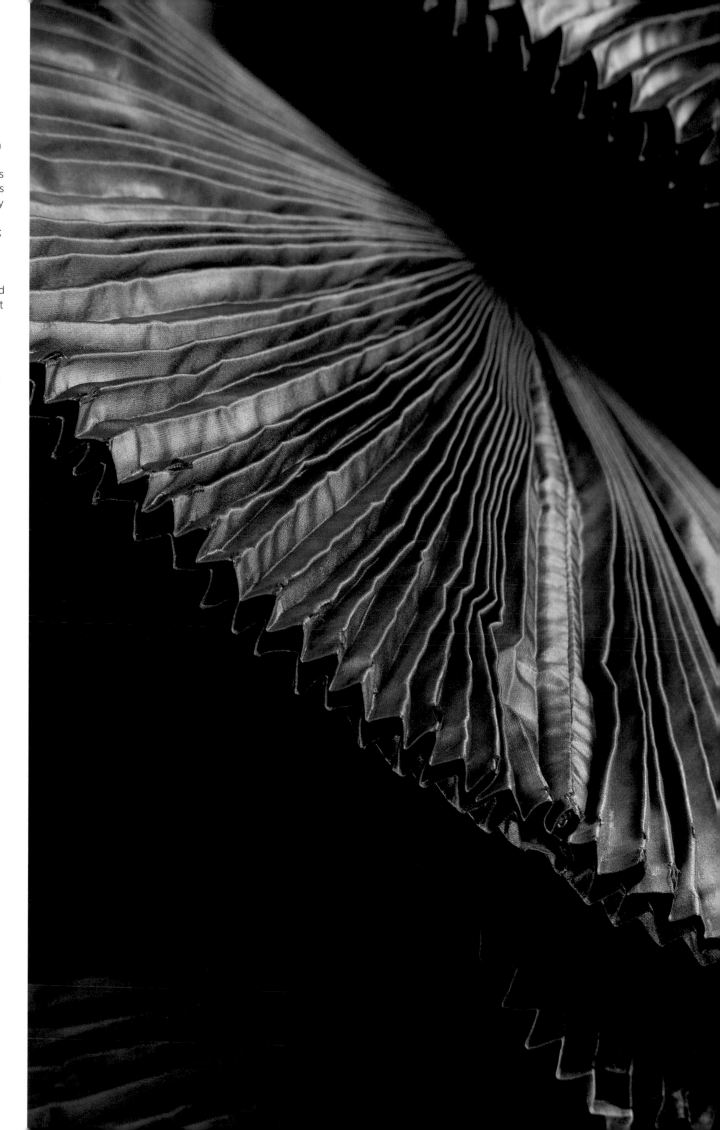

## MUSEO DI PALAZZO VENEZIA, ROME, JANUARY 1987

At the conclusion of the spring/ summer high-fashion showings in Rome, Capucci presented 148 gowns in the former headquarters of Benito Mussolini. Fashion models paraded down the runway, two by two, in dresses made of magnificently colored pleats (figs. 76a–d; see figs. 77a–c through 80a,b), and, for the finale, in black-and-white gowns (see figs. 81a,b and 82a,b). Although Capucci had used pleating in his designs throughout his career, his interest in the technique was renewed in 1972 when he came across a cache of nineteenth-century pleating machines used for making accordion and waffle effects on fabric. Capucci and his assistants went through countless yards of fabric before perfecting the technique; he has since been praised for the rediscovery and mastery of the "art of press pleating."[15]

Figs. 76a,b. Sculpture Dress, 1987, silk velvet and pleated silk taffeta (N.100)

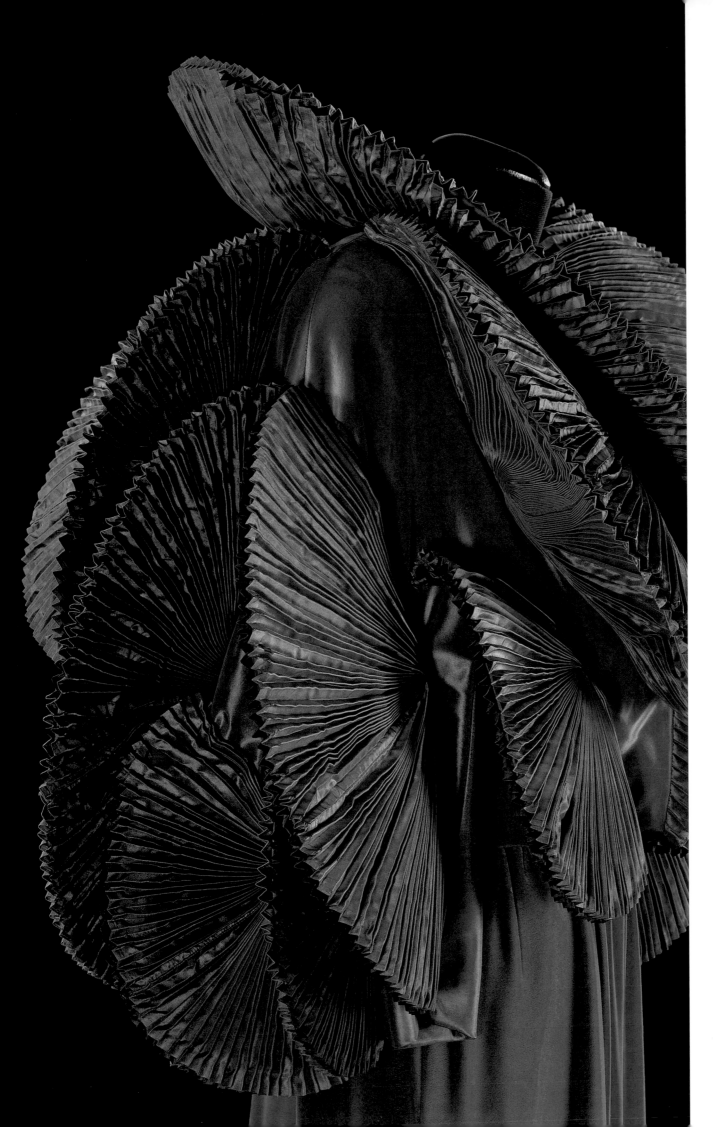

Figs. 76c,d. Sculpture Dress, 1987, silk velvet and pleated silk taffeta (N.100)

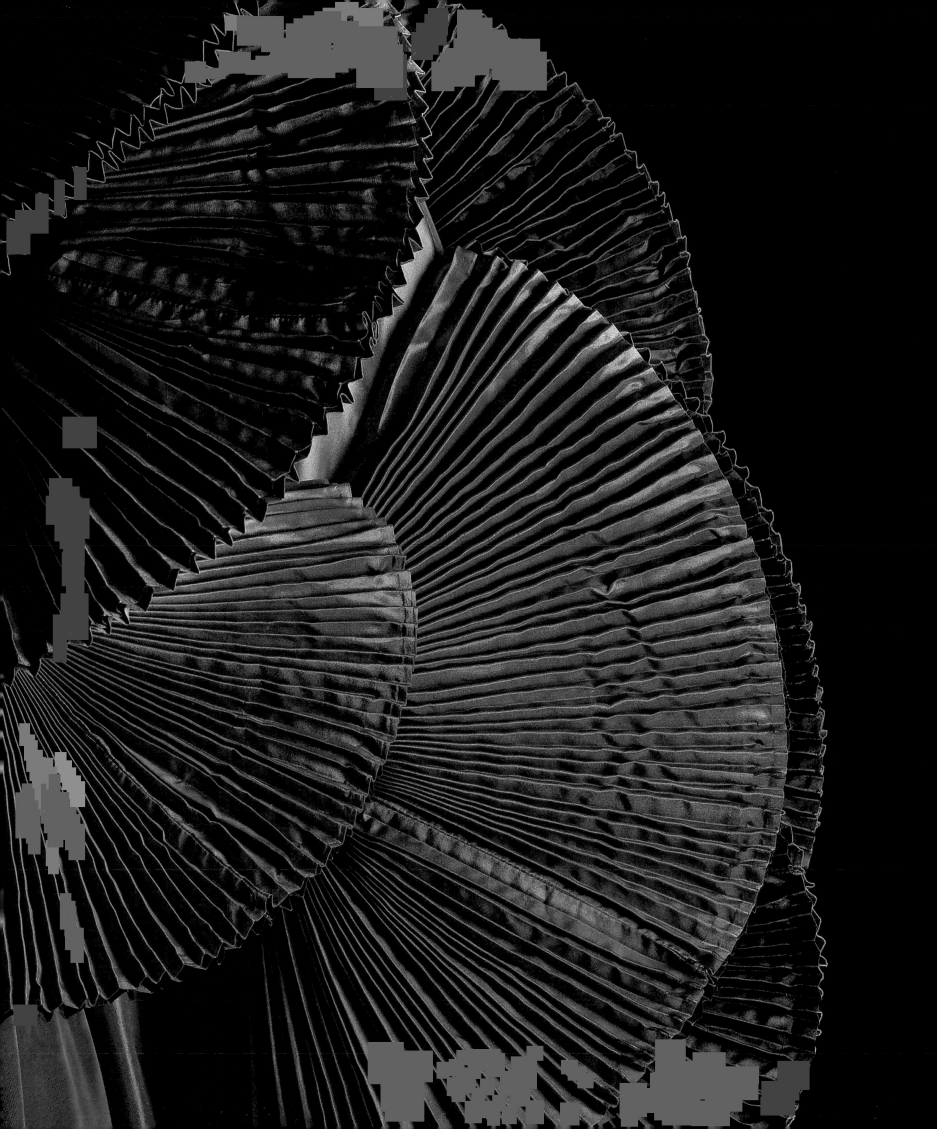

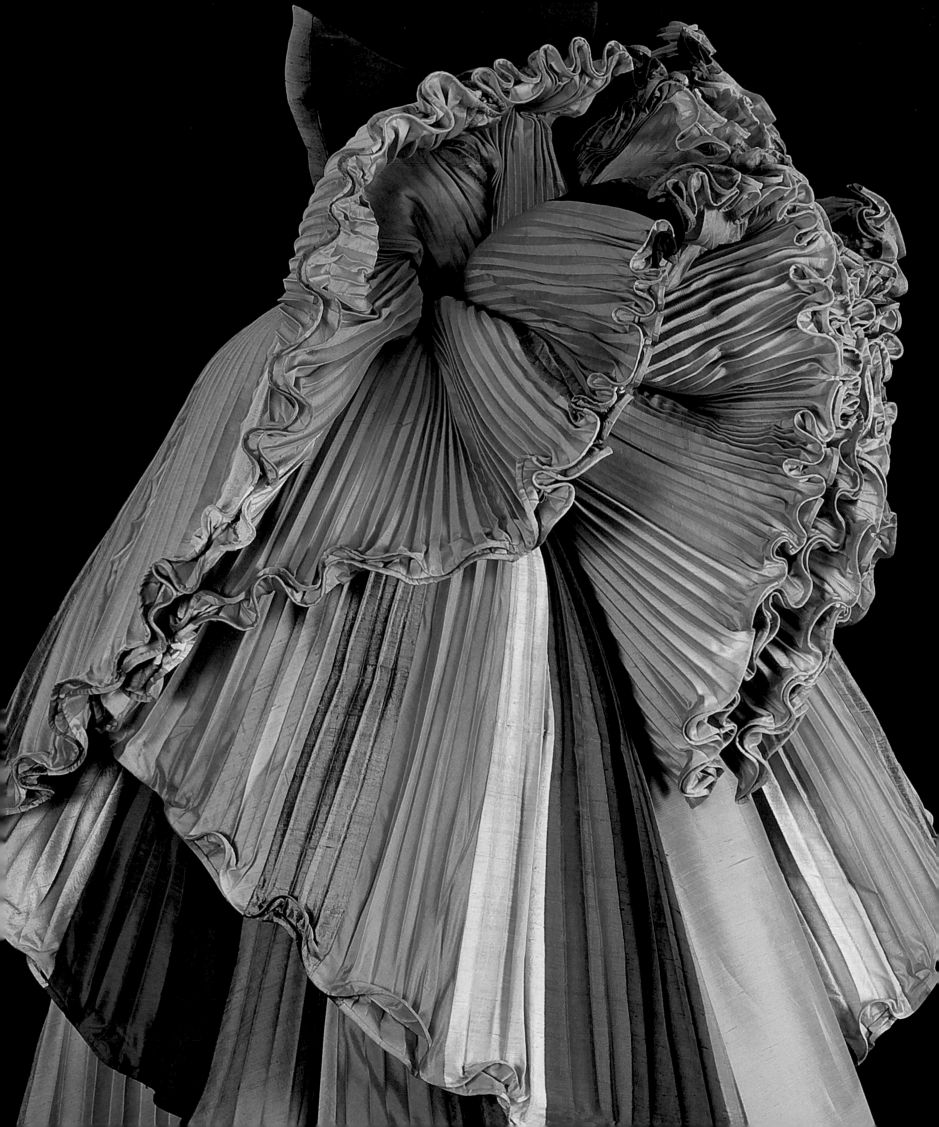

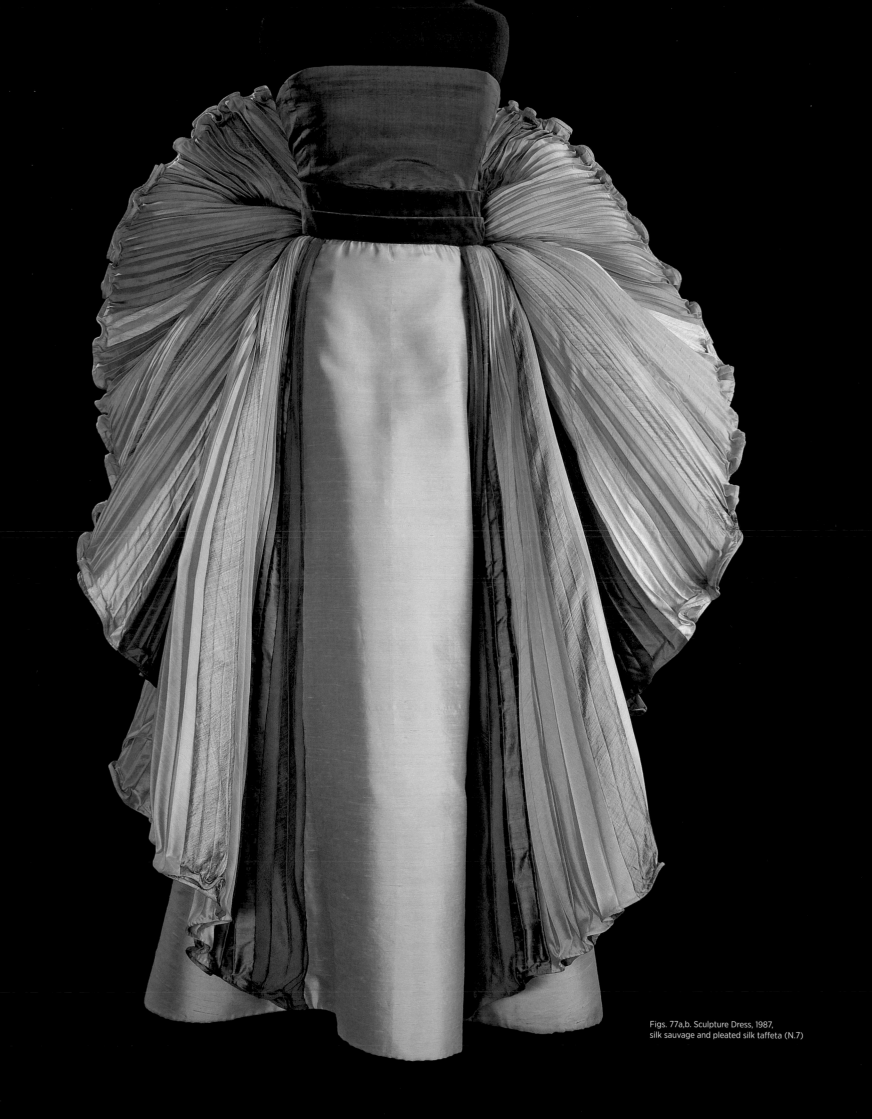

Figs. 77a,b. Sculpture Dress, 1987,
silk sauvage and pleated silk taffeta (N.7)

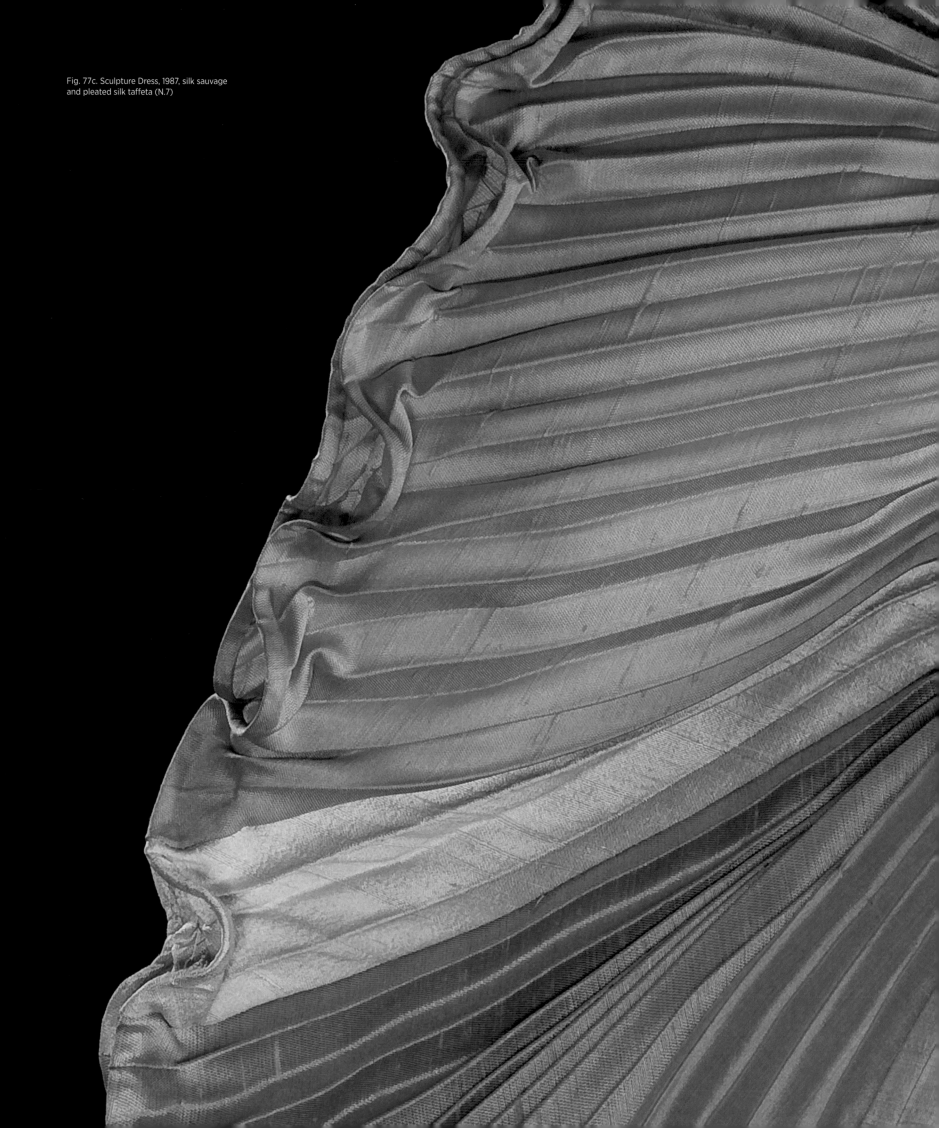

Fig. 77c. Sculpture Dress, 1987, silk sauvage
and pleated silk taffeta (N.7)

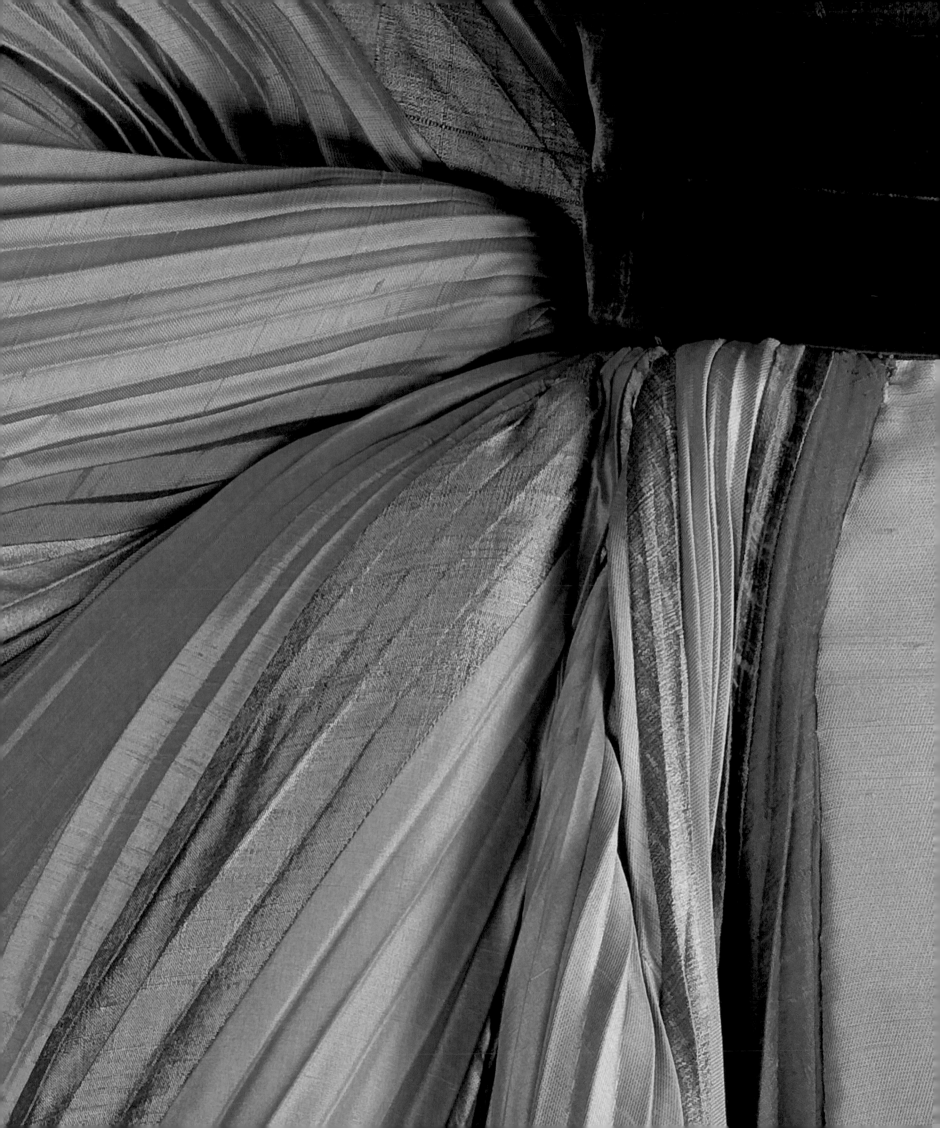

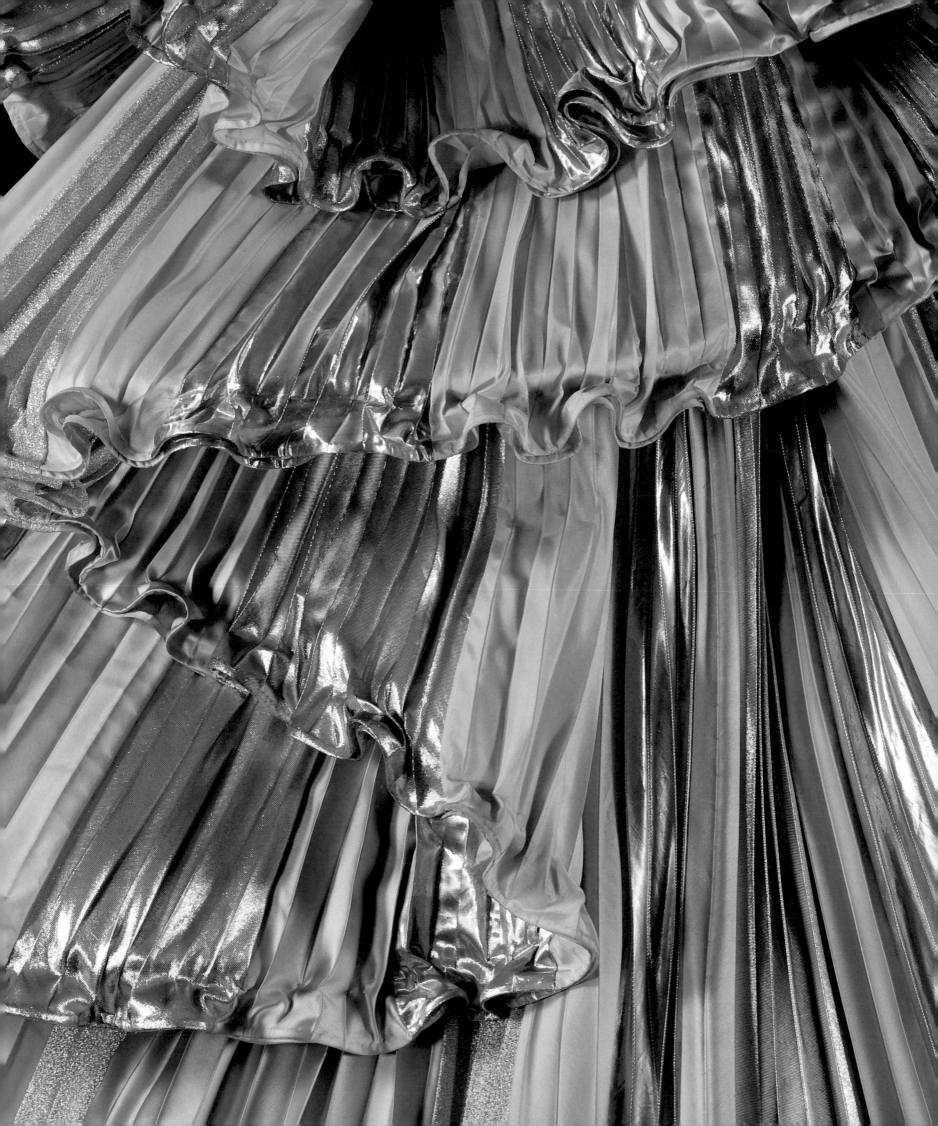

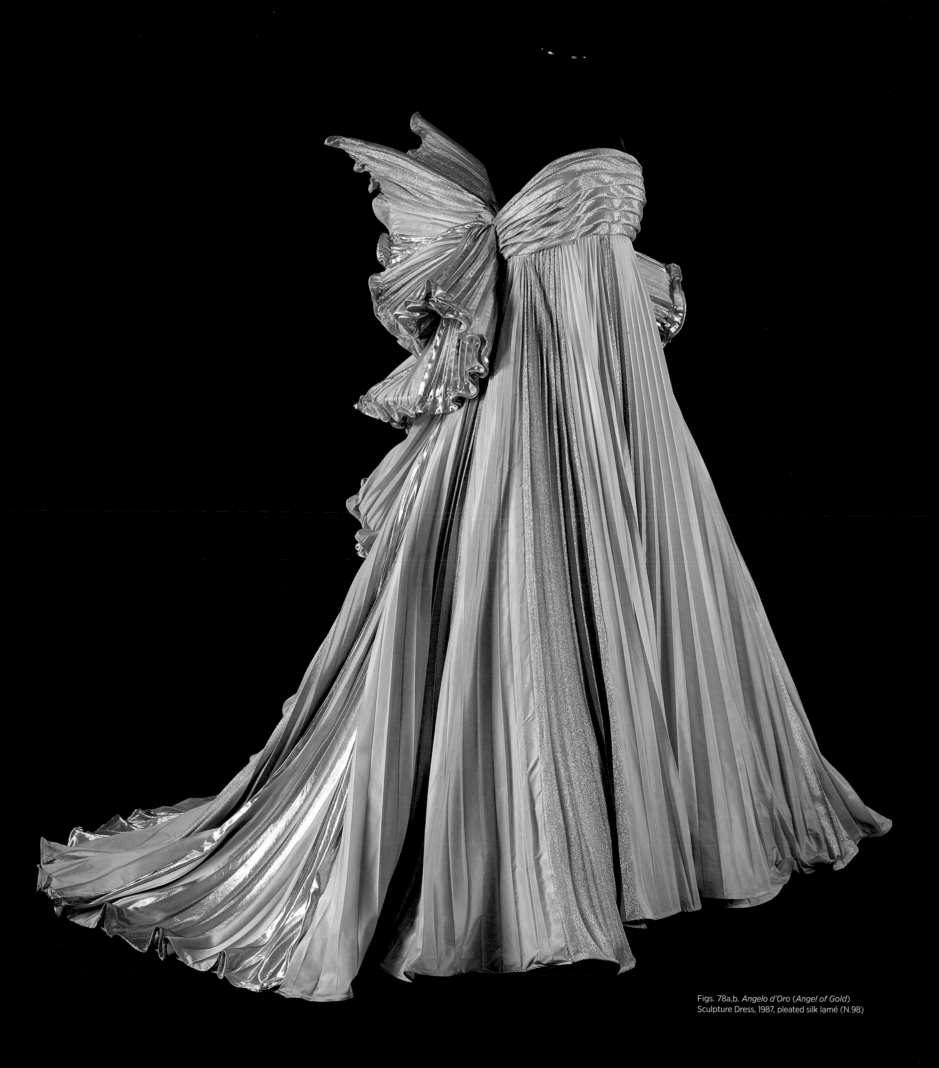

Figs. 78a,b. *Angelo d'Oro* (*Angel of Gold*)
Sculpture Dress, 1987, pleated silk lamé (N.98)

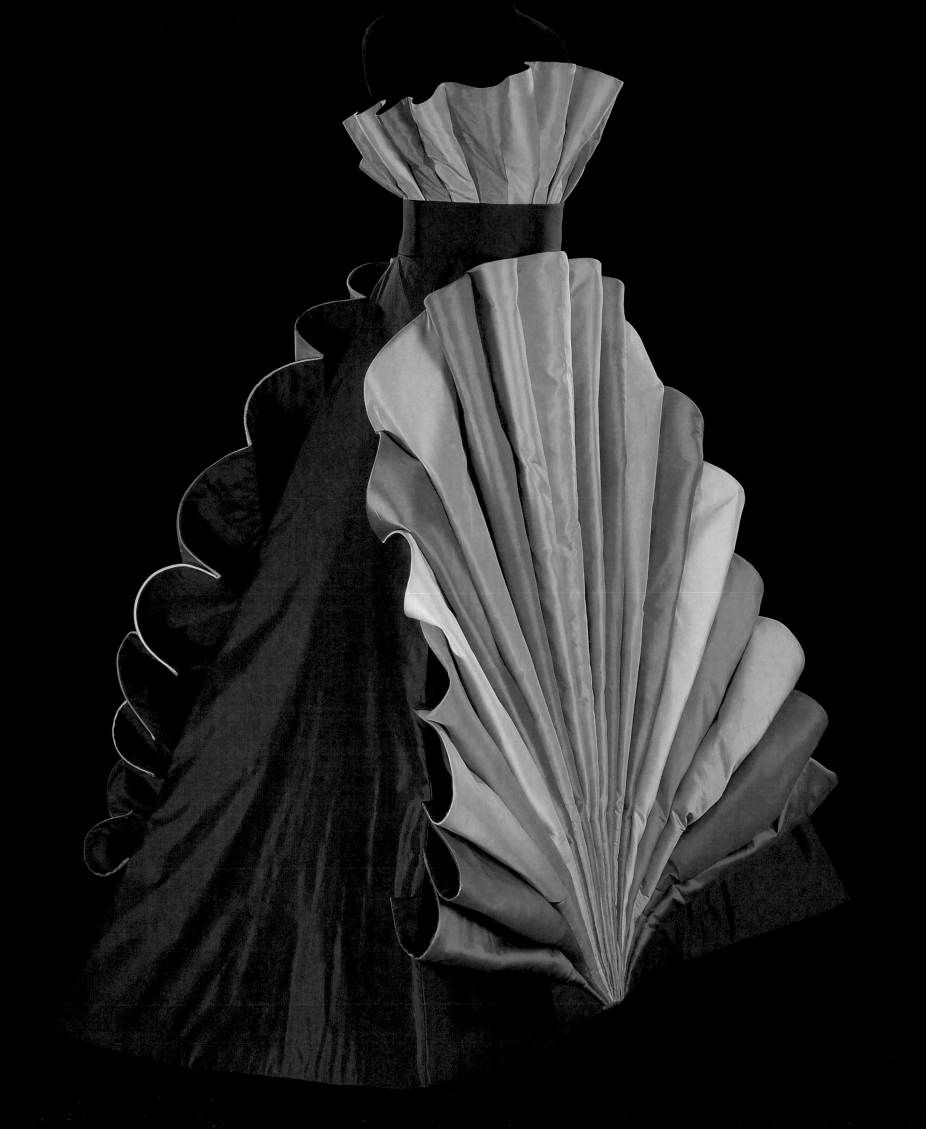

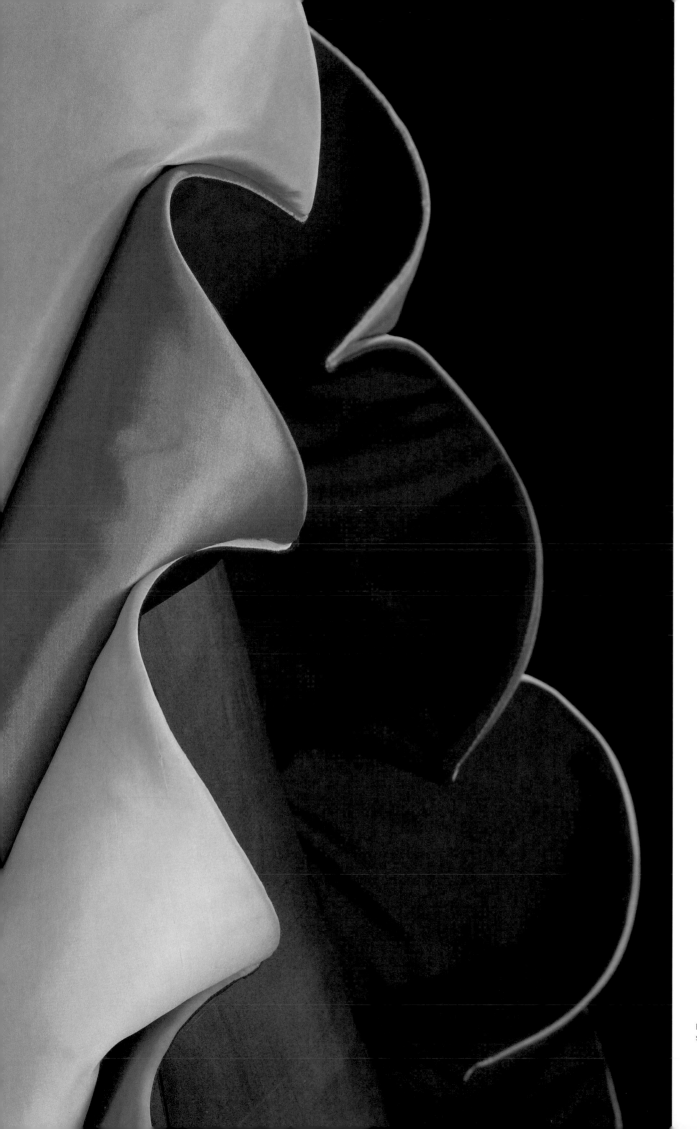

Figs. 79a,b. Sculpture Dress, 1987,
silk taffeta (N.119)

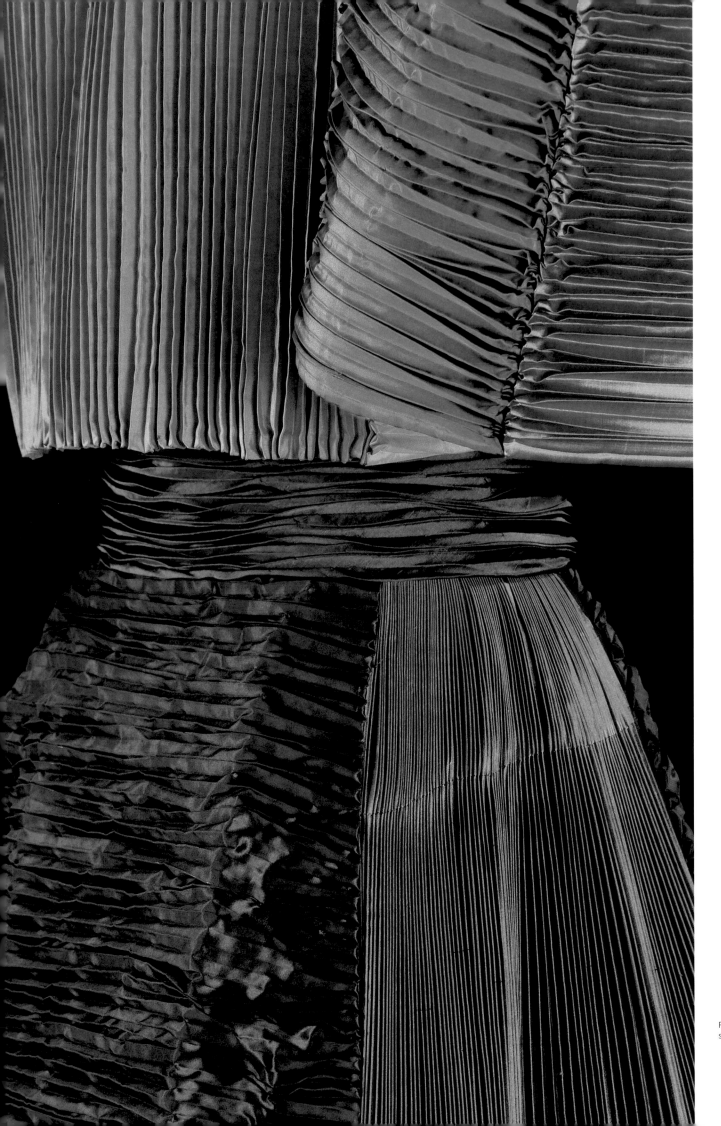

Figs. 80a,b. Sculpture Dress, 1987, pleated silk shot taffeta (N.104)

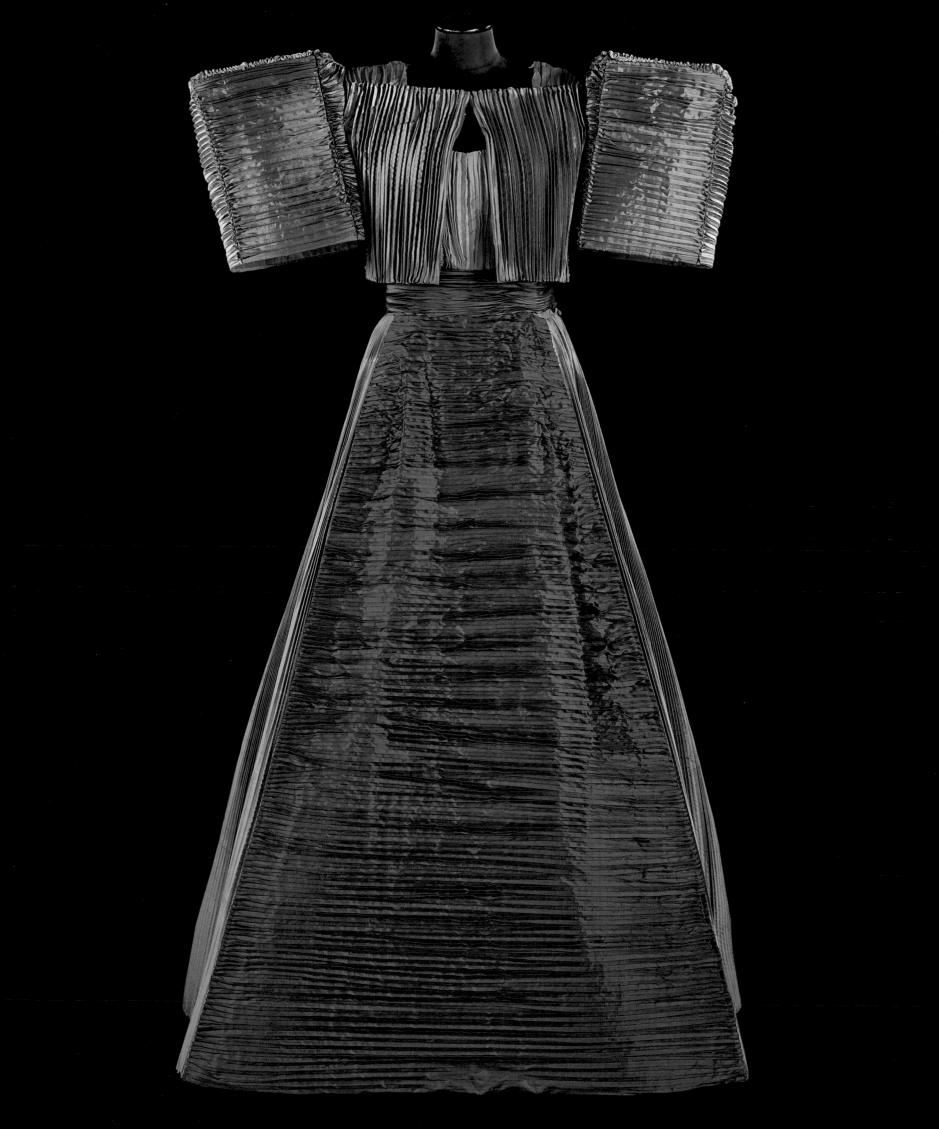

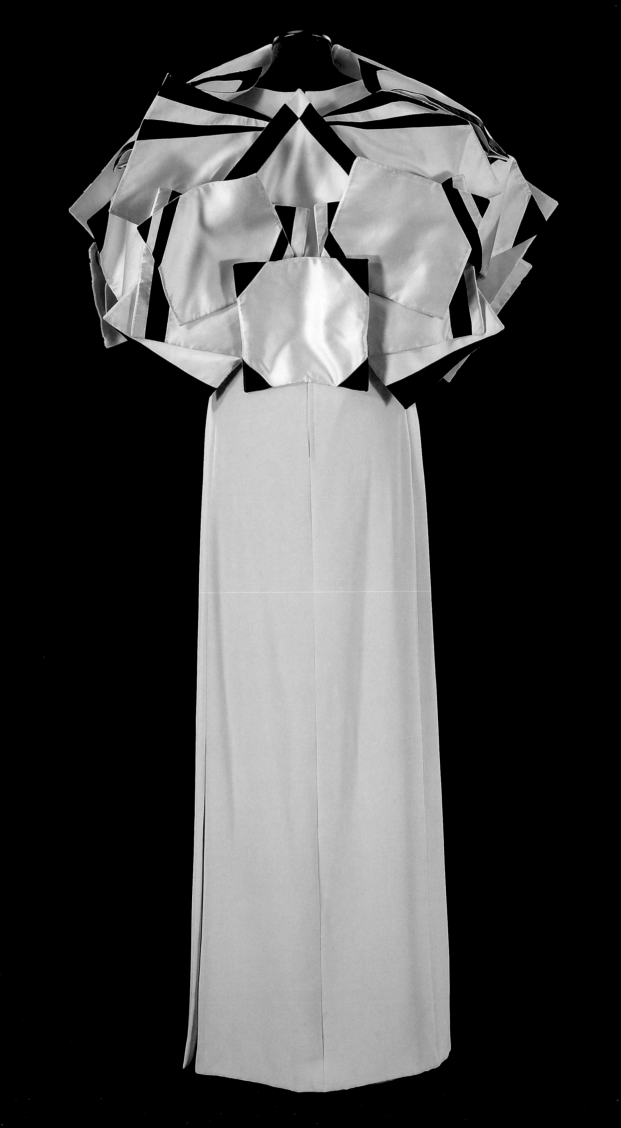

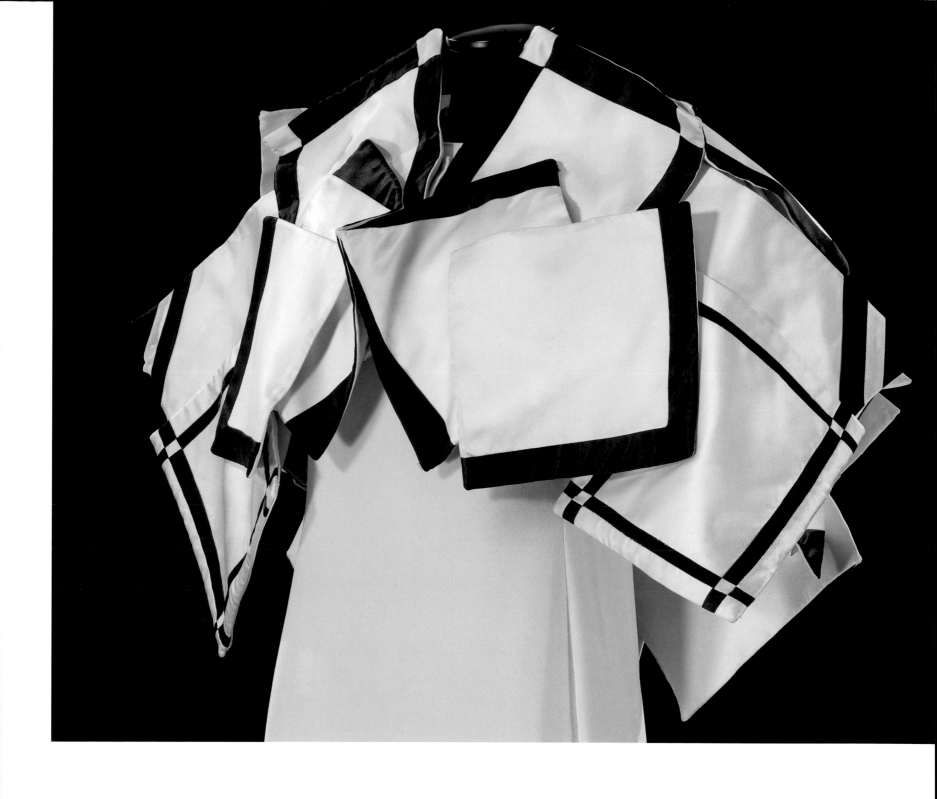

Figs. 81a,b. Sculpture Dress, 1987, silk crepe
and silk satin (N.24)

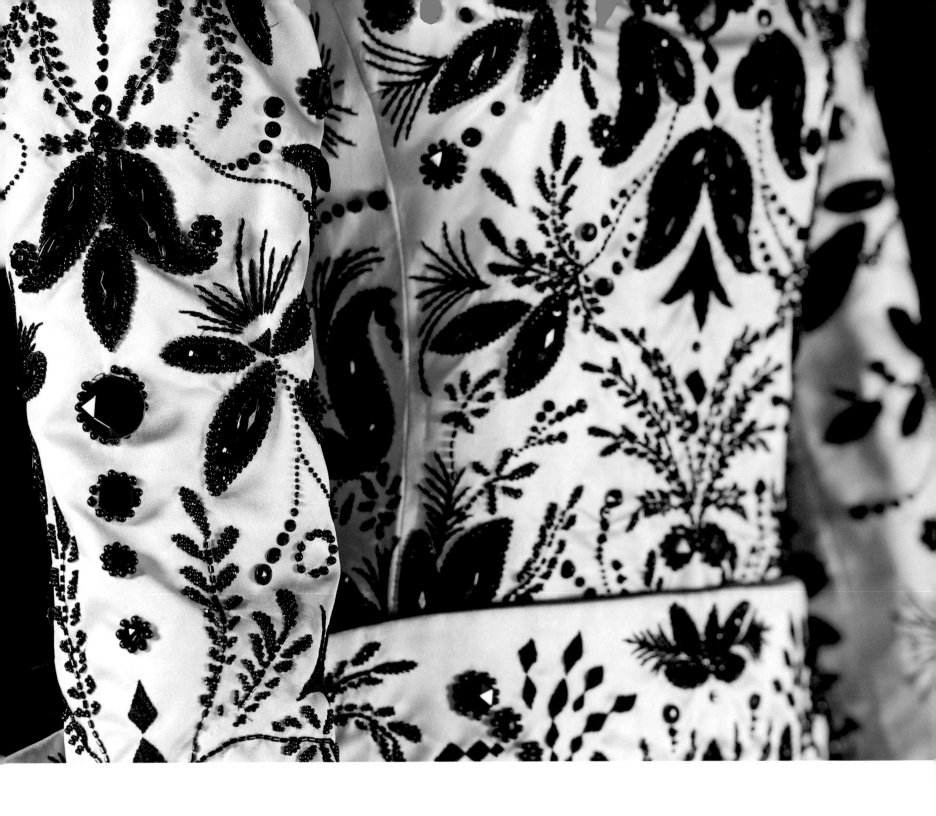

Figs. 82a,b. Sculpture Dress, 1987, silk satin
embroidered with cabochons (N.23)

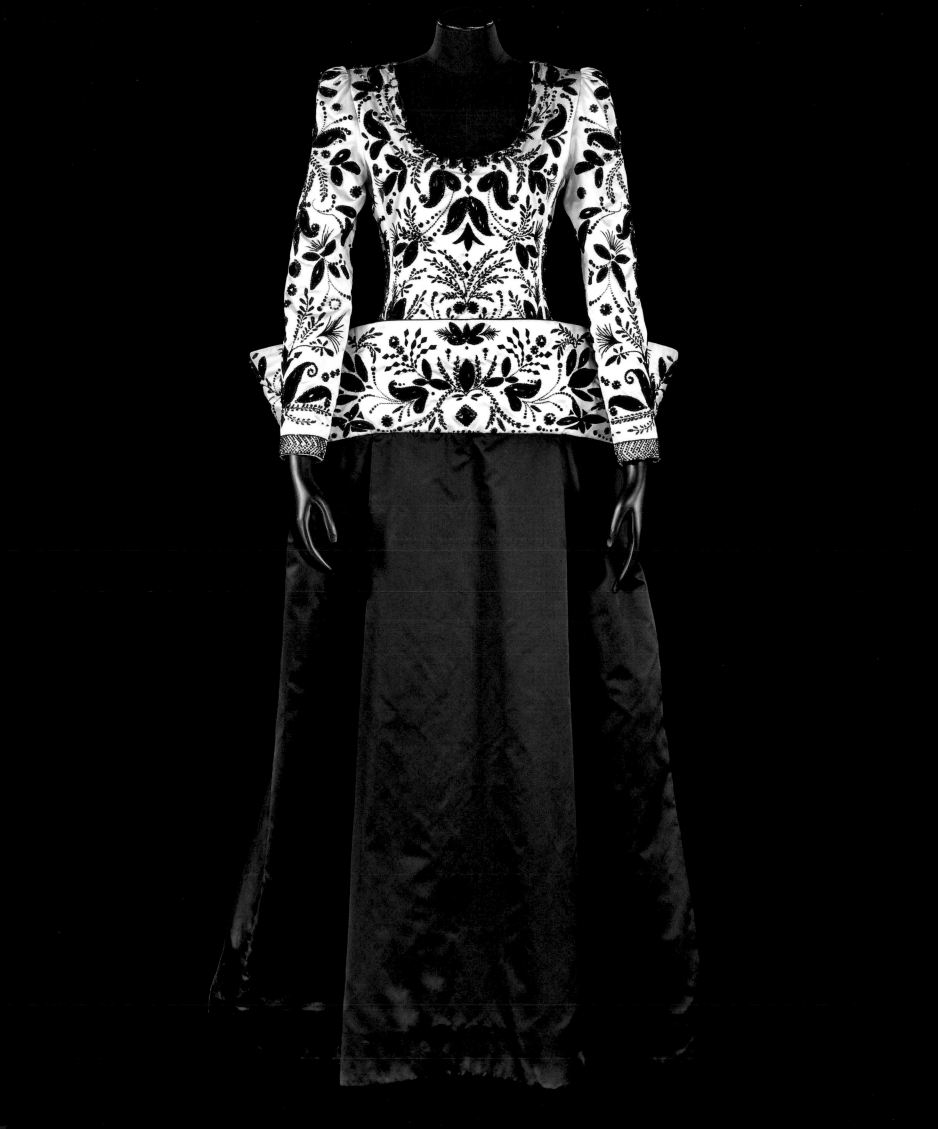

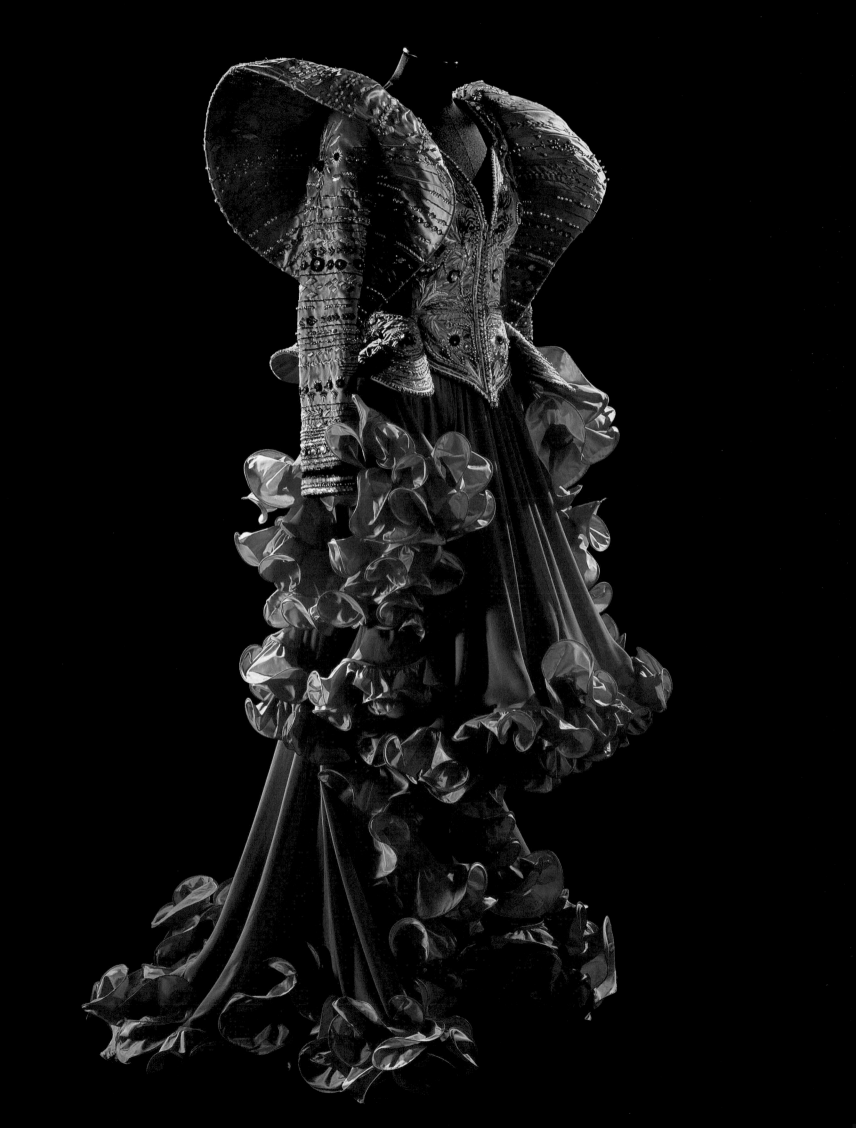

## GALLERIA NAZIONALE D'ARTE MODERNA, ROME, JANUARY 1989

Capucci drew more than 1,200 sketches and worked with 60 workroom assistants to create the 150 designs he presented in Rome in January 1989 (figs. 83a,b; see figs. 84a,b–91). One dress comprised more than sixty-eight yards of taffeta; another featured pleating made up of forty-two different shades, the nuances of which could be detected only when examined closely.[16] For Capucci, the selection of fabric is paramount; he rarely uses prints, preferring instead solid-colored textiles, with which he can experiment freely. Although his working method is demanding and costly, Capucci's pleasure comes not from selling a dress but rather from "exploiting the possibilities of the fabric."[17]

Figs. 83a,b. Sculpture Dress, 1989, silk georgette and silk satin with multicolored embroidery (N.113)

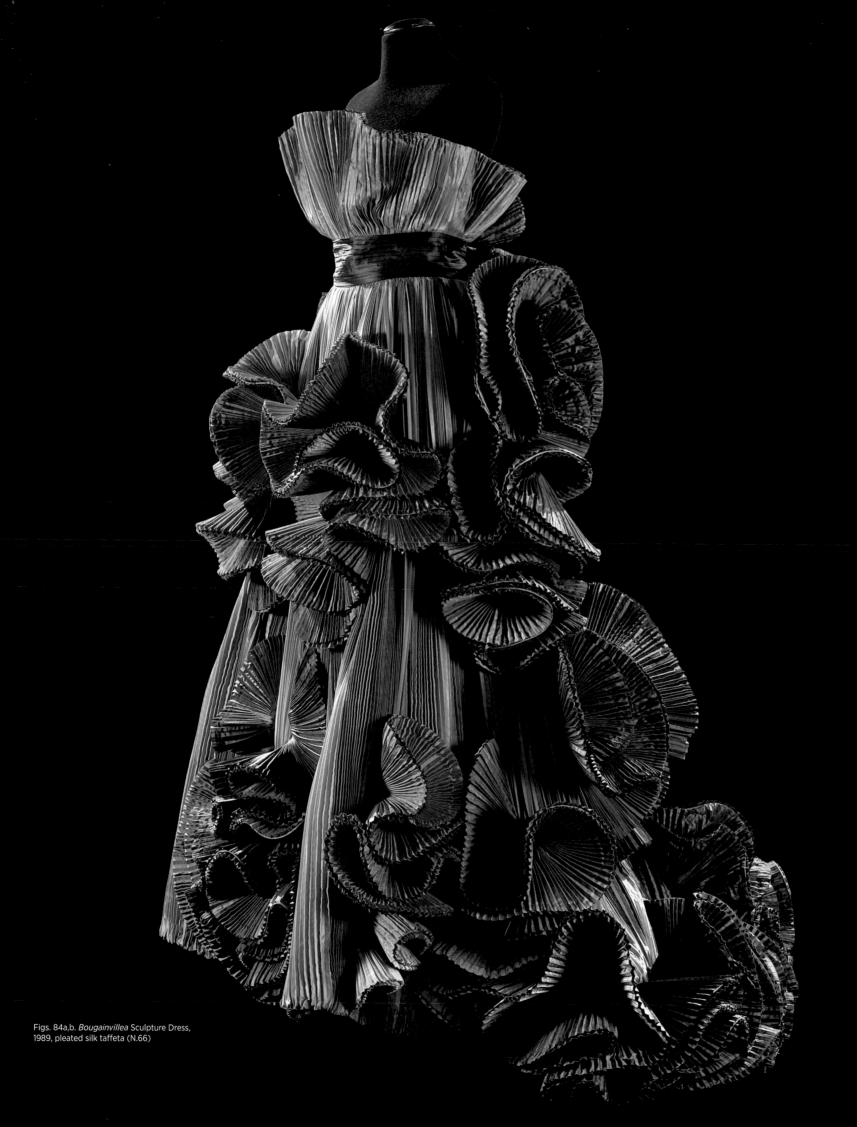

Figs. 84a,b. *Bougainvillea* Sculpture Dress, 1989, pleated silk taffeta (N.66)

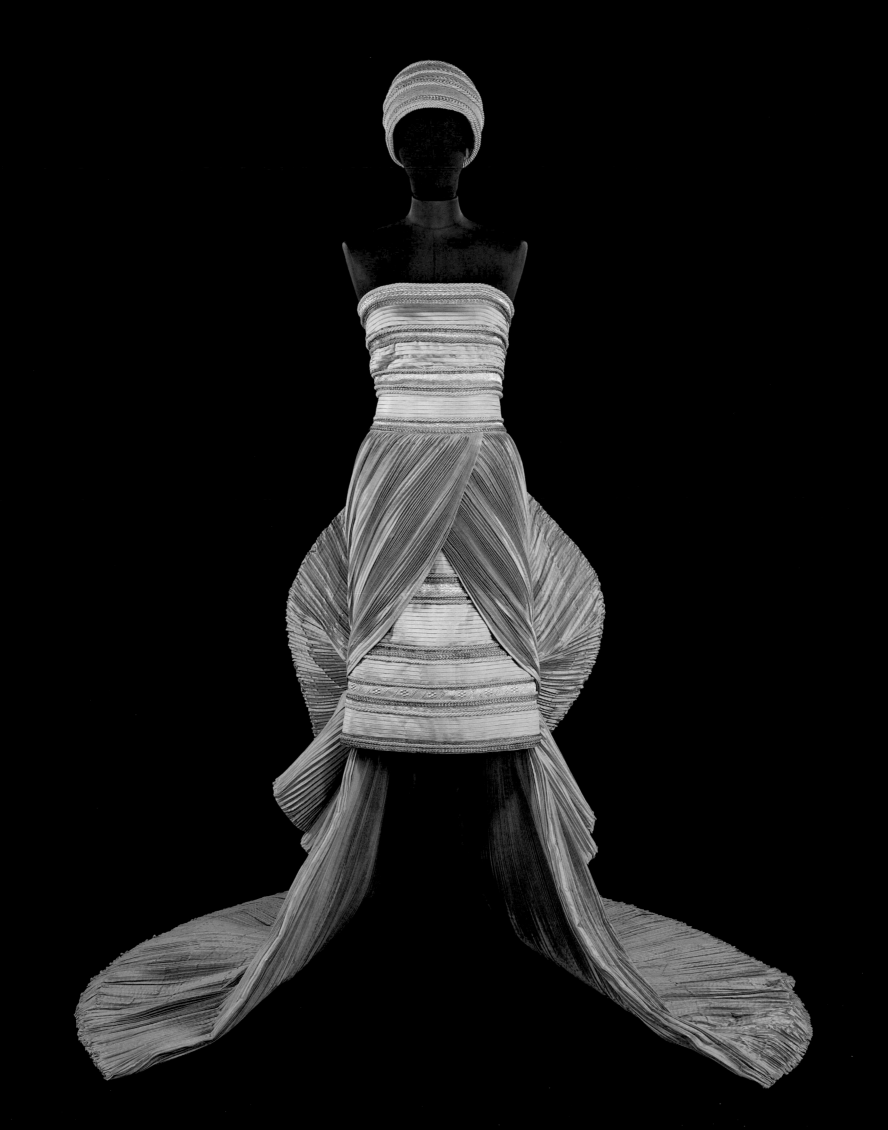

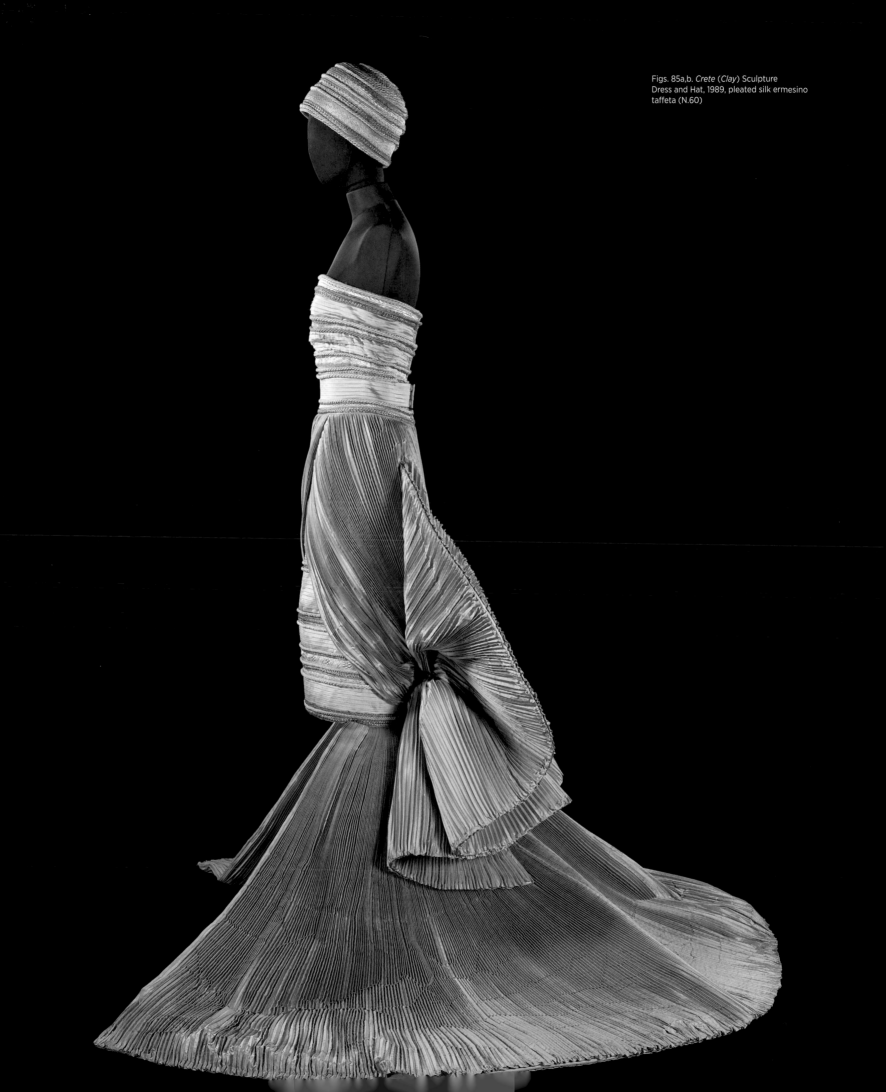

Figs. 85a,b. *Crete* (*Clay*) Sculpture
Dress and Hat, 1989, pleated silk ermesino
taffeta (N.60)

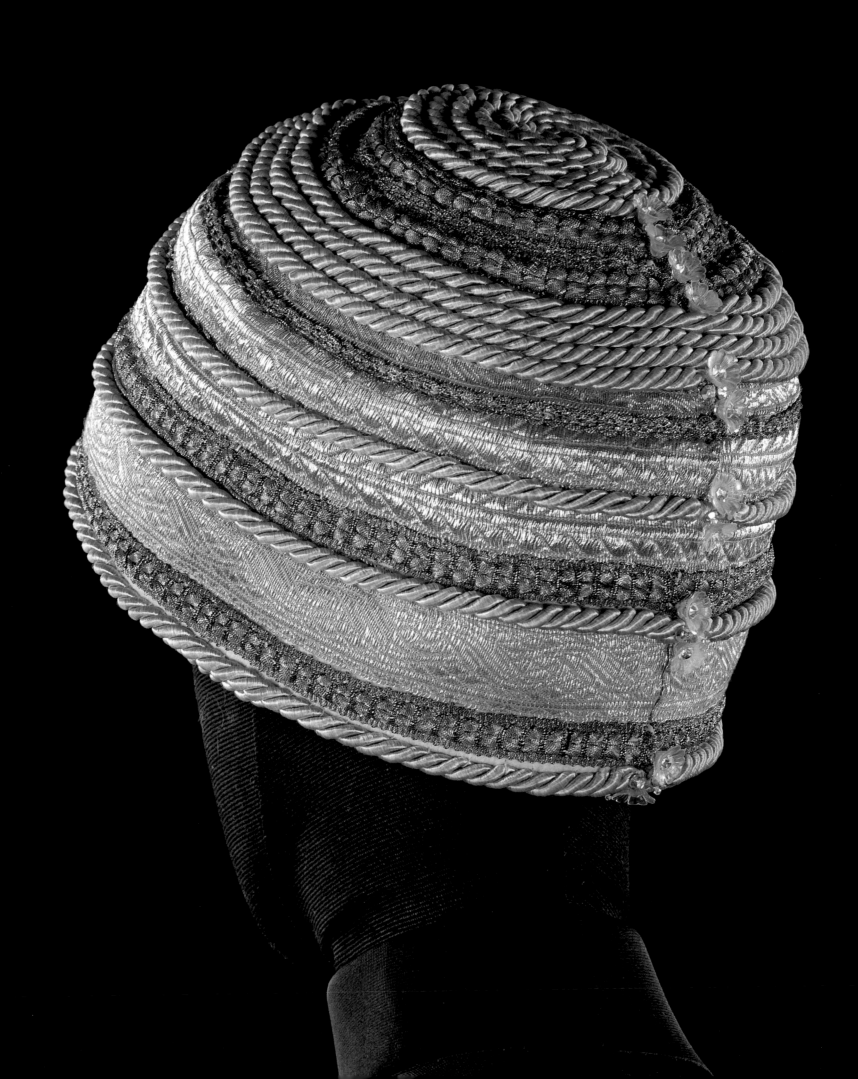

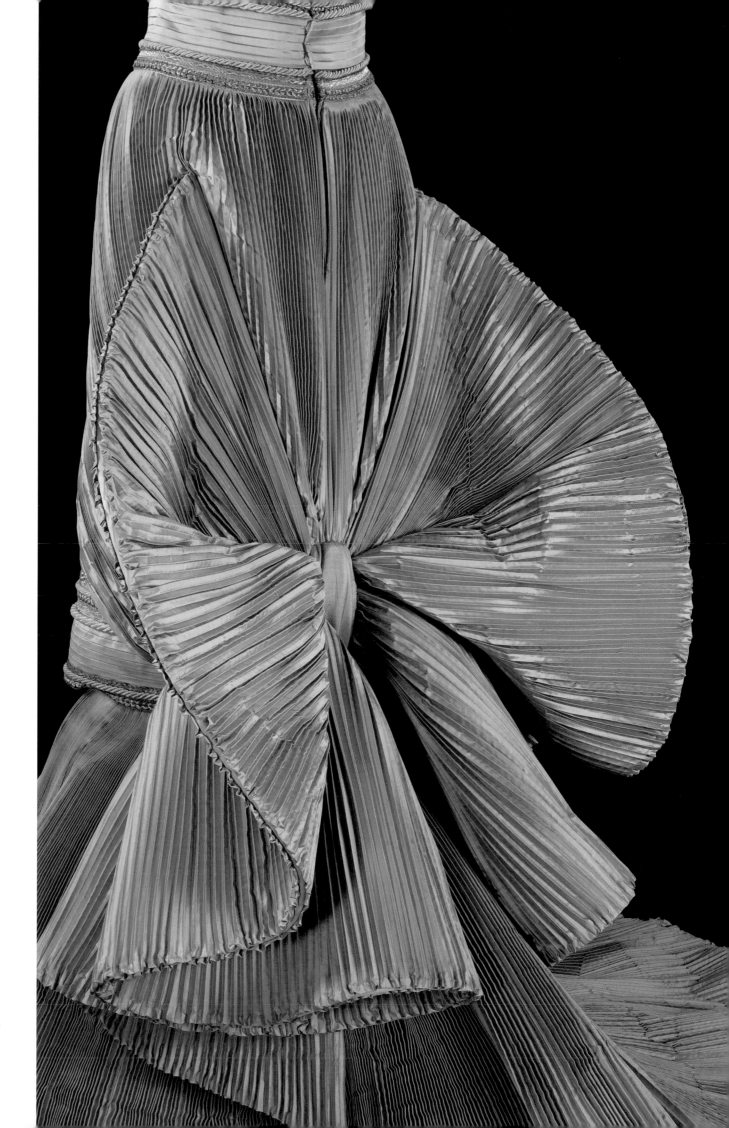

Figs. 85c,d. *Crete* (*Clay*) Sculpture
Dress and Hat, 1989, pleated silk ermesino
taffeta (N.60)

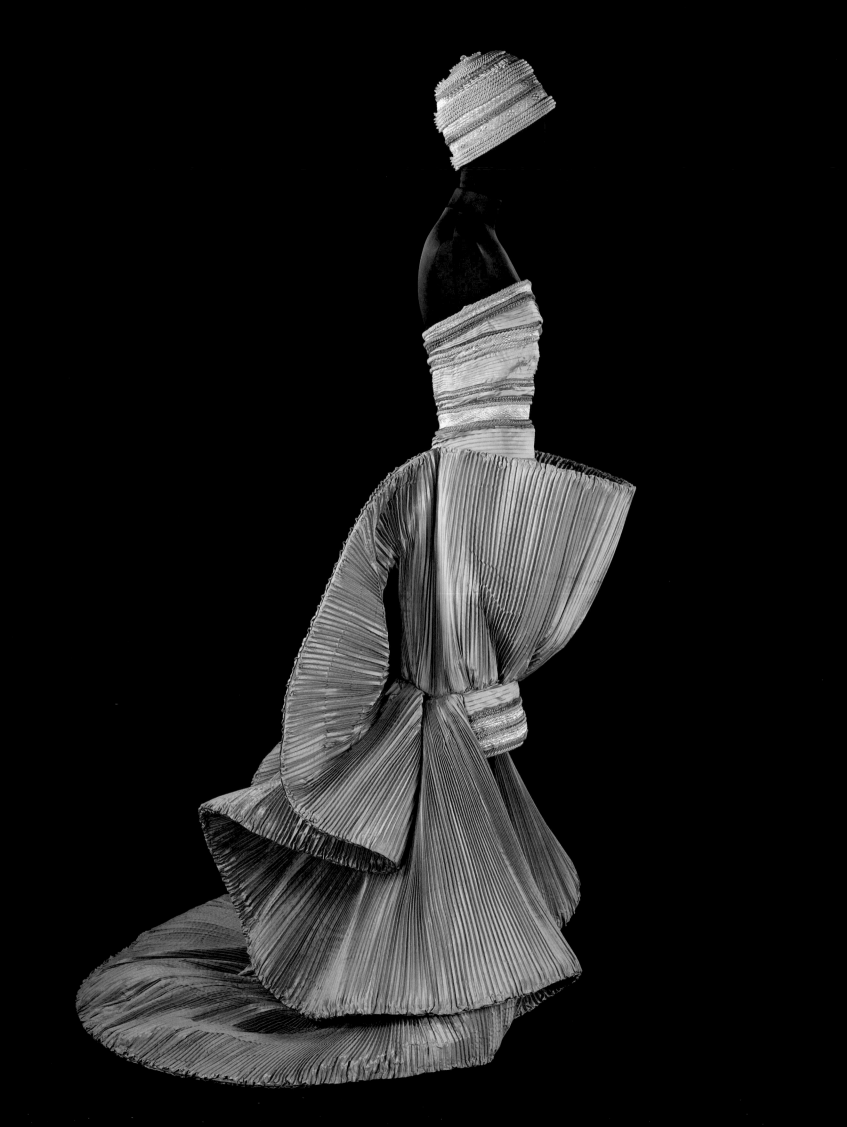

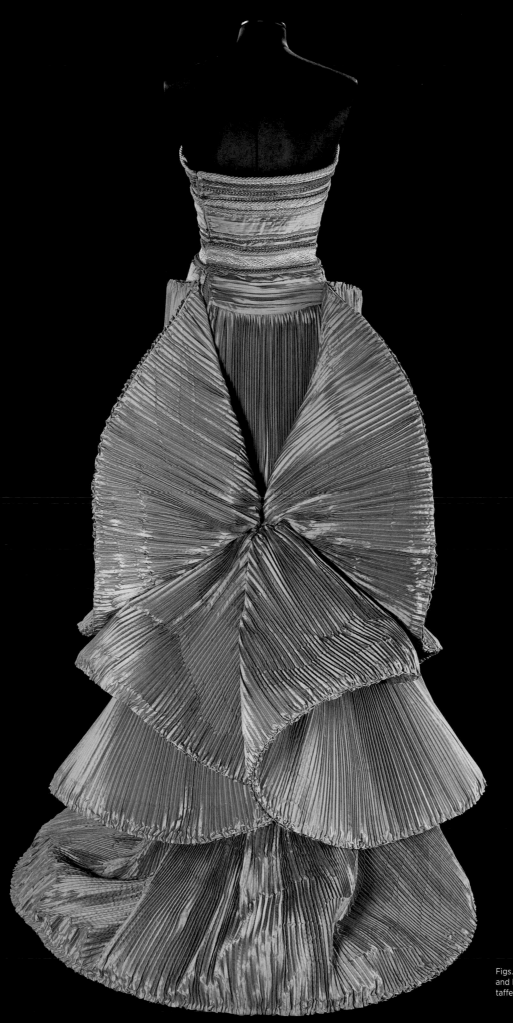

Figs. 86a,b. *Crete* (*Clay*) Sculpture Dress
and Hat, 1989, pleated silk ermesino
taffeta (N.59)

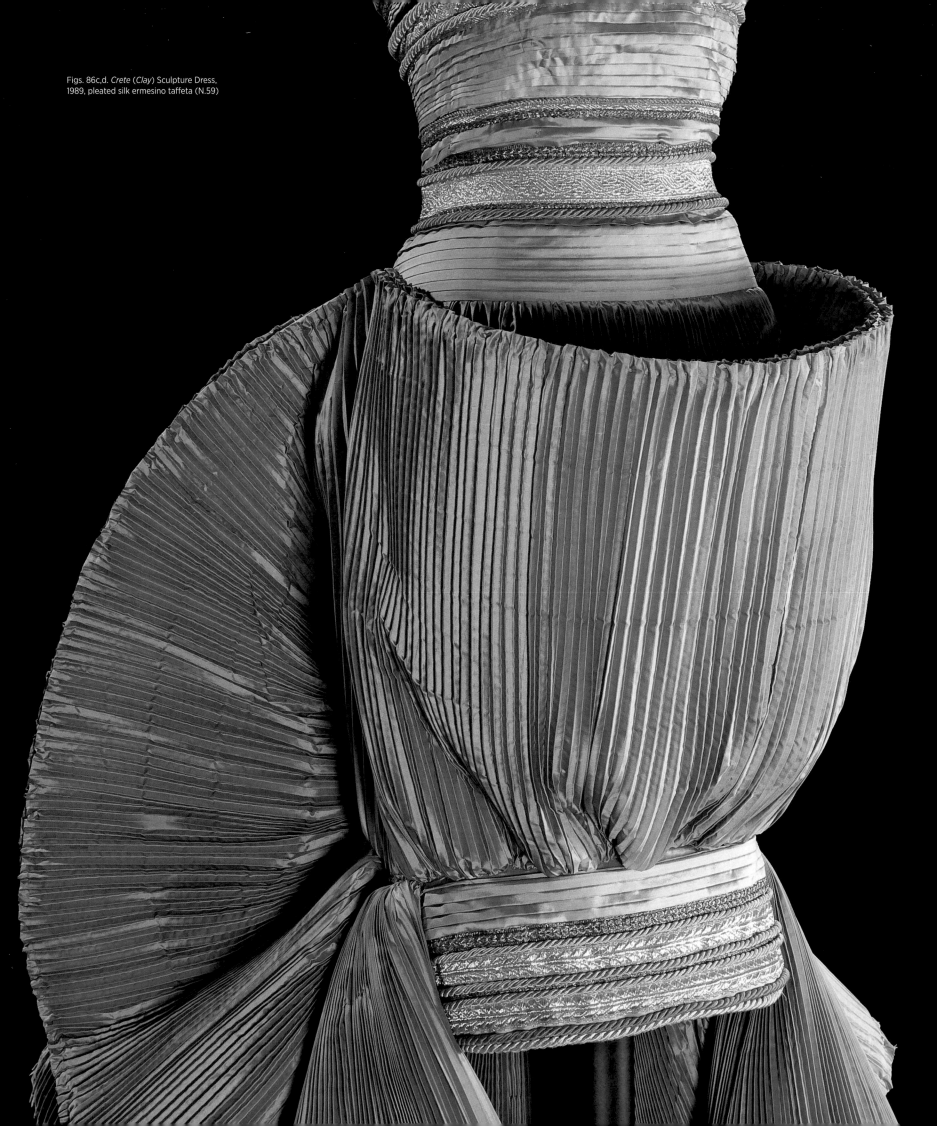

Figs. 86c,d. *Crete* (*Clay*) Sculpture Dress, 1989, pleated silk ermesino taffeta (N.59)

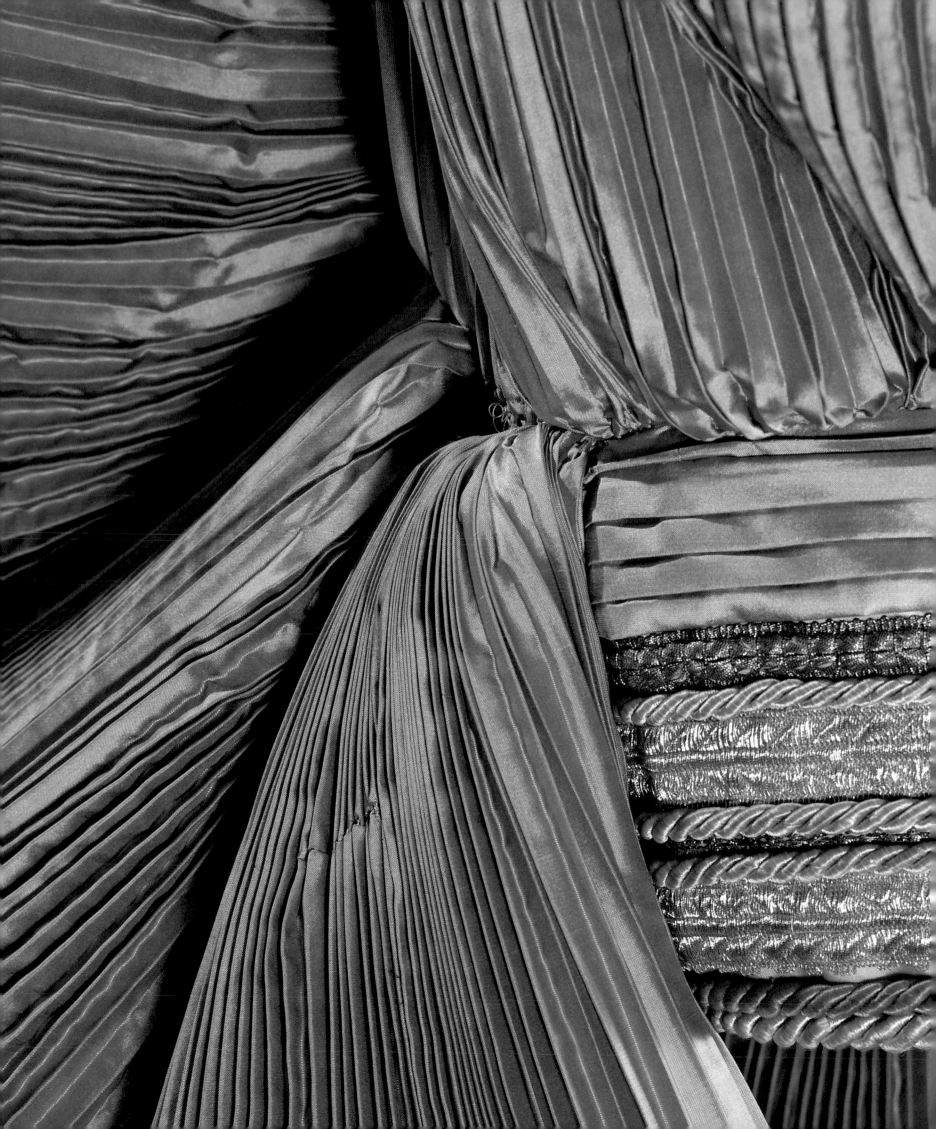

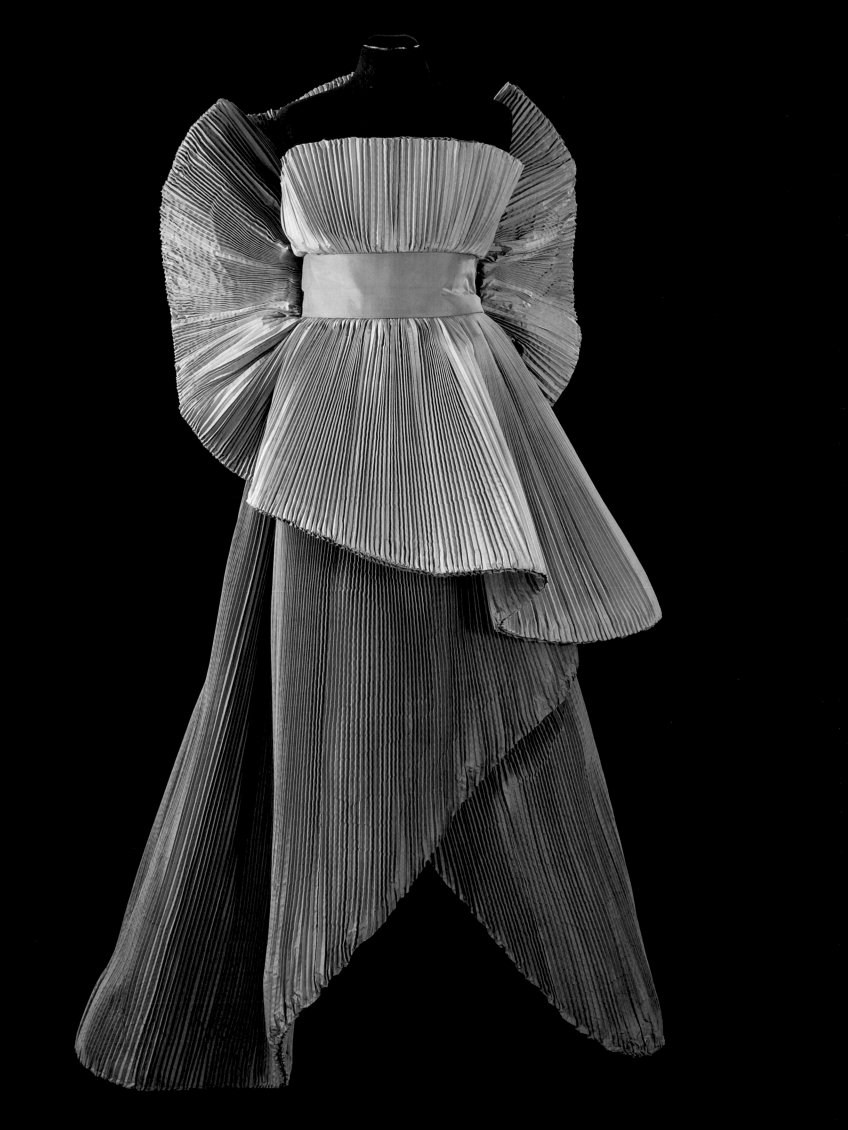

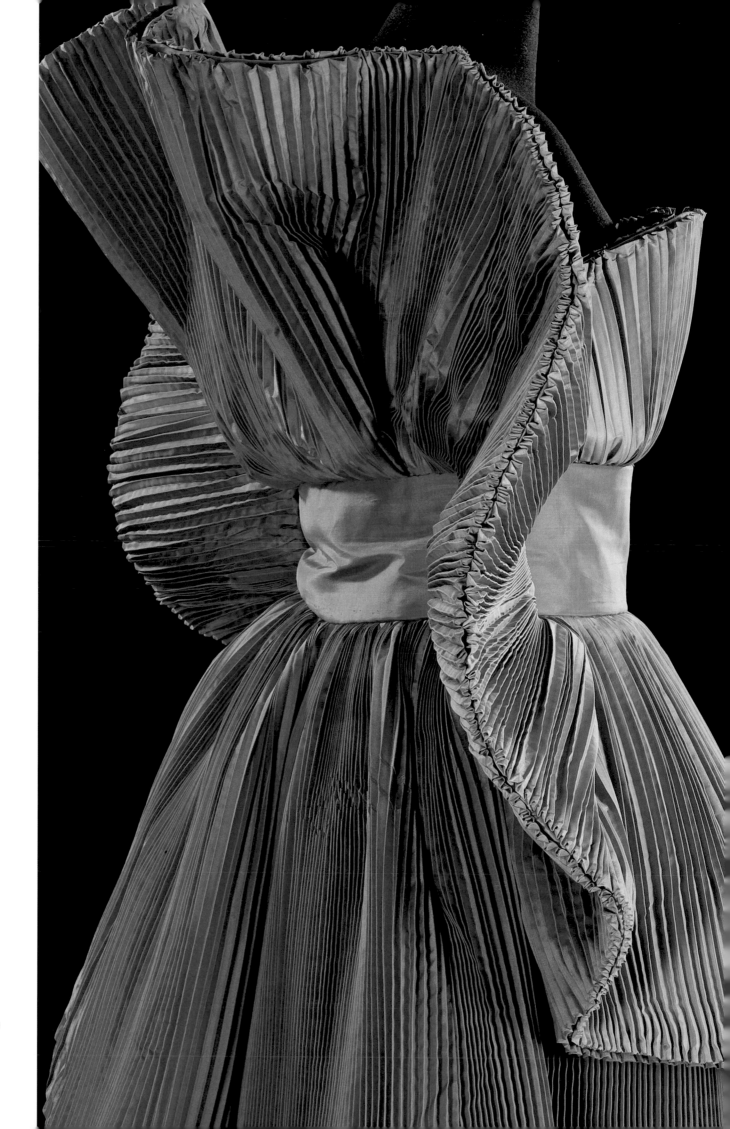

Figs. 87a,b. Sculpture Dress, 1989, pleated
silk taffeta (N.5)

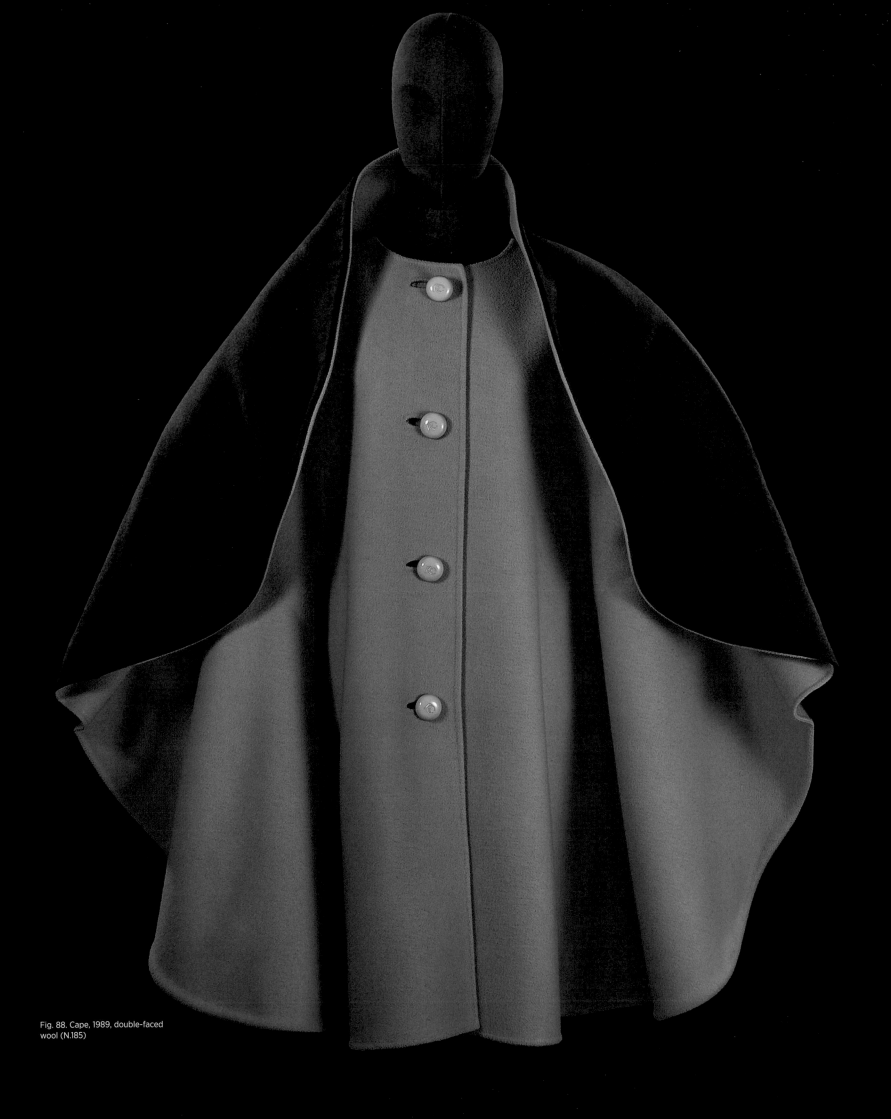

Fig. 88. Cape, 1989, double-faced
wool (N.185)

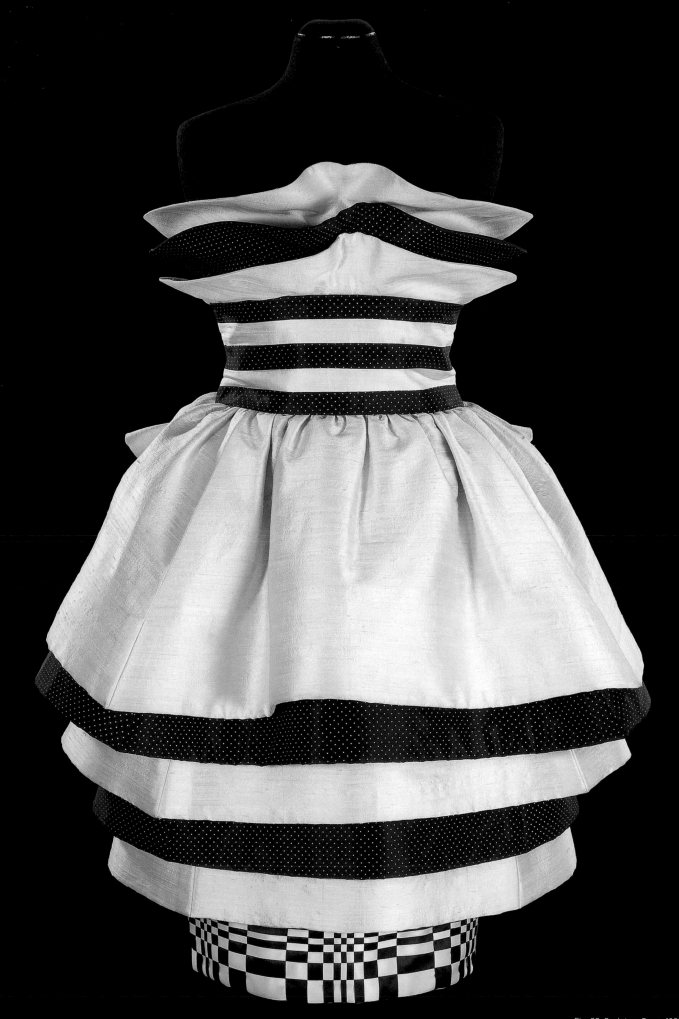

Fig. 89. Sculpture Dress, 1989, silk sauvage
taffeta and silk satin ribbons (N 242)

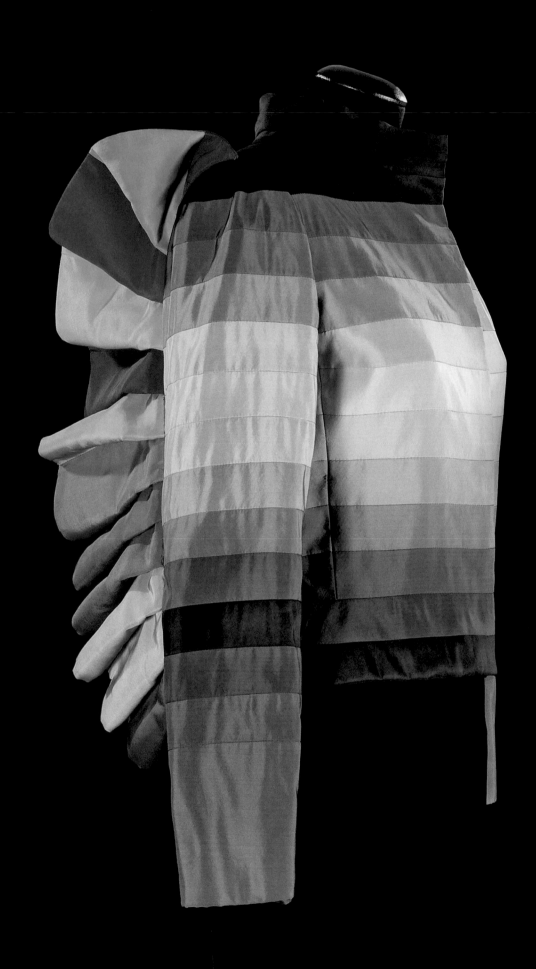

Fig. 90. Sculpture Suit, 1989, silk velvet and
silk faille (N.230)

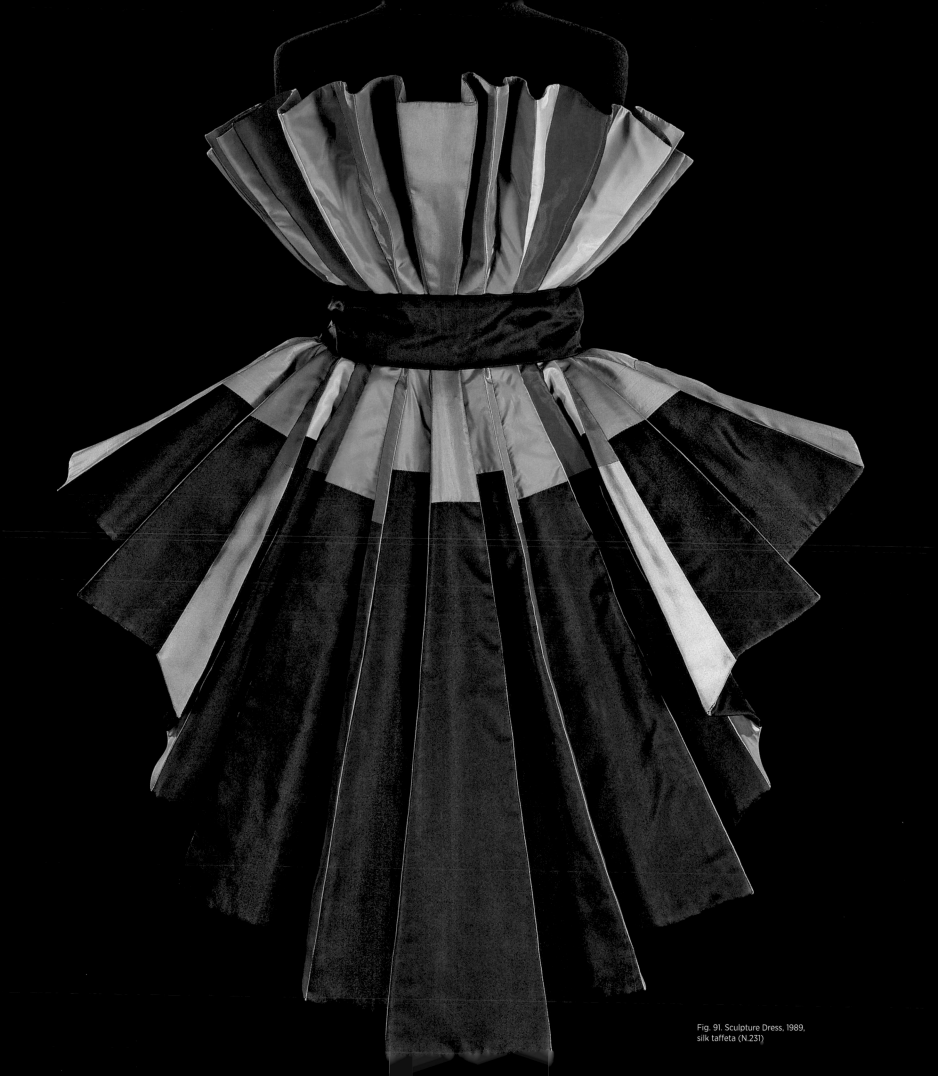

Fig. 91. Sculpture Dress, 1989,
silk taffeta (N.231)

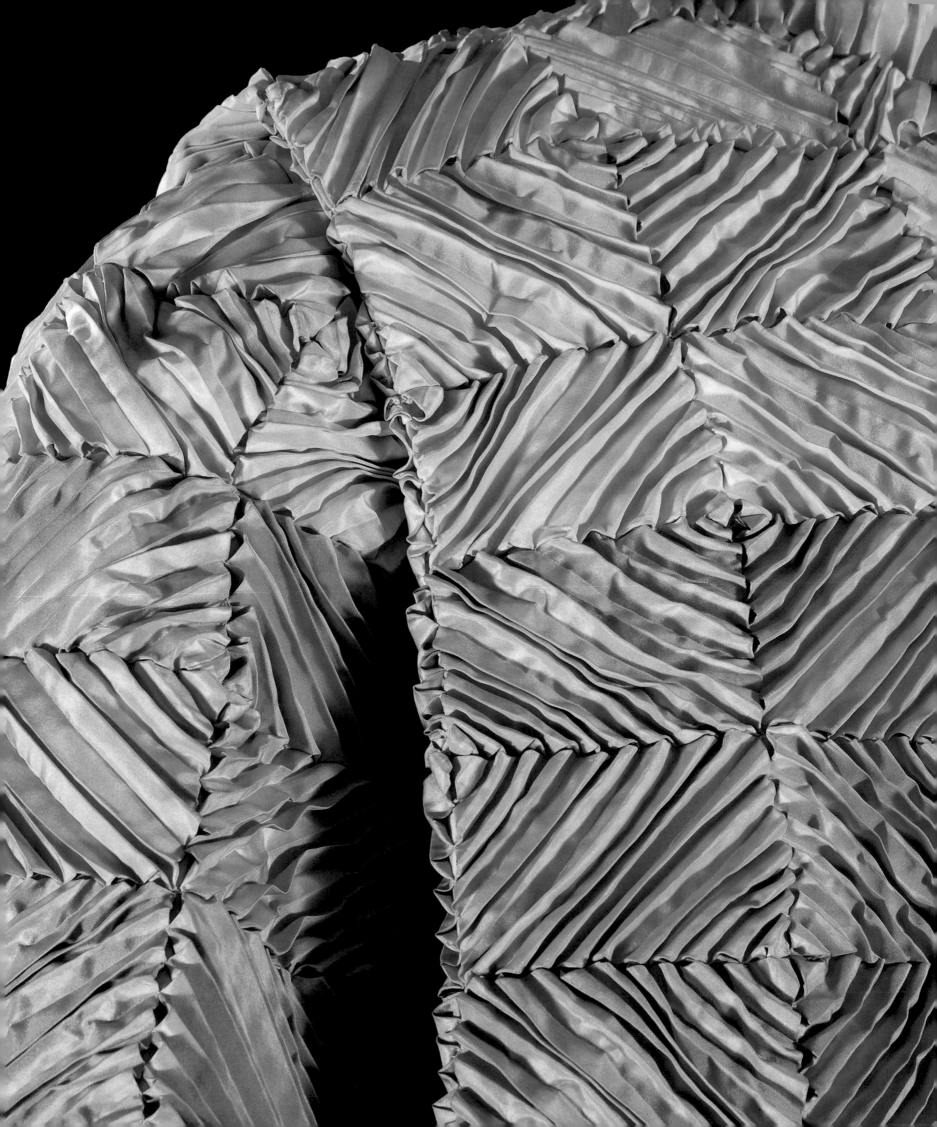

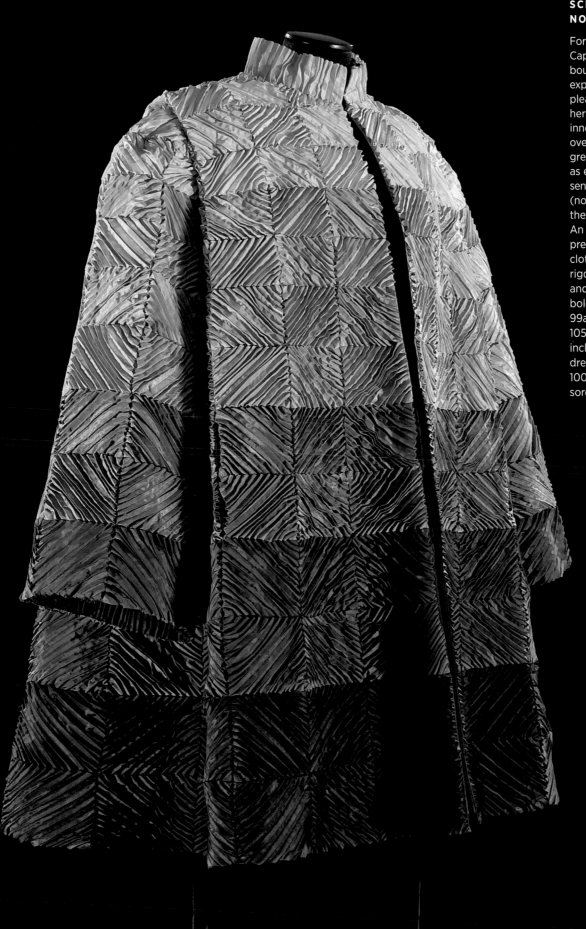

For his final original collection, Capucci continued to push the boundaries of fashion through experiments with pleating, creating pleated squares, triangles, and herringbone patterns. Such innovations transformed his work over the years, moving it toward greater and greater abstraction, as evident in the designs he presented at the Schauspielhaus (now Konzerthaus), the home of the Berlin Symphony Orchestra. An ensemble accompanied the presentation of the magnificent clothes, sometimes geometric and rigorous (figs. 92a,b; see figs. 93 and 94), other times baroque—bold and extravagant (see figs. 99a,b; 101a,b; 102a,b; 104a,b; and 105a–c). The collection, which included a series of short evening dresses (see figs. 95a,b–98a,b; 100a,b; and 103a,b), was sponsored by *Madame* magazine.

Figs. 92a,b. Cape-Coat, 1992, pleated silk taffeta (N.16)

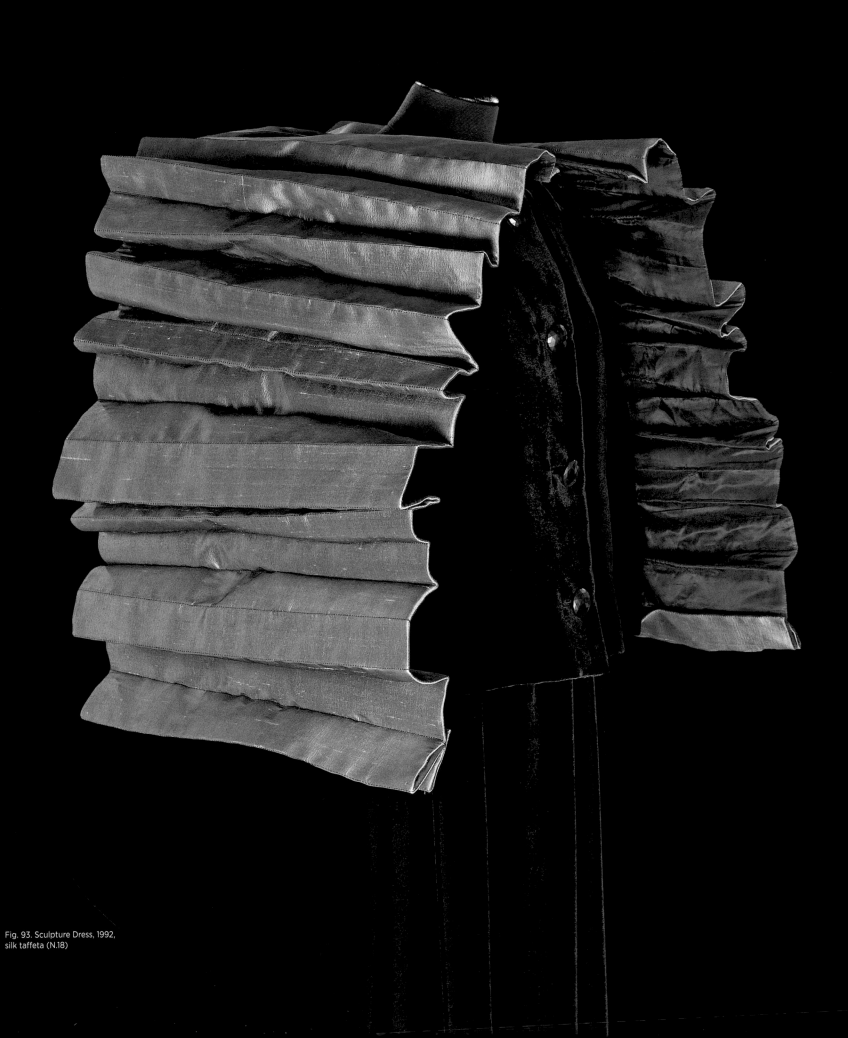

Fig. 93. Sculpture Dress, 1992,
silk taffeta (N.18)

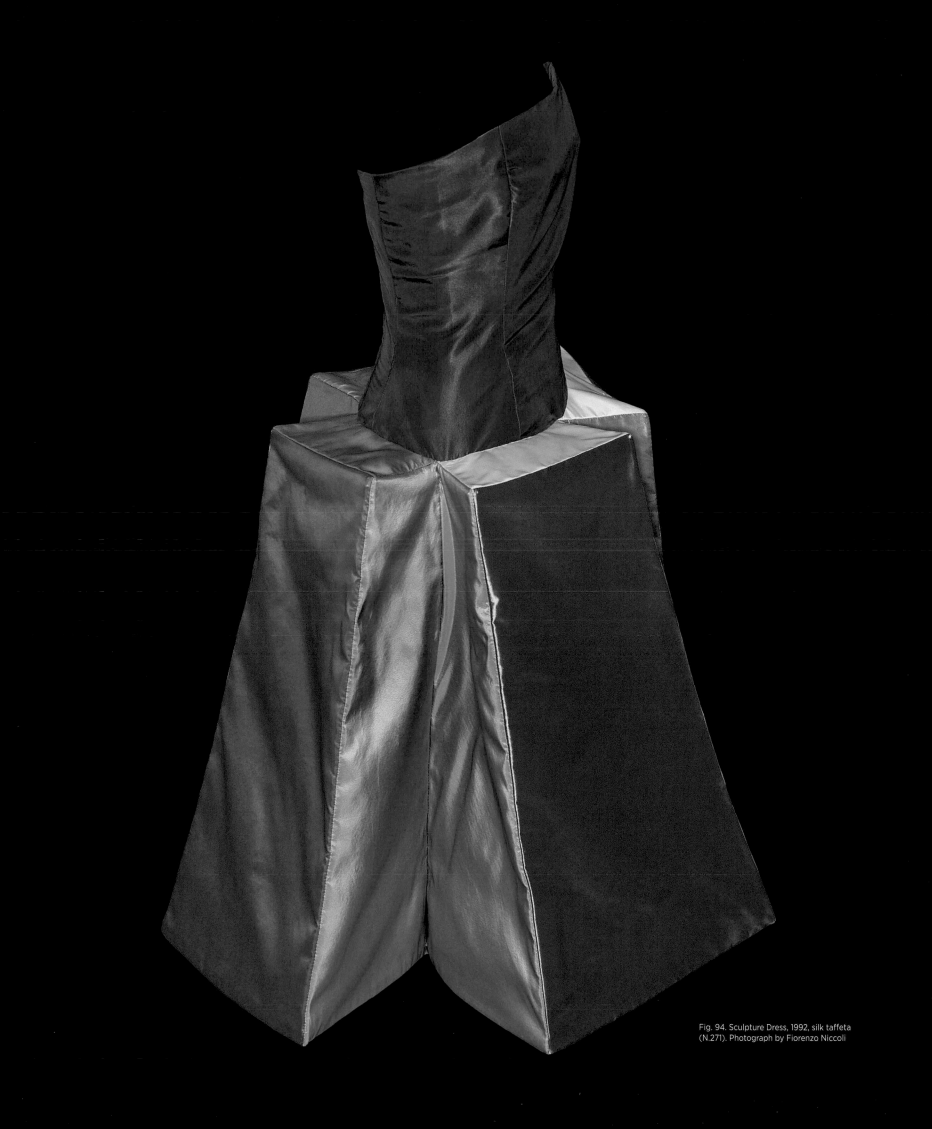

Fig. 94. Sculpture Dress, 1992, silk taffeta
(N.271). Photograph by Fiorenzo Niccoli

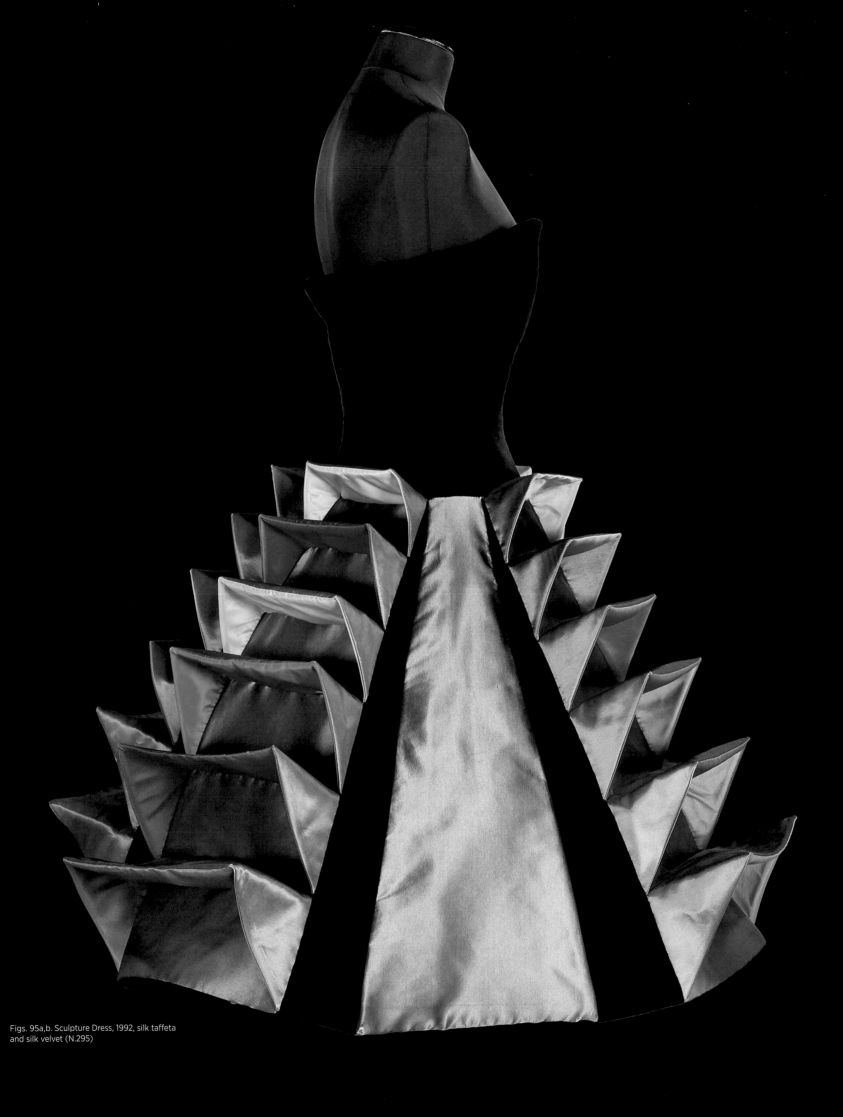

Figs. 95a,b. Sculpture Dress, 1992, silk taffeta and silk velvet (N.295)

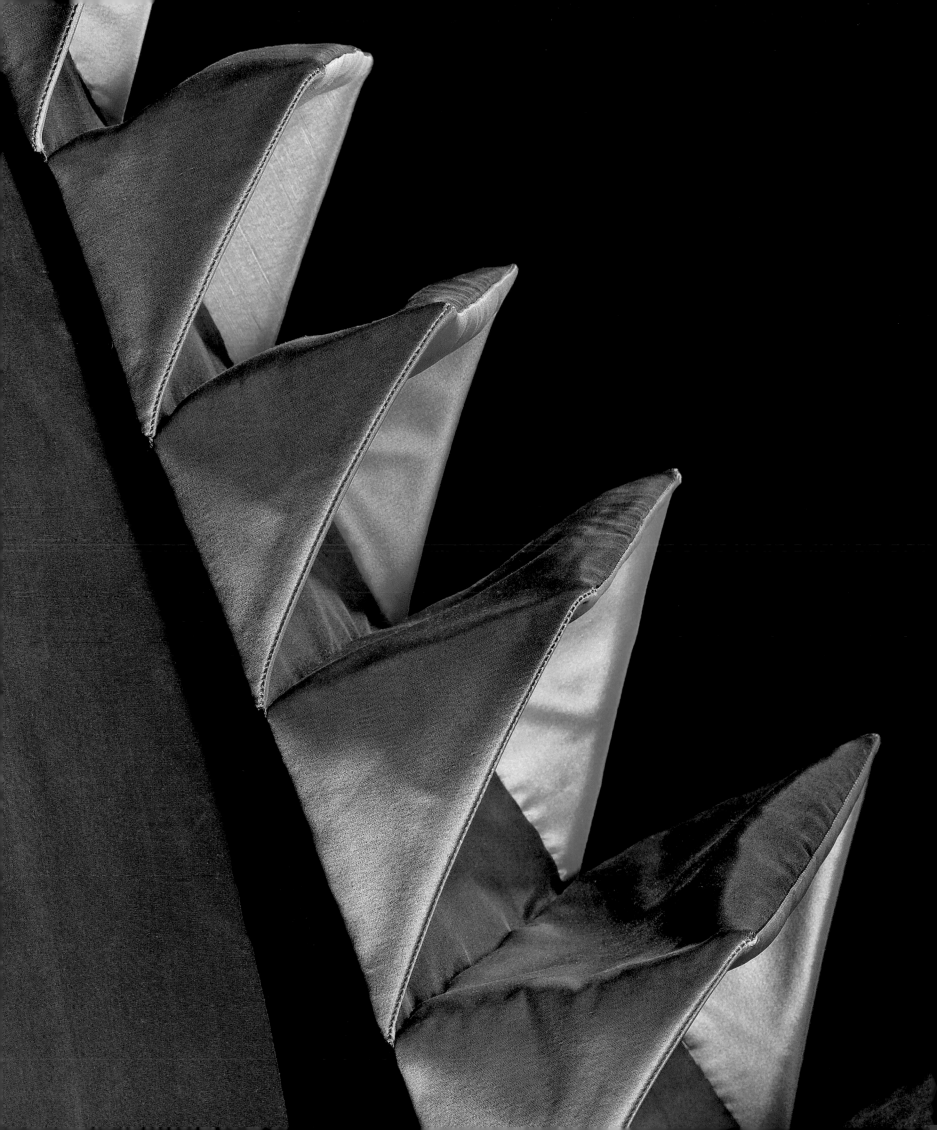

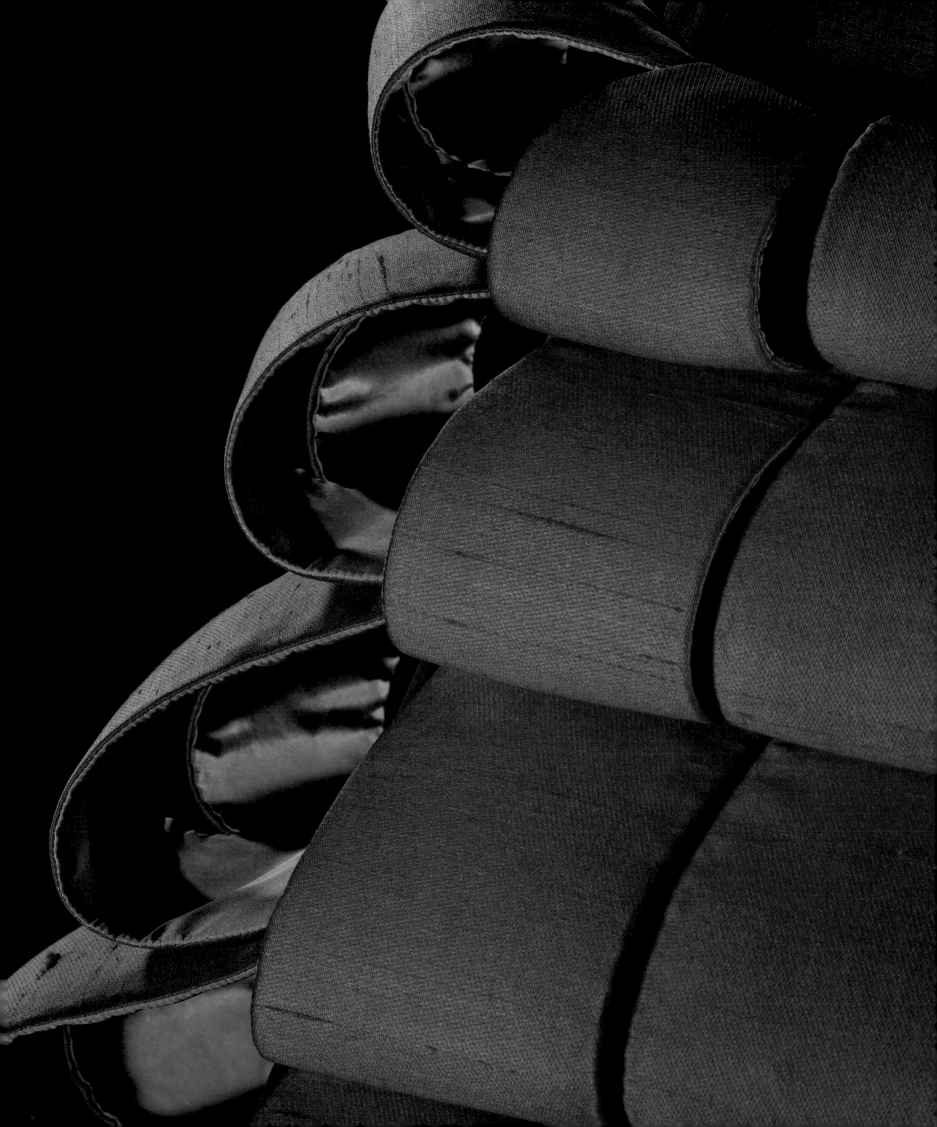

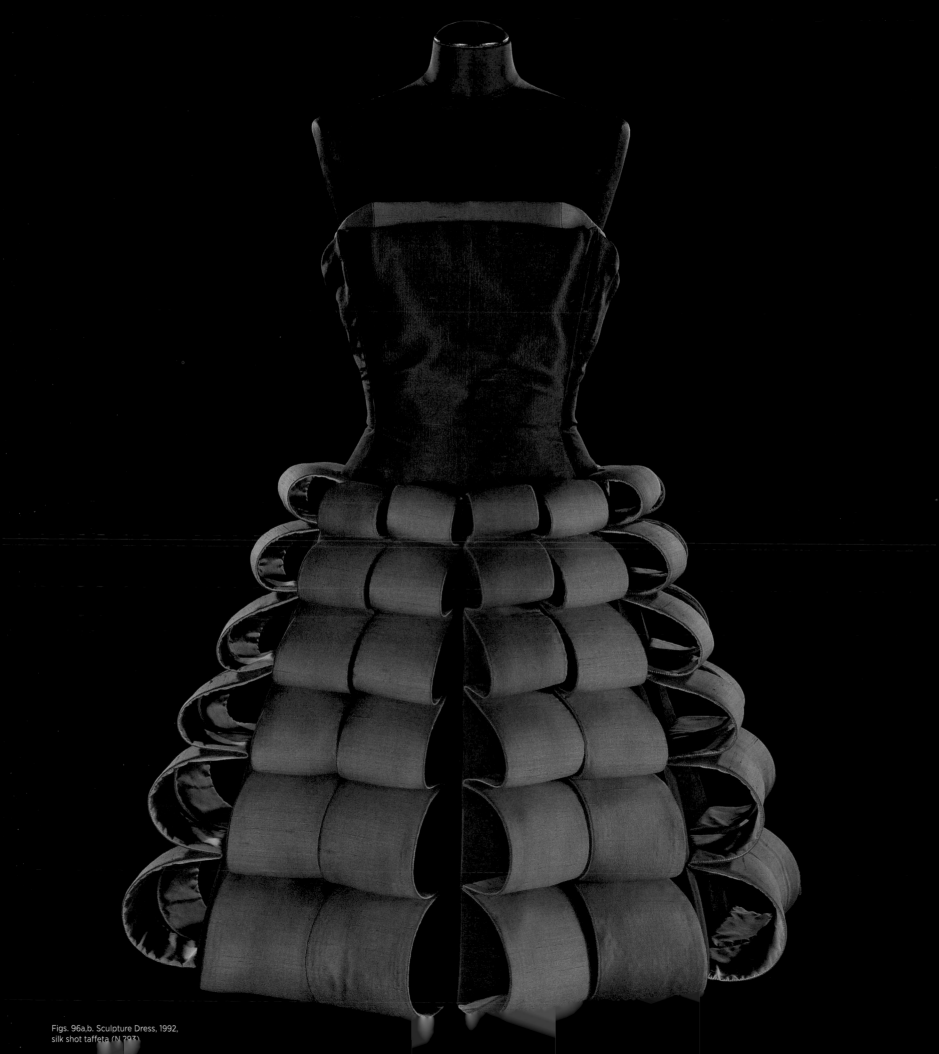

Figs. 96a,b. Sculpture Dress, 1992,
silk shot taffeta (N 293)

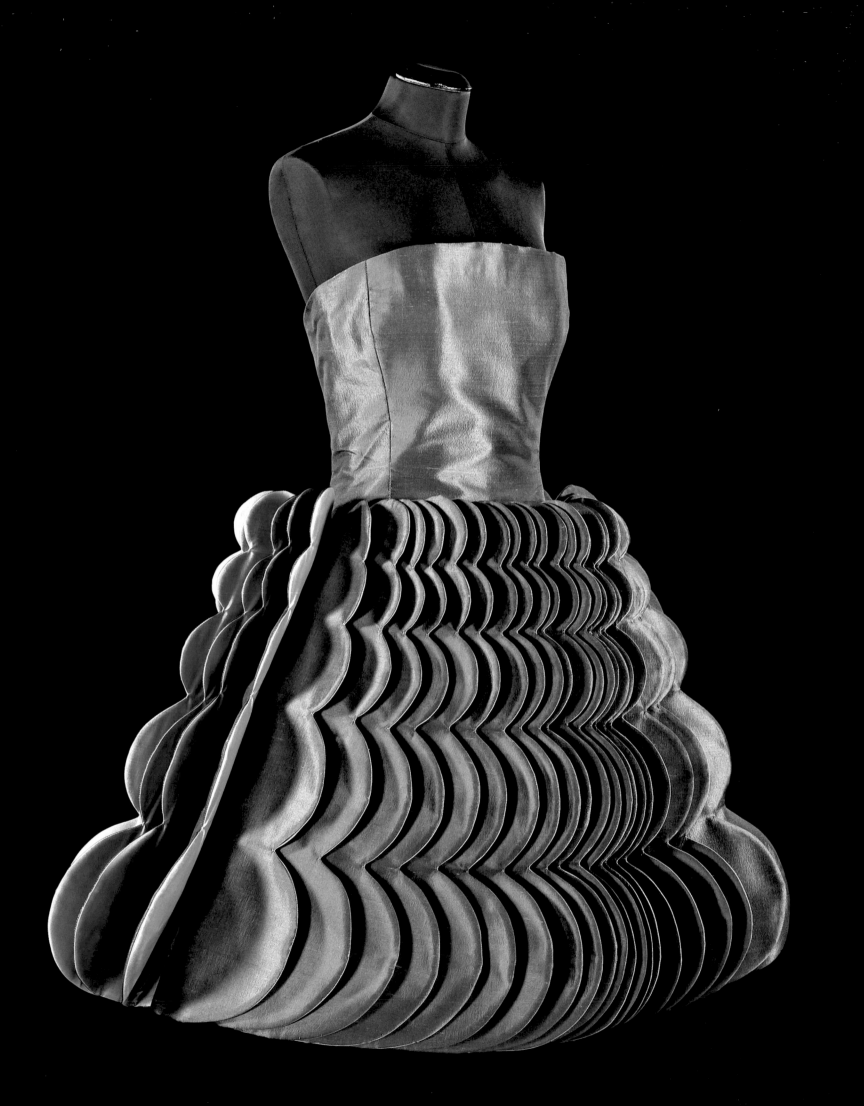

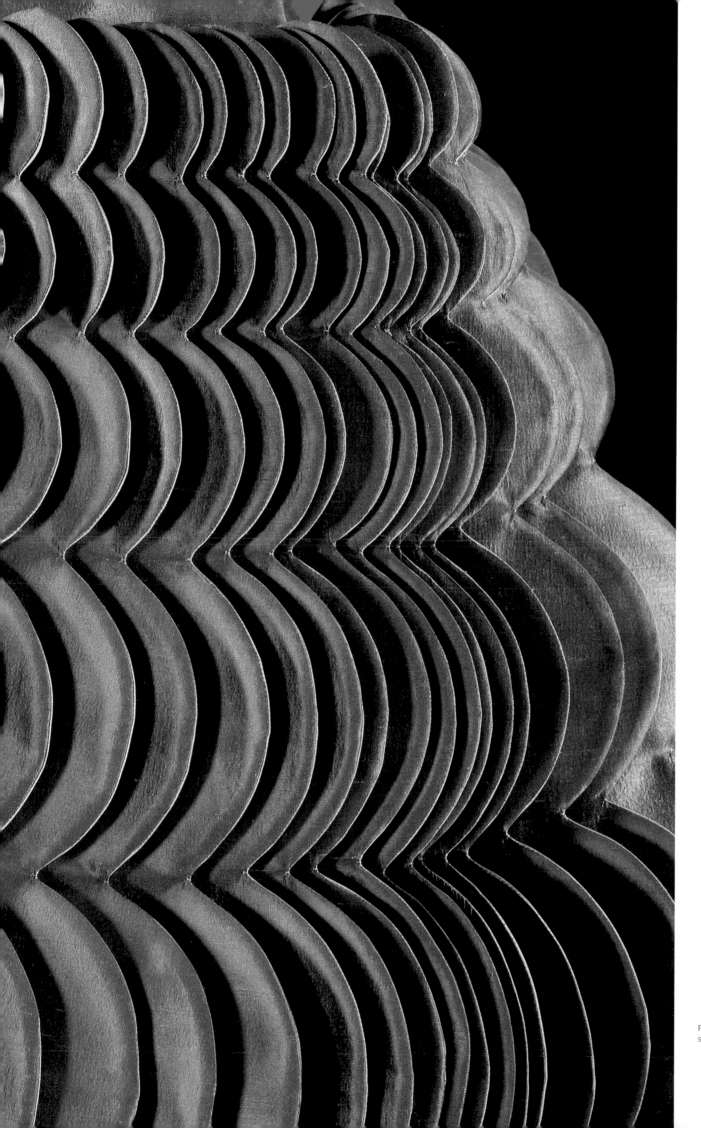

Figs. 97a,b. Sculpture Dress, 1992,
silk taffeta (N.286)

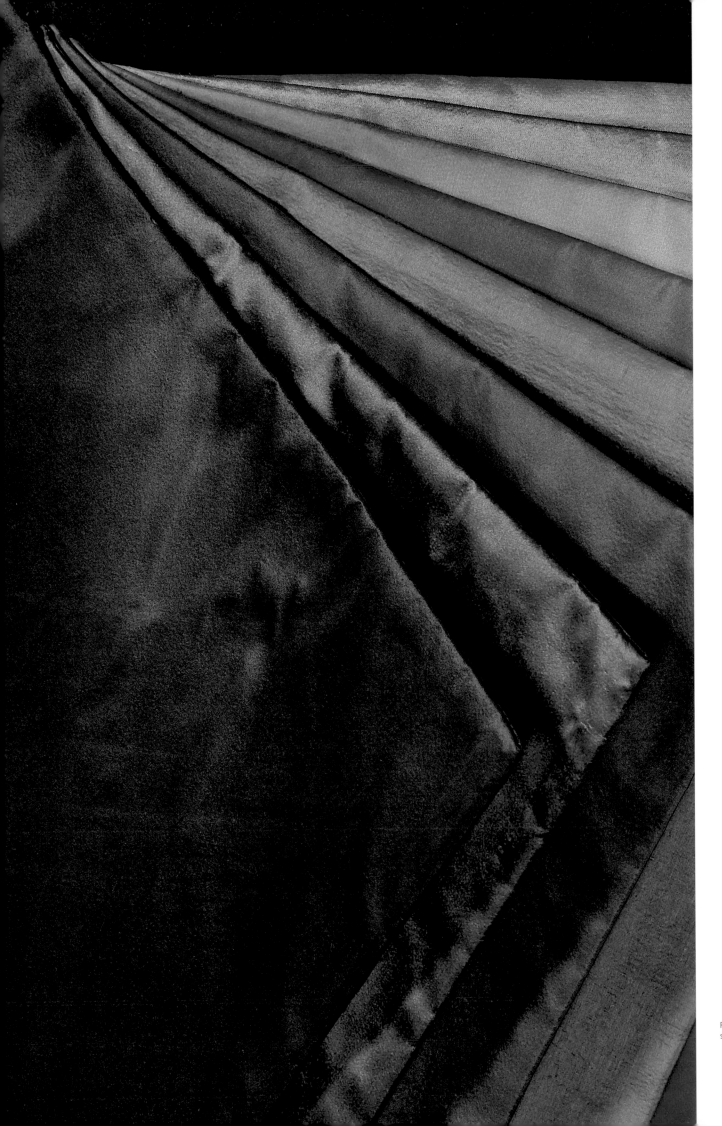

Figs. 98a,b. Sculpture Dress, 1992,
silk taffeta (N.285)

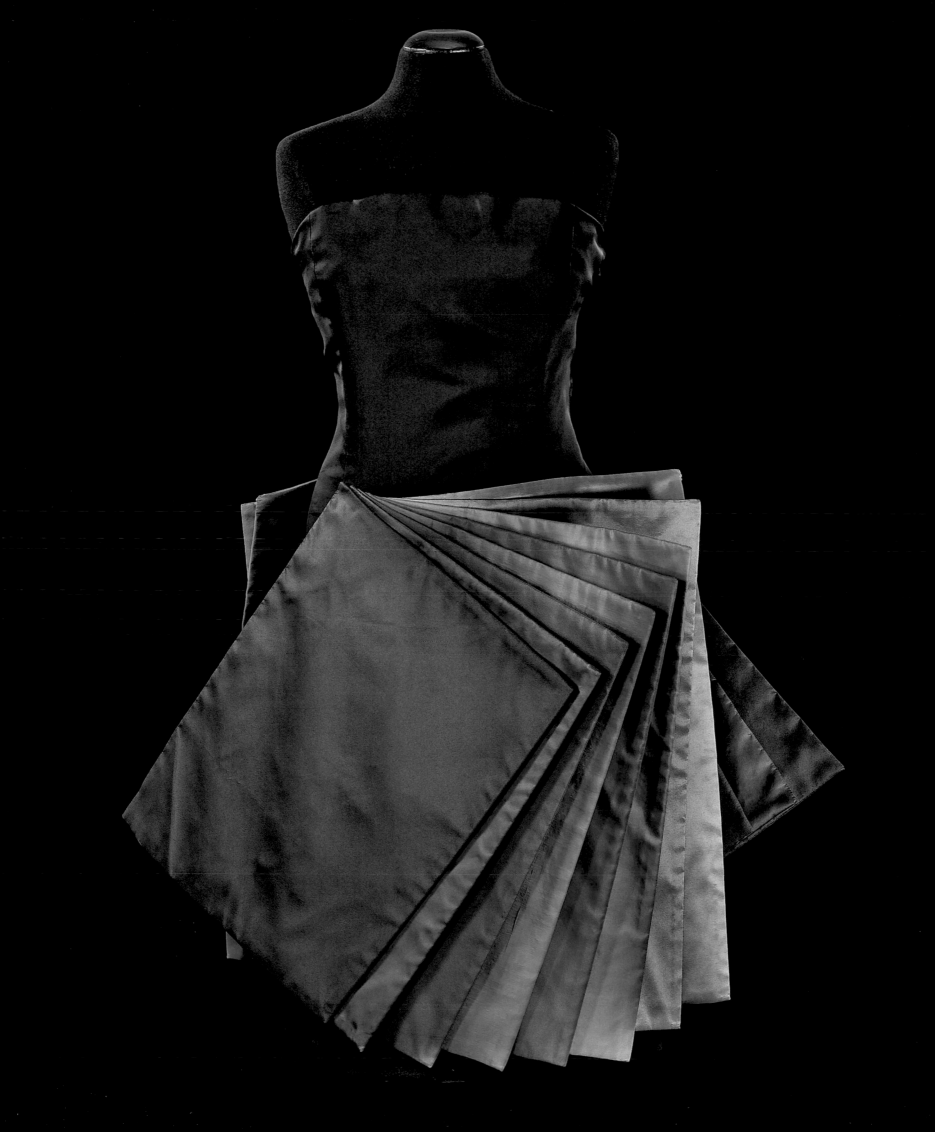

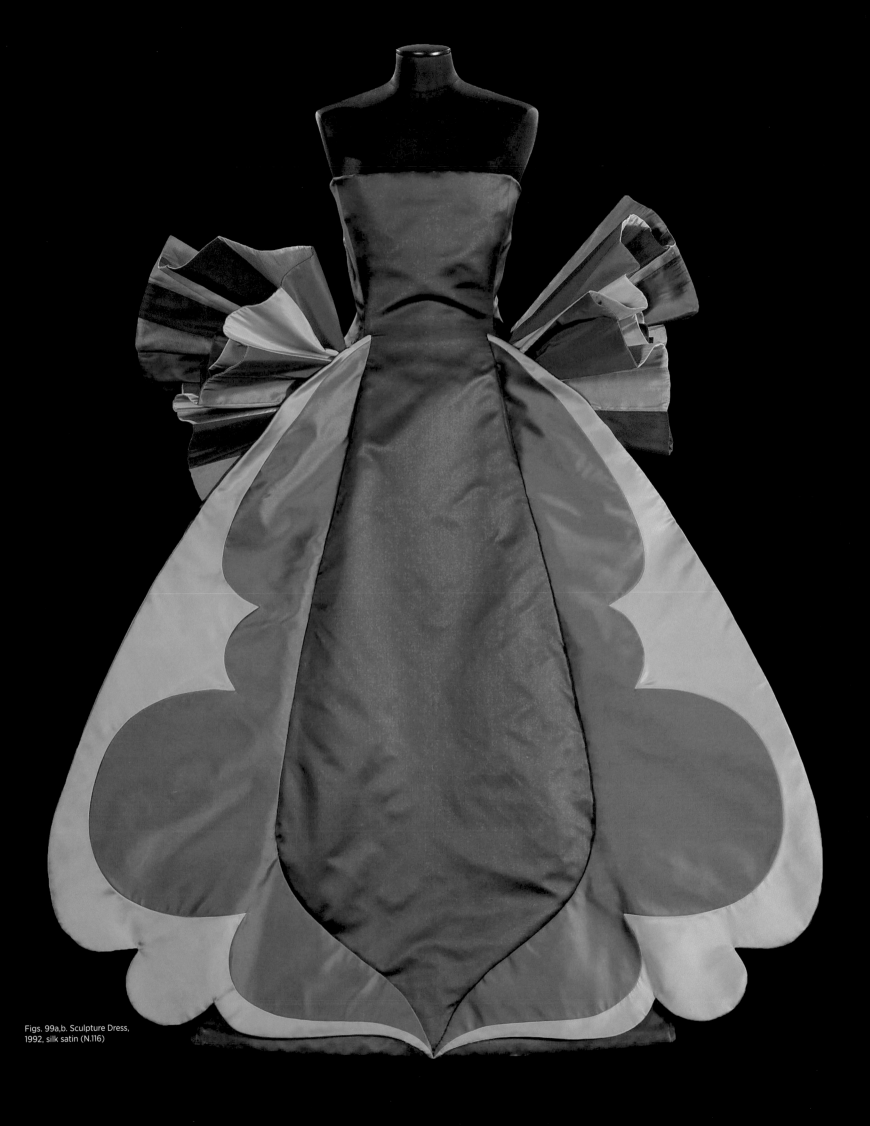

Figs. 99a,b. Sculpture Dress, 1992, silk satin (N.116)

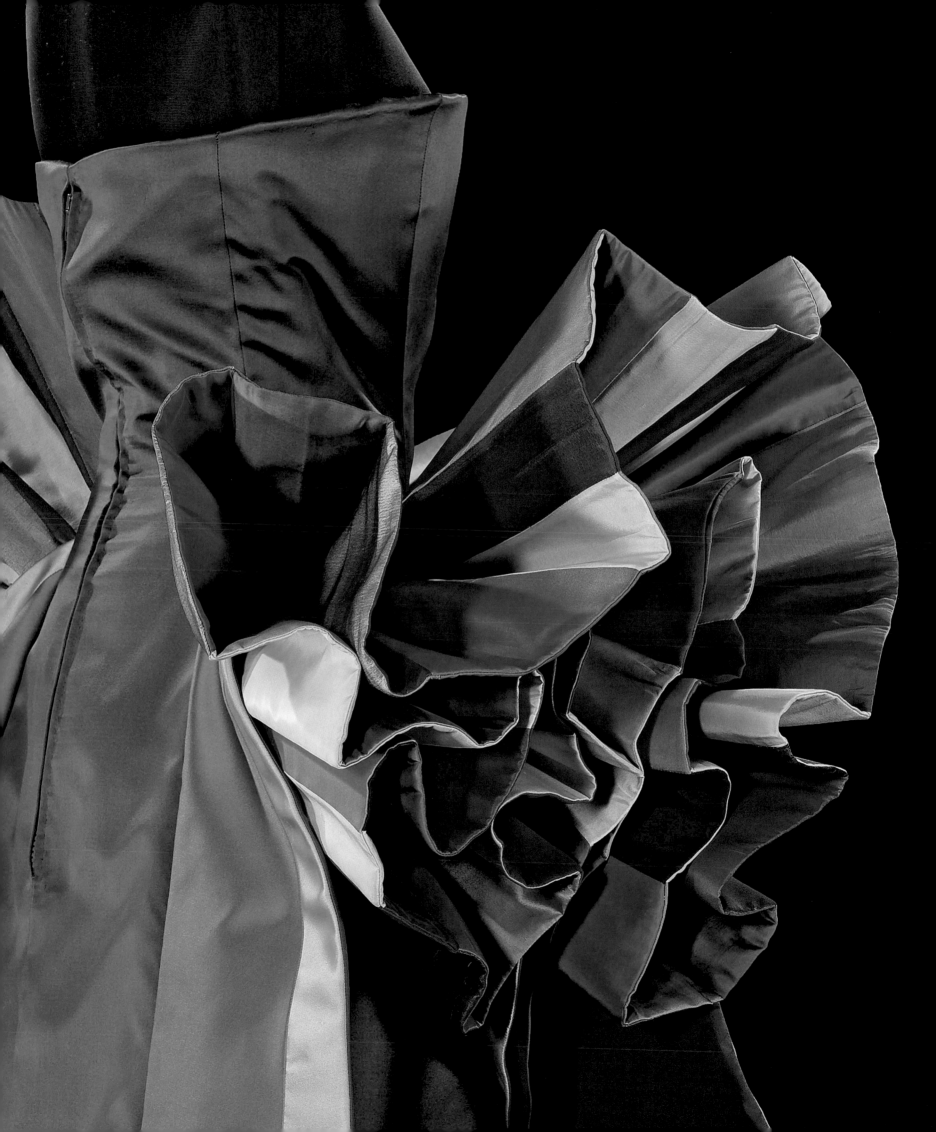

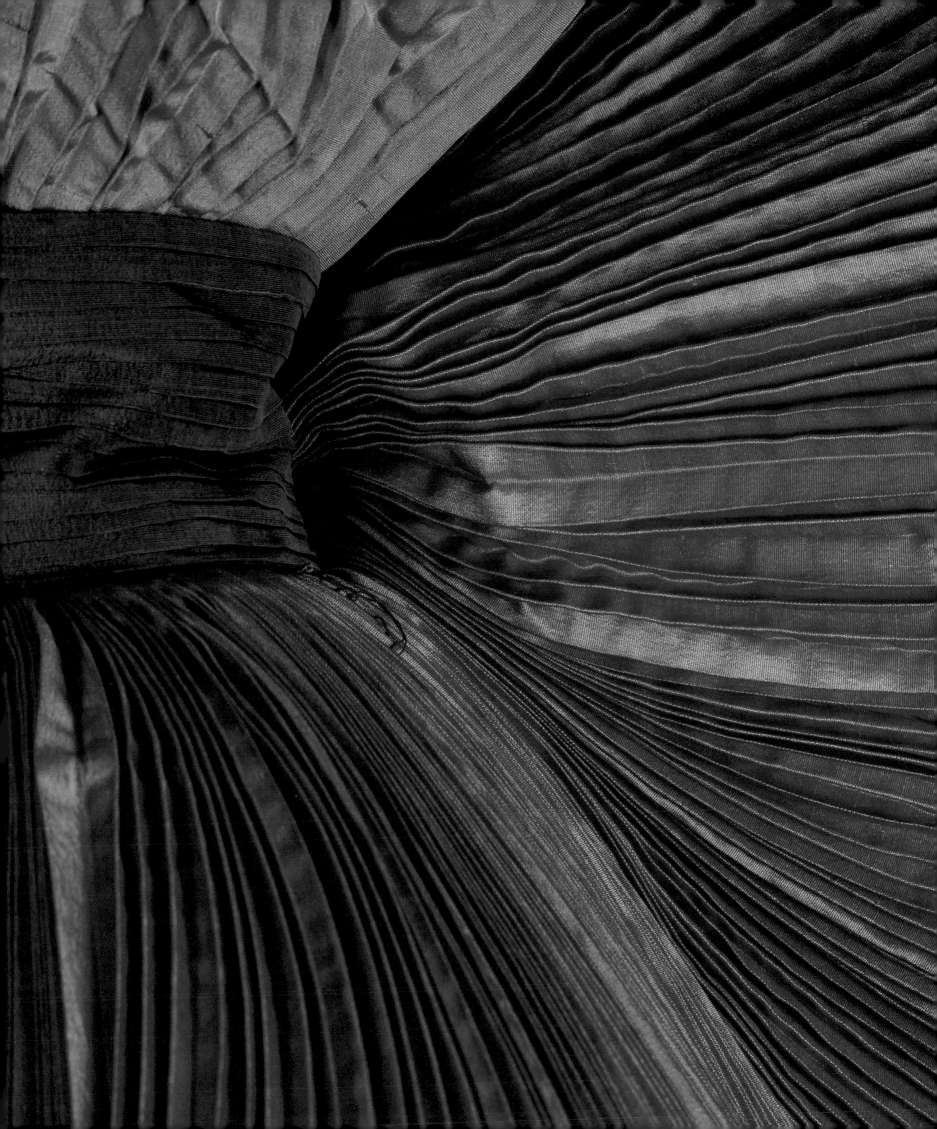

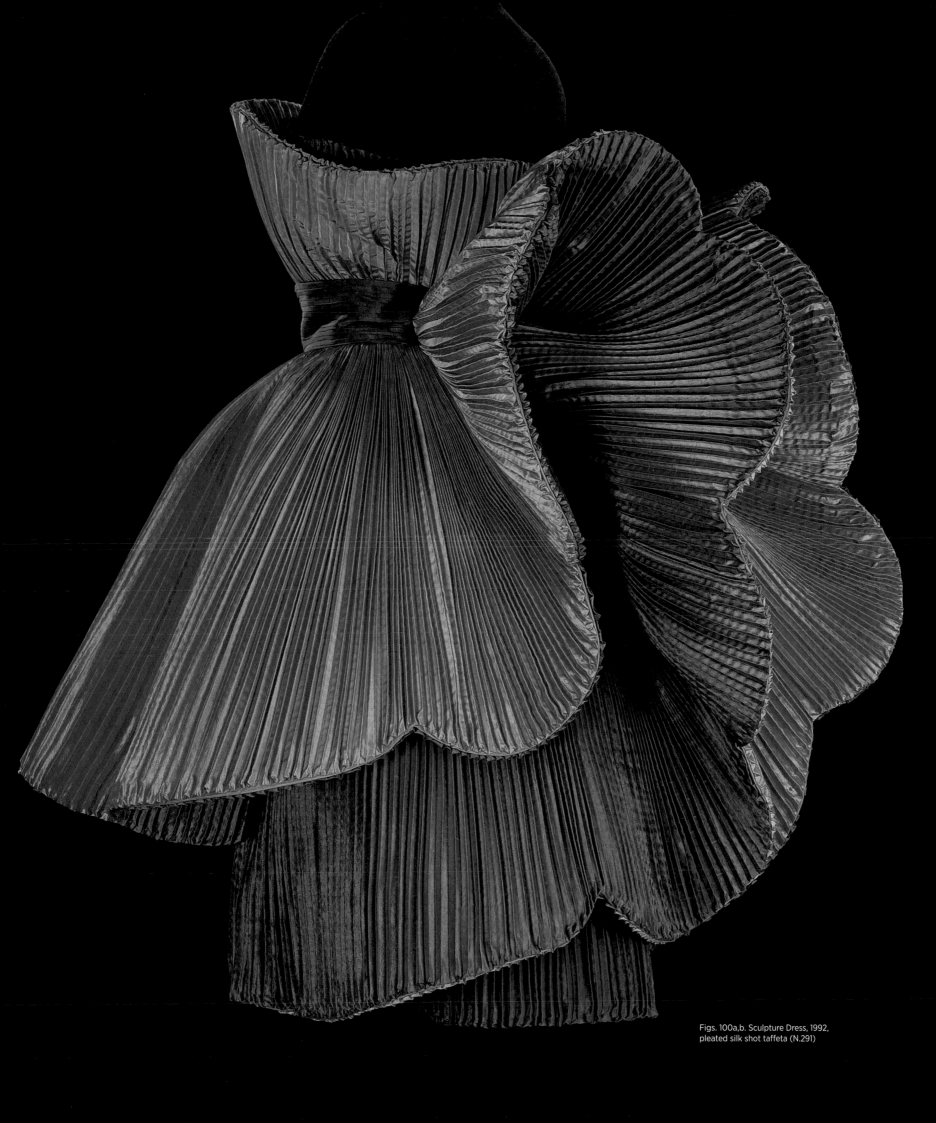

Figs. 100a,b. Sculpture Dress, 1992,
pleated silk shot taffeta (N.291)

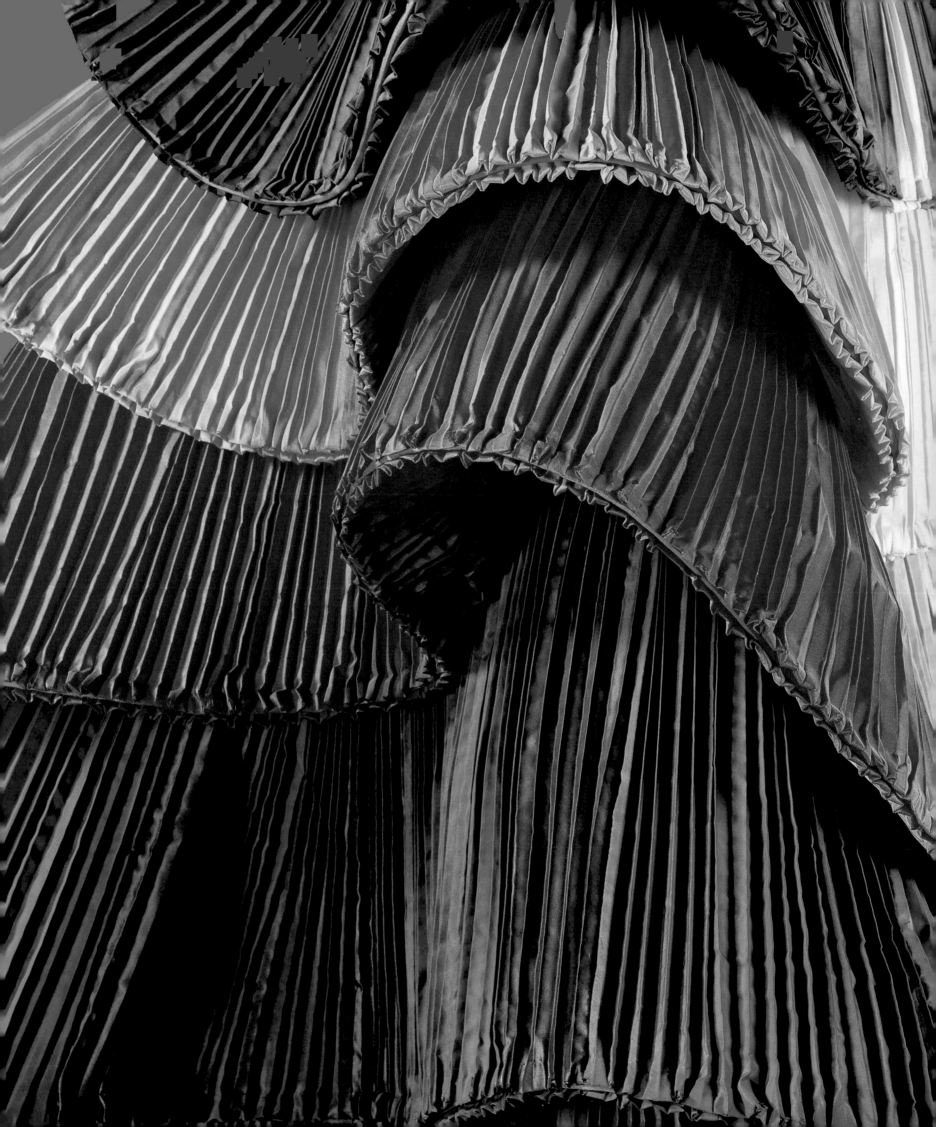

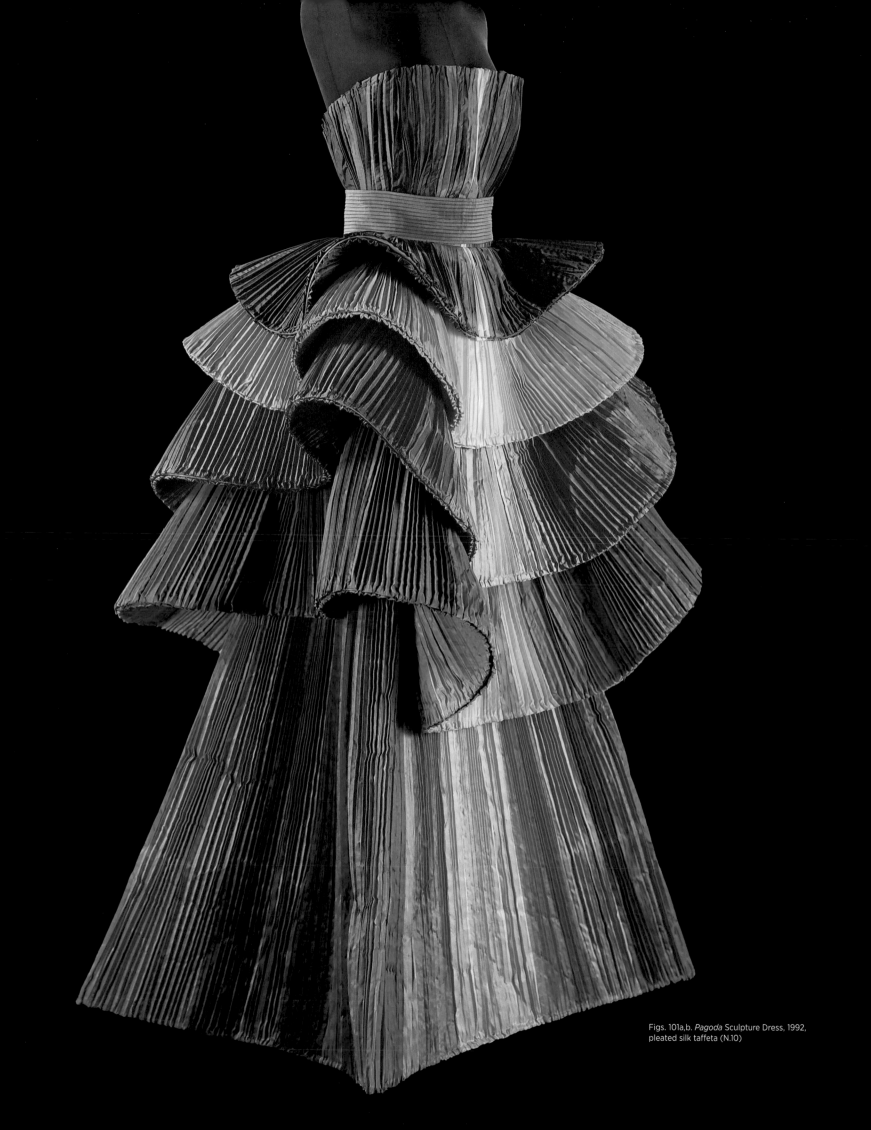

Figs. 101a,b. *Pagoda* Sculpture Dress, 1992, pleated silk taffeta (N.10)

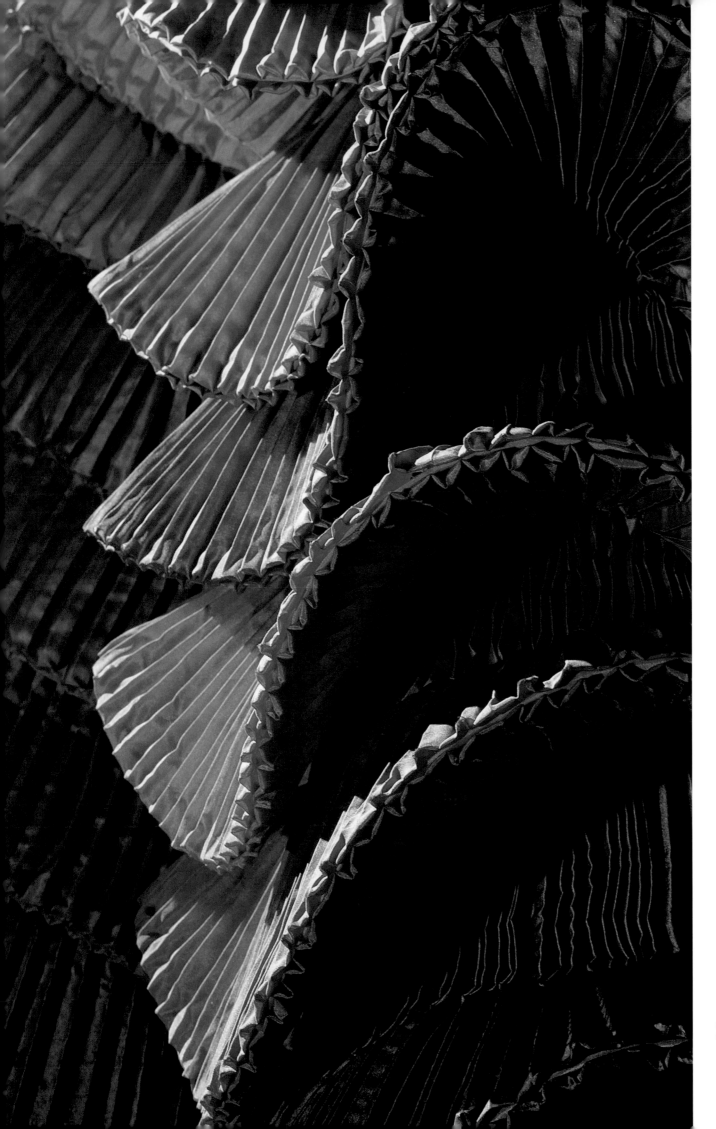

Figs. 102a,b. Sculpture Dress, 1992, pleated silk taffeta (N.8)

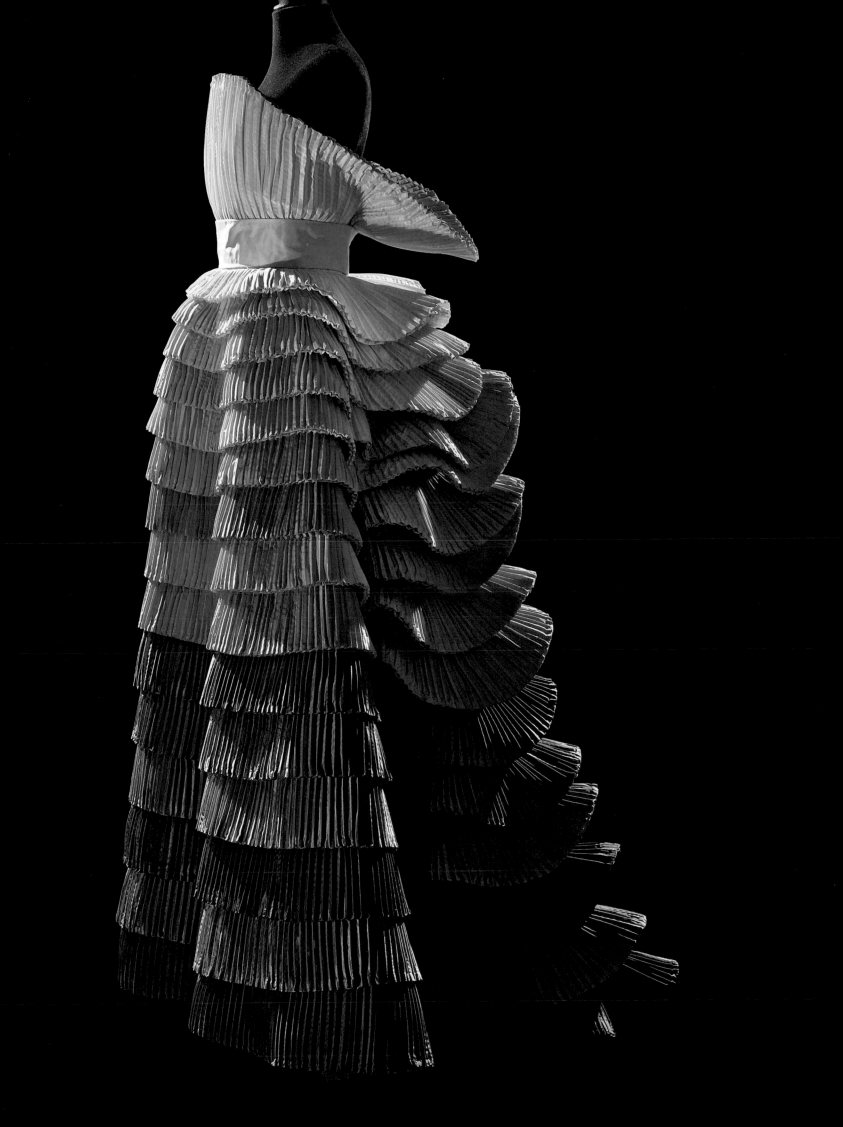

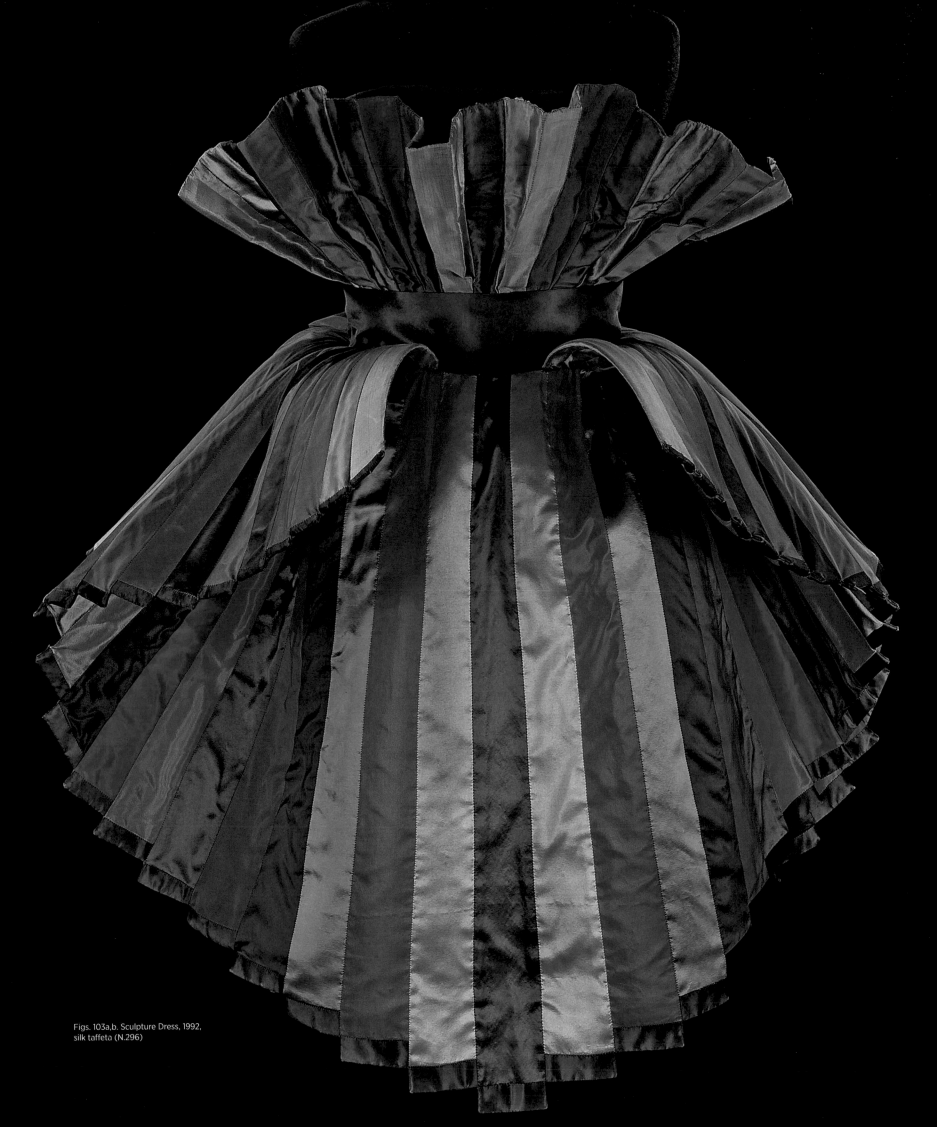

Figs. 103a,b. Sculpture Dress, 1992,
silk taffeta (N.296)

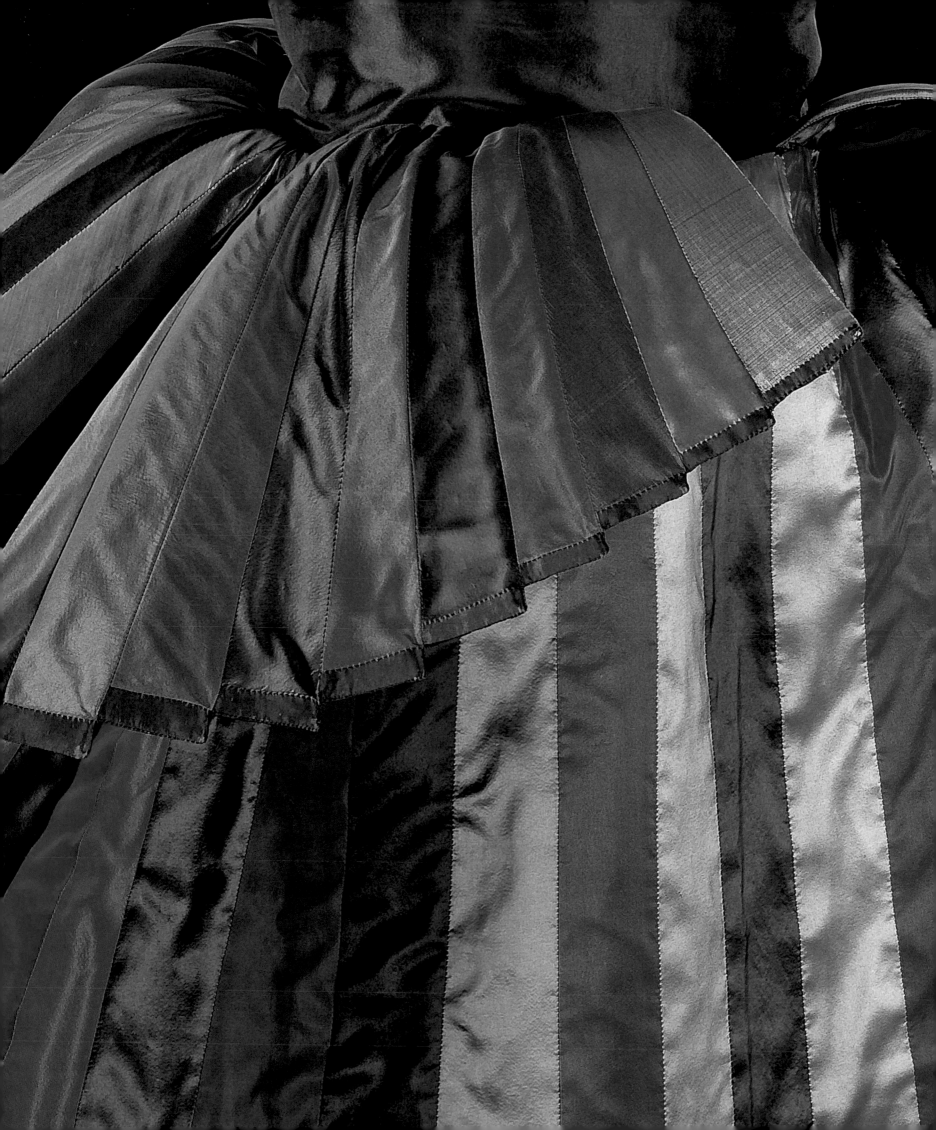

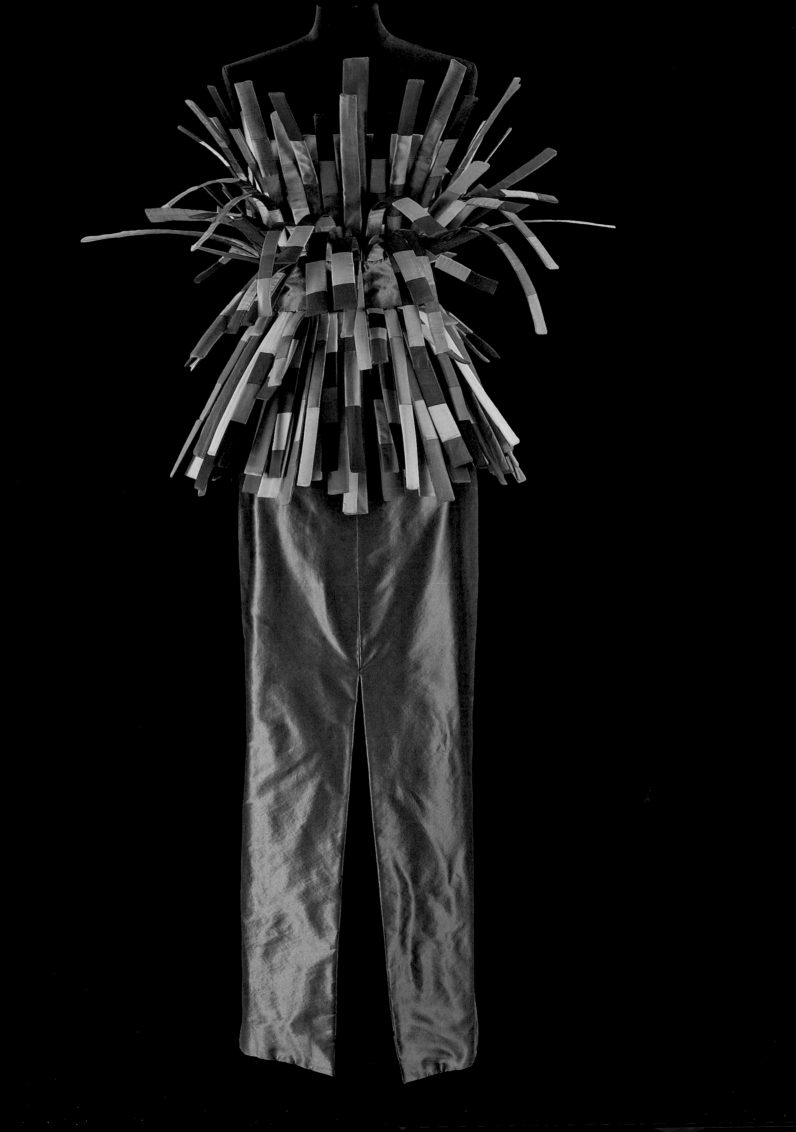

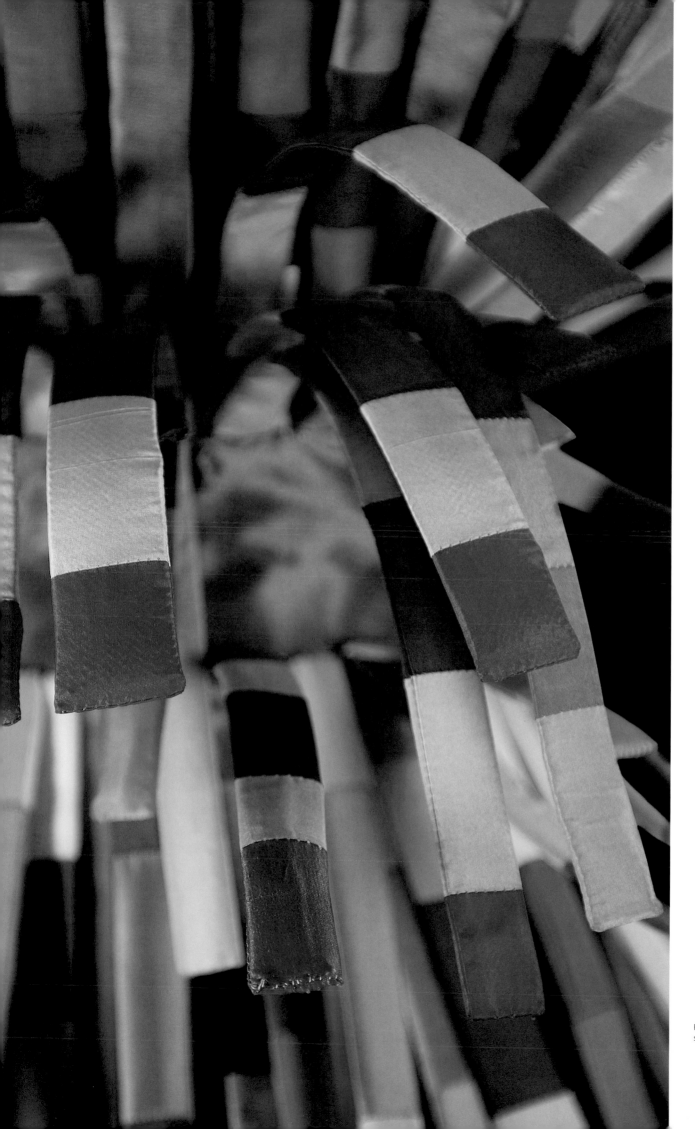

Figs. 104a,b. Sculpture Dress, 1992,
silk taffeta (N.71)

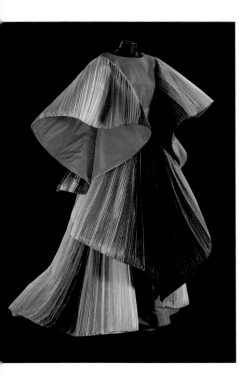

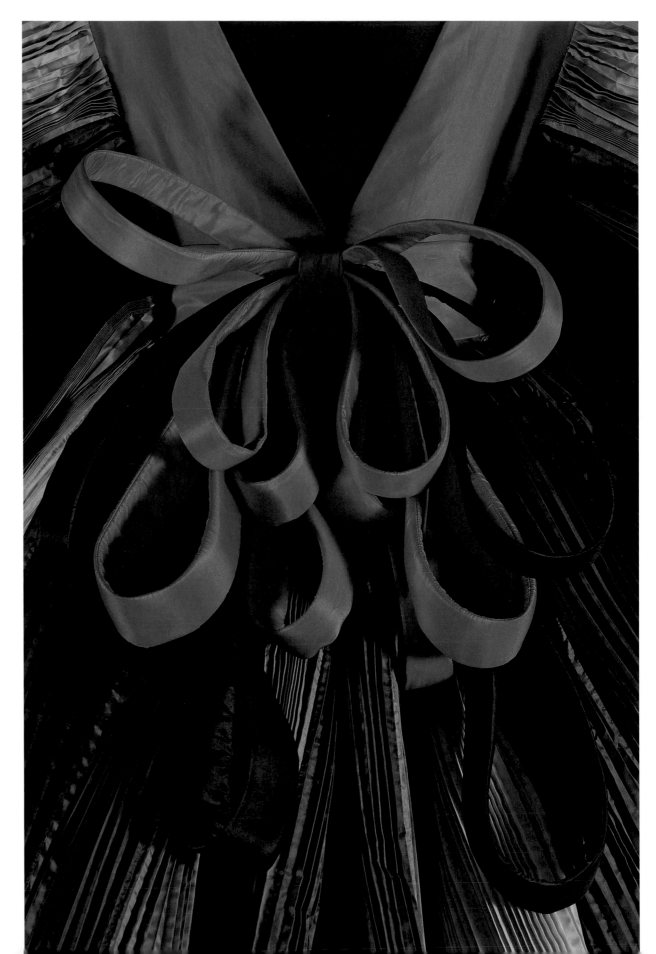

Figs. 105a–c. Sculpture Dress, 1992,
pleated silk taffeta (N.118)

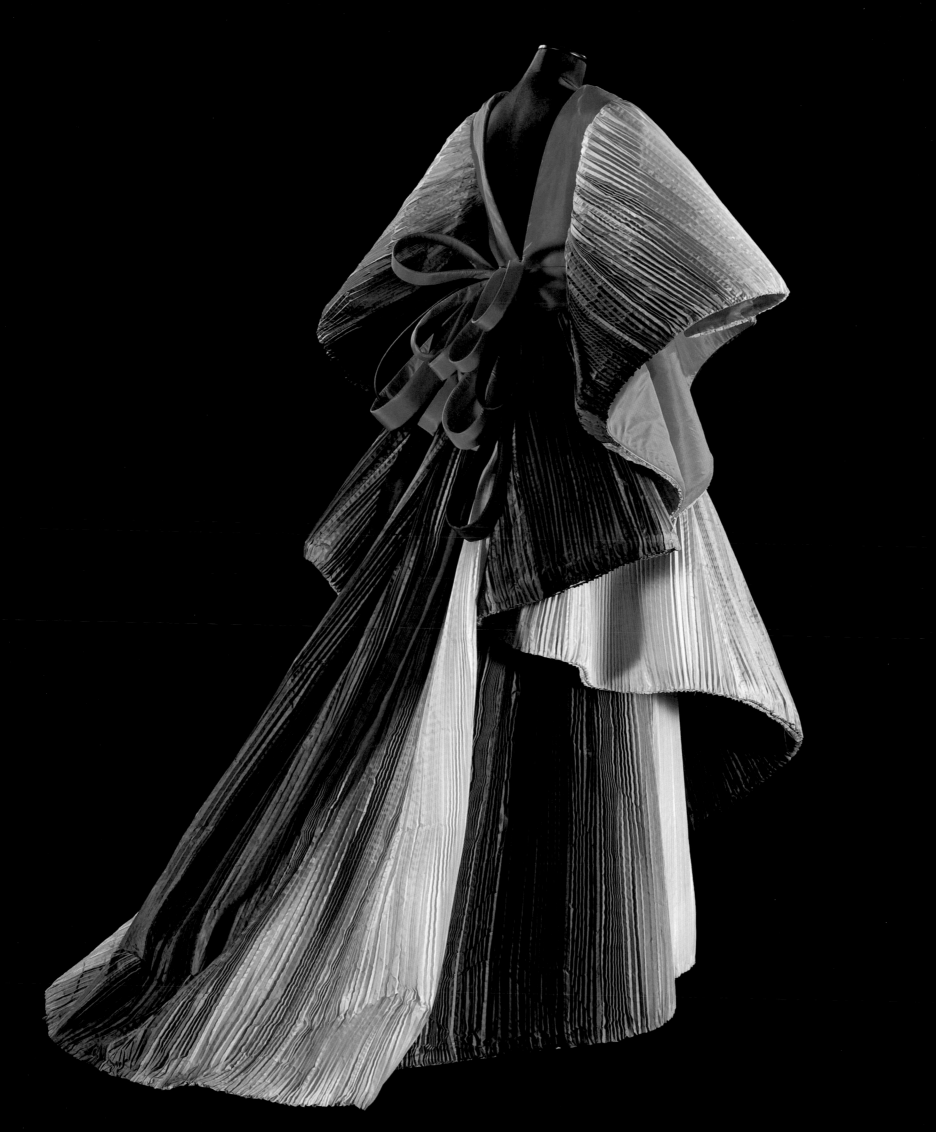

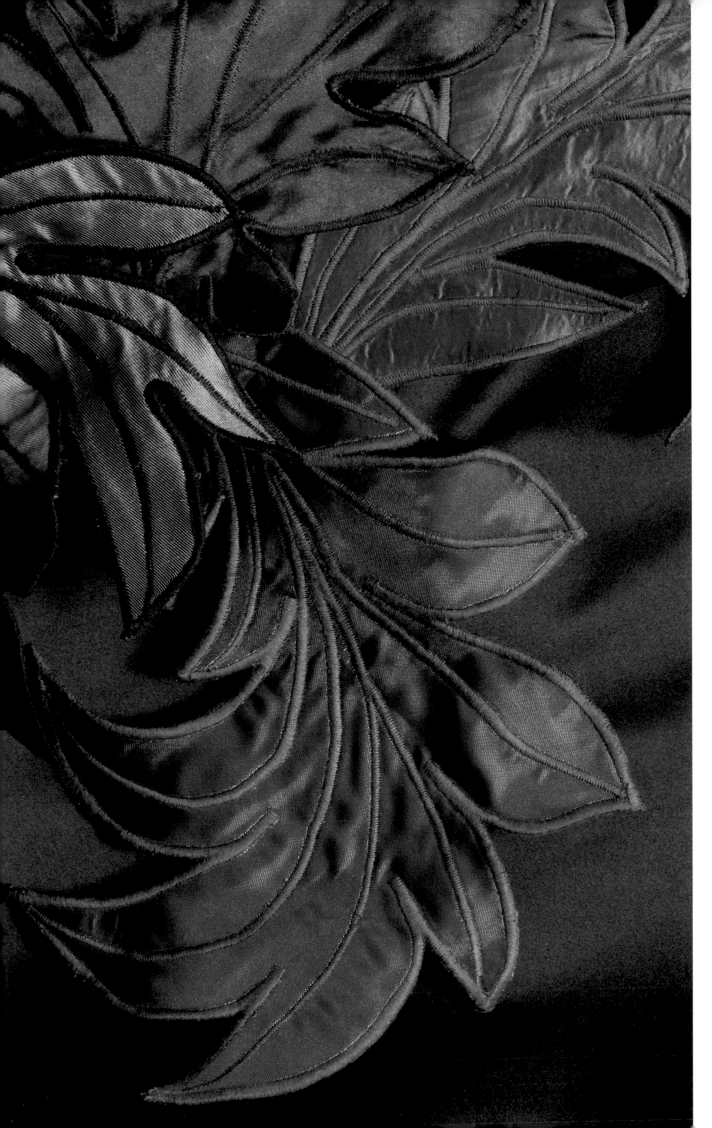

For its inauguration, the Museo della Fondazione Roberto Capucci, established at the Villa Bardini in Florence, organized the exhibition *Ritorno alle origini* (*Return to Origins*) in homage to the city of Florence and its inspiration on Capucci's work.[18] The exhibition featured eight original sculptures by Capucci in which he reinterpreted the forms, materials, techniques, and themes that have inspired him throughout his career (figs. 106a–e; see figs. 107a–c through 113a–d). Nature, his favorite muse, was represented literally in a sculpture decorated with silk leaves (figs. 106a–e), and abstractly in a design made of bright pink and green circular shapes that resemble flowers (see figs. 111a–e). Other works, such as the *Corde* (*Cords*) sculpture made with gold thread, captured the architectural precision for which he is renowned (see figs. 112a–e). Each sculpture is a spectacular display of the virtuoso artistry and masterful craftsmanship of their creator, embodying the static magnificence of architecture and the dynamic emotion of art.

Figs. 106a,b. *Foglie* (*Leaves*) Sculpture, 2007, silk velvet and silk satin (N.326)

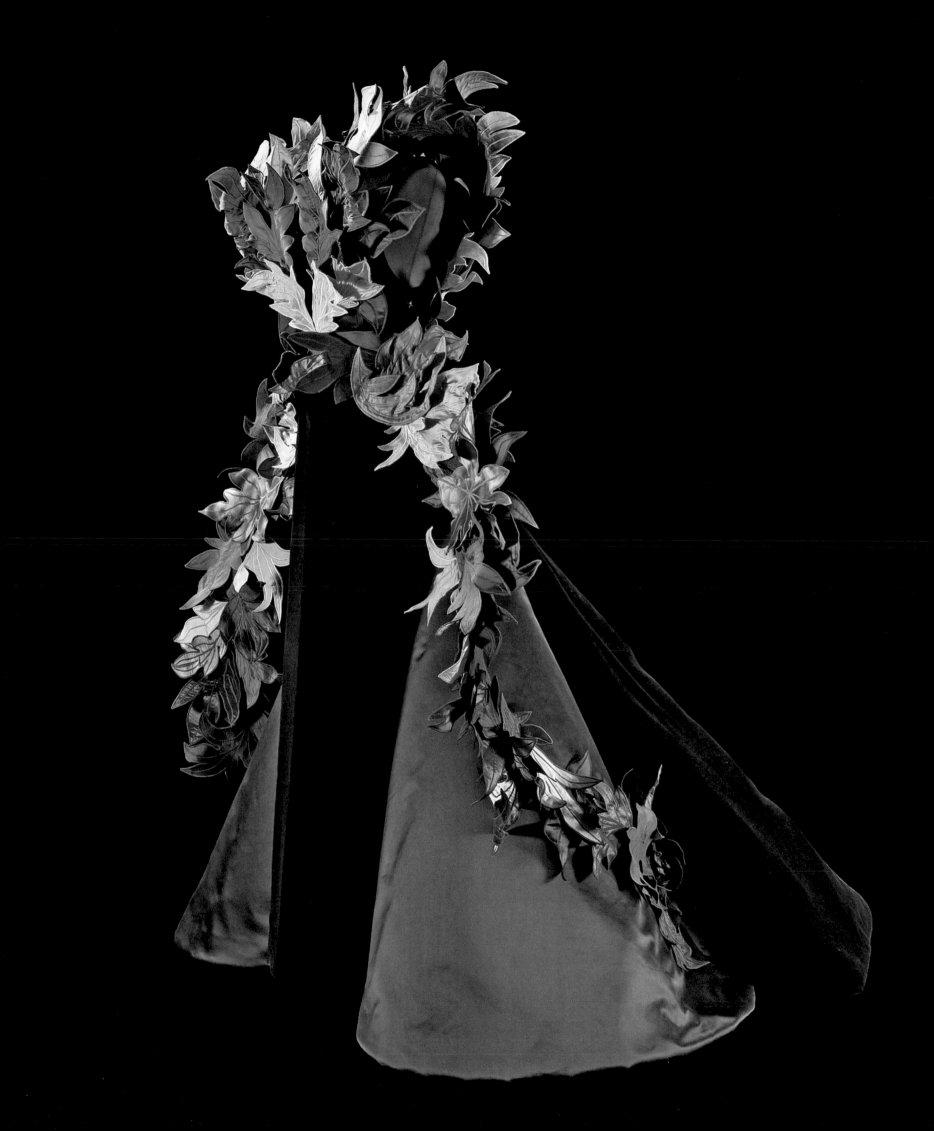

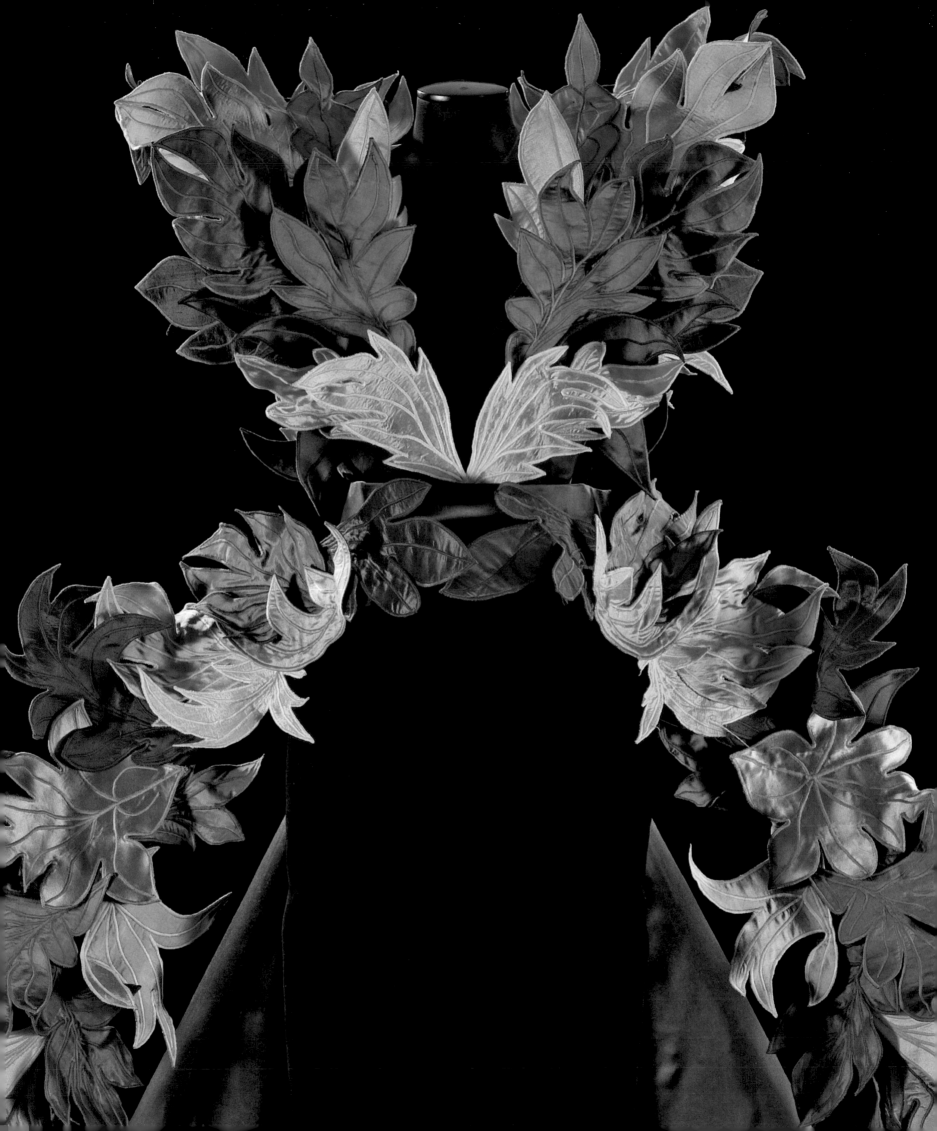

Figs. 106c–e. *Foglie* (*Leaves*) Sculpture, 2007, silk velvet and silk satin (N.326)

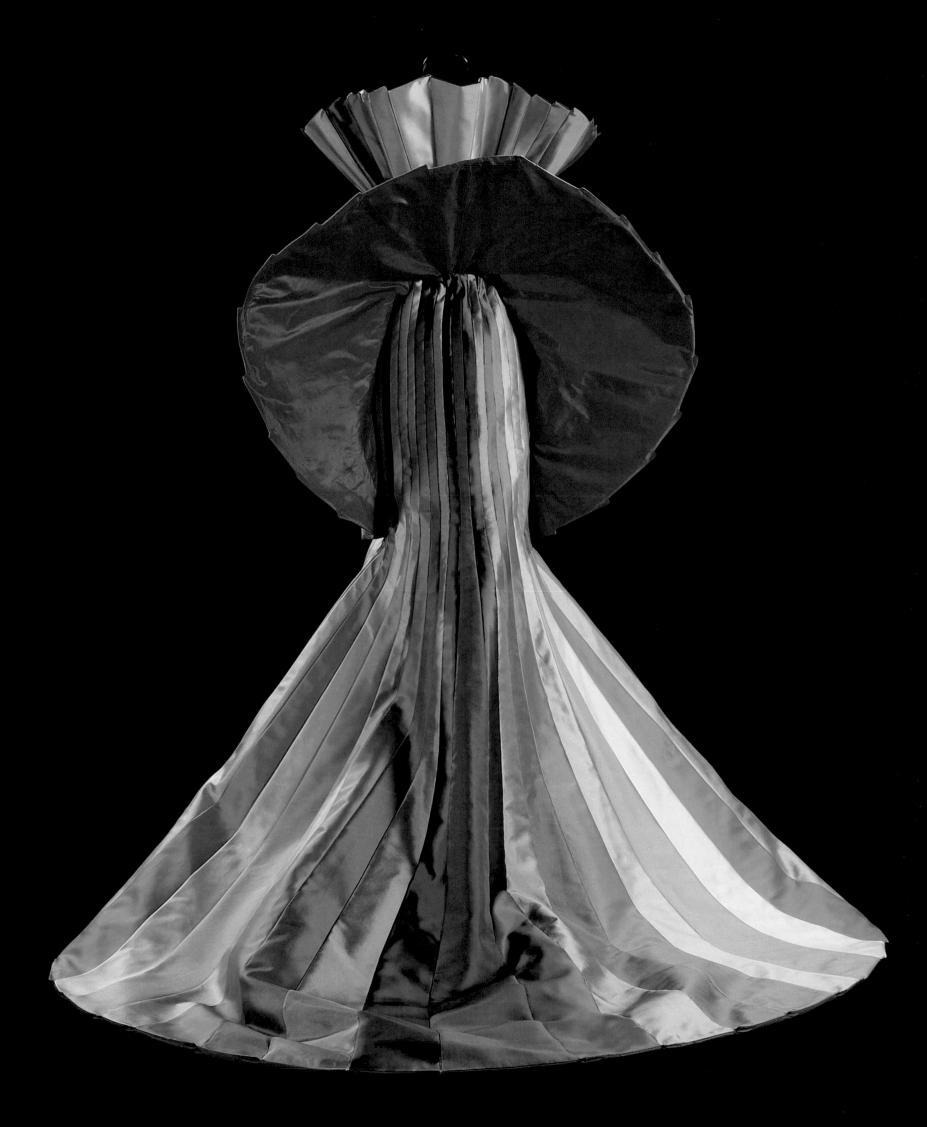

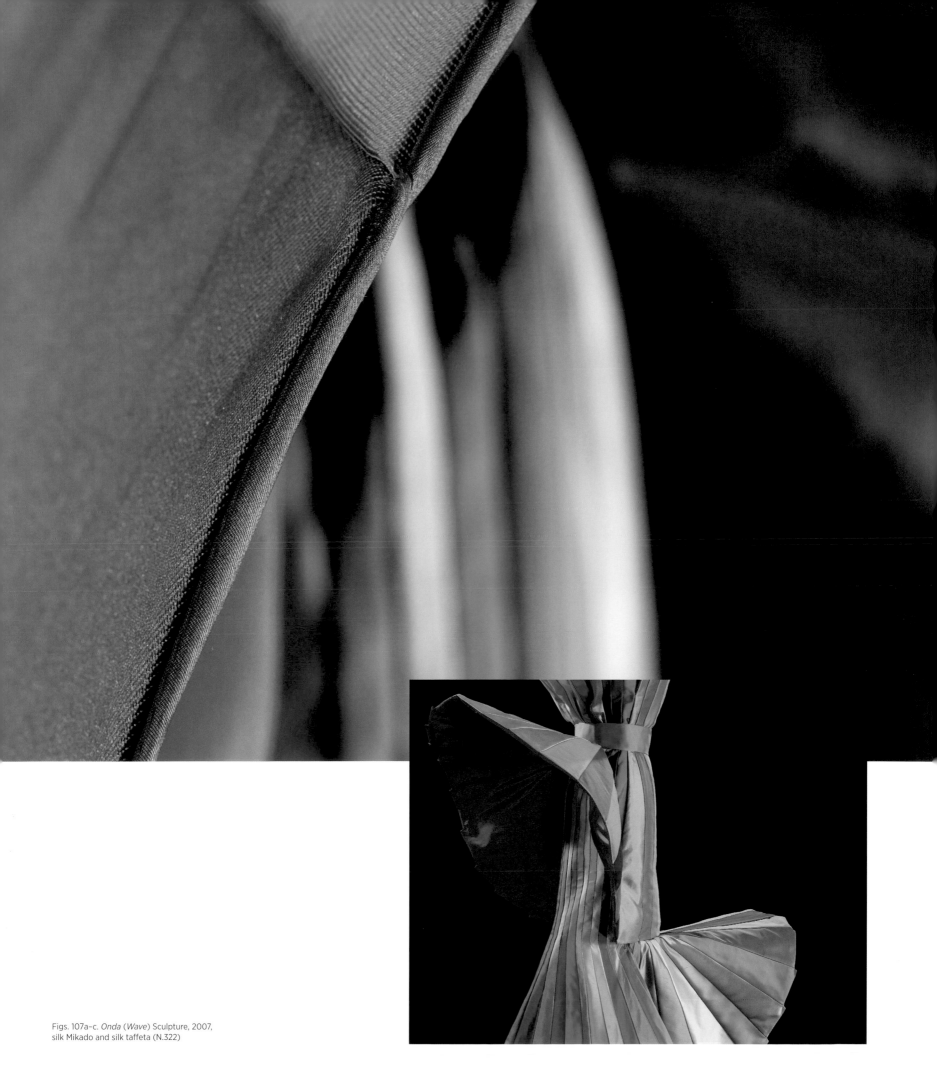

Figs. 107a–c. *Onda* (*Wave*) Sculpture, 2007,
silk Mikado and silk taffeta (N.322)

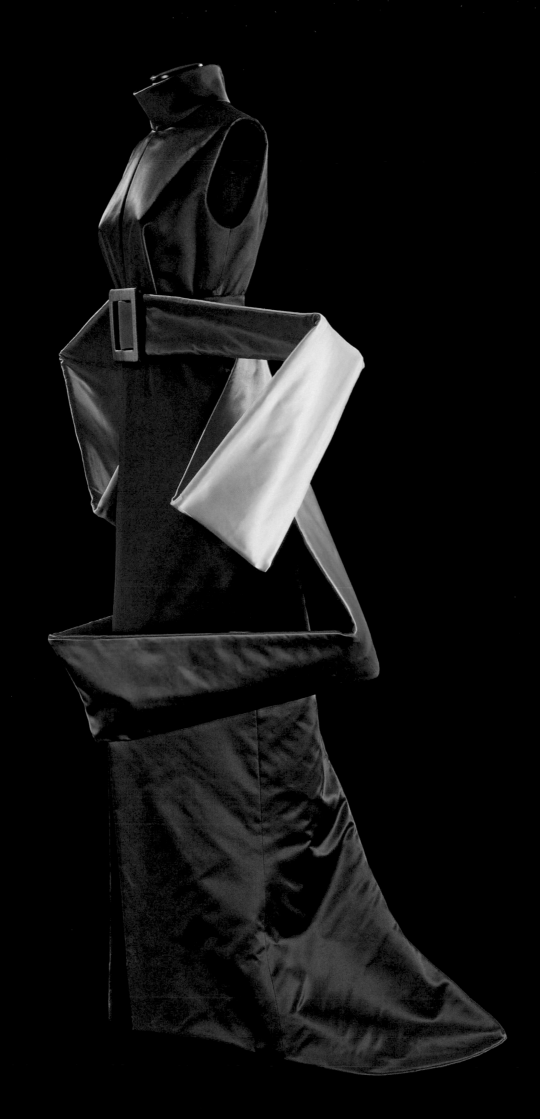

Figs. 108a,b. *Fascia* (*Band*) Sculpture, 2007,
silk satin (N.325)

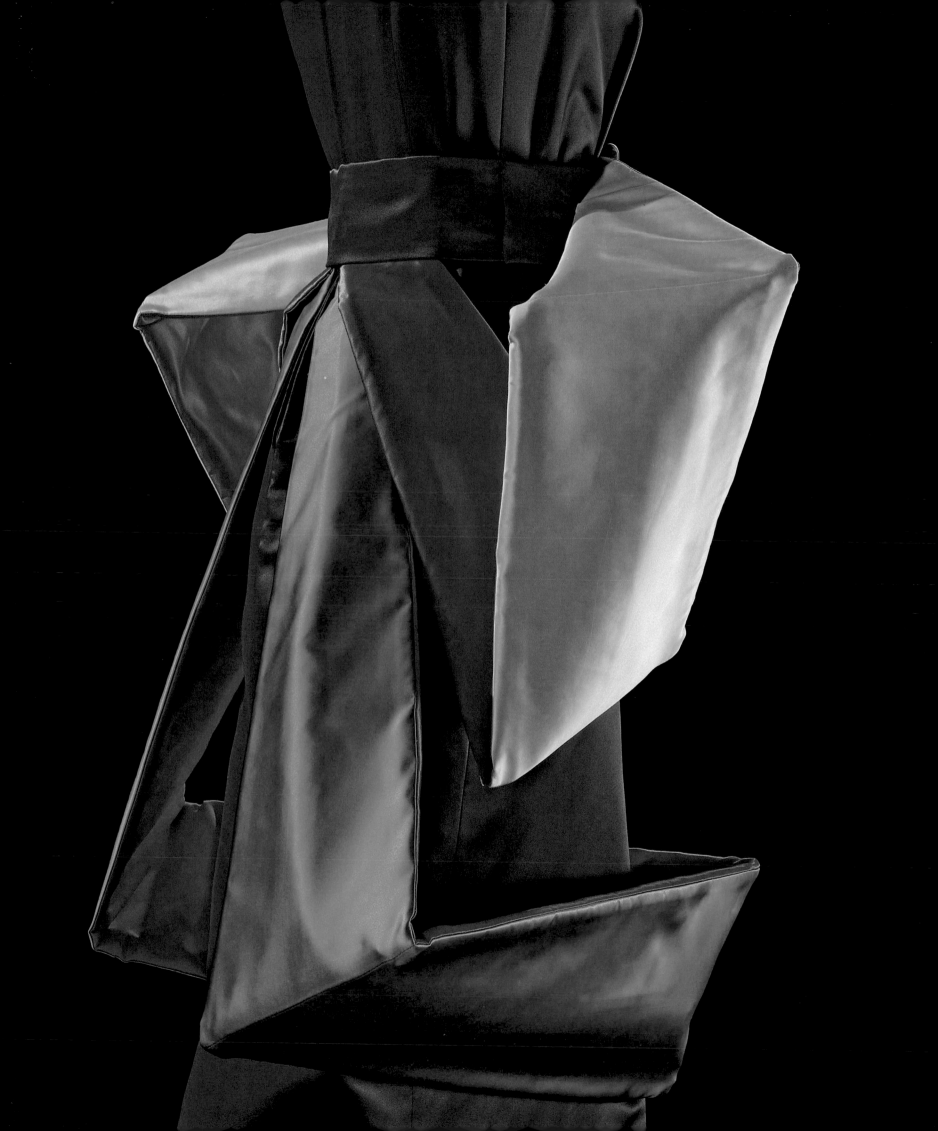

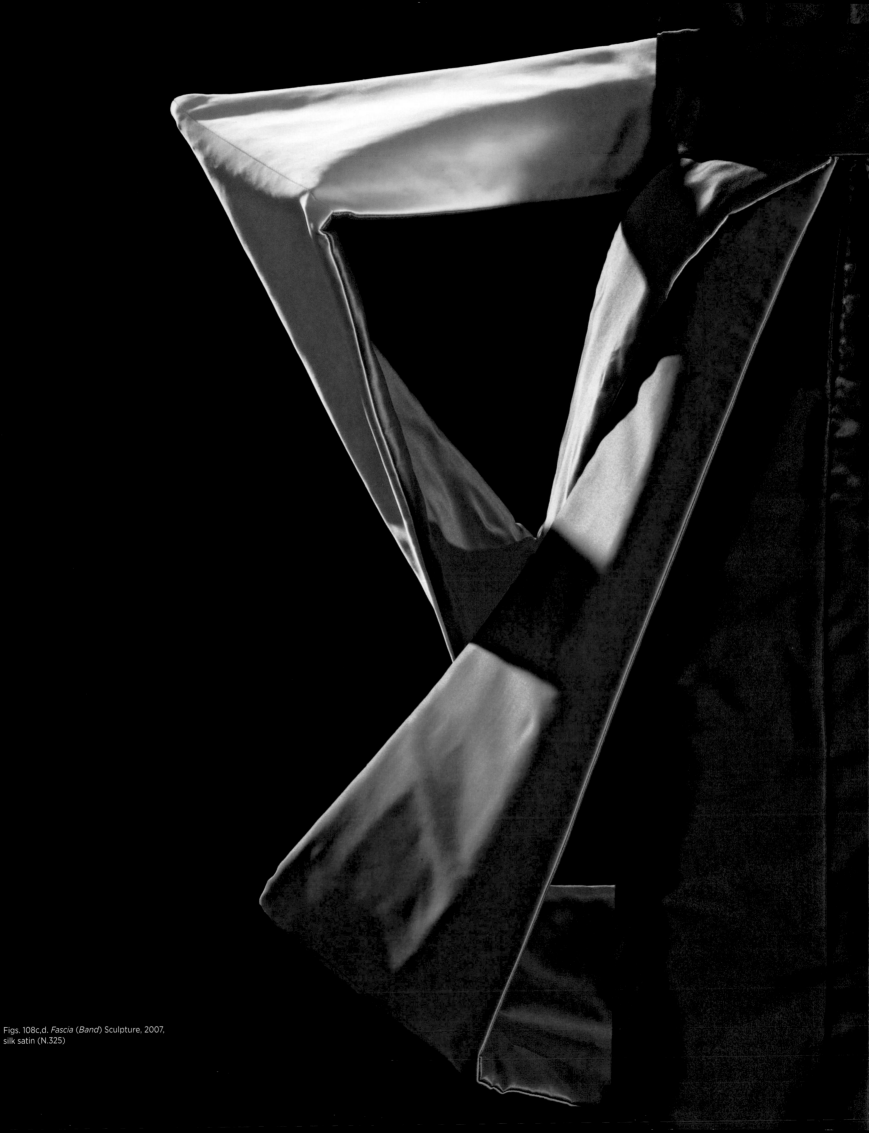

Figs. 108c,d. *Fascia* (*Band*) Sculpture, 2007,
silk satin (N.325)

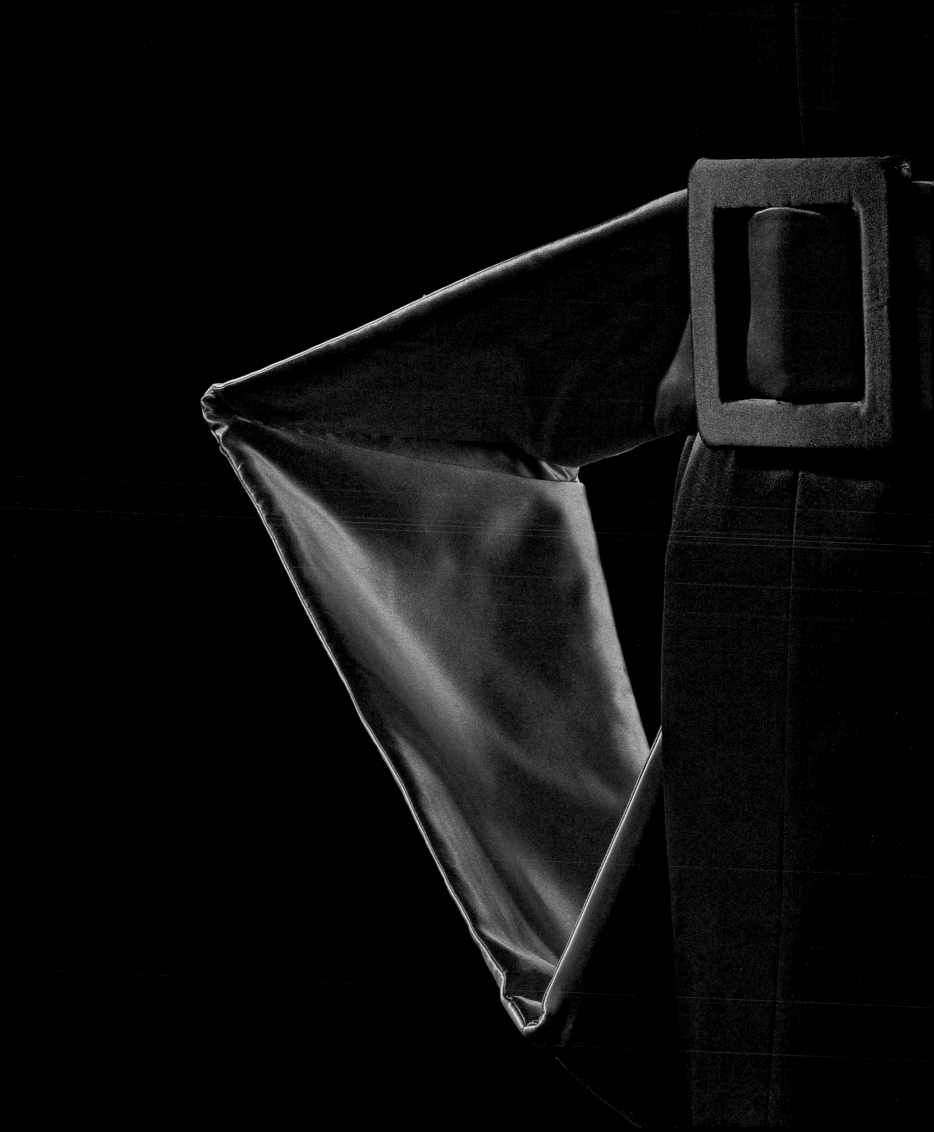

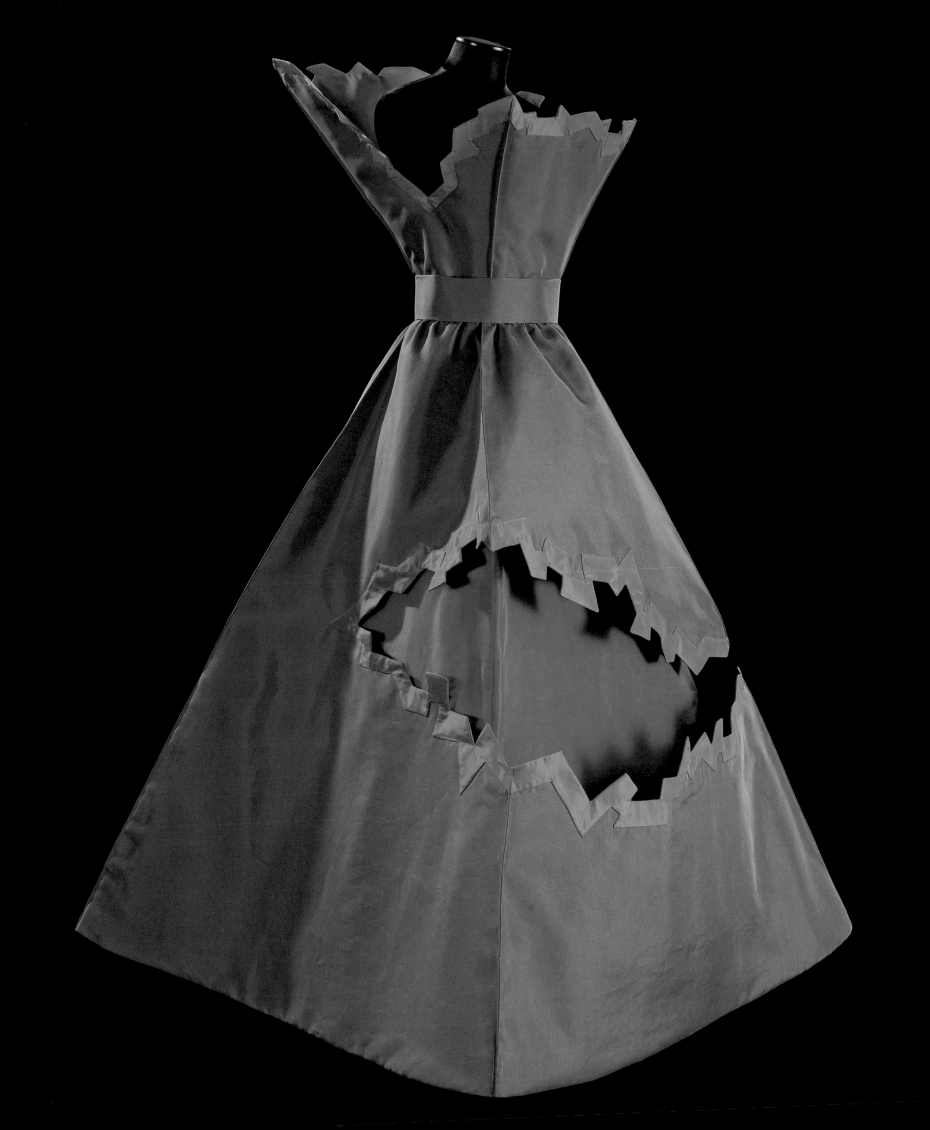

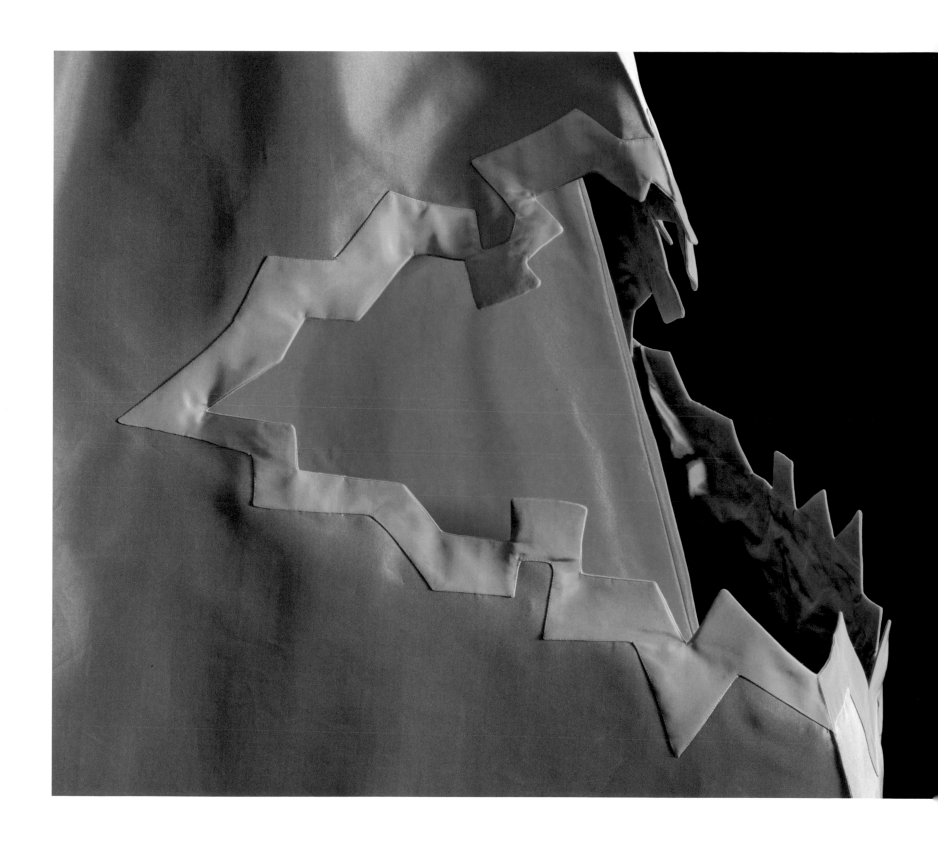

Figs. 109a,b. *Crepe* (*Cracks*) Sculpture, 2007,
silk taffeta (N.321)

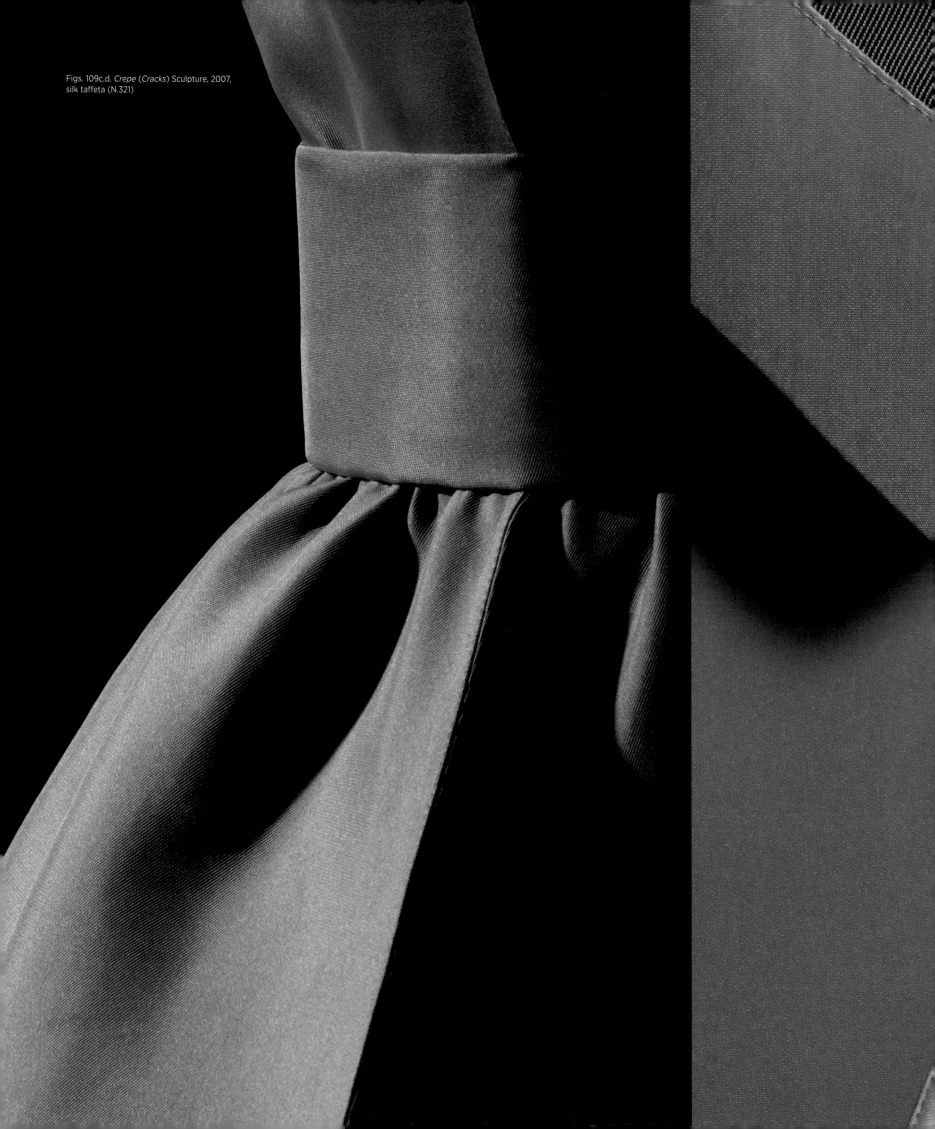

Figs. 109c,d. *Crepe* (*Cracks*) Sculpture, 2007,
silk taffeta (N.321)

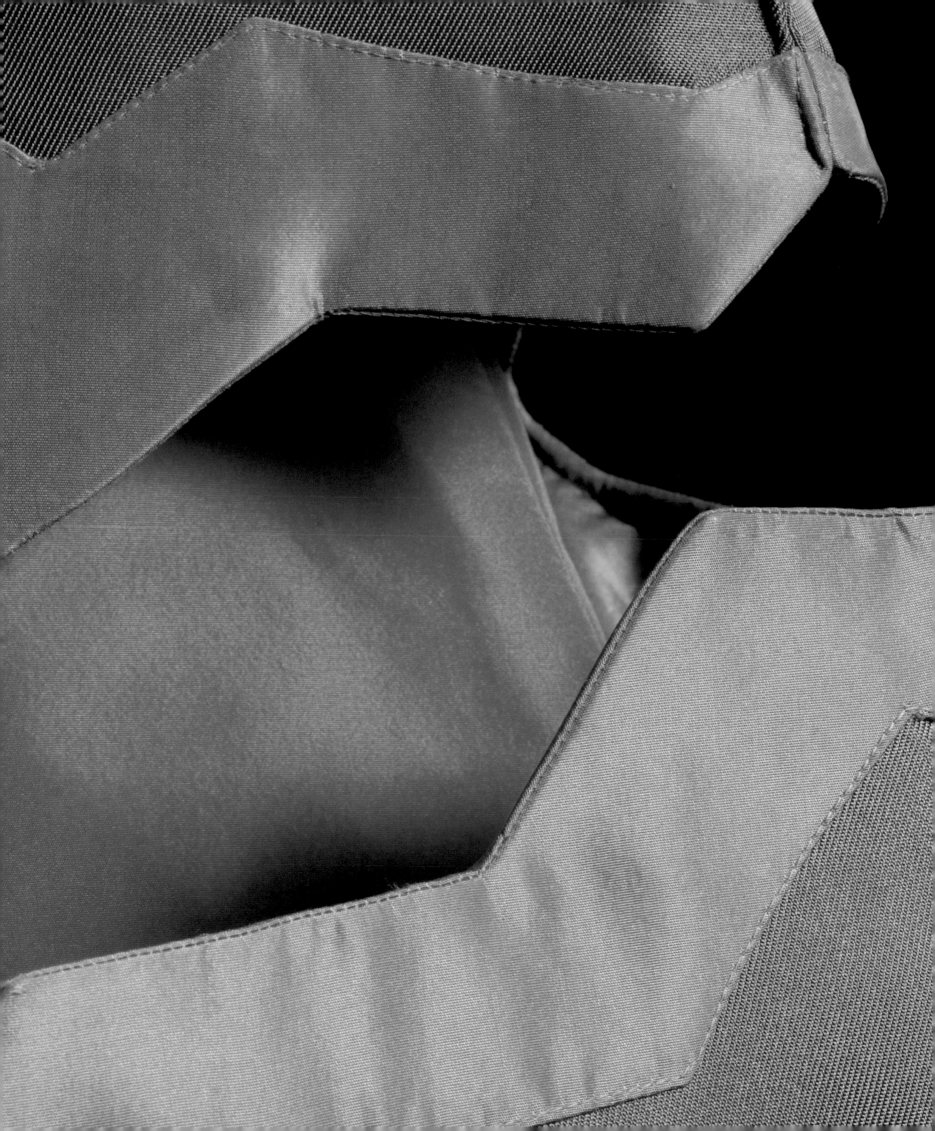

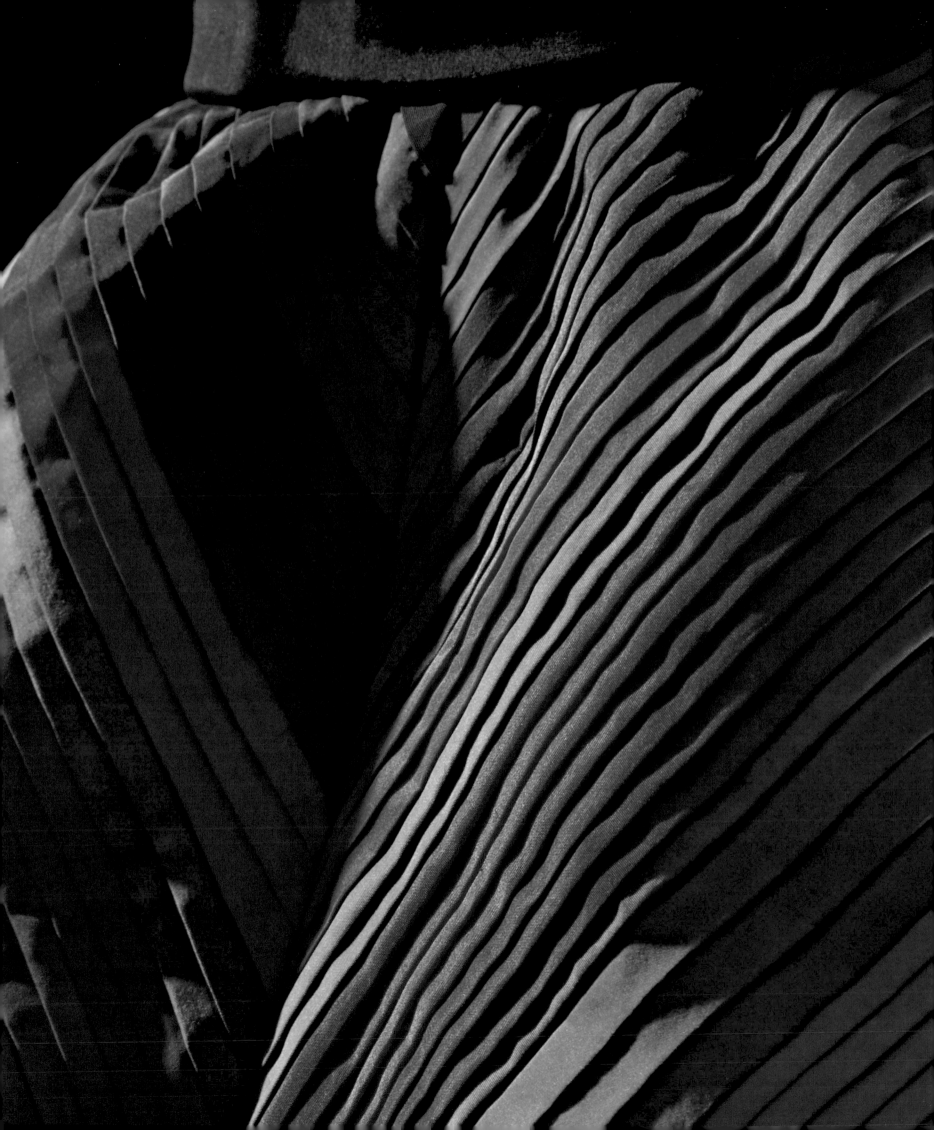

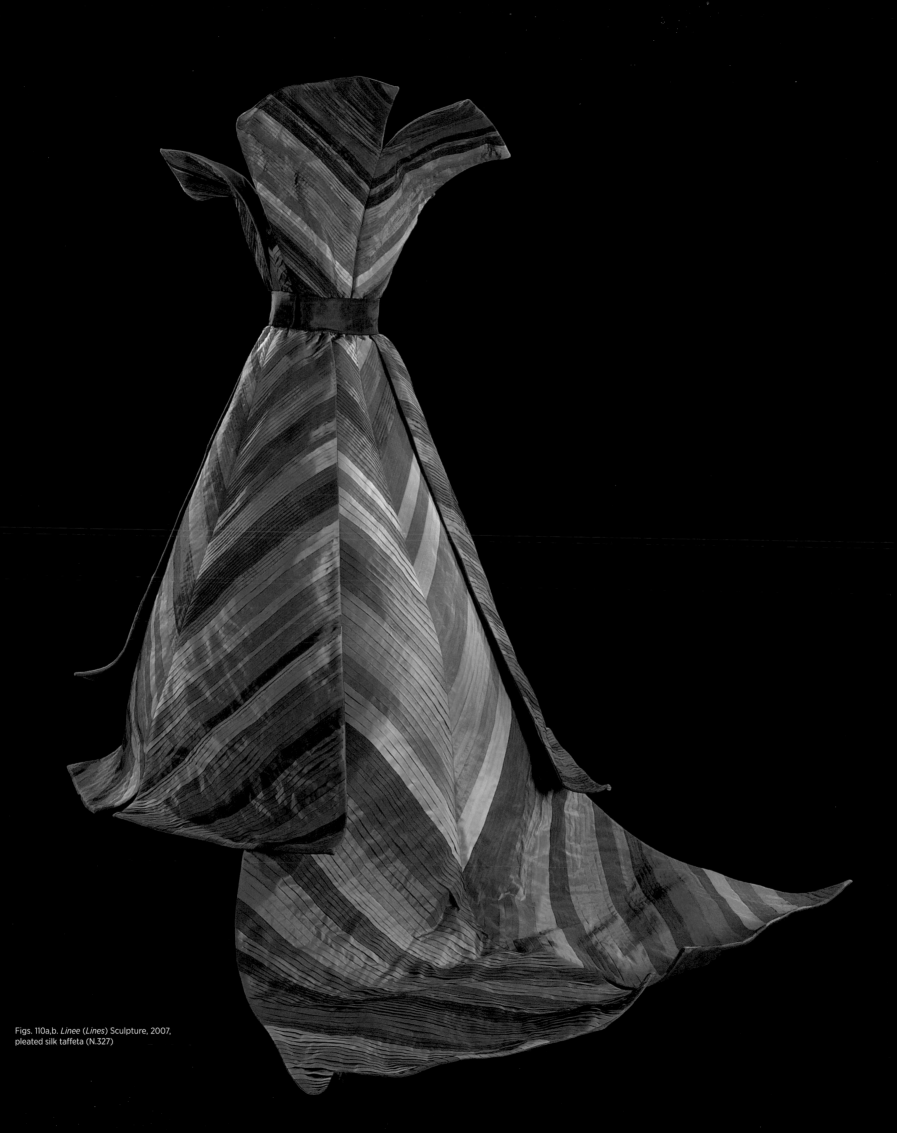

Figs. 110a,b. *Linee* (*Lines*) Sculpture, 2007, pleated silk taffeta (N.327)

Figs. 110c,d. *Linee* (*Lines*) Sculpture, 2007, pleated silk taffeta (N.327)

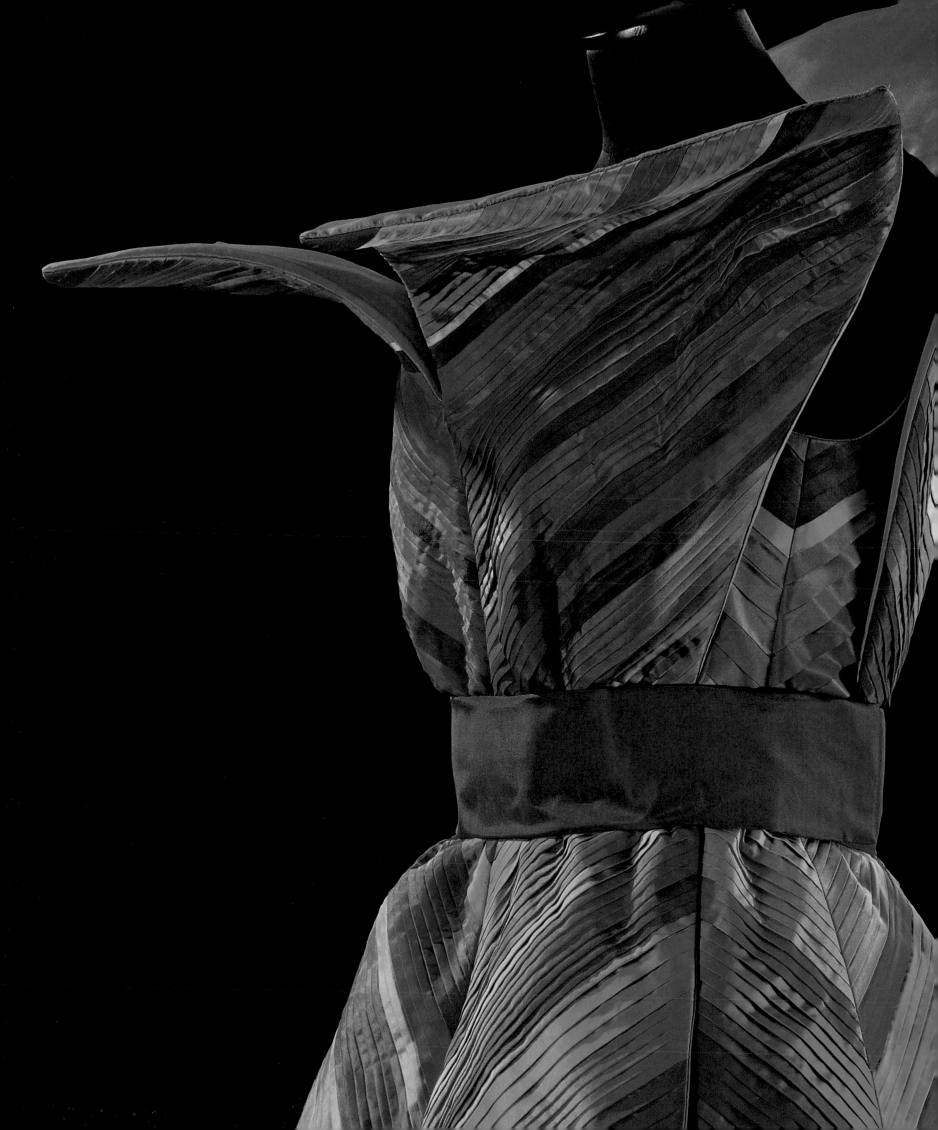

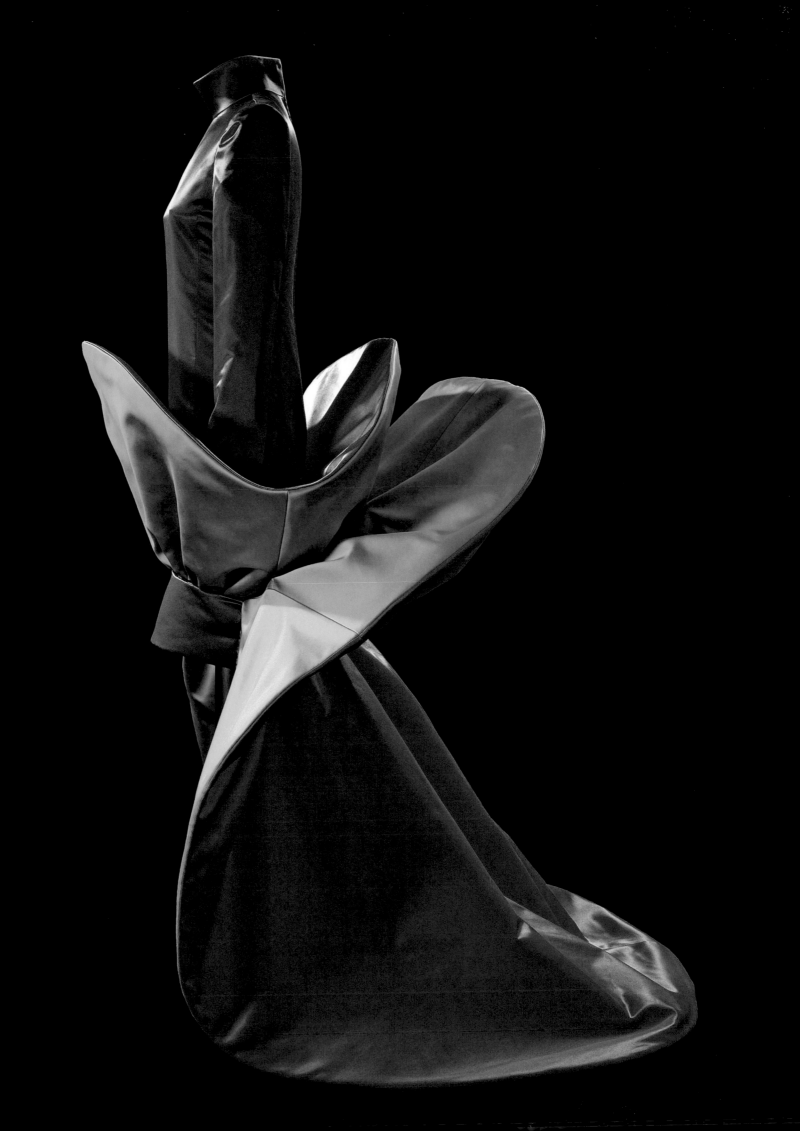

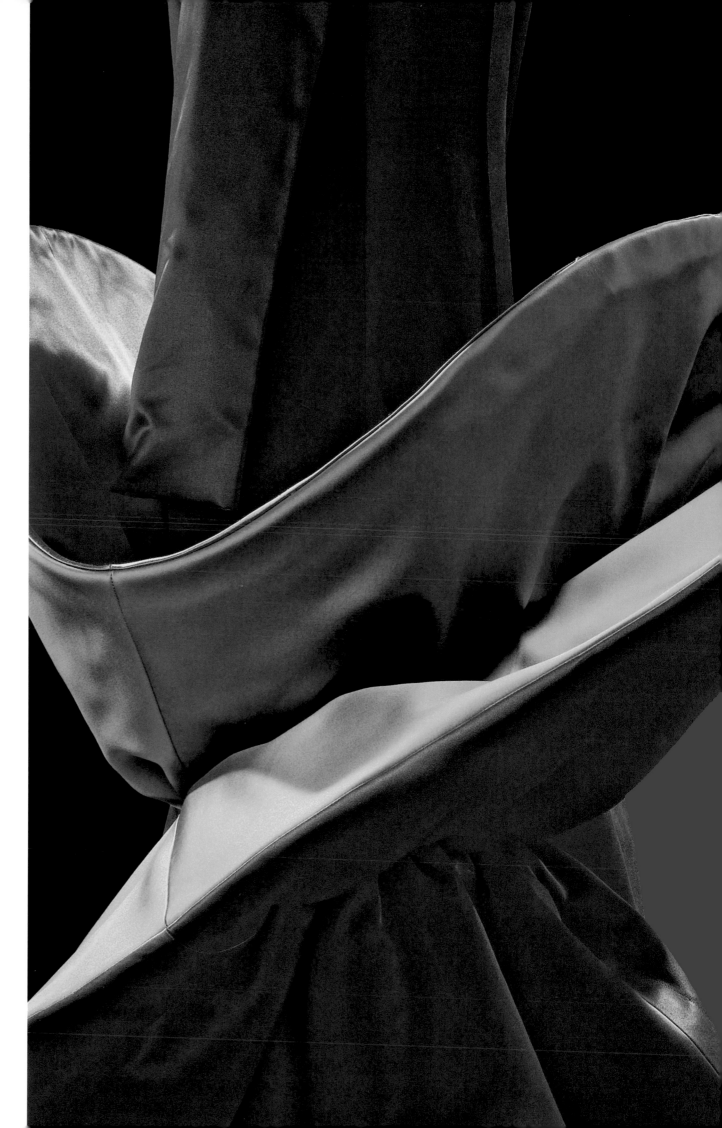

Figs. 111a,b. *Cerchio* (*Circle*) Sculpture, 2007, silk satin (N.323)

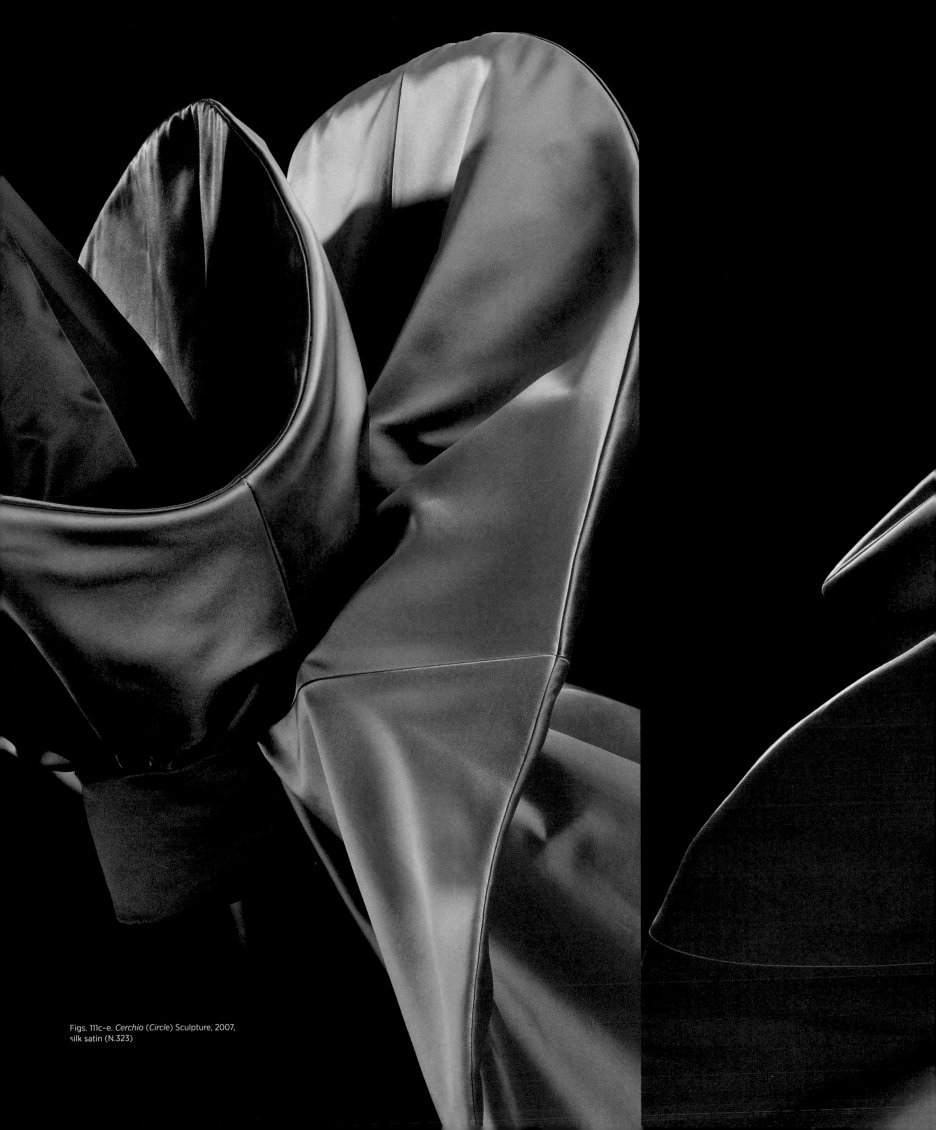

Figs. 111c–e. *Cerchio* (*Circle*) Sculpture, 2007,
silk satin (N.323)

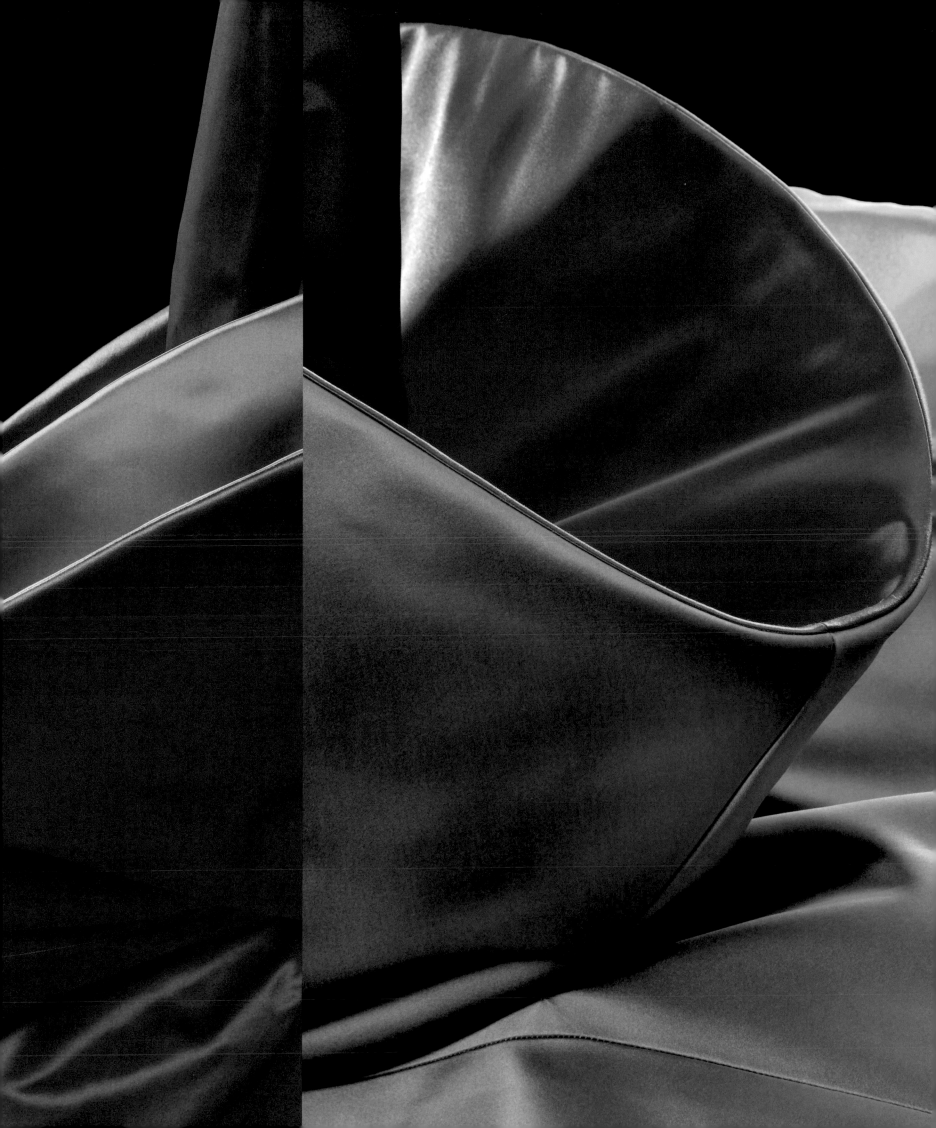

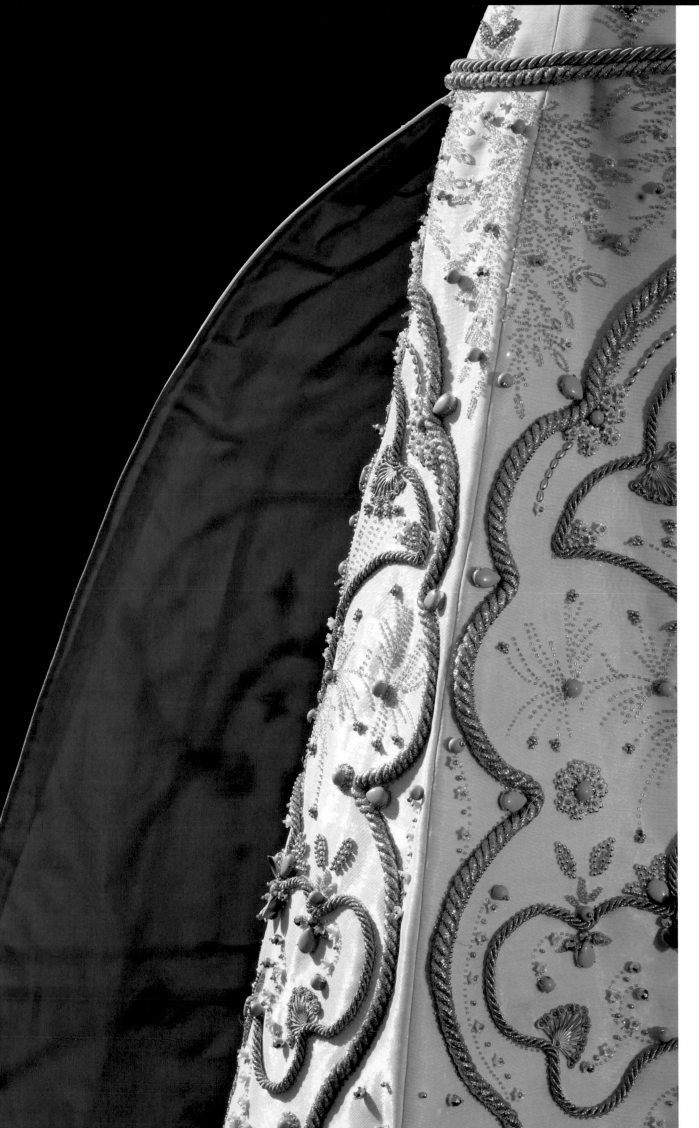

Figs. 112a,b. *Corde* (*Cords*) Sculpture, 2007, silk Mikado embroidered with cord, gold thread, and turquoise (N.320)

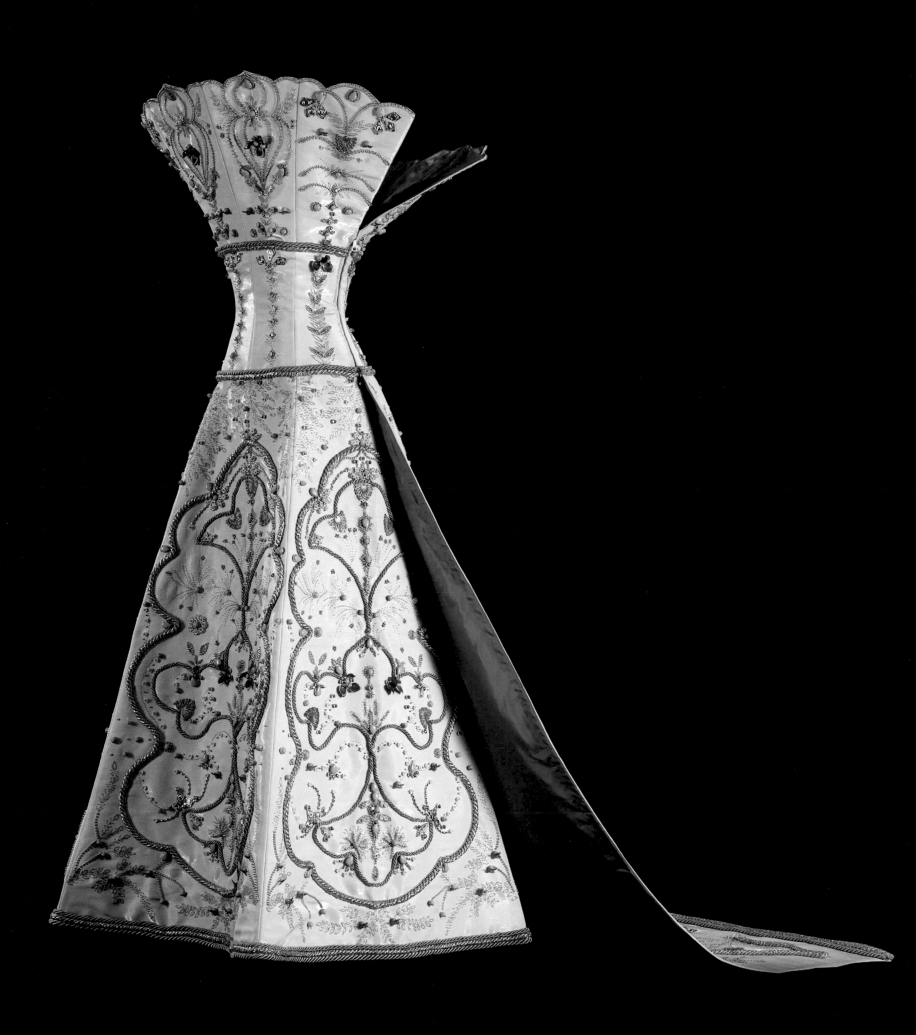

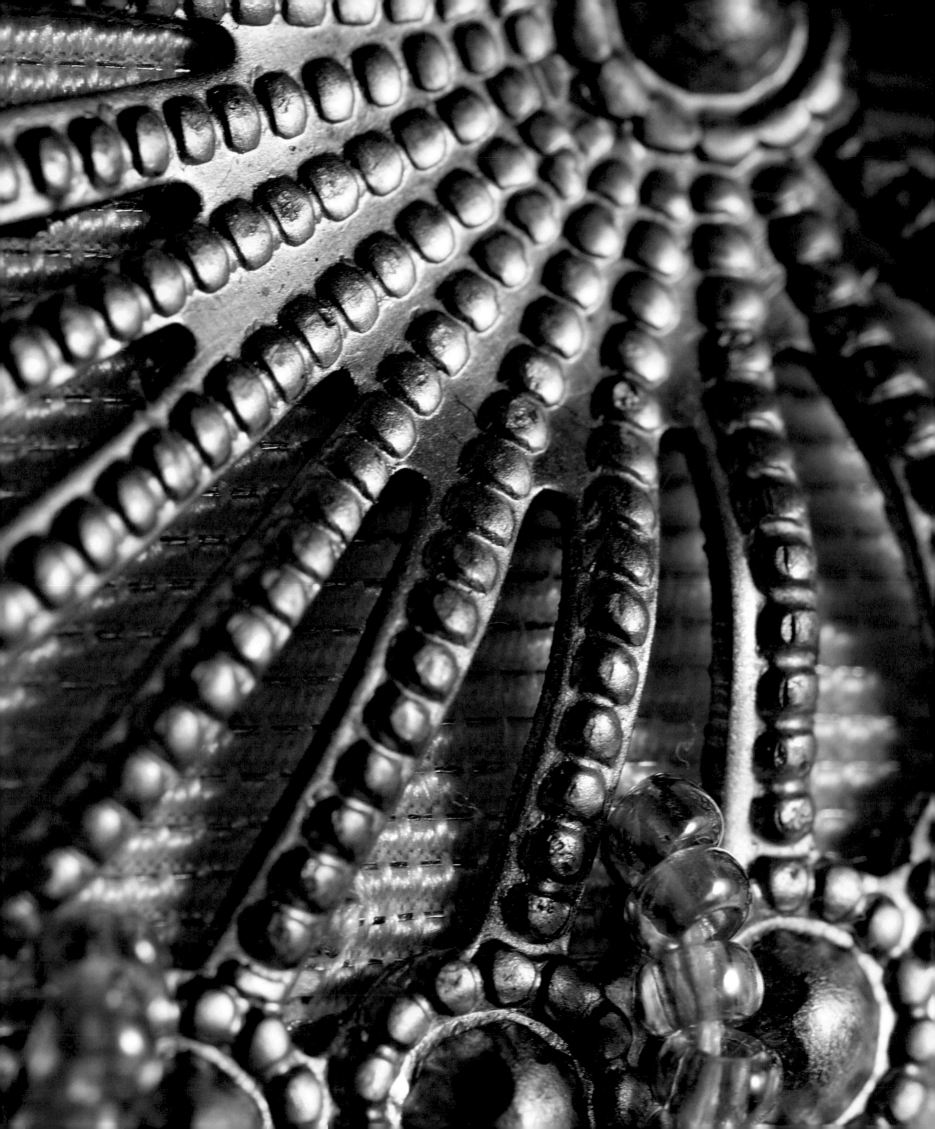

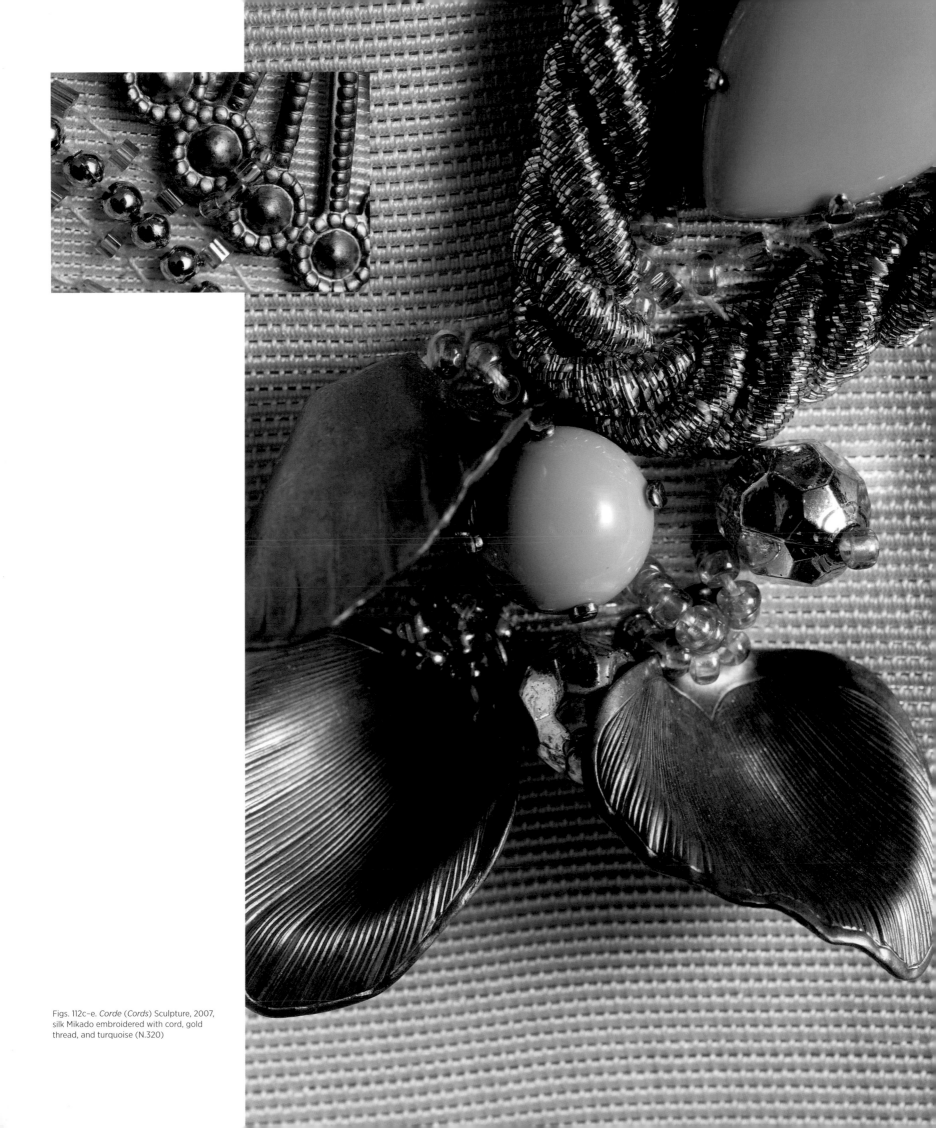

Figs. 112c–e. *Corde* (*Cords*) Sculpture, 2007, silk Mikado embroidered with cord, gold thread, and turquoise (N.320)

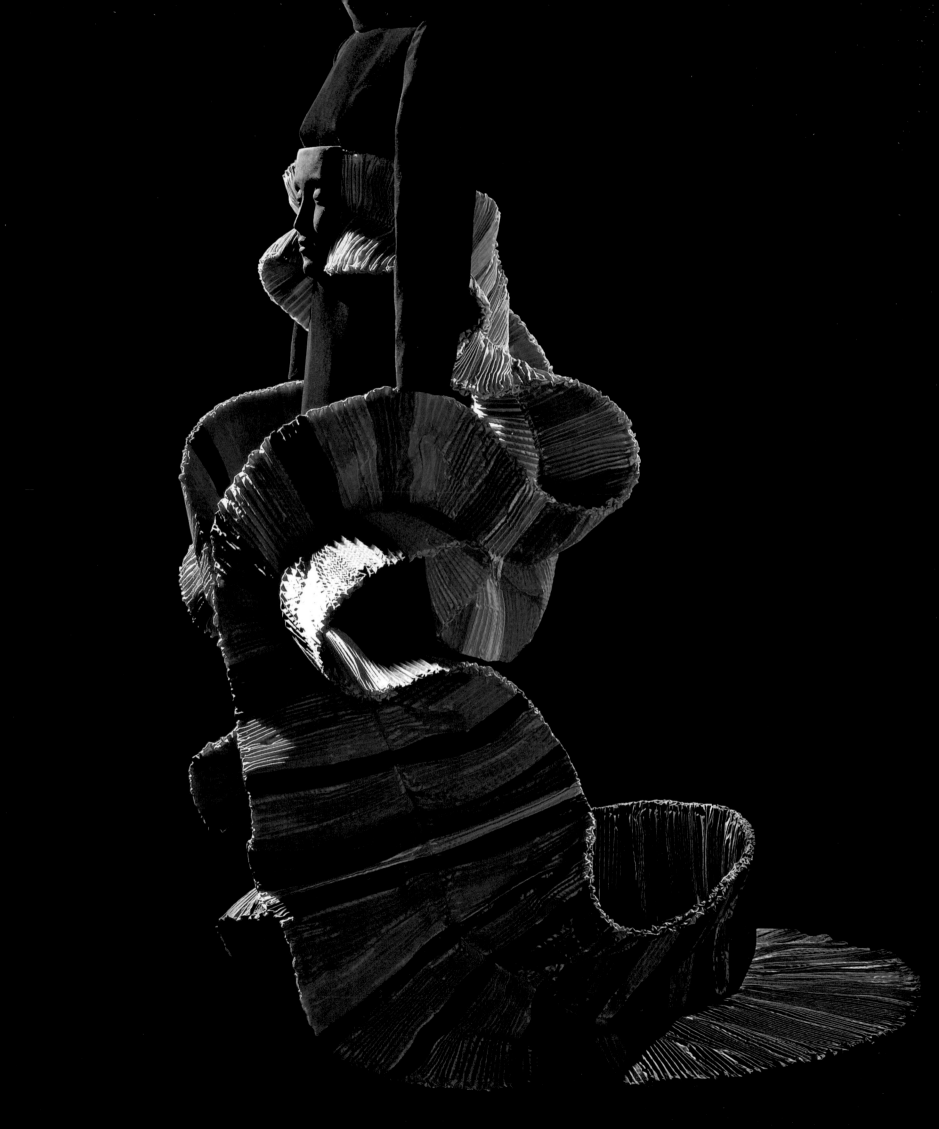

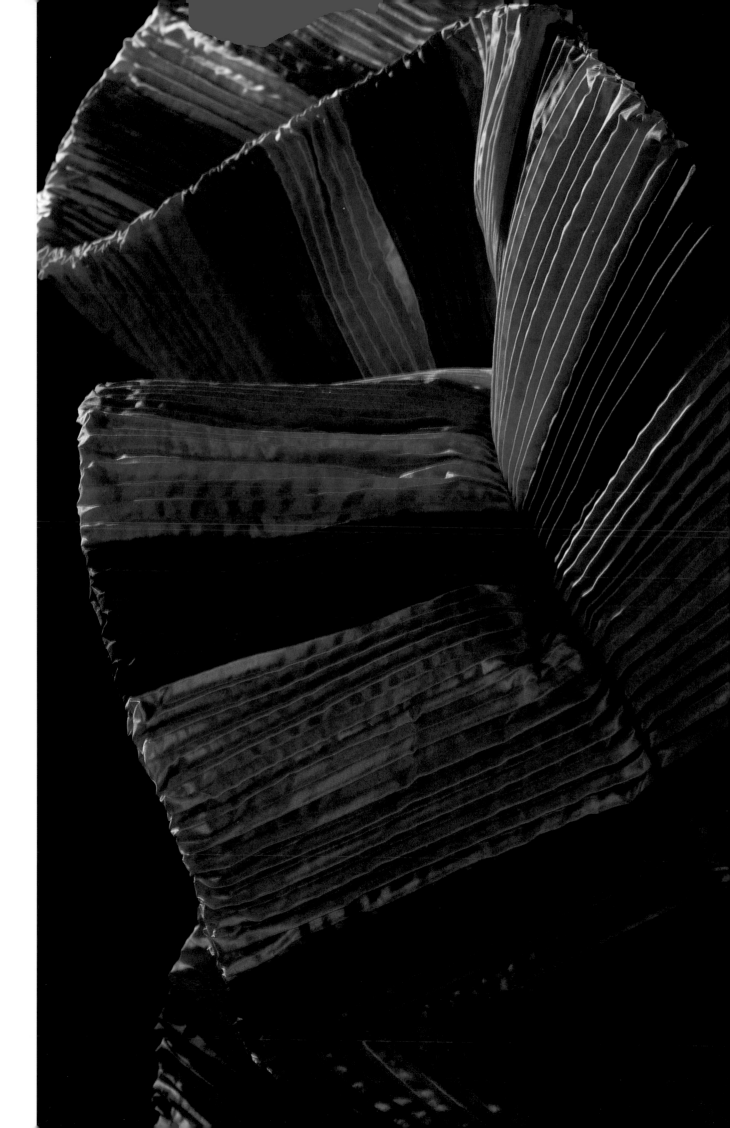

Figs. 113a,b. *Spire* (*Coils*) Sculpture, 2007,
pleated silk velvet and silk taffeta (N.324)

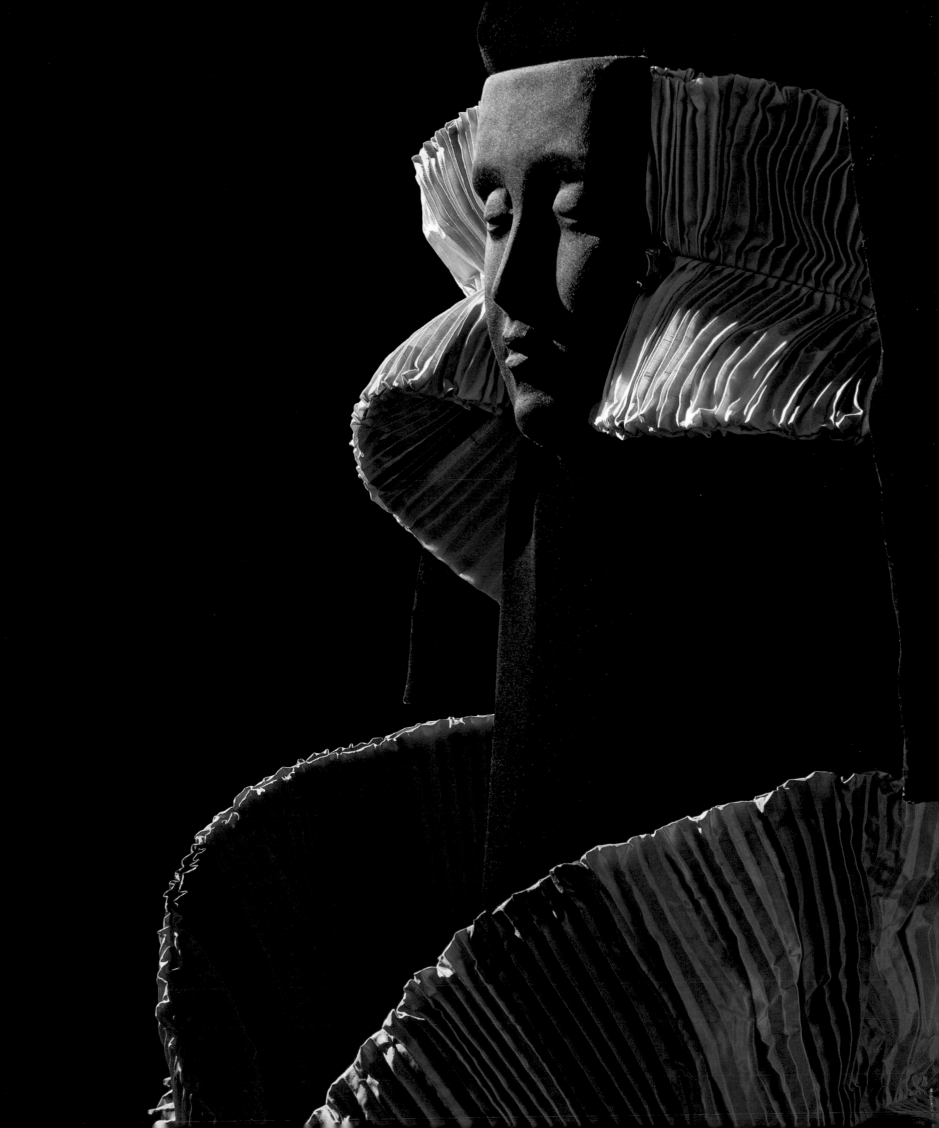

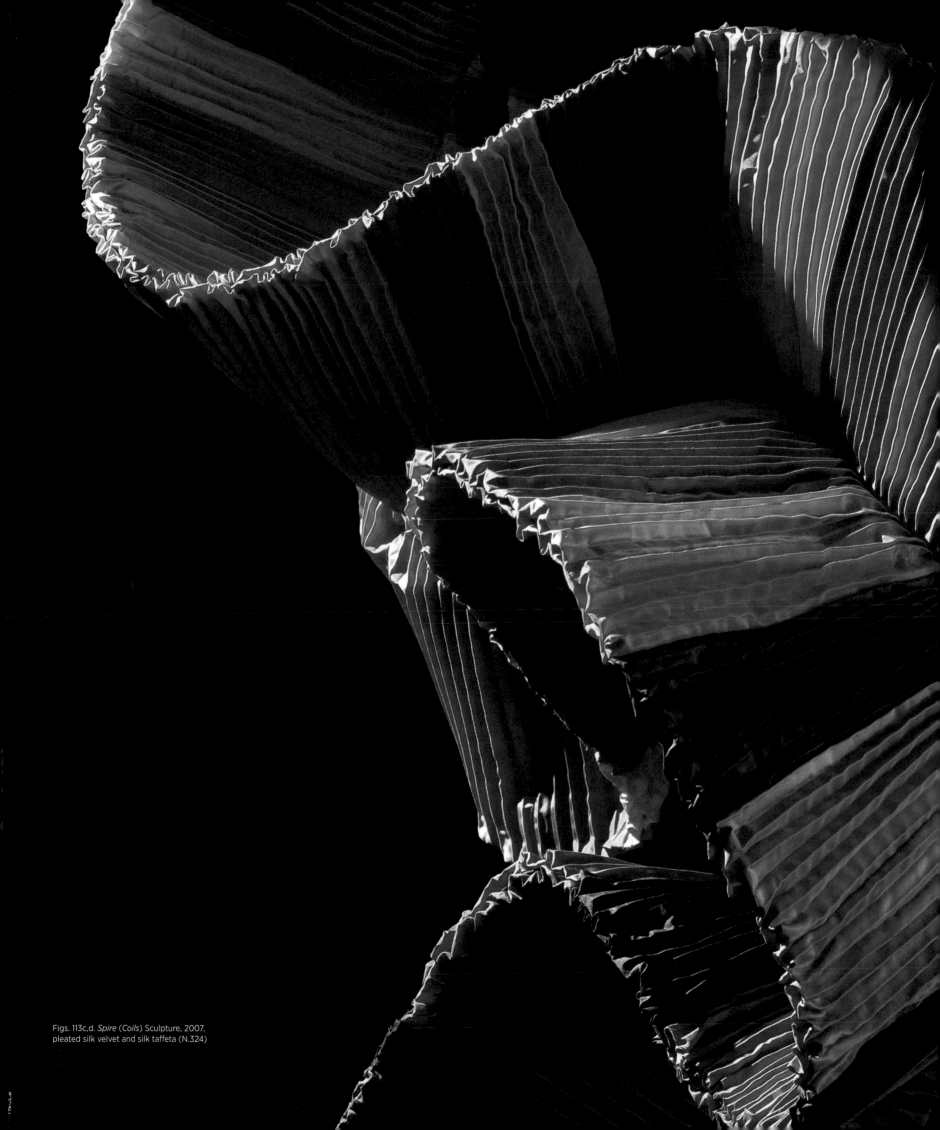

Figs. 113c,d. *Spire* (*Coils*) Sculpture, 2007, pleated silk velvet and silk taffeta (N.324)

# Notes

## Roberto Capucci and the Birth of Italian Fashion, 1951–61

1. By 1951 twenty-two million dollars of U.S. aid had been invested in the modernization of the Italian textile industry, and that year 60 percent of Italy's raw cotton came from the United States; see Walter Lucas, "Florence Has Designs on Fashions: Italian City Makes Debut," *Christian Science Monitor*, August 28, 1951. According to Elisa Massai of *Women's Wear Daily*, "Italian textiles were the most important factor, about 60 per cent, in the success of the Italian fashion industry"; quoted in Nicola White, *Reconstructing Italian Fashion: America and the Development of the Italian Fashion Industry* (Oxford: Berg, 2000), p. 31.

2. Marya Mannes, "Italian Fashion," *Vogue*, January 1, 1947, p. 156. In September 1946 Mannes had observed that despite the "bitter division between north and south, between right and left" in Italy, the people were pulling together in a "sort of defiant unity": "There is a ferment in the Italian air that makes one believe, rightly or wrongly, that if Italy is allowed a period of peace and freedom, she may contribute to Europe and to us an extraordinary creative vitality"; Marya Mannes, "Italy Revives," *Vogue*, September 15, 1946, pp. 197, 198. Nearly a year later Frances Keene of *Harper's Bazaar* reported on the vitality of Italian artisans and craftsmen, stating that the country's best chance of economic renewal was in "the encouragement of the luxury trades"; Frances Keene, "The New Italy," *Harper's Bazaar*, July 1947, p. 36. Keene credited Italy's astonishing revitalization less to a structured recovery plan and more to the "aggressive imagination and dogged persistence" of the country's artists, designers, weavers, etc.; ibid., p. 31. For a closer examination of the roles of the Italian fashion and textile industries in the regeneration of the country's economy after World War II, see White, *Reconstructing Italian Fashion*.

3. "Hollywood on the Tiber," *Time*, June 26, 1950, p. 92. The article's title appears to be the origin of this nickname.

4. The Roman fashion house of Sorelle Fontana—founded in 1944 by sisters (*sorelle*) Giovanna, Micol, and Zoe Fontana—was a particular favorite among actresses, including Ava Gardner (1922–1990), who wore the sisters' designs on and off the set of *The Barefoot Contessa*.

5. For a more detailed look at Giorgini and the first Italian fashion shows, see Guido Vergani, ed., *The Sala Bianca: The Birth of Italian Fashion*, trans. Antony Shugaar (Milan: Electa, 1992).

6. The invitation to the ball for Giorgini's first fashion show is reproduced in Guido Vergani, ed., *Fashion Dictionary* (New York: Baldini Castoldi Dalai Editore Inc., 2006), p. 541.

7. See "Italian Styles Gain Approval of U.S. Buyers," *Women's Wear Daily*, February 14, 1951, quoted in White, *Reconstructing Italian Fashion*, p. 45.

8. Carmel Snow, *The World of Carmel Snow*, with Mary Louise Aswell (New York: McGraw-Hill, 1962), p. 181.

9. [Sally Kirkland], "Italy Gets Dressed Up," *Life*, August 20, 1951, pp. 104–12.

10. "Florence Extols Designer Capucci," *New York Times*, July 23, 1952.

11. "La bombe de Florence a ébranlé les salons de la haute couture parisienne et menacé son monopole," *Paris-presse l'intransigeant*, August 6, 1951, reproduced in Vergani, *Sala Bianca*, p. 22. Giorgini's next Italian fashion show, the third, would precede the Paris openings by three weeks, prompting an Italian designer to declare, "So there, . . . this time [Paris] can't say we copied"; Italian designer, quoted in Associated Press, "Italian Fashions Shown," *Christian Science Monitor*, January 23, 1952. In an interview in January 1953, Giorgini, responding to the French media's ongoing accusation that Italian designers copied Paris styles, asserted, "That's not true at all. I know of at least two Milan designers who go four times a year to sell designs to French couturiers"; Associated Press, "Rivalry Hot: Italy Bids for Fashion Supremacy," *Washington Post*, January 27, 1953.

12. See Lucas, "Florence Has Designs on Fashions"; and Nadeane Walker, "Italian Look 'Prettier' than the Paris Look," *Washington Post*, September 16, 1951.

13. "From the Italian Collections, Casual Clothes," *Vogue*, September 1951, p. 189.

14. See B. J. Perkins, "Two U.S. Firms Arrange Style Tieups in Italy," *Women's Wear Daily*, August 2, 1951.

15. Walker, "Italian Look 'Prettier.'"

16. See Glenn Fowler, "'Italy-in-Macy's, U.S.A.' Offers Colorful and Lavish Displays," *Women's Wear Daily*, September 11, 1951; and "Macy's Devotes 48 Window Displays to 'Italy-in-Macy's' Promotion," ibid.

17. *Italy at Work: Her Renaissance in Design Today*, Brooklyn Museum, Brooklyn, NY, November 30, 1950–January 31, 1951. The exhibition traveled to several other American cities, including (in the following order) Chicago, San Francisco, Portland, Minneapolis, Houston, Saint Louis, Toledo, Buffalo, Pittsburgh, Baltimore, and Providence. American industrial designer Walter Dorwin Teague (1883–1960) was among the selection committee members who toured Italy for two months to identify objects to include in the show; see Meyric R. Rogers, *Italy at Work: Her Renaissance in Design Today*, exh. cat. (Rome: Instituto Poligrafico dello Stato, 1950).

18. The *New York Times* reported that representatives from all 150 American department stores and manufacturers who attended Giorgini's third fashion show made purchases; see "Italian Is Praised for High Fashions: Florentine Exporter's Third Show a Success, but Paris Is Still the Style Center," *New York Times*, January 29, 1952.

19. See Walter Lucas, "Choice Fabrics, Fair Prices, and Gay Sportswear Interest Overseas Buyers in Italian Fashions," *Christian Science Monitor*, February 8, 1952; and "Italian Fashions Shown," *Christian Science Monitor*.

20. Roberto Capucci, quoted in James E. Parlatore, "Young Italian Designer Caters Only to Youth," *Dallas Morning News*, May 18, 1952.

21. See Barbara E. Scott Fisher, "Rome and Milan Designers Highlight Summer Styles," *Christian Science Monitor*, June 16, 1952.

22. See "An Italian Designer at Work Here," *New York Times*, May 21, 1952; and advertisement for Gimbels published in the *New York Times*, May 18, 1952.

23. In 1982 the Italian fashion shows moved to Milan, where the majority of the country's textile manufacturers are located.

24. See Reuters, "Fashion Spotlights Italy," *Christian Science Monitor*, July 30, 1952. In 1946 Dior opened his fashion house in Paris with financial support from Boussac.

25. "Florence Extols Designer Capucci."

26. Examples of Capucci's tailor-mades were illustrated in "The Narrow Silhouette Stands Up," *Women's Wear Daily*, July 30, 1952.

27. Fay Hammond, "Pitti Palace Style Show Sets Pace," *Los Angeles Times*, July 31, 1952.

28. "Italian Collections Notebook," *Vogue*, September 15, 1952, pp. 154 (repro.), 155.

29. "Florence Styles Emphasize Details," *New York Times*, July 24, 1953.

30. See Fay Hammond, "Textiles Unsurpassed," *Los Angeles Times*, August 4, 1953. Italian textile manufacturers, whose magnificent fabrics continued to receive praise from buyers and the press, would commission couturiers, including Capucci, to create special models to showcase their products. The manufacturers presented in Florence until 1955, when they began to show separately in Milan. As Nicola White in *Reconstructing Italian Fashion* noted, Italy's textile manufacturers were "very keen to use Italian fashion designers to promote their materials, because it was extremely cost-effective publicity, and enhanced the elite status of their fabrics, . . . The couture houses did not generally have the money for extensive promotion and advertising, but the textile houses did and they undoubtedly helped to promote Italian high fashion in the process"; White, *Reconstructing Italian Fashion*, p. 29.

31. Cynthia Cabot, *Retail Report from Italy*, Fashion Teletype for the *Philadelphia Inquirer*, July 26, [1953]. A copy of the report resides in the Departmental Files of the Department of Costume and Textiles, Philadelphia Museum of Art.

32. See Miriam Neubert, *European Report*, Philadelphia Fashion Group, March 1, 1954; and Kittie Campbell, *Kittie Campbell Reports to the Trade from Rome, Florence*, Trade Report for the *Philadelphia Bulletin*, Spring 1954. Copies of the reports reside in the Departmental Files of the Department of Costume and Textiles, Philadelphia Museum of Art.

33. Cynthia Cabot, quoted in Campbell, *Kittie Campbell Reports*, Spring 1954.

34. Campbell, *Kittie Campbell Reports*, Spring 1954.

35. Virginia Pope, "Glamour Marks Capucci's Gowns," *New York Times*, July 23, 1954; and Pope, "Fine Italian Hand," *New York Times Magazine*, September 5, 1954, p. 36.

36. Kittie Campbell, *Kittie Campbell Reports to the Trade from Rome, Florence*, Trade Report for the *Philadelphia Bulletin*, Fall and Winter 1954–55. A copy of the report resides in the Departmental Files of the Department of Costume and Textiles, Philadelphia Museum of Art. The Paris fashion shows were held in individual designers' salons, so buyers and journalists had to hurry from atelier to atelier in order to view the presentations.

37. See Jane Cianfarra, "Italy: Suit Jackets with Bloused Back," *New York Times*, July 26, 1955. The illustrations of Capucci's fuchsia-inspired dresses were reproduced in the August 2, 1955, edition of the *New York Times*.

38. Gloria Swanson, "Designer Creates New Idea for Ladies' Style," *Neosho (MO) Daily News*, February 10, 1956.

39. Ann Carnahan, "Fashions from Abroad: Florence; Capucci Stunning Success," *New York Times*, January 28, 1956.

40. Ailsa Garland, "Roberto Wins—with Romance," *Daily Mirror* (London), January 27, 1956. On February 12, 1947, Dior presented his debut collection during the Paris spring/summer fashion shows. The collection, which *Harper's Bazaar* editor Carmel Snow named the New Look, revolutionized women's fashion; the soft shoulders, small waists, and full, flowing skirts made of luxurious fabrics marked a major shift from the stringent postwar styles. The influential New Look helped Paris regain its prominence in the fashion industry.

41. See "Italy: Four Roman Beauties, in Dresses from the New Italian Collections," *Vogue*, March 15, 1956, pp. 116–17. The caption for a photograph of Mayneri reproduced in the September 15, 1946, issue of *Vogue* referred to her as "Rome's most ravishing beauty"; Mannes, "Italy Revives," p. 200.

42. See "Fashions from Italy," *Look* (Des Moines, IA), May 1, 1956, pp. 68–72.

43. Until 1971, when the United Kingdom implemented a decimalized currency system, one guinea equaled one pound and one shilling (or, twenty-one shillings).

44. "I. Magnin Import Themes: Tri-Section Coat, Rose Print Taffetas," *Women's Wear Daily*, March 9, 1956.

45. Advertisement for Marks and Spencer published in the *Daily Mirror* (London), February 20, 1956.

46. Alison Adburgham, "Warm Squash at the Palazzo Pitti," in *View of Fashion* (London: Allen and Unwin, 1966), p. 134. Originally published in *Punch*, August 14, 1957.

47. See Gloria Swanson, "French Couturiers Are Not All French So Says Swanson," *Weirton (WV) Daily Times*, June 20, 1956. Swanson, who had covered the royal wedding for the United Press, also reported that before going to Monaco she had spent two to three hours a day for ten days at Capucci's atelier in Rome while being fitted for a dress to wear to the ceremony.

48. The title *Nove gonne* sometimes appears as *Dieci gonne* (*Ten Dresses*). The discrepancy derives from whether the sheath that is underneath the nine overlaying skirts is counted.

49. The Cadillac advertisement was published in *Harper's Bazaar*, August 1957, p. 9. The syndicated cartoon *It's Me, Dilly*, written by Mel Casson and drawn by Alfred Andriola under the pseudonym Alfred James, appeared in the November 24, 1957, edition of the *Dallas Morning News*.

50. See Hedda Hopper, "Italian Plum Handed to Mamie Van Doren," *Los Angeles Times*, July 2, 1957.

51. According to Martinelli, Capucci taught her "how to hold herself, how to smile, and how to walk as a 'real' model"; Martinelli, quoted in E. L., "Elsa Martinelli: da Trastevere a Hollywood, la lunga strada verso il successo della ragazza che in Italia non riusciva a fare del cinema," *Bolero Film*, December 2, 1956, pp. 16–17, quoted in Réka Buckley, "Elsa Martinelli: Italy's Audrey Hepburn," *Historical Journal of Film, Radio and Television* 26, no. 3 (2006), p. 332.

52. "Italian Celebrity of Fashion World Here," *Los Angeles Times*, August 6, 1956.

53. Dorothy Hawkins, "Rome: Eyes on Capucci," *New York Times Magazine*, September 9, 1956, p. 28.

54. The couturiers who presented in Rome this season included Capucci, Carosa, Fabiani, Garnett, Gattinoni, Giovannelli, Mingolini-Guggenheim, Simonetta, Sorelle Fontana, and the boutique La Tessitrice dell'Isola; see Dina Tangari, "Rome, Too, Dictates Styles," *Christian Science Monitor*, January 31, 1957. Although it appears that Antonelli, Marucelli, Pucci, Schuberth, and Veneziani were among the participants in Florence this season, accounts vary regarding exactly which (and how many) other designers presented. Tangari, for example, cited the number as ten, but her ensuing list comprised eleven designers. For other reports see Anita Ricci de Beltran, "New Florentine Fashions Make Dramatic Pictures," *Washington Post*, February 10, 1957; and Cele Wohl, "Unusual Styles Mark Italian Fashion Show," *Spokane (WA) Daily Chronicle*, January 23, 1957.

55. Marjorie J. Harlepp, "Italian War in Fashion Said Over," *Montreal Gazette*, July 23, 1957.

56. Alison Adburgham, "Wholly Roman Empire," *Punch*, August 7, 1957, p. 162. Subsequently published in Adburgham, *View of Fashion*, pp. 129–30.

57. Eugenia Sheppard, "Some Horrors Too: Suits are Beribboned," *Winnipeg Free Press*, July 24, 1957; and Adburgham, "Wholly Roman Empire," p. 162 (italics in original).

58. See "Rome Burns Again," *Washington Post*, January 14, 1958.

59. See White, *Reconstructing Italian Fashion*, p. 52; and "Italian Style Fetes to Aid Polio," *New York Times*, March 6, 1958.

60. The couturiers whose designs were included in the festival included Antonelli, Capucci, Carosa, Fabiani, Marucelli, Schuberth, Simonetta, and Veneziani; the boutiques of Avolio and Bertoli; the men's tailoring shops Brioni and Datti; and ready-to-wear knitwear designers Mirsa and Gino Paoli. The organization of the show was a mammoth undertaking: According to the *New York Times*, the collections filled fifty-seven suitcases and weighed two tons. Moreover, each participating store provided its own fashion models, who had to be fitted before every show; see "Italian Style Fetes to Aid Polio."

61. Capucci's hemlines were the shortest among the fashions shown at the import show. Reporter Gloria Emerson, who observed that Capucci's skirts barely covered the models' kneecaps, pointed out that Alexander's copies of his designs would likely have longer hems; see Gloria Emerson, "Everything Just 'Roger' in Idlewild Style Show," *New York Times*, September 9, 1958.

62. Roberto Capucci, quoted in Herta Lorraine-Lerner, "In Italy . . . Elegant Fashions Cast Slimmest of Shadows," *Washington Post*, August 14, 1959.

63. Machado, Avedon's muse, is of Chinese and Portuguese descent. Avedon's photograph was reproduced in *Harper's Bazaar*, October 1959, p. 150.

64. Eugenia Sheppard, "Baby-Faced Robert [sic] Capucci's Crazy Mixed-Up Kid or Hero," *Dallas Morning News*, January 22, 1960.

65. Carrie Donovan, "Spring Fashion Trends Abroad: Florence; Loud 'Bravos' Greet Capucci Collection," *New York Times*, January 21, 1960.

66. Advertisement for Alexander's (New York) published in the *New York Times*, March 6, 1960.

67. Patricia Peterson, "Fashion Trends Abroad: Florence; Thunderous Applause Greets Simonetta Collection," *New York Times*, July 20, 1960.

68. Fay Hammond, "Pitti Palace Rocks: Italian Styles Win Bravos," *Los Angeles Times*, July 20, 1960.

69. See Gloria Emerson, "Capucci Will Leave Italy to Open House in Paris," *New York Times*, July 15, 1961.

70. The Philadelphia fashion show, advertised as "A Gala Presentation of 1961 Originals for Spring and Summer," took place on February 20, 1961. The Festival of Italy opened on January 21, 1961, and continued for nine weeks.

71. Patricia Peterson, "Capucci Seen at His Best in Final Italian Showing," *New York Times*, July 19, 1961.

72. Marjorie J. Harlepp, "U.S. Ordering at Florence Houses Strong," *Women's Wear Daily*, July 21, 1961.

### From the Tiber to the Seine: Capucci in Paris, 1962–68

1. Press clippings, c. January/February 1962, Roberto Capucci press files, Fondazione Roberto Capucci, Florence. Capucci's first Paris collection, *Linea pura*, was named after his working method in which he begins each drawing with a central axis and sketches the design from there. As Capucci later explained to Germano Celant, "I have a method, as one can see in the drawings, based on the center . . . [T]his is my working method, even for the softest dresses. When I draw I trace a central line, and then I think on top of it"; "Roberto Capucci," by Germano Celant, *Interview* (New York) 20, no. 9 (September 1990), p. 130. The innovative and influential designs of Spanish-born couturier Cristóbal Balenciaga (1895–1972), who opened a salon in Paris in 1937, had a profound impact on twentieth- and twenty-first-century fashion.

2. Patricia Peterson, "Capucci Has Exciting Paris Debut, Bringing the Best of Italy with Him," *New York Times*, January 27, 1962.

3. Chicago Daily News Foreign Service, "Capucci Applauded for New Collection Rated as 'The Most,'" *Los Angeles Times*, January 27, 1962.

4. See "Double Debut in Paris Style," *Life*, March 2, 1962, p. 85. The *Life* article incorrectly described Saint Laurent as twenty-six years old (his twenty-sixth birthday was not until August 1962).

5. See "Barentzen's Move Slated for January," *New York Times*, May 2, 1962. In the end, Barentzen decided to remain in Italy (where he maintained a studio in Rome until 1972), claiming he was "furious" with the French critics' negative reviews of Capucci's, Fabiani's, and Simonetta's fall/winter 1962–63 collections; see Carrie Donovan, "Barentzen's Move to Paris Is Canceled," *New York Times*, September 28, 1962.

6. See Bernadine Morris, "Couture Copies in Debut Here," *New York Times*, March 6, 1964; Angela Taylor, "Here's a Look at the New Alexander's," *New York Times*, August 27, 1965; and Gloria Emerson, "3 Young Paris Designers Take a Look at Spring," *New York Times*, January 31, 1966.

7. Peterson, "Capucci Has Exciting Paris Debut."

8. Carrie Donovan, "Couturiers Favor the Trouser Skirt," *New York Times*, July 28, 1962; and Aline Mosby, "Italian Mode Wins Paris," *Los Angeles Times*, July 30, 1962.

9. Donovan, "Barentzen's Move to Paris Is Canceled."

10. Gloria Emerson, "Paris Having Fun with Fashion," *New York Times*, August 2, 1965.

11. For illustrations of Vasarely's work, including his Op art compositions, see Belinda Firos, Maria Fedas-Kondoprias, and Tristan Cormier, trans. and eds., *Vasarely: To apolyto mati (L'oeil absolu; The Absolute Eye)*, 3 vols., exh. cat. (Athens: Artistic Investments, [2006]).

12. Patricia Shelton, "Wardrobe Update: Paris Makes It Plain," *Christian Science Monitor*, January 31, 1967.

13. Eugenia Sheppard, "Ungaro's Skirts at Mid-Thigh, Paris' Shortest," *Los Angeles Times*, January 31, 1967.

### The Return to Rome: Experimentation and Discovery, 1968–79

1. Employees of the Paris couture houses did not strike, but the lack of buses, subways, and taxis due to the transport walkout meant that many personnel had no means of getting to work (Dior claimed that 50 percent of its staff was unable to report; Saint Laurent, 75 percent); see Gloria Emerson, "Paris Couturiers Cheer Up: They Now Doubt a Delay in Showing Winter Styles," *New York Times*, June 5, 1968. Fortunately, the strike ended and the fall/winter 1968–69 fashion show went on in July as scheduled.

2. In reaction to de Gaulle's denunciation of Israel's attacks on Egypt, Jordan, and Syria in the Six-Day War of June 1967, a group of leading American dress manufacturers announced it would protest the French president's statements. The group later backed down from this position, suggesting instead that dressmakers register their complaints individually; as a result, several manufacturers refused to attend the Paris spring/summer 1968

fashion shows (see Isadore Barmash, "Dress Producers Drop Protest Against de Gaulle Statements," *New York Times*, December 17, 1967; and Douglas Robinson, "Americans Voice Anger at de Gaulle, but Active Francophobia Seems Limited," *New York Times*, February 7, 1968). Further upsetting Paris couture was the announcement in late May 1968 that Cristóbal Balenciaga, the "king of the high fashion world," was closing his salon permanently, partly due to financial difficulties related to rising costs and fewer clients of haute couture. Other couturiers had maintained financial stability by branching out into children's wear, menswear, ready-to-wear, or merchandise such as jewelry, scarves, but Balenciaga preferred to retire than to compromise; Joan Deppa, "Fashion King Closes Salon," *Washington Post*, May 23, 1968. See also "Nothing Left to Achieve, Balenciaga Calls It a Day," *New York Times*, May 23, 1968; and Lucie Noel, "After Revolt, Comes Couture," *Washington Post*, July 21, 1968.

3. Capucci's return to Rome was rumored as early as September 1962, just months after he arrived in Paris, when the French press had "doomed" the fall/winter 1962–63 collections of Capucci, Fabiani, and Simonetta; see Carrie Donovan, "Barentzen's Move to Paris Is Canceled," *New York Times*, September 28, 1962. In her review of the Paris spring/summer 1967 collections, Eugenia Sheppard had commented that "Capucci, a transplant from Italy, would have had an ovation anywhere except in Paris couture"; see Eugenia Sheppard, "Ungaro's Skirts at Mid-Thigh, Paris' Shortest," *Los Angeles Times*, January 31, 1967.

4. "I missed the colours of Rome. It may be a vulgar, self-assertive, even nasty city but it has this wonderful colour—I had to return"; Roberto Capucci, quoted in Colin McDowell, "Roman Splendour," *Country Life* (London), February 27, 1986, p. 542.

5. Roberto Capucci, quoted in Logan Bentley Lessona, "Italian Designer Sights End of High-Fashion Era," *Christian Science Monitor*, September 15, 1975.

6. Although Capucci had designed the personal wardrobe of actress Elsa Martinelli for Mario Monicelli's film *Donatella* (1956), his role for *Teorema* was more formal, as he worked closely with the director and was responsible for interpreting the costume needs of the characters throughout the film.

7. In response to an increased foreign interest in Indian craft goods, in 1965 the Handicrafts and Handlooms Corporation opened a store in New York, followed by branches in Cambridge, Hamburg, and Paris. Capucci was one of several designers who collaborated with the organization on Indian fabrics. Others included French couturiers Pierre Cardin (born 1922) and Charvet, a bespoke boutique specializing in neckties, shirts, and suits; and Japanese designer Hanae Mori (born 1926; see Niti Salloway, "India's Rural Art Flourishes," *Christian Science Monitor*, August 3, 1971).

8. Patricia Shelton, "Italian Couture Takes a Lengthy Look at Fall-Winter," *Christian Science Monitor*, July 16, 1970. Although Shelton praised Capucci's collection as beautiful, she questioned the practicality of his designs ("they're hardly the kind [of clothes] you'd wear in the metro or cross-country"); ibid. Moreover, the press reported that the few American buyers in Rome for the fall/winter showings were unsure if Capucci's dresses could easily be copied; see "Three Collections Livened Things Up," *Lowell (MA) Sun*, August 5, 1970.

9. See Leonora Dodsworth, "Designer's Homecoming Highlights Fashion Show," *High Point (NC) Enterprise*, January 26, 1969.

10. For illustrations of Alberto Burri's work, including his *Cretti* paintings, see Maurizio Calvesi, *Burri inedito*, exh. cat. (Milan: Edizioni Charta, 2000). American couturier Ralph Rucci (born 1957) later would adapt Capucci's intarsia method in his own designs. Rucci admired Capucci for his "mastery of volume, the liberation of color, and the idea of fashion as sculpture"; Ralph Rucci, quoted in Valerie Steele, Patricia Mears, and Clare Sauro, *Ralph Rucci: The Art of Weightlessness* (New Haven, CT: Yale University Press, 2007), p. 46.

11. By the next season, fall/winter 1971–72, critics began to complain about the Italian designers' repetition of the "return-to-the-classics theme" and commended Capucci for presenting "one of the few collections that said 1970 rather than 1940"; Logan Bentley Lessona, "Florentine Flair," *Christian Science Monitor*, May 18, 1971. See also "Roman Fashion Fizzle," *Washington Post*, July 21, 1971. Fashion writer Bernadine Morris lamented that Capucci had not reclaimed his place among the top Italian couturiers, commenting that his clothes were the most modern shown that season: "[H]e's an original talent. He doesn't copy the looks in the street. He doesn't copy Saint Laurent"; see Morris, "The Big Message from Rome: Real Clothes Are Back in Style," *New York Times*, July 21, 1971.

12. Bernadine Morris, "Couturiers Bring Back '40's Look," *New York Times*, January 19, 1971.

13. Among the designers who did not show in the spring/summer 1972 show in Rome were Sorelle Fontana, whose factory was on strike; Carosa, who had decided to focus on prêt-a-porter; and Antonelli, who held a private showing for friends and potential buyers (see Bernadine Morris, "Italy's Designers Decide to Play It Safe and Send Those Wild Styles to the Attic," *New York Times*, January 19, 1972).

14. Logan Bentley Lessona, "Rome Reports 'Luxury-Loving' Fabrics and Styles," *Christian Science Monitor*, September 11, 1978. Bentley described Capucci's gowns as "'sculptured' evening dresses which looked as if they would stand up on their own"; ibid.

15. Daniela Petroff, "Italian Fall Couture: Ciao to Limitations," *Los Angeles Times*, July 21, 1978.

### Beyond Fashion, 1980–2007

1. Daniela Petroff, "High Fashion Being Promoted," *Spokane (WA) Daily Chronicle*, July 28, 1980.

2. Ibid. During the fall/winter 1980–81 high-fashion shows in Rome, Balestra and Valentino showed sunglasses that coordinated with their clothing collections. Capucci, endeavoring into commercial ventures, and Valentino created luxurious couture bed linens.

3. Roberto Capucci, quoted in Lucia Fornari Schianchi, ed., *Roberto Capucci al Teatro Farnese*, trans. Edward Steinberg and James MacDonald, exh. cat. (Rome: Progetti Museali Editore, 1996), p. 109.

4. Bernadine Morris, "Milan: Italian Designers Turn to Clean Lines," *New York Times*, October 5, 1982.

5. Capucci, quoted in Schianchi, *Roberto Capucci al Teatro Farnese*, p. 109. Regarding how he chose where he presented his solo shows, the designer explained he went to "[w]hatever city" was "ready to welcome" him; ibid., p. 184.

6. Capucci exhibited twelve original sculptures in fabric, each bearing the names of natural materials, such as elements or minerals. A checklist of the designs presented at the Biennale can be found in *La Biennale di Venezia: 46. esposizione internazionale d'arte* (Venice: Marsilio, 1995), p. 13. The catalogue includes illustrations of four of the designs—*Antimonte (Antimony)*, *Cinabro (Cinnabar)*, *Sagenite*, and *Ossidiana (Obsidian)*; ibid., pp. 12, 14, 15 (repros.). Capucci's work has been the focus of several art exhibitions: *Roberto Capucci, l'arte nella moda: volume, colore, metodo*, the first retrospective of his work (Palazzo Strozzi, Florence, January–February 1990; and Stadtmuseum, Munich, April–September 1990); *Roberto Capucci, Roben wie Rüstungen Mode in Stahl und Seide, Einst und Heute*, in which eight of his designs were shown with fifteenth-century European armor (Kunsthistorisches Museum, Vienna, December 1990–April 1991); and more recently, *Fantasie Guerriere: una storia di seta fra Roberto Capucci e i Samurai*, in which his work was exhibited with Japanese armor (Filatoio di Caraglio, Caraglio, Italy, September 27, 2008–January 6, 2009).

7. Roberto Capucci, quoted in Diana Loercher, "Italian High Fashion—A Return to the Full, Soft, and Flowing," *Christian Science Monitor*, July 31, 1972.

8. Logan Bentley Lessona, "Italian Designer Sights End of High-Fashion Era," *Christian Science Monitor*, September 15, 1975.

9. Associated Press, "Italian Shows End in Blaze of Sequins," *Baltimore Sun*, January 29, 1980. The article described Capucci's clothes as "theatrical rather than practical," but commended the designer's innovative ideas, which invariably would "show up in other collections the following seasons"; ibid.

10. See Fondazione Roberto Capucci, "Biography," 1980–84, http://www.fondazionerobertocapucci.com/bio/80-84_en.xml.

11. Bernadine Morris, "Milan: Italian Designers Turn to Clean Lines," *New York Times*, October 5, 1982.

12. Capucci, quoted in Schianchi, *Roberto Capucci al Teatro Farnese*, p. 106.

13. Anne-Maria Schiro, "Notes on Fashion," *New York Times*, May 7, 1985.

14. *Nocturnalis*, with visual direction by Franco Angeli, was staged at the Casina del Cardinale Bessarione in Rome on May 29, 1985; see Laboratorio di ricerca Multimediale Intersettoriale, "Vritti Opera," *Nocturnalis*, http://www.ips.it/vrttiopera/teatro/nocturnalis1.html.

15. Diana Loercher, "Italian High Fashion—A Return to the Full, Soft, and Flowing," *Christian Science Monitor*, July 31, 1972. According to Loercher, Capucci found eight or nine pleating machines, which he then had restored; see ibid.

16. Capucci discussed this collection in "Roberto Capucci," by Germano Celant, *Interview* (New York) 20, no. 9 (September 1990), p. 130; and Minnie Gastel, "A Solitary Artist," *Donna* (Milan), March 1990, n.p.

17. Roberto Capucci, quoted in Colin McDowell, "Roman Splendour," *Country Life* (London), February 27, 1986, p. 542. According to Capucci, "Io non lavoro soprattutto per vendere. Io lavoro il piacere di lavorare, per dare alla gente occasione di eleganza e di cultura" (I do not work primarily for selling. I work for the pleasure of working, for giving people an opportunity of elegance and culture); Capucci, quoted in Maria Armezzani et al., *Davanti alle opere di Roberto Capucci: una lettura psicologica* (Padova: Imprimitur, 1999), p. 143 (my translation).

18. *Roberto Capucci: ritorno alle origini; omaggio a Firenze*, Museo della Fondazione Roberto Capucci, Villa Bardini, Florence, October 27, 2007–June 27, 2008.

## Selected Bibliography

Bianchino, Gloria, Grazietta Butazzi, Alessandra Mottola Molfino, and Arturo Carlo Quintavalle. *Italian Fashion*. 2 vols. Translated by Paul Blanchard. Milan: Electa, 1987.

Paris, Ivan. *Oggetti cuciti: l'abbigliamento pronto in Italia dal primo dopoguerra agli anni Settanta*. Milan: F. Angeli, 2006.

Steele, Valerie. *Fashion, Italian Style*. New Haven, CT: Yale University Press, 2003.

Vergani, Guido, ed. *Fashion Dictionary*. New York: Baldini Castoldi Dalai Editore Inc., 2006.

——, ed. *The Sala Bianca: The Birth of Italian Fashion*. Translated by Antony Shugaar. Milan: Electa, 1992.

White, Nicola. *Reconstructing Italian Fashion: America and the Development of the Italian Fashion Industry*. New York: Berg, 2000.

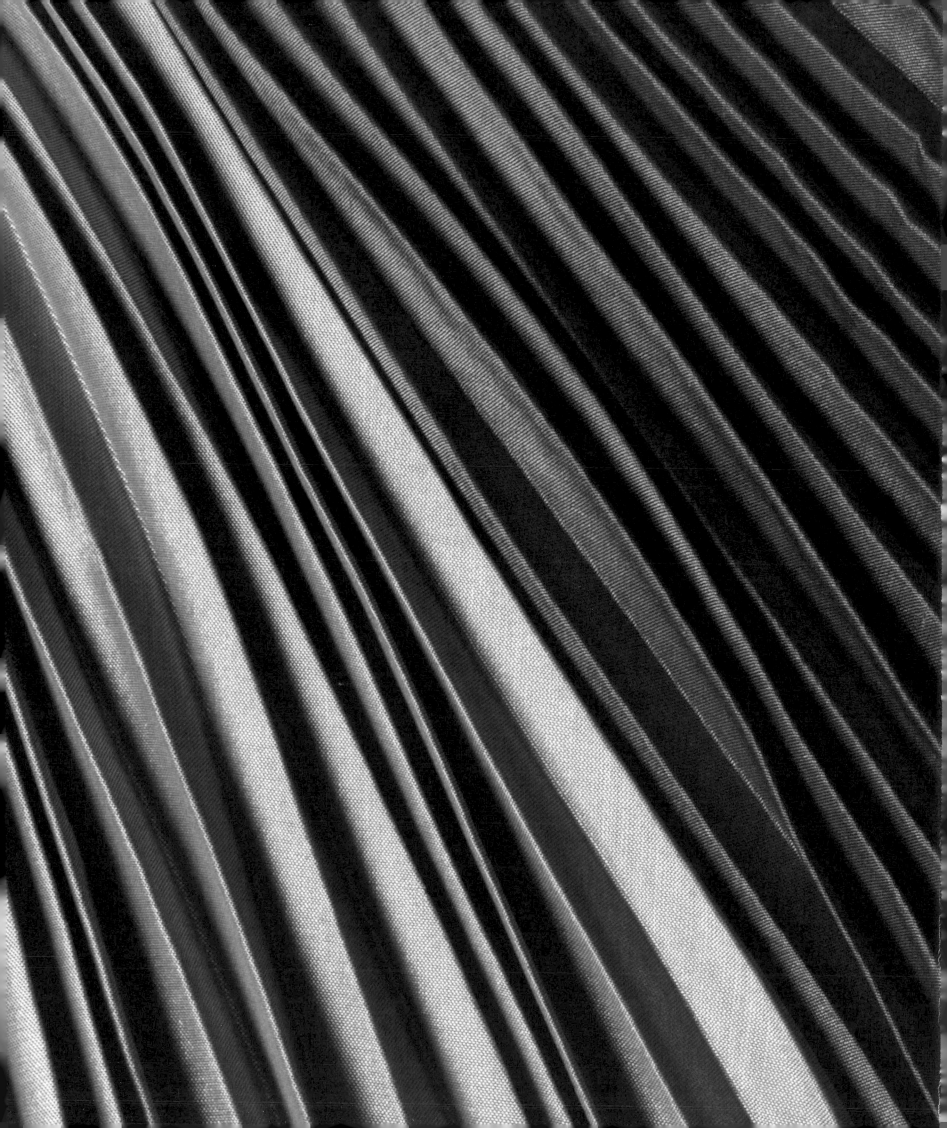